LOOKING AT PICTURES
WITH BERNARD BERENSON

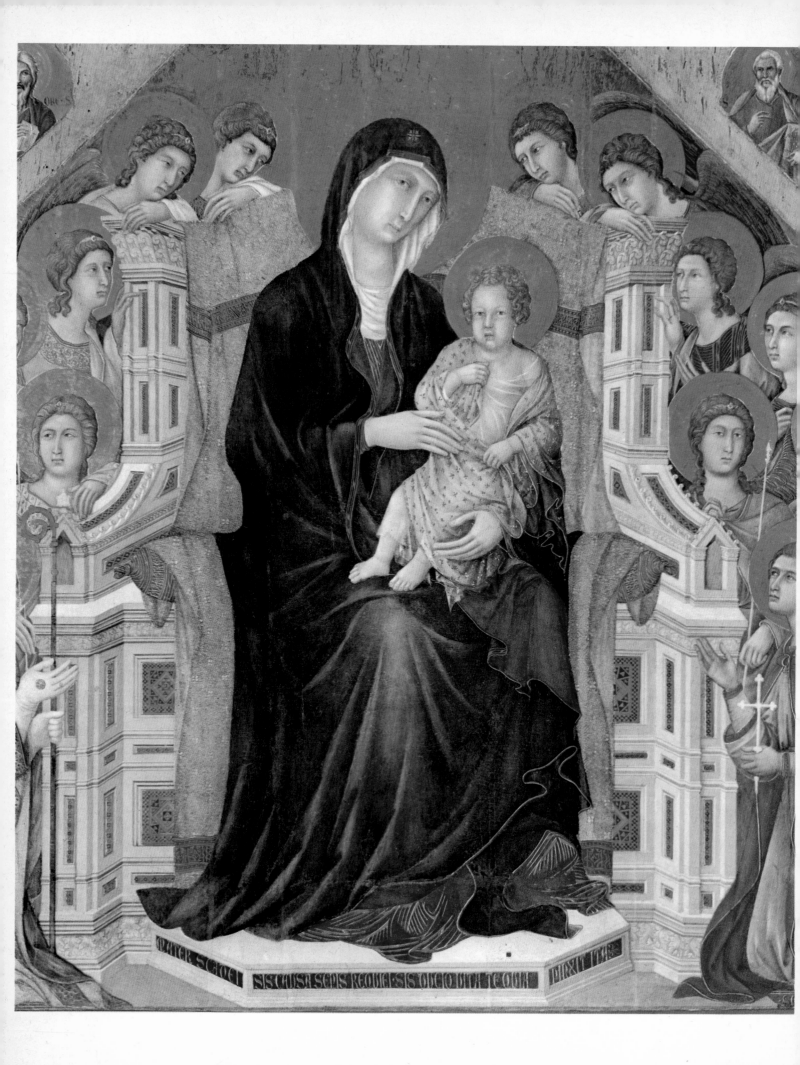

LOOKING AT PICTURES WITH

Bernard Berenson

Selected and with an introduction by *Hanna Kiel*

With a personal reminiscence by *J. Carter Brown*

HARRY N. ABRAMS, INC.

PUBLISHERS · NEW YORK

Madonna Enthroned

1308–11. Central Panel of the Siena Maestà. Detail.
Museo dell'Opera del Duomo, Siena

DUCCIO DI BUONINSEGNA
Siena, active 1279–1318

Standard Book Number: 8109–0042–4
Library of Congress Catalogue Card Number: 72–125795
© Copyright 1974 in Israel by Massada Press, Jerusalem
Printed and bound in Israel
by Peli Printing Works Ltd.

TO THE MEMORY OF B.B. AND NICKY MARIANO IN DEEP GRATITUDE

We must look and look and look till we live the painting and for a fleeting moment become identified with it. If we do not succeed in loving what through the ages has been loved, it is useless to lie ourselves into believing that we do. A good rough test is whether we feel that it is reconciling us with life. No artifact is a work of art if it does not help to humanize us. Without art, visual, verbal and musical, our world would have remained a jungle.

I Tatti, Settignano, Florence, January 1952

CONTENTS

LIST OF ILLUSTRATIONS

A PERSONAL REMINISCENCE

by J. Carter Brown, Director National Gallery of Art, Washington, D.C.

Bernard Berenson was in his middle thirties—my present age—already in the nineteenth century. Living at I Tatti, his villa outside Florence, and hurling myself into his tutelage, was like walking into some mad doctor's time machine out of science fiction. Henry James, Oscar Wilde—these were contemporaries, acquaintances. Berenson's comments in this book are rooted visibly enough in nineteenth-century aestheticism. Yet so much of what he says is just as eye-opening for us today. There is a justice in the thought of a man so passionately dedicated to the instant being able to defy time. Such, at any rate, was the miracle of my own brief experience of Berenson the man, working under him in that setting from another age, and being made to feel a preternatural rapport across a generation gap of close to seven decades.

Communication had not started quite so smoothly. I first met Berenson almost by accident. The Harvard Glee Club was touring Europe shortly after my graduation in the spring of 1956, and we had just finished singing in Florence as part of the "Maggio Musicale" festival. The concert was one of the most moving of the tour. Held in the dimly lit spaces of Santa Trìnita, it was an occasion where Renaissance motet and Renaissance architecture reinforced each other, creating a new totality. Nicky Mariano, the womanly incarnation of everything I Tatti was about, came up to us afterward and insisted that, with his double interest in Harvard and in music, B. B. must have a private concert in his library the next day. A few of us went out. During lemonade on the terrace after the concert we were brought up, one by one, to meet the little bearded figure wrapped in shawls.

I was about to accompany my father to Istanbul on a trip he was taking for the Byzantine Institute. I remember being pretty defensive

about the Byzantine style, quoting to Berenson Thomas Whittemore's description of Italian primitive painting as "trying to put out hellfire with holy water." It was not a harmonious conversation. In passing I mentioned that when I got through my course in business administration as preparation for a museum career, my next step would be to plunge into the graduate study of art history. In view of the tone of our exchanges, it was something more than a surprise when, at the end of the discussion, not to say argument, I found myself invited to come to I Tatti and study with Bernard Berenson.

In the cavalier manner of youth, to which mortality is only a known, not a felt concept, I did not get around to taking him up on the offer until September of 1958. I had harbored in the interim a very specific mental picture of a kind of dormitory attached to the villa where a band of young novitiates was quartered. It was news, then, to learn after ringing for the great metal gates in Settignano to open, and finding that B.B. and Nicky were still at his summer place in Vallombrosa, that no such quarters existed, that there were no more students (the last, Willy Mostyn Owen, having gone home), and that the arrangement simply was that I would be welcome to use the library on weekdays between certain hours.

This I did, following almost daily reports that the return of the master from Casa al Dono was set for the next day, only to find the trip put off again. Berenson always regarded that library as his most significant achievement and, in a sense, as his autobiography. I remember its stillness and its specific smell, a combination of old paper and bindings and a special lemon oil used on the paneling and floors. Rumor would rustle through the small staff as through a Gothic court, while the honey-colored Tuscan sun slanted in through windows and imprisoned, as in amber, the silent lemon trees and cypresses outside. Today? No, tomorrow, without fail.

Late one morning the arrival of Nicky Mariano set everything in motion. B.B. would like to know if I would have lunch with him the next day. Lunch would be served in the little library of French novels; Nicky and I were to meet in the Salone di Musica before going in to join him.

As we foregathered, Nicky offered me an aperitif from a small bar to one side. Hoping to make a good impression, I refused. "I think," she said with a twinkle, "you better take it."

It was elaborately explained why, in breach of protocol, I was to sit on his left. It had to do with the light on my face. As we entered, he was already ensconced in a special large chair at the far side of the room, at the head of a small table, his shawls around him, and on his head a Doge's cap. I sat down. No word was spoken. Instead, Berenson leaned over in my direction and proceeded to stare through his spectacles right at me. I felt like some Nardo di Cione brought in for authentication. A few dry remarks, and from then on it was like rolling down one unending hill, gathering momentum. I remember even discovering that we had each tried to write verse at Harvard, some seventy years apart, using the same imagery.

I have often wondered since how someone who knew so little could get along so musically with one who knew so much. Whitehead divided the rhythm of education into Romance, Precision, and Generalization, and perhaps the explanation is that people at the first and last stages have more in common with each other than either has with the second. Certainly I had heard frightening tales of what it could be like at I Tatti. Berenson himself was reminded by his colleagues, in *The Passionate Sightseer,* of the dogs of Constantinople who were put on an island to eat each other or starve. Certainly anyone who had had it quite so good was fair game. For a poor Jewish immigrant to attain such social and financial success must have threatened the self-concepts of many who had explained their own privations as a necessary consequence of scholarly integrity. The worst sin was to have become a *popular* legend into the bargain. Things were quieter, though, by the time I got there. I remember overhearing Nicky on the telephone time after time explaining to visiting potentates from the museum, academic, and aristocratic worlds that B.B. simply wasn't up to seeing anyone; and then having to pinch myself that there we would be, the three of us, at lunch.

Meals were the great times. Intellectually, he seemed totally unimpaired by age, although he complained of his memory "falling away in chunks." Physically, his strength ebbed and flowed, rather like a man recovering from a leg operation who is his old self when stimulated but who tires easily. I was there to provide youth transfusions, mainly in the form of ideas. "Give us this day our daily idea," was the old Berenson prayer, "and forgive us the one we had yesterday." There were assignments of things to read and, above all,

of things to go look at. "You must look, and look, and look, until you are blind with looking," he would admonish me in his 1880s Boston elocution, every consonant sounded, "and out of blindness will come illumination."

For some time my quarters remained a small *pensione* in Florence, distinguished principally by the lowness of its rent and the noise level of its television set, which blinked out over the silent inmates as we partook together of the same meal. Then I was invited to move into the time machine itself. The room I was given had been Mary Berenson's. It had an adjoining study and a view over the valley. The dress for dinner every night, every night the same three of us, was black tie. In the morning, breakfast was on a tray. On the tray was a flower. Each morning it was a different kind of flower.

The walks in the garden and in the Tuscan landscape, the rides in the chauffeur-driven limousine that seemed to have escaped from the era of the silent movies, the smells on the terrace, everywhere the bibelots and works of art collected over a lifetime, some Italian, some classical, some Oriental, the phonograph concerts in the evening, the ongoing bustle in the photo library, the sound of Nicky's voice reading to B.B. in any of several languages — all blur into a single evocation of one of Berenson's dominating ideas, "to suggest that art could point a way to leading a life as if it were a work of art that we were creating. . . ."

Works of art of the more usual kind live on. A life lived as a work of art dies with the one who lives it. It was perhaps the keenness of Berenson's perception of this fact that lay at the roots of his continuing drive to get things written down, and to communicate them to people younger than himself. The problem of the written word was a leitmotif of his life, and it is a besetting one for all of us who would voyage into that silent world of the object, the world of purely visual experience.

As early as 1890, in Venice, Berenson had written Mary Costelloe, later his wife: "Yet I still question whether it is *at all* possible to communicate a feeling for art to people except by personal contact... the real feeling with which a picture inspires me. The feeling is so wonderful, so delicate, so subtle, that I can scarcely define it to myself. . . . I believe that the expression of such a feeling is impossible. A sufficient power of expression never goes with such a capacity for

feeling." Here is the essence of what made my own brief time with him so rewarding, and at the same time tormented his career.

The fact is that he had a prodigious power of expression, in a wide range of languages. It is well known that his wife Mary lessened his self-confidence as a writer. Yet it is doubtful whether, even if he had been encouraged to fashion long treatises at high levels of abstraction, posterity would have been better served. His gift was for those intensities of experience and thought that, like the flash of a strobe light, require brevity to sustain their brilliance. As he put it in his diary in 1950: "I enjoy epigrammatic and aphoristic writing, because I believe they are real, the spark struck out by matter on mind, I mean by any subject on mind. Elaborate writing is the product of a convention to put through a dialectical process the flashes of intuition that inspire one. To me either an idea is axiomatic at first flash or it never comes home, no matter how much it is coaxed by blandishing arguments."

Taken together, these two basic aspects of Berenson's gift — his feeling for the individual work of art and his intellectual economy — provide the rationale for this book. Never before in the Berenson literature have we had the process laid out so conveniently before us. Hypothesize as he will, the art historian usually ends by coming to grips with the fact that works of art have a life of their own, and that the study of them begins with the individual object. Here, each object gets its page and, in a one-to-one equation, its Berenson quotation. In how many of these juxtapositions we see Berenson practicing what he preached, quietly, in his diary: "The only so-called criticisms of literary, artistic, or musical works to be considered as worth while are those which impell the reader with the force of an hypnotic suggestion to read, to see, to hear what he has been reading about. The rest may be good metaphysics, aesthetics, cosmology, economics, etc., etc., etc., but is not specific criticism, and generally is cultivated by readers as well as writers who do not care for the work in question but for problems to which the work of art merely serves as a springboard for the discussion of irrelevancies."

The last time I saw B.B. was in spring of the following year, 1959. I had driven down from Paris, where he had asked me to keep in "almost daily touch" by letter, en route to Rome and Naples. B.B. had requested that the two of us have lunch alone. The phrase of

Yeats, "fastened to a dying animal," kept running through my mind. In every cadence of his voice was his clear belief that we would never meet again. And so it was, for soon afterward his health took a sharp downward turn, and a few days after my graduate study in New York began that fall, word came that he had died.

I was thus the last and youngest, and surely the most tangential, of a long series of student admirers of B.B.'s, a series of which Kenneth Clark was perhaps the first, and which included also John Pope-Hennessy and, most intimately perhaps, John Walker. B.B. had no children. Yet he will transcend time in many ways. He will live on through his writings, as this, yet another compilation of them, amply proves. He will live on institutionally. I Tatti continues, as was his wish, as a center for Renaissance studies under the aegis of Harvard University. The National Gallery in Washington is itself more a product of his eye and taste than many realize, for during its period of rapid acquisition in the Italian field he was virtually an adjunct curator; and his vision, shared by John Walker, of an art museum as a company of scholars, will soon become a reality in the Center for Advanced Study in the Visual Arts that the Gallery is about to build. But he will live on, too, in the way that Pericles described: "For the whole earth is the sepulchre of famous men, and their story is not graven only on stone over their native earth, but lives on far away, without visible symbol, woven into the stuff of other men's lives."

J. Carter Brown

Washington, D.C., March, 1970.

INTRODUCTION *by Hanna Kiel*

Bernard Berenson's experience of art sprang from a rich background. It was intimately related to the varied course of his interests. At first, through different fields of study, he aimed at familiarizing himself with some of the more essential currents of human thought. His roots remained in Europe, in his native Lithuania. Born in 1865 at Butremanz near Vilna, he spent the first decade of his life in the Russian Pale of Settlement, where he grew up in the tradition of a Jewish community. After his parents had emigrated to New England, he went to school in Boston.

A tireless reader, driven by a quenchless curiosity, he became his own teacher and soon attained a level of education which gained him admission to Harvard University. He attended courses for three years and, before taking his degree, put in for a travelling fellowship. In his application, dated March 30, 1887, he wrote an autobiographical essay which gave a complete picture of his years of apprenticeship. "I am desirous," he wrote, "of devoting myself to the study of *belles lettres* towards which I have for many years felt myself strongly drawn. My interest in the subject is not merely a personal one: I am anxious to fit myself for the position of a critic, or historian of literature.

"The function of a critic, at all times an important one, is especially so now, when much new information has to be assimilated, and many facts that have been regarded in various ways demand to be set in a new light, according to modern ways of thought.

"The full importance of this task may be gathered from the fact that the mere statement of this plan probably will have appeared almost trifling, in such contempt has the greater part of current criticism properly fallen in the estimation of men who really work. The prevailing criticism, a mere expression of prejudices and personal feelings,

is of interest to few except to writers of such criticism; but there surely is a criticism which consists of an exposition of the ever changing thought of mankind, which is a part of contemporary history, requiring profound knowledge of what has been, and the comprehension of what is now, which alone can furnish the necessary sympathy for the proper examination of past and present work. It is for this serious criticism that I wish to prepare myself, and the proper performance of this task requires, it seems to me, the most thorough and painstaking preparation.

"I was born in Russia, in Lithuania. My native language was German, but I used to hear Russian, Polish and Lithuanian spoken about me; and this accidental familiarity with many languages fostered within me what I afterward found to be the comparative or historic method of study. At eight years of age, I could read German, Russian, and Hebrew, and could understand Polish and Lithuanian a little at that time. I remember that I used to compare different words, and speculate on their origin, and that I often felt fastidious about the sound of words. A love of philology thus grew up unconsciously within me, which later, in my sixteenth and seventeenth years, tempted me away for a time from the study of literature; and my former interest in comparative literature has widened my horizon and given me some knowledge of the scientific method.

"The comparative spirit fostered in me as I have described, found enough upon which to exercise itself when, at the age of eleven, I came to this country. I was quick to be inspired by the contrast between the life I had known interestedly in Russia, and the life I was seeing with such wonder and pleasure here. I went to the public schools immediately upon coming here, and learned a good deal from those teachers who personally appealed to me, and nothing at all from mere pedagogues, or such as were not sympathetic.

"But my great school has been the Public Library of Boston. I began to use it upon coming here, and have used it since. I fear the attendants at the library used to consider me a pest. I came so often, and drew so many books which they could not believe I read. I used to read many hours each day, even during school hours, with the permission of wise teachers.

"Reading and thinking naturally urged me to write, and in my fourteenth year, I was making efforts to write for publication.

Bernard Berenson at Fernhurst (Sussex), 1901.

"At first I read everything that came in my hands, especially popular science, Oriental history and antiquities, books of travels, and all books about Russia. But my reading more and more became purely literary, until I entered college, when I devoted myself almost exclusively to this subject.

"For eight years now I have been following a principle of conduct to which I can say I have subordinated everything. I have tried to build myself up with one aim in view: the comprehension of literature. I have endeavoured to augment my capacity to observe, to understand, and to be able to convey to others what has been done, and is done in literature, not as mere expounding of books, but of our expression of human life.

"During this time I resisted two temptations, one, less powerful, to strive for academic rank, and marks, the other, to abandon my studies and make money. This temptation has been incessant and strong. I have seen the toil to which my father has subjected himself in order to earn even the necessaries of life for himself and his five children of whom I am the eldest, and I have never been anything but miserable at the thought of the burden I have been to him from the expenses of my apparently immunerative education. The fact that I resisted the first temptation not only enfeebles my confidence in this application for a Parker Fellowship; it makes it necessary that I should describe my college courses, now coming to an end.

"My Freshman year I spent at Boston University.... It was quite natural, however, that I should find Boston University insufficient for my needs, and I came here in Sept. 1884.

"My first year I took a number of courses from each of which I got as much as I could use, profiting especially from the Greek that I then read, but less from the Latin.... In the required physics and chemistry of that year I gained no more glory than I meant to gain....

"In my second year, the Junior, I took the first courses in Arabic, Assyrian, and Sanskrit, and the second course in Hebrew. Of that the only one to profit me was the Arabic. It was well I took the others. Otherwise I should have been haunted all my life with the thought that there were treasures of literature in Sanskrit and Assyrian, of which I knew not. It was well to take them, and to find that by taking hold of them I was biting the trunks of trees, the fruit of which I already had enjoyed....

"But from the beginning of my Junior year, my heart shut itself completely against all that was not *belles lettres,* or art; and my living interest became my writing, an interest fostered not a little by the required themes.

"Aside from my Arabic, this year, I have done nothing, and cared to do nothing but write and prepare for writing. . . .

"The Arabic which I am reading... is interesting me more, and more, and it is my intention to devote a good portion of my time in the future to the literary study of Arabic literature. I feel what few have realized: that Arabic literature has a tangibility, a virility, and a sanity of passion not only to inspire the student, but also to be a revelation to the Occident, where Arabic literature has been very little appreciated.

"It is not my intention, however, to hunt for new treasures, or to edit new editions. I mean to learn to appreciate the Arabic classics so well, that my appreciation may tempt others — a temptation I hope to foster by my writings. . . .

"I have given a fair summary of my college work, which never in reality meant anything to me compared with the reading I was doing. For many years, it always has been my reading first, my school-work afterwards, and whatever I am now, I owe to this. I have by no means idled away my time. Few men sleep less and devote themselves to their true interests more than I do.

"I may be allowed to call my already semi-published writings to speak for me. They bear the traces, as any one must acknowledge, of a good deal of reading, and thought.

"It is because I have had the idea of fitting myself so to speak to my age, that I have pursued the courses I have described. I feel some power as a critic, already. In time, if my growth ceases not, I may be able to address my generation, in the most direct way, that is through the novel, and the story.

"I graduate this year if at all. What I shall do afterwards depends largely upon your decision. I have no money. I can not ask my parents even "to keep" me another year. I should be obliged therefore to take what I could by which to earn my livelihood; although, come what may, I mean to devote every spare minute to literature.

"This is the most decisive period of my life. Whatever is in me may

be incalculably fostered or hindered by what the next three years bring me.

"I feel that if I stay here longer I shall stagnate, and lose my savour. And it is because I love this my adopted country so well, and have such hopes for its future that I long to be able to prepare myself to serve it, in as far as literature and art can serve it.

"My plan, if I should be fortunate enough to obtain this fellowship, would be something like this, which I had dreamed of for a single year, although, of course, I can not speak very definitely.

"From the middle of July to the opening of the University at Berlin I should make Paris my head-quarters, and devote myself to the study of the buildings, and the galleries of Paris, and to the cathedrals in the Isle de France. The Winter semester I should spend in the study of practical art problems, and of Arabic at Berlin. Then I should go to Italy where I should spend the rest of the year in the study of art, and Italian literature.

"Art prevails in this programme, because it is there where I feel myself weakest. One can study literature, after a fashion, here; but art, not at all. And if I am to do what I want to do, I must have at least a fair familiarity with art. My thought, moreover, is, and for some time has been occupied with aesthetic problems that I must solve for myself, and which I can not begin to solve until I have the necessary first-hand acquaintance with art.

"In a sojourn of three years I should much extend my plans. I should devote a good part of the time to the study of the literature which had its origin in the places in which I happened to sojourn. I also should avail myself as much as possible of opportunities for literary study of Arabic, Hebrew and Persian. My first winter, for instance, I should spend in Paris, taking courses each in Arabic and Persian at the school, listening to Renan, studying French literature, art and theatre. I should make much longer stays at each of the places I have mentioned, and make short stays in England and Russia also. I should be able to let things dye me through and through, instead of having to swallow them. I should be able to acquire that indispensable thing for the critic: familiarity with the atmosphere of the writers of whom he is to speak.

"I should employ every minute of my time in fitting myself by reading, study, observation, and susceptibility to all cultivating in-

fluences, to enable me to do the work I feel I may do."

In this virtual confession, which did not in the end achieve its object, we can discern the basic elements which were to contribute to his activity and achievement. As well as a keen curiosity, which remained with him to the very end of his days, he soon revealed a talent for comparing, weighing and evaluating and had already developed a critical approach. He was not content with the accumulation of knowledge for its own sake without critical involvement. This applied not only to his approach to original material, but to current modes of criticism as well. Consequently he sought a form of criticism which would enable him — the next step — to address his own generation through his writing. This urge to write did not originate in a need to talk about himself or to explain personal experiences. He apparently wished to share, and this was a decisive factor, an experience of values formulated by others and to proceed toward a critical analysis. Both analysis and interpretation required, as he was well aware, a precise knowledge of details, of all the particular conditions and circumstances in which a creative work was conceived.

Villa "I Tatti" in its surroundings, with a distant view of Florence.

Although at this time Berenson's interests were concentrated on literature, the word art also appeared in the program of studies he had in mind. Here again it was not understood as a private experience to be explored, but as a means for resolving general aesthetic problems which then occupied him. Already manifest was the personal approach to art that was to remain unmistakably his throughout his life. He was willing to let himself be "dyed through and through" by an artistic impression without haste or aggressiveness, yielding to the work of art, looking at it without demanding or insisting. This was an attitude which even after decades of erudition he never abandoned. His position remained unaltered even when he had become a renowned authority. It might find its parallel in Toscanini's attitude of humility before his score.

When he left Harvard, Berenson was given the opportunity to embark upon his three-year program of studies in Europe, thanks to a fellowship privately financed by several members of the Harvard community and including a contribution from Isabella Stewart Gardner, whom before long he was to recompense by forming with her a great collection, one of the first important private collections in the United States. The rapidity with which he equipped himself with the expertise necessary for such a task testifies to the unusual quality of his gifts. An impulse to devote some time to the field in which he felt himself to be weakest led him toward the visual arts. A sure intuition with an unerring instinct drove him to the experience of art. He put seeing before meditating and chose a path that, while it estranged him from his former literary program, brought close to him the visual experience which was to prove of paramount importance in his life. Here began a new chapter. The decision was pivotal. Berenson was responsive to all forms of artistic expression but, on his arrival in Paris, it was painting which made the deepest impression on him. It moved his imagination powerfully and before long was to become the focus of his interests and studies.

He was intimately familiar with the ideas and principles of two writers whose works he had perused again and again at Harvard. These were Walter Pater and Giovanni Morelli, who were to serve as guides and mentors during his early visits to European museums in Paris, London, Belgium, Holland, Germany, Vienna and more particularly during his journeys through Italy. Pater's *Studies in the*

History of the Renaissance (1873) opened a new horizon for Berenson; they prepared his vocation and gave him poetical insight. It was Pater's influence that incited him to choose the painting of the Italian Renaissance as his specialty. Due to Pater's suggestion he began to conceive of the work of art as an illuminating experience and to appreciate its true value as a life-enhancing impression according to Goethe's definition.

His second master was Giovanni Morelli, whose studies of Italian masters in the galleries of Munich, Dresden and Berlin* induced Berenson to take up research and supplied him with a method. Morelli's system of studying pictures by comparing recurrent and prevailingly "physiognomic" characteristics in paintings in order to achieve a critical analysis of style established a new procedure for attributing pictures which did not depend on the not always reliable crutches of signature and documentary sources. This method gave Berenson his clue, his starting point. It formed the basis for setting up and developing his own way of defining style. It was the training ground for his chosen profession of connoisseurship. With Pater and Morelli as the sponsors of his career, of whom one gave him the melody for his *Leitmotiv* and the other the fingering exercises for practicing the art of attribution, he attained an almost unequalled mastery as a connoisseur. Connoisseurship was his aim and he was willing to dedicate to it "his entire activity, his entire life," as he wrote to his patroness Isabella Gardner. He took Morelli as his model, regarded himself as his pupil and went on calling himself a "Morellian" even after he had gone beyond the narrow limits of Morelli's method. The first fruit of his apprenticeship to Morelli was an essay analyzing the fundamental problems of connoisseurship. It appeared in print under the title "Rudiments of Connoisseurship: A Fragment"** about a decade after he had published the first part of his detailed studies on the various schools of painting in the Italian Renaissance.***
The problems are expounded, but not yet finally resolved. He was to discuss them further in later essays even after he had accepted connoisseurship as the vital implement of his research, and he was to continue to speculate as to why this discipline should be so fre-

* Giovanni Morelli, *Italian Masters in the German Galleries. A Critical Essay on the Italian Pictures in the Galleries of Munich-Dresden-Berlin* (transl. L. M. Richter). London, 1883.
** In *The Study and Criticism of Italian Art*. Second Series, 1902.
*** *The Venetian Painters of the Renaissance*. 1894.

quently misunderstood or regarded as dubious. He argued that only a prolonged familiarity with an artist's work could lead toward connoisseurship and that this familiarity demanded patience and watchfulness, if the image of the artist was to be fully appreciated. "Our studies," he wrote, "if properly pursued, make demands upon all of a man's mental energies, and furnish a discipline inferior to few. They require the first-hand observation of the naturalist, the analysis of the psychologist and the skill in weighing and interpreting evidence necessary to the historian.*

Connoisseurship as a craft implies the gift for attributing. For more than half a century, Berenson practiced this craft brilliantly and with great success, although in later years he did so more reluctantly. He made no secret of his method. He tried to make it understood to others and to explain its system especially to younger generations. He wrote *Three Essays in Method* and demonstrated the process of attribution in several essays concerning pictures by different masters from various schools. The reader is admitted into his workshop, is shown the tools and also the technique which yield the result. He is invited to participate in the delights of discovery which scholarship affords. Berenson did not favour industrious cataloguing: according to him "a problem cannot be treated dialectically and forensically alone. It has to be experienced and lived, it has to be tasted and felt." **

To the very end Berenson kept faith with his own particular way of approaching the work of art as a revelation of life-enhancing experiences. He trained himself as a scholar, but remained always the enthusiast in front of a creative work. The scholar and the enthusiast inspired one another and he adjusted the key of his writing to both. Scholar and art-lover expressed themselves with the same immediacy. He regarded the study of art as a humanistic pursuit which should not be limited to attributing, but which ought to interpret the aim and meaning of distinct artistic tendencies by exploring the vision of the world at a given period in a given place. "Until we so-called 'connoisseurs' become as good archeologists for the epoch we are studying," he reasoned, "as the students of classical antiquity are of theirs, possessing, like them, all the tools, and all the books of reference concerning every phase of the material and spiritual life of

* *Essays in the Study of Sienese Painting.* 1918.
** *Three Essays in Method.* 1927.

The New Library at "I Tatti."

the periods under consideration, we shall inspire no more confidence than our know-nothing dandyism deserves."*

Berenson was the first to follow his own rules. The advice he gave, the principles he defended, had been evolved through experience and study. With Morelli's grammar at hand, he easily learned the new language and grew fit for his task. No longer obsessed by fears for his future — such as he repeatedly confessed to in his early letters to his patroness Mrs. Gardner — he wandered from museum to museum, from picture to picture, and in Italy from church to church, from province to province, from one town in the Veneto to another, from one valley at the foot of the Alps to the next. He was driven by an unflagging zest and travelled like a prospector for gold, a man with a divining rod. "I am trying to write about Italian painting, soberly and appreciatively," he wrote in 1893 in the first of his five annual reports to Harvard. "I spend the winters in Florence, the springs and autumns elsewhere in Italy, the summers in Paris and London, or else in Germany."

His vast labour yielded its first harvest in 1894 with the publication of his work *The Venetian Painters of the Renaissance.* It was the first of the four slim volumes on *The Italian Painters of the Renaissance,* which made his name and which more than half a century later he still described as his "art gospel." In presenting his subject he followed a principle which a decade later he was to set forth as a program. He started his argument with a short discussion of the spirit and essence of the Renaissance as a frame for the Venetian painting of that period. The single artists step forward into the limelight of his critical interpretation, each characterized by a few incisive lines. Berenson emphasized the importance of colour in the development of Venetian painting and the far-reaching influence of the Venetian school on the whole of European painting, from Tiepolo to Goya and through him on the French Impressionists, thus furnishing manifest proof of the continuity of artistic creativeness. In addition this first volume offered something entirely new: the lists of the works of the leading Venetian painters with an index of places. Together with the lists of the following three volumes, these formed the basis for the completed lists and were to be revised, added to and corrected for more than three decades. In 1932 they were finally

* *Studies in Medieval Painting.* 1930.

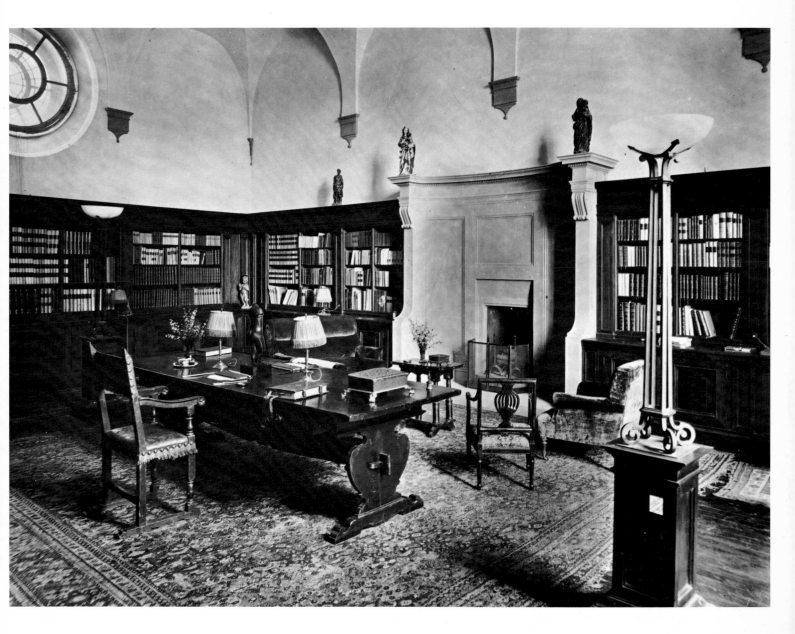

The Big Library at "I Tatti."

published together as *Italian Pictures of the Renaissance,* with short biographical notes and indexes of places. It was an achievement which in its field may be compared to Johnson's *English Dictionary,* and became a current handbook. It remains indispensable for all scholars studying the Italian painting of the Renaissance and is useful even to those who have no regard for Berenson's art criticism and his aesthetic theories, either because they consider them outdated or because they disagree with them.

In the same year that his *Venetian Painters* came out, he prepared the way for a steady source of income by acquiring the first picture* for Isabella Stewart Gardner's Boston Collection. A year later his *Lorenzo Lotto: An Essay in Constructive Art Criticism* appeared. This was a new type of monograph on an artist, based upon the researches during his wanderings in the Veneto and in the Marches. As in the *Venetian Painters,* he interpreted the painter Lotto not as a single artist isolated from his surroundings, but as characteristic of the various contrasting influences of his time. According to Berenson, it is by studying the ambience which inspired the artist that a comprehensive judgment may be made. An appreciation, for him, is equal to a confession and its value depends upon its sincerity, for it is as revealing of the critic as of the artist. A perfect masterpiece speaks for the attitude of a certain human being toward the universe, and therein also the critic betrays his philosophy through his mode of valuation.

On the occasion of the great *Exhibition of Venetian Art* at the New Gallery in London, Berenson's Venetian experiences led him to write a pamphlet which was issued as a special catalogue.** In it he stripped most of the pictures exhibited of their proud names, infuriating the collectors and rousing the interest of critics and dealers. This was the involuntary start of his spectacular career as a professional expert, a career he himself later on condemned as ambiguous, since it absorbed the major part of his creative energies.

In *The Florentine Painters of the Renaissance,* published a year later, he characterized the Florentine school in its essential and decisive outlines with deliberate simplicity. The new definitions he used — no longer dependent on either Pater or Morelli — have passed into

* Sandro Botticelli, *The Story of Lucretia* (ex Lord Ashburnham Collection).
** *Venetian Painting, Chiefly Before Titian....* 1895.
 From *The Study and Criticism of Italian Art.* First Series, 1901.

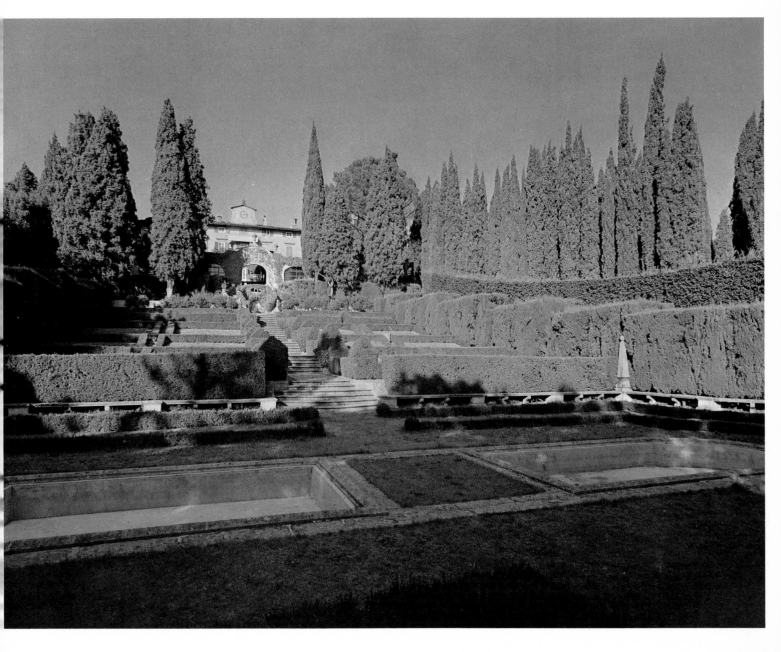

The formal garden at "I Tatti," descending from the Lemon House.

our general terminology. In place of the usual concept of form, Berenson chose the widely discussed and criticized phrase "tactile values." This phrase perfectly reflected his own view of the work of art and of the relation between the observer and the art object. The elements of form in the two-dimensional representation suggested to him the three-dimensional shapes and thereby communicated the life-enhancing image of pictorial reality. A similar process is demonstrated in the analysis of "movement" in the Florentine treatment of figures in action, which we see as a well-balanced harmony, without experiencing all the fatiguing intermediate stages of movement ourselves.

In the following volume, *The Central Italian Painters of the Renaissance,* Berenson introduced the terms "decoration" and "illustration" in preference to the usual "form" and "content," which he considered excessively restrictive. He failed to allow for the fact that the term "decoration" is generally used to designate an accessory and ornamental aspect of a work of art and that "illustration" refers to a merely narrative side of the subject represented. A new idea proposed in this essay is the definition of "space-composition."

Space-composition, as found in the works of the Central Italian painters, is described as an essential contribution to the art of the Renaissance, but also as an emotional experience which reaches beyond the boundaries of time. He presented it as an experience which, although having its source in the ego of the artist, can liberate the viewer from the thrall of his own ego and, by transporting him into the spaciousness of the world represented, permit him for the length of a blessed moment to feel one with the universe.

For about ten years Berenson dedicated himself almost exclusively to researches for his *Drawings of the Florentine Painters* (1903). He was the first to penetrate a largely unexplored territory and was followed by a number of serious scholars. He realized that in the visual arts the evolution of the artist may be best traced in his drawings, where it can be identified in its utter immediacy and sincerity. In his drawing the artist reveals himself unrestrained by the chain of finality. His intuition may take wing without being linked to his patron's requests. Berenson studied, compared and confronted about three thousand drawings of Florentine masters which have come down to us. He named them, though in many cases not altogether in agreement with

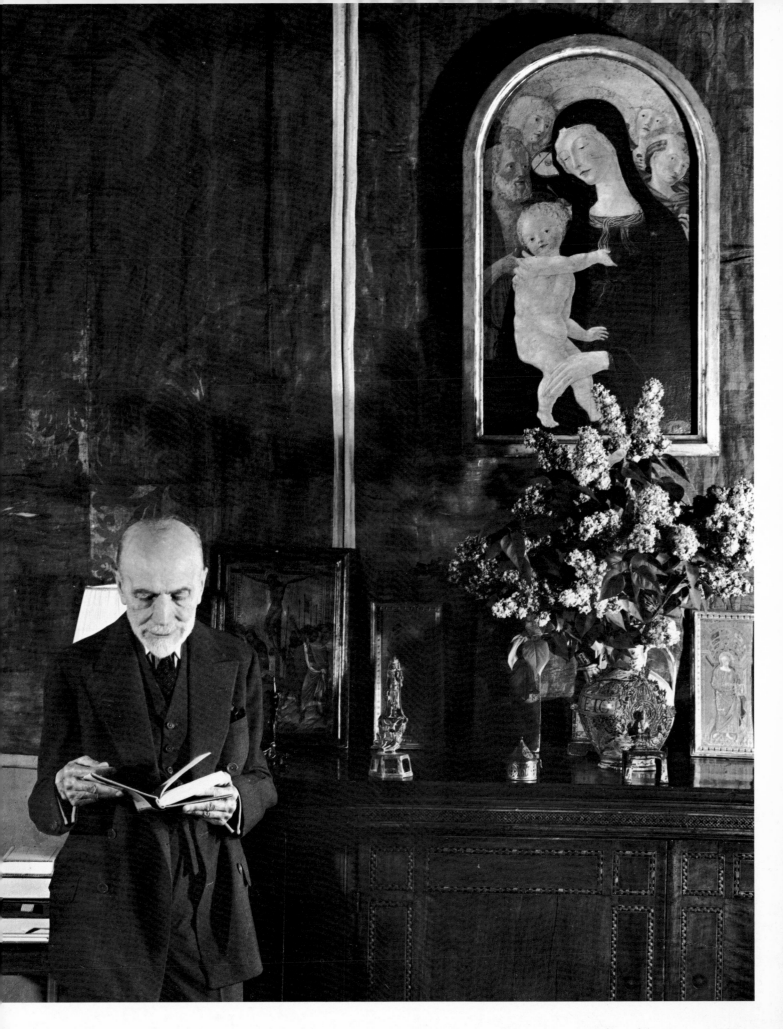

Bernard Berenson, 1954, in his study in front of the Neroccio Madonna.

their more illustrious former attributions. Berenson's dual approach to art and art criticism was becoming manifest. The scholar compiled the catalogue, whereas his interpretative texts were the quintessence of creative art criticism. Using his carefully selected material, he drew the image of the artist and presented him in a new light, namely at work as an active human being.

Artists like Signorelli, Leonardo and Michelangelo were seen and interpreted from a new angle. In connection with the late Florentine painters he discusses an eye-opening definition of Mannerism, as well as the problem of the relation between master, pupil, follower and imitator. His comments written for the scholar are no less illuminating, inspiring and fascinating for the layman. Berenson was wrong, in later years, in considering this accomplishment as a "mere rivalling with the scholars" and in pretending that, once the way had been laid out, this major task which took up so many of his active years might have just as well been carried through by others. He also touches in the *Drawings* on the problem of the decline of art, which excited his curiosity up to his last years.

A first and as yet fragmentary attempt to explain the phenomenon of decline, its origin and apparent inevitability, is found in the concluding chapter, entitled "The Decline of Art," of *The North Italian Painters of the Renaissance,* published in 1907. This fourth volume on *The Italian Painters of the Renaissance* contained a summary account of the new terms and aesthetic theories proposed in the preceding volumes.

With the beginning of the new century Berenson's life took a decisive turn. The private scholar and personal adviser of private collectors became the stipendiary of the dealer Duveen, who at that time monopolized the commerce of Italian pictures, and he remained on Duveen's payroll for almost three decades. He married Mary Costelloe. He was sinking his roots in Tuscan soil; he had chosen to make his home in the villa "I Tatti," which he was able to buy a few years later. It turned out to be the ideal setting for his activity. He left it only during the summer months, for the professional journeys to the United States and the more frequent pilgrimages to the cultural centers of the Mediterranean and the Near East.

Within the walls of "I Tatti" he began building his library in fulfillment of a dream cherished almost since boyhood. He now was

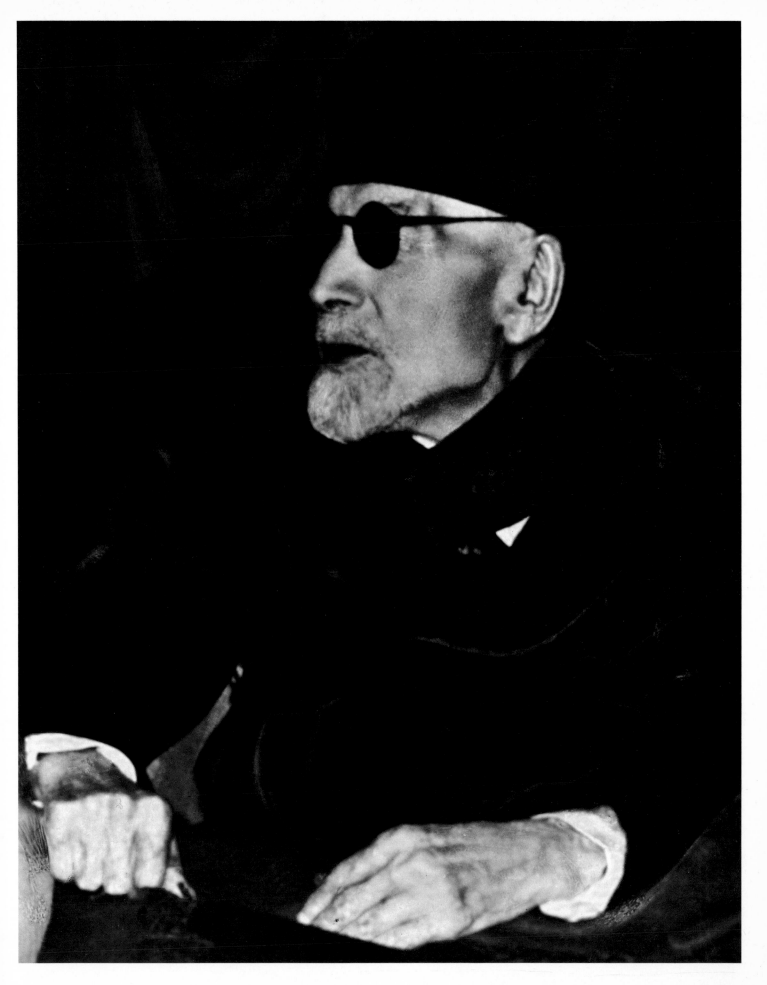

Bernard Berenson, 1959, after listening to Yehudi Menuhin.

able to carry it through, and did so up to the last years of his life with unwavering interest and with that rare and surprising awareness only possessed by someone who from the very beginning has visualized a whole project. He describes it half a century later as a library that "contains nearly everything, although not everything that my lust for knowledge required," as "the last and only attachment to a personal future from which I have not yet emancipated myself." For him "the main object is to have books at hand so as to be able to use them when one is piping hot with eagerness for them and malleably receptive to what one can get out of them."★ He would have liked to haunt it after his death as its familiar ghost. He regarded it as the nucleus for the donation by which he wanted to show his profound sense of gratitude toward Harvard University for having provided the financial means to embark him upon his future career. Discussions concerning the conditions of the bequest started about 1930. The outbreak of the Second World War delayed their conclusion, and only in 1955 was a final arrangement established. In the years of his professional activity as an art expert, the literary output of his connoisseurship dwindled to contributions in the field of strict scholarship. He prepared several catalogues of American private collections. He wrote articles for American, English, French, German and Italian art reviews, about recently discovered, or homeless, or wrongly attributed works and minor masters. They were reprinted in part as collected essays about medieval, Sienese and methodological studies.★★ He published a report on Venetian painting of the Cinquecento in America, ★★★ presenting the different groups of artists chronologically as representative of their period. He describes their stylistic elements and their spheres of influence. He analyzes the concept of "generation" as applied in art history, "characterized by common purpose, by common ways of visualizing, and by common ways of execution," and points out the essential difference between "pupil" and "follower" in the visual arts.

The essay on Sassetta, *A Sienese Painter of the Franciscan Legend* (1909) is the only truly poetical interpretation of a work of art written during this period. Years later it was republished in Italian with the addition of an epilogue, and it still conveys the original sense of

★ *Sketch for a Self-Portrait.* 1949.
★★ *Studies in Medieval Painting,* 1930; *Essays in the Study of Sienese Painting,* 1918; *Three Essays in Method,* 1927.
★★★ *Venetian Painting in America: The Fifteenth Century.* 1916.

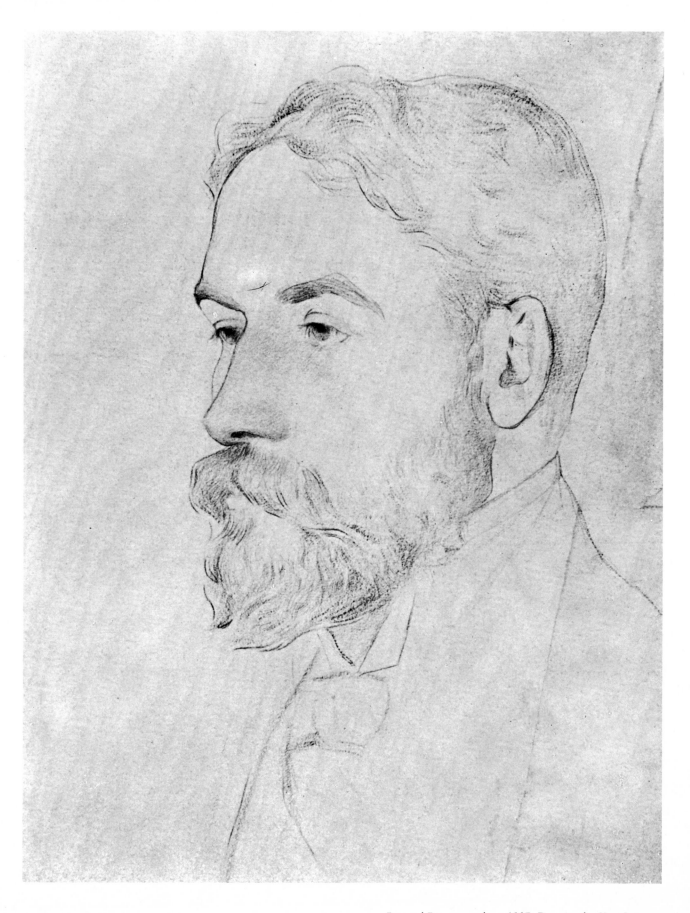

Bernard Berenson, about 1897. Drawing by Kerr Lawson.

strong enchantment.

Berenson's activity as a professional art expert for Duveen came to an end because of his refusal to deliver a certificate contrary to his own conviction. He had been asked to attribute to Giorgione the famous Allendale *Nativity,* which he believed at that time instead to be an early Titian, although later on he had to acknowledge the requested attribution to be the right one. He thus was free again to take up his work of research. He completed the revised edition of *The Drawings of the Florentine Painters* (1938) in three volumes and dedicated himself to the preparatory studies for an essay on the problem of decline and recovery in the figure arts which he had had in mind for some time. An attempt to explain the alternations of high and low tides in the creative process of humanity was a worthy challenge for a scholar of his age and experience.

But the outbreak of the Second World War and the frightening events which threatened the culture of the whole Western world with complete destruction had a paralyzing effect on his studies. The German occupation made it necessary for him to leave "I Tatti" and to take refuge for more than a year in the extraterritorial home of a diplomat. He was cut off from the inspiring resources of his library and consequently his research was brought to a complete halt.

At the age of sixty he had for the first time "suddenly [become] aware of 'time's wingèd chariot hurrying near.'" Abruptly he became sensitive to the waning of time, to the fleeting hours and "would have stood at street corners hat in hand begging passers-by to drop their unused minutes into it." And now, at the age of eighty-seven, he saw a vast horizon of leisure spreading out in front of him. It was not, however, to be a period of vacuous leisure and vague meditation. Berenson had started keeping a diary — the first page is dated January 1st, 1941 — and he went on with it until the ninety-third year of his life. In 1942 he wrote a kind of second version and gave an account of his reading of that year, the impressions of it and his critical arguments, issued in a separate volume.* His wartime diary up to 1944 was published in Italian and in English.** The diaries show their author's vast range of culture and reflect the true image of a mind whose persistent curiosity for any kind of cultural infor-

* *One Year's Reading for Fun (1942).* 1960.
** *Rumor and Reflection.* 1952.

mation and experience was only surpassed by his passion for seeing. A look at the index will suffice to ascertain the quantity of problems he pursued, the complexity of his ideas, the wisdom and insight gained through his extensive historical studies. We come across meditations of lasting interest and validity: on the meaning and intrinsic value of old age; on the priority of visual art in comparison with poetry; on the dawning consciousness of the individual in the earliest civilizations as the origin of his faith in the continuity of life, which led up to the formation of the Jewish-Christian ideology; on the Jewish and the Christian way of interpreting and evaluating the significance of Jesus.

Berenson's interest in the impact of Jewish thought on the formation of Christian dogma — "Christianity is detribalized Judaism in nearly everything but its Neoplatonic and Gnostic theology," he wrote — gained actuality with the outbreak of German anti-Semitism and consequently made him more strongly aware of his Jewish descent. Soon after settling down in the United States, Berenson's father had turned into a fanatic freethinker who deliberately estranged his family from Judaism and strictly forbade any further connection with the Synagogue. This must have been for Berenson one of the determining factors in seeking a new religious affiliation, and at the age of fifteen he decided to join the Episcopal Church. He evidently never felt quite at ease, nor part of the new community, which made him all the more disposed to a second conversion in the monastic atmosphere of Monte Oliveto Maggiore in 1893. This time it meant sharing the faith and the cultural background of the Mediterranean world. He was actually converted not only to Catholicism, but to Italy as a whole, to her art, her landscape, her people. He did not maintain the fervour of the early convert, but he became a "Christian graduate," as he called it, one beyond the restrictions of ritual and dogma. He remained, however, throughout his life a religious person with an ever stronger faith in humanity, and regarded the Church as "humanity's grandest, completest, and most beautiful achievement." He also believed and foresaw "that in a future not too distant it may be hard to believe that Judaism and Christianity were not the same religion, answering to the evolving needs of successive ages."

At the same time as the first diaries he also wrote the *Sketch for a Self-Portrait*. It offered merciless "glimpses into that chaos" of his

own self, as he defined it, and was not intended for publication. In his career, in his material successes with their depleting effect on his creative energies, he found the reason for having been a failure and for being frequently misunderstood. He sees himself and shows himself as a man with two differently shaped profiles, each of which, when in full light, will stand out as the final one and real one. As a rational man, with a critical mind, thoroughly trained in the discipline of thought, he was opposed to any magical cult or to any mystifying practice or pseudoscience. Four decades earlier, in his essay on Sassetta, he had given an illuminating interpretation of Franciscan mysticism, while now in his *Sketch* he approaches mysticism as a personal experience and conceives of immortality as comprehensible only in the mystical sense. "A complete life," he argues, "may be one ending in so full an identification with the not-self, that there is no self left to die." During seventy years of conscious living the moments of greatest happiness were those, he admits, when he was able to lose himself completely in some perfect harmony. "In consciousness this was due not to me but to the not-me, of which I was scarcely more than the subject in the grammatical sense." At the same time he was convinced that at his end nothing would die, since he already would have handed over to others whatever he had to give. In a certain sense, this conclusion might be understood as a detachment from the former mystical vision and a return to a more rational concept. On the other hand he wished and hoped that a life like his may have "somehow contributed — not so much through what I spoke or published, but in some mystic way — to the capacity for joy of the rest of mankind." *

The project for the major work on decline and recovery in the figure arts was carried out only in part. In 1941 an introductory part dealing with general aesthetic principles, with questions of terminology and particular problems of art history had been finished. This, published separately in 1948, was given the title *Aesthetics and History in the Visual Arts*. In it Berenson detaches from their original context terms and definitions used in his former writings and analyzes anew their essential meaning. They are revaluated and grouped in categories from the visual arts: the "classical" and the "archaic"; the principle of "Novelty"; the "Originality of Impotence"; the "Life-enhancing"

* *Sketch for a Self-Portrait.* 1949.

and the "Significant" as qualities of visual art. The chapter "History" contains an interesting discussion of "The Jews and Visual Art" and "The Problem of Personality." Despite profound knowledge, the varied material is presented with a striking casualness, but the book is full of new ideas and requires and deserves careful study.

In another introductory essay, which appeared in a Memorial * as "Decline and Recovery in the Figure Arts," Berenson set forth a research method evolved to fit his own needs, which was in part an adaptation of the one used by Jacob Burckhardt in his *History of Renaissance Architecture* and was appropriate for the solution he wanted to find. His essay *The Arch of Constantine or The Decline of Form* (1954) is part of the same complex of preparatory studies. Here the leading idea is demonstrated by analyzing a single work of art and its style. Berenson indicated twelve basic factors which may be used to establish the particular qualities of the work in question and to interpret its stylistic elements. Unlike fashion, style, according to him, is neither swift nor casual in its development, in its progress. It presents itself as a final result and as such can be neither conceived nor comprehended, nor be effective at the moment of its appearance, but only after having permeated the entire being of the artist. Style therefore, he concluded, is never consciously present in the awareness of the creator. It reveals itself in its significance as fertilizer or destroyer and shows its influence only in the following generation. This might explain our perplexity when asked to judge or interpret the style of our own time.

Berenson's critical judgment and negative opinion of modern art have been frequently questioned. In any case they should not be mistaken for an old man's myopia, for Berenson was among the first to defend Matisse's painting and to recognize the genius of Picasso, whose range as a draughtsman he found comparable to Raphael's. He was all the more impatient with Picasso's apparently willful changes of style, which must inevitably, he felt, have a confusing effect on his contemporaries. Berenson held out against abstract art, presenting it primarily as a symptom of the cleavage of our time and the instability of modern man in his relation to the world around him. It was a symptom familiar to him from periods of abstract art in earlier epochs, which always coincided with periods of historical crisis.

* *Studies in Art and Literature for Belle da Costa Greene.* 1954.

The essay *Seeing and Knowing,* written in 1948, treats of the interchange between visual experience and subconscious perception of reality. He saw the realization of this process in the creation represented in art. In his comment he touched again on the phenomenon of nonfigurative art and came to the conclusion that a representation of any kind, whether visual, verbal or musical, corresponds to a compromise with chaos. Within time the compromise becomes a convention. This convention in turn requires creative genius to keep it alive and invigorate it. Abstract art is to him the result of the "manquake" we have undergone during the last fifty years, which he believed would survive another fifty or a hundred years. "Eyes and ears," he argued, "will reconquer their right to inform hand and heart, and these will use them for new compromises between seeing and knowing, between feeling and thinking."* He hoped and was firmly convinced that these new compromises between seeing and knowing would inspire the artist of the future to new visions and new creations.

In *Alberto Sani: An Artist out of His Time* (1950) Berenson discussed the Sienese peasant and self-taught sculptor Alberto Sani. Cut off from the dominant style of his time, Sani ought to be regarded as an exception who fitted no contemporary artistic category. Berenson noted moreover that some of Sani's stylistic characteristics were also to be found in late Roman reliefs — although the sculptor had never had an opportunity to see these.

The early monograph *Lorenzo Lotto* had been a first attempt to deduce the personality of an artist and the sum of his typical qualities from the given conditions and his surroundings. Berenson now applied the same principle in the essay *Caravaggio: His Incongruity and His Fame.* This was written before Caravaggio was brought into the limelight of public interest by the great exhibition *Caravaggio and the Caravaggeschi* ** and it met the waves of enthusiasm with critical objections. An etymological definition of "manner" and "mannerism" in their meaning in different languages leads Berenson to distinguish between "affectation" and "manner." He cites groups of artists as examples to support his conviction that the artist's influence on his contemporaries is in no way dependent upon the inherent qualities of his

* *Seeing and Knowing.* 1953 (Italian edition, 1951).
** *Mostra del Caravaggio e dei Caravaggeschi.* Milan, 1951.

style and his achievement; nor can it be ascertained by the objective value of his creation. The historical importance of an artist with regard to his followers, in other words, is an autonomous fact, but not a gauge of his artistic impact.

The ideas for *Alberto Sani, Caravaggio Today* (interim title for the essay written two years later), and *Seeing and Knowing* came to him early one morning in August 1948, whereas the main theme of his essay *Piero della Francesca or The Ineloquent in Art* had already been outlined in his diary in February 1947. This essay belongs to the series of arguments which were to form part of Berenson's last and unfinished work. It may be considered as a final, sincere confession of a man who for the span of more than six decades had lived in close touch with the arts of all time and of all regions. Berenson confronted the "ineloquent" form of artistic representation, which he defined as "classical" form, with the "expressionistic" form. Pictures of both tendencies are interpreted. He again touched on contemporary art and he linked Piero della Francesca, Degas and Cézanne together as representing the "classical" current. Artists of this kind refrain from expressing emotions of the passing moment; they emphasize the characteristic, the intrinsic quality of their subject; they replace activity by inherent potentiality. They offer the equivalent to the "home of the mind," in the true sense of the phrase. The work of art that avoids overexpressiveness transmits instead its true essence and becomes the ideal meaning for a deepened life-enhancing experience. Berenson presented his idea as an act of faith. To him, faith was a necessary equipment particularly for the art critic, since objectivity in matters of history is a vain ambition. All those periods that universally are called great and represent certain high points in human history, according to Berenson, invariably produced a quality of art which possessed the "ineloquent" greatness of silence, as in Piero della Francesca, and always tended to visualize the human figure in its entity. "Perhaps real art in the visual arts," he concluded, "(as distinct from no matter what information, what mere newness, what drolleries, what jokes), always tends to communicate the pure existence of the figure presented."*

Berenson's daily schedule remained unchanged up to his ninety-third year of life. It followed an unchanging rhythm from the time he

* *Piero della Francesca or The Ineloquent in Art.* 1954 (Italian edition, 1950).

settled down at "I Tatti," with work early in the morning; walks at noon; work in the afternoon interrupted for a second walk; and in the evening a period of reading or being read to in different languages and about a variety of subjects, extended until about midnight. A series of reviews written for a leading paper and published later in a volume of collected essays* reveal his persistent interest in art events and exhibitions. Regular journeys brought him back again to places known and loved in the past. He went to Sicily in 1953; in 1955 at the age of ninety to Tripoli, Leptis Magna, Calabria and the Romagna; and of course again and again to Rome, Venice and its surroundings, and to all the neighbouring parts of Tuscany. In 1956 he methodically revisited his chosen home, Florence and its art centers. He was thus given the chance to check and compare his former impressions, to approach them from another angle, to see them in a warmer light and with a wiser eye. His traveling diaries** faithfully report these experiences. Of the two problems that he still wanted to consider and resolve, "Functioning as the Basis of Action" and "Man as a Work of Art," only a fragment of his discussion of the latter was found among his papers; it was included in an anthology of published and previously unpublished writings.*** His love for art of all kinds was matched by one rival only: his love for nature. It had been an inexhaustible and dominant revelation since childhood. It offered new wonders and new delight every day and became more compelling with the fading of his physical strength and vigour of mind. Perception of nature and of landscape in particular was for him an incomparable experience and superior to any impression conveyed by a work of art, inasmuch as it excluded any longing for possession such as works of art may arouse. Landscape therefore gave rise to a purified form of contemplation entirely detached from the animal self. "The greatest achievement of art," he maintained, "is to teach us to enjoy Nature — even human nature." On the other hand, his long years of indefatigable looking had taught him to *see* as the creative artist sees, to take in the world around him with the eye of a painter, sculptor or architect. Nothing escaped him, neither the curl of a tendril, the luster of an autumn leaf nor a floating fragment of

* *Essays in Appreciation.* 1958.
** *The Passionate Sightseer.* 1960.
*** *The Bernard Berenson Treasury.* 1962.

cloud. He rarely missed being present at the dawn and the sunset. He enjoyed them silently, just as he held silence before a work of art. He looked at pictures "ineloquently" for a long time without even becoming aware of how long he had been looking. It was often by these tense and vibrant silences that he most effectively communicated his own aesthetic experience to those about him.

Yet Berenson was a master of the word, the spoken word, although not an orator, public speaker or lecturer. After the one and only course of lectures organized by Mary Costelloe, given in front of the paintings in the London National Gallery, he never again made public speeches, not even on formal occasions when he himself was being officially honoured. He was considered one of the great conversationalists of our time, and an ideal partner in intelligent conversation, but he was a talker who gave of his best in a narrow circle. As happens sometimes, his gift matured and approached perfection in his later years, being constantly renewed and revivified by his voracious intellectual curiosity and by the scope of his interests. An acute and thrilling speaker, his interest always responded with vigour to the challenge of an open problem and there were many which time alone prevented him from solving satisfactorily. These conversations were an unforgettable experience for those who actively or passively took part in them, although the participants rarely determined their course. Unexpectedly a spark would flash and ideas would burst forth as from a spring that had been dammed for too long. Berenson himself considered his talk, his spoken word, and not the written one in his writings, as his genuine gift. He therefore regretted that it would die away unrecorded or at best live on for a short while in the memory of casual guests.

In the diaries of his last years* he acted as his own judge and gave a detailed account of himself. As a self-examination it complements the early autobiographical essay which appeared in his application for the Parker Travelling Fellowship. He regarded his achievements in the field of art criticism — to which he had devoted all his free energies — as mere attempts at research and became aware only toward the end that he might and how he might have done better. These attempts, he considered, had merely stirred the waters while the big catch was made by others and would continue to be made

* *Sunset and Twilight: From the Diaries of 1947–1958. 1963.*

by others in the future. Without false modesty he admitted his unusual capacity for recognizing and naming pictures, but he valued it as an ability of a purely professional kind. The conception of art for which he had trained himself by looking at art during his long life aimed at a sincere appreciation of fundamental artistic values, although, in order to make his vision alive to others, he ought to have been endowed with a painter's brush or a poet's pen. "What am I?" he asked himself. "Not a scholar, i.e. one who knows everything that has been written on his subject. I am not an archaeologist, nor an antiquarian, nor even an art historian or art critic. If anything definable, I am only a picture-taster, the way others are wine- or tea-tasters."

Berenson judged his library as the only truly satisfactory accomplishment of his life, wherefore he hoped that it might serve future generations for their profit and their enjoyment. He regarded it even as the ideal starting point for a future biographer who might draw an illuminating picture of its former owner, suggested by the date showing when each item was bought and by the signs and traces of when it was read. His library, he thought, would be the only means for transmitting to those who were to come after him an impression of what he was and to what he aspired.

In this connection the future of "I Tatti" and his bequest assumed paramount importance. It dominated his ideas, all the more so when he was facing the approaching end. His intent had been to found a lay monastery, where selected workers in the realm of the mind might devote themselves to their own cultural formation. Due to the want of the necessary means, this wonderful project, to his great disappointment, came to nothing more than the bequest of a library. That at least was the way he looked at it and he completely forgot that "I Tatti" with its paintings, sculptures and art objects is endowed with treasures which even for the wealthiest of monastic orders would represent an almost inestimable possession. He hardly succeeded in ridding himself of anxiety over how and to what extent the personal atmosphere of a home, as he had created it in the course of a long life, might change in order to provide the functional conditions required for the institution he had in mind.

"My idea for what is to become of I Tatti," he wrote in March 1954, "could be stated in a few words, although to be made official it would

take many. I want it to be a hostel for a number of students between twenty-five and thirty to enjoy the leisure to mature their talents, their gifts as talkers and writers, the leisure to sip works of art in all phases and kinds, verbal, visual, musical, to express them so vividly that they will want to communicate their experience to others, after finding the words to do so. At the same time I want them to live in the present as the continuation of the past, to study the past that is still alive or deserves to be resuscitated, and to live in and study the present as the matrix of the future, and of this future not as remote, removed, but as beginning today and going on quietly with no jerks, still less leaps. In short, a preparation for *im Ganzen, Guten, Schönen resolut zu leben.*" *

In September of the same year he sketched a scheme for the rational study of art as an equivalent to a humanistic approach to art. "My recommendation... would be...," he wrote, "to universalize the study of art history, to get away from painting (and its shadows, drawing, engraving, etc.), and to launch out into a program that would include all the visual arts of all times and places. Beginning with pre-reflective, pre-self-conscious arts, to. Mesopotamian and Egyptian, and Greek, and Hellenistic, and post-Hellenistic, Romanesque, Gothic, Byzantine, of course, then Renaissance, and post-Renaissance in Italy, France, Spain, with side steps to Holland, to Germany, to England, not to speak of Flanders *à travers les âges,* etc., to our own year and day. This would imply a faculty of its own, with its own separate interests, represented by competent teachers, who would regard themselves as part of one unit, whose business it was to teach and inculcate a rational and acceptable knowledge of all the visual arts in all fields, including not only painting chiefly, but sculpture, architecture, and all contributory ornamental arts. All studied first in themselves, and then as contributing with literature and music and philosophy and ritual to the humanization of man."

His act of gratitude toward Harvard University was carried out. His donation became a reality. After Berenson's death — in October 1959 — the villa "I Tatti" started its new life as the "Harvard University Center for Italian Renaissance Studies."

It was not his only legacy. He left to us the image of a man who began his way in "the neolithic civilization of a Lithuanian ghetto,"

* *Sunset and Twilight: From the Diaries of 1947–1958.* 1963.

who acquired his learning in New England, who chose Walter Pater and Matthew Arnold as his favourite writers and the art historians Jacob Burckhardt and Giovanni Morelli as his models, and who, "born to see," followed his path. This path guided him to an intuition comparable to a confession of faith: the intuition that through the work of art achieved by man, man as a creator will be raised above himself and become one with the universe.

*T*he Byzantine phase is represented by the greatest and completest master of that style anywhere in the world, namely, Duccio. The sturdy, severely tactile Romanesque mode by Giotto, its most creative and most accomplished master, and by his best followers, Andrea Orcagna and Nardo di Cione.

Then comes the fifteenth century, and the struggle started by Masolino and Masaccio to emancipate painting from degenerate calligraphic Gothic affectation. Masaccio was a resurrected Giotto, with even increased power of communicating dignity, responsibility, spirituality by means of appropriate shapes, attitudes and grouping of figures. After his early death, Florentine painting, profiting by the great sculptors Donatello and Ghiberti and developed by artists like Fra Angelico, Fra Filippo Lippi, Pollaiuolo, Botticelli and Leonardo, culminated in Michelangelo, Andrea del Sarto and their immediate followers, Pontormo and Bronzino. By that time the Florentines not only had recovered the indispensable mastery of the nude that the Greeks cherished, but in the painting of landscape went beyond them, thanks to their better understanding of light and shade and perspective. They handed on these achievements to Venice and to the rest of Italy, but to Venice particularly and later to France and Spain.

Venice and Umbria were sufficiently gifted to take advantage of what Florence could give them. They

could throw away the scaffolding that the Florentines were too pious or too proud to cast off and produce painters like Perugino and Raphael at their most radiant best, and Giorgione, Titian and Tintoretto, with all their magic and colour, splendour of form and delight in placing the human figure in lordly surroundings and romantic scenery.

Excepting Paolo Veronese (who came, it is true, from Verona, but ended in Venice and was as Venetian as his only equals, namely, Titian and Tintoretto), the north of Italy produced only one artist of the highest mark, Andrea Mantegna of Padua. Milan to be sure had Foppa, Borgognone and Luini, the last valued by Ruskin as Italy's most communicative and convincing religious painter. Nowadays we care more for the energy and vehemence and fancy of the Ferrarese, Tura, Cossa and Ercole Roberti. They put to good use what they took from Donatello, Fra Filippo, Andrea Mantegna, as well as from Piero della Francesca.

Southern Italy during the centuries we are dealing with had no painter worth considering. Sicily had but one, Antonello da Messina, who never would have been the artist we admire without coming in touch first with Petrus Christus and then with Giovanni Bellini, the most creative, the most fascinating of fifteenth-century Venetians.

Preface from
The Italian Painters of the Renaissance.
Phaidon Press, London, 1952.

LOOKING AT PICTURES
WITH BERNARD BERENSON

The Three Maries at the Sepulchre

1308–11. Panel from the Siena Maestà. Museo dell'Opera del Duomo, Siena.

DUCCIO DI BUONINSEGNA
Siena, active 1279–1318.
Heir to the finest Byzantine traditions of the eleventh and twelfth centuries.

Letter to Mary Costelloe.
Siena, November 17th, 1890.

By Duccio there still remains the great Madonna he painted in 1310, and the reverse containing twenty-six chapters as it were from the life of Christ. There are a number of small pictures besides. They impress me more than ever. As I looked at them it struck me more than ever that the history of Italian painting has hitherto been studied from Giotto's tower "so to speak."... Of course very little of the art of the past does seem contemporary to us, yet the final test of a supreme work of art is perpetual contemporaneity. Now Duccio satisfies this test to a markedly greater degree than Giotto does. Duccio models, in Duccio the human form is so pliable that it is full of expression, and character, while the face is capable of being kindled with a look that really corresponds to the emotion inspired by the subject. His perspective, too, is good without being scientific, the perspective of sharp observation. His draperies cling to the body, help to mould and to outline it, instead of masking it as in Giotto and his followers. But it is something more than all this that accounts for my great admiration for him. It is his sweetness, his elegance, his charm, his poetry. It sounds almost absurd to ascribe these qualities to an early *Trecentista,* but I am sure Duccio has them. So little in all art is more saturated with poetry of the greatest kind than the compartment in which the three Maries come to the tomb and find the angel sitting upon it. You are made to feel so glad.

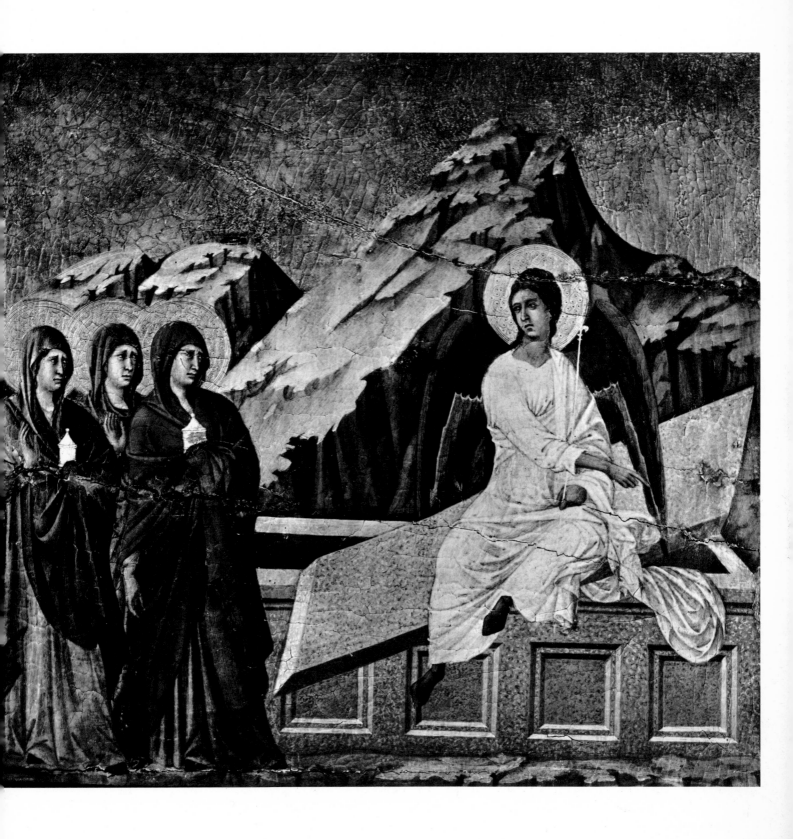

Calling of the Sons of Zebedee

1308–11. Predella panel from the back of the Siena Maestà.
National Gallery of Art, Washington, D.C. Kress Collection.

DUCCIO DI BUONINSEGNA
Siena, active 1279–1318.

"The Central Italian Painters." 1897.
The Italian Painters of the Renaissance.
Phaidon Press, London, 1952.

For Duccio, the human figure was in the first place important as a person in a drama, then as a member in a composition, and only at the last, if at all, as an object whereby to stimulate our ideated feelings of touch and movement. The result is that we admire him profoundly as a pictorial dramatist, as a Christian Sophocles, somewhat astray in the realm of painting; we enjoy his material splendour and his exquisite composition, but rarely if ever do we find him directly life-communicating....

Duccio must have got his training from some Byzantine master, perhaps at Constantinople itself. Whoever and wherever this master was, he must have been imbued with the feelings of that extraordinary revival of antique art which began at Byzantium in the ninth and lasted on into the thirteenth century. Duccio, properly regarded, is the last of the great artists of antiquity, in contrast to Giotto, who was the first of the moderns.

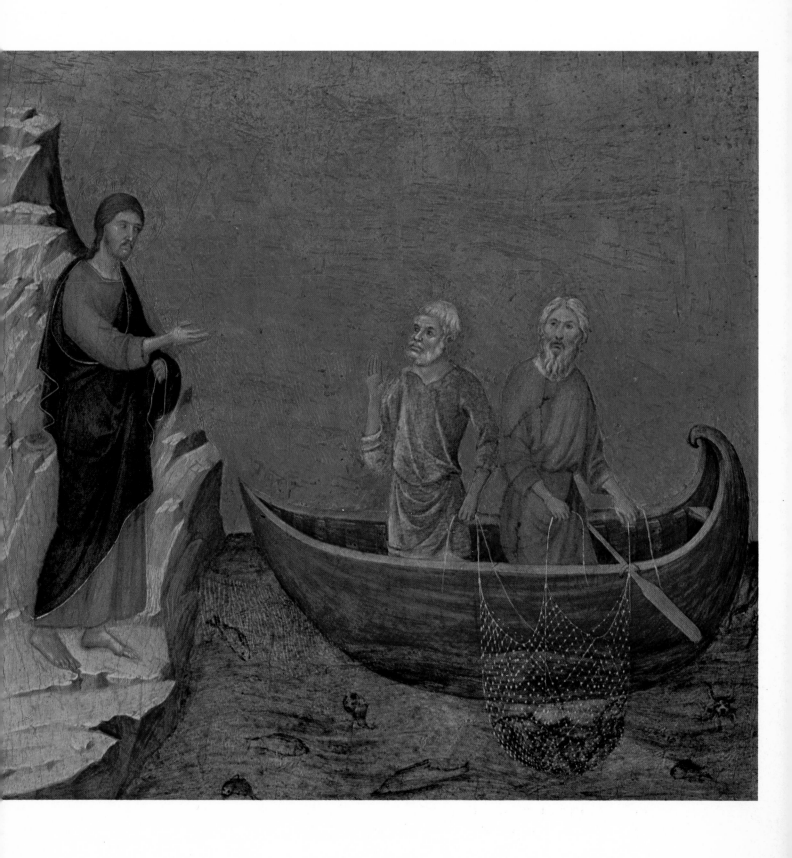

Salvator Mundi, with Saints Peter and James

Three panels from a polyptych. National Gallery of Art, Washington, D.C. Mellon Collection.

CIMABUE
Florence, active c. 1272–1302.
Completed the revolution in Tuscan painting inaugurated earlier in the thirteenth century by Byzantine artists, apparently of popular monastic tendencies, who migrated to Pisa, Lucca and Florence.

"A Newly Discovered Cimabue." 1920.
Studies in Medieval Painting.
Yale University Press, New Haven, 1930.

The three separate figures constitute but one perspicuously concentric and even dramatic design, as free from pomp as it is free from rhetoric; and yet it is grand, monumental. The masses take full possession of the spaces, filling them almost to overcrowding, as never again till the sixteenth century. They do not shrink timidly into the background, as in dominantly Gothic and Quattrocento design. All converge upon the center — mass and line, and look. And yet there is no approach to simplicistic balance and rhythms. On the contrary, these are studiously avoided.

The hands play an unusual part. Here again, it took three centuries before a Leonardo appeared to make the hands again as important as the face.

The volumes refrain from the slightest suggestion of "cubism," and yet are splendidly geometrical, as in all great art. The masses avoid the slovenly bulge, and the contours the sagging, flabby line of most works carved and painted during the so-called "Dark Ages"....

The drawing is free, the modeling large, or, in the language that has prevailed in my time, "impressionistic." The drapery is faultless and in the grand manner....

The author of this masterpiece must have held the highest rank among the painters of his day.

CHRIST BLESSING, WITH PETER AND SAINT JAMES MAJOR

Attributed to CIMABUE

Salvator Mundi

Central panel of polyptych. National Gallery of Art, Washington, D.C. Mellon Collection.

CIMABUE
Florence, active c. 1272–1302.

"A Newly Discovered Cimabue." 1920.
Studies in Medieval Painting.
Yale University Press, New Haven, 1930.

This triptych, then, is as surely by Cimabue as scholarship at the present day can ascertain. That being so, a great deal follows that cannot be discussed here. How shall one exaggerate the importance for our better acquaintance of the thirteenth century, of a masterpiece like this, in the greatest style, and, what is perhaps even more precious, in marvelous, in almost miraculous preservation? At last we can study the technique and coloring of the panel painting of that great period.

Before leaving the subject for the present, a word must be said about the probable date of this precious triptych.

It is still very Byzantine. It is tighter than the Assisi frescoes. It is more meticulous than the Florence altarpiece. Probably, then, it is earlier than any other known work of Cimabue. Is it possible that the master painted it as early as 1272, and in Rome, where he is known to have been sojourning in that year? A little later, but quite likely in Rome.

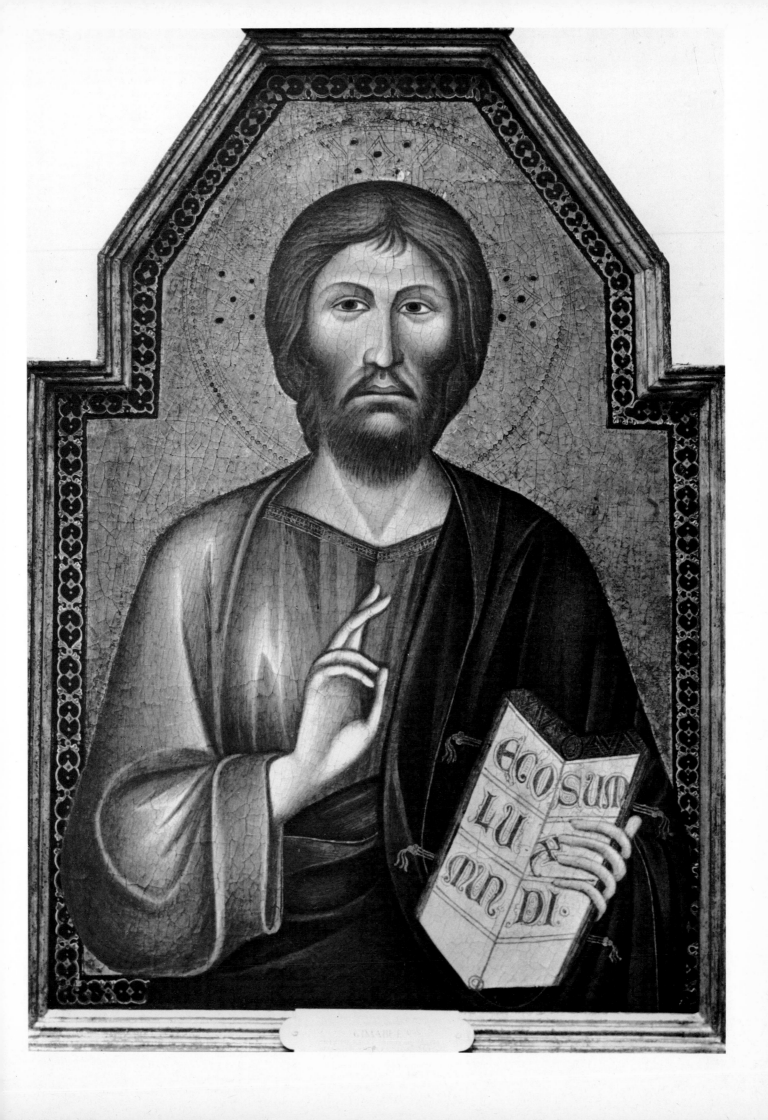

Madonna and Child Enthroned with Four Angels, and Saint Francis

Fresco. Detail. Lower Church, San Francesco, Assisi.

CIMABUE
Florence, active c. 1272–1302.

"A Newly Discovered Cimabue." 1920.
Studies in Medieval Painting.
Yale University Press, New Haven, 1930.

When I say "Cimabue," I mean the artist who designed the darkened and faded but sublime frescoes, now but "cloudy symbols of some high romance," in the transept of the Upper Church at Assisi, the sadly damaged "Madonna with St. Francis" in the Lower Church, the great altarpiece at Florence, severe and imposing as a Romanesque façade, and the somewhat less imposing but still very wonderful Madonnas (studio work perchance) in the Servi at Bologna and in the Louvre.

If not this genius whom I have in mind when I utter the name "Cimabue," who else could have painted this triptych?

Among known contemporaries there is but one great enough, the Roman Cavallini; but between him and Cimabue there are the exact differences that obtained nearly two hundred years later between the equally great and kindred artists, Mantegna and Giovanni Bellini. The one is precise and schematic as the other is large and spontaneous. And our triptych is in its style and for its epoch very large and free, not only in conception but in handling as well.

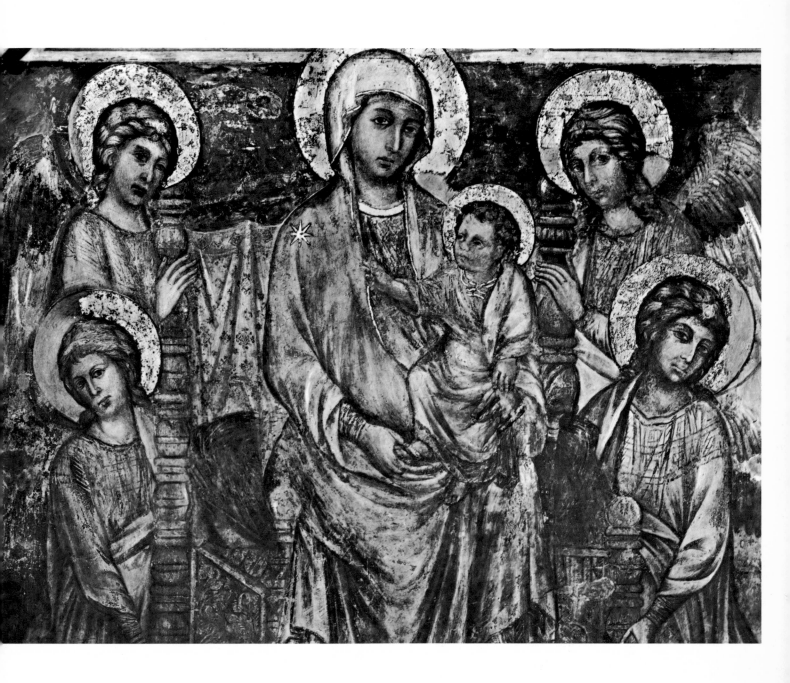

Saint Francis' Ordeal by Fire

After 1317. Fresco. Detail. Bardi Chapel, Santa Croce, Florence.

GIOTTO
Colle di Vespignano, c. 1267–Florence, 1337.
Follower of Cavallini; influenced by Cimabue and Giovanni Pisano.

Sunset and Twilight. From the Diaries of 1947–1958.
Harcourt, Brace & World, New York, 1963.

March 20th, I Tatti

Giotto — what a problem. Procacci brought photos of the St. Francis frescoes in Santa Croce — so shamelessly made over a hundred years ago. Perspective more admirable than any in Italy till Alberti and Piero della Francesca. Magnificently manly the Sultan with his wonderfully wound turban. Genius if ever — but no followers to take up his teaching, and follow his example, not even the greatest of the Giotteschi, Andrea Orcagna. In his own career he owes nothing to Cimabue, perhaps something to Cavallini. Difficult to get an idea of his successive phases. Then in mid-career he seems to have suddenly changed over from a Romanesque to a Gothic style. After which it would seem that he was more of an *entrepreneur* than executant. Of course he must have designed all (or nearly all) the frescoes and polyptychs ascribed to him, but in the frescoes particularly there seems little convincingly his own, except at Padua, and much in Santa Croce of Florence. A central figure in universal art history, who yet remains a problem, and to me an insoluble one, more than any other in my range of continuous study. I feel baffled, and humiliated, and ready to say "Enjoy him" and leave the problems to others.

Dream of Joachim

1305–6. Fresco. Arena Chapel, Padua.

GIOTTO
Colle di Vespignano, c. 1267–Florence, 1337.

Sunset and Twilight. From the Diaries of 1947–1958.
Harcourt, Brace & World, New York, 1963.

June 5th, Abano
The *Giottos* in the Arena! Surely art never achieved anything finer in execution, more jewellike in colour, nobler in composition, and deeper in conception than these interpretations of the Gospel narrative. Of course one must learn the language as one learns Latin, even if one's mother tongue is a Romance language. When one has, then it is as intelligible as Raphael's, or Titian's, or Poussin's, and perhaps even more accomplished as artistry than any of them. It is puzzling, however, to link these up with the frescoes of the upper church at Assisi.

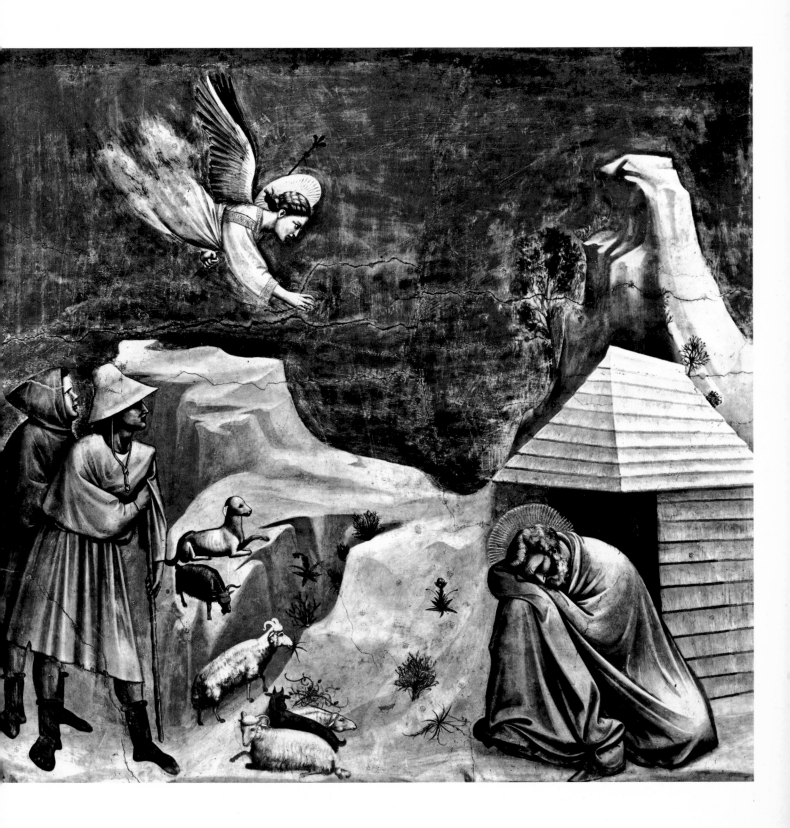

Annunciation to Saint Zacharias

Fresco. Detail. Peruzzi Chapel, Santa Croce, Florence.

GIOTTO
Colle di Vespignano, c. 1267–Florence, 1337.

"The Florentine Painters." 1896.
The Italian Painters of the Renaissance.
Phaidon Press, London, 1952.

With the simplest means, with almost rudimentary light and shade, and functional line, he contrives to render, out of all the possible outlines, out of all the possible variations of light and shade that a given figure may have, only those that we must isolate for special attention when we are actually realizing it. This determines his types, his schemes of colour, even his compositions. He aims at types which both in face and figure are simple, large-boned, and massive — types, that is to say, which in actual life would furnish the most powerful stimulus to the tactile imagination. Obliged to get the utmost out of his rudimentary light and shade, he makes his scheme of colour of the lightest that his contrasts may be of the strongest. In his compositions he aims at clearness of grouping, so that each important figure may have its desired tactile value.... There is not a genuine fragment of Giotto in existence but has these qualities, and to such a degree that the worst treatment has not been able to spoil them. Witness the resurrected frescoes in Santa Croce at Florence!

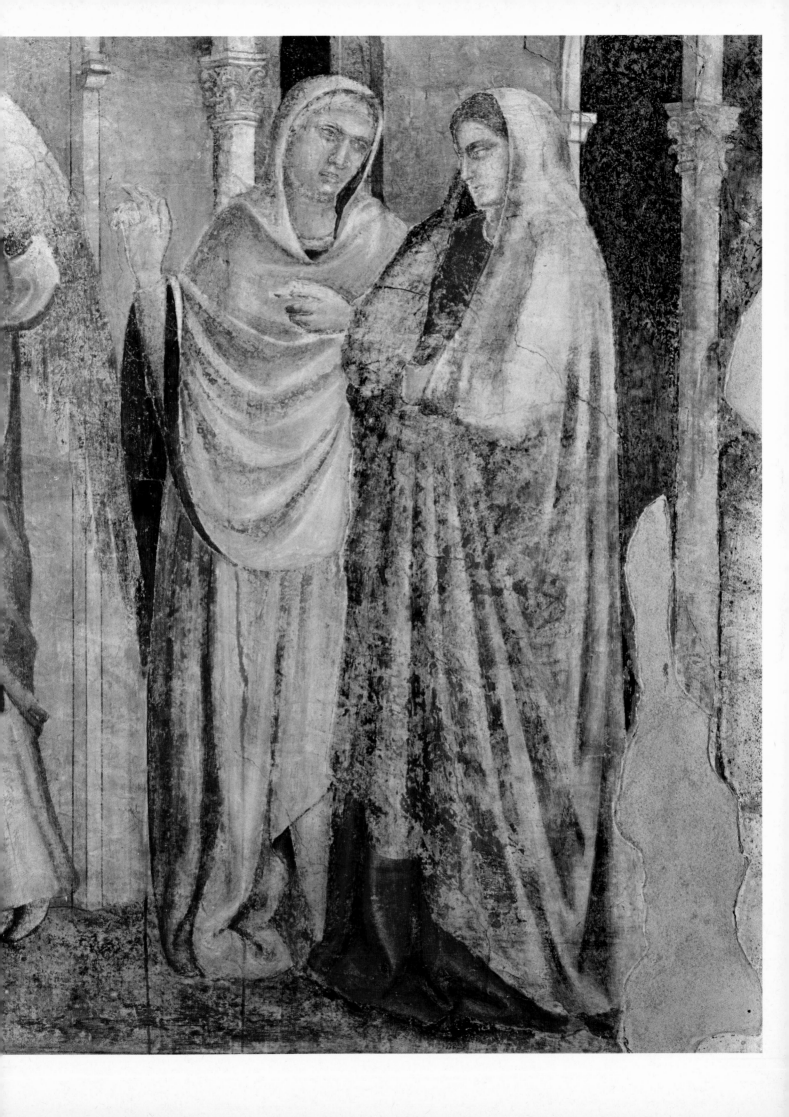

Birth of the Virgin

Before 1365. Fresco. Detail. Rinuccini Chapel, Santa Croce, Florence.

GIOVANNI DA MILANO
Mentioned in Florence 1346–66, in Rome 1369.
Probably trained by Lombard Giotteschi but influenced by Orcagna and Nardo.

"Homeless Pictures. The Florentine Trecento." 1930.
Homeless Paintings of the Renaissance.
Indiana University Press, Bloomington and London, 1970.

Although a foreigner by birth and training, Giovanni da Milano, during his long sojourn in Florence, came under the influence of the Orcagnas, imbibed something of their idiom and a good deal of their fervour, and himself, in turn, exerted an influence over such an artist as Andrea da Firenze....
Giovanni was one of the great men of the Trecento, and I wish I knew how he got his style. He was much more plastic than any of his Italian contemporaries. Not only are the relations of his voids to his solids in the nature of full or half relief, but his planes are differentiated and approached in a way that anticipates the Quattrocento. At times he depicts a sort of glorified actuality, as did the more refined painters of the High Renaissance. And his tone, curiously enough, is almost as silvery as in certain Milanese painters like Foppa and Borgognone, of so much later a period. Altogether a mysterious figure....
Subjects are treated with a Romanesque severity, not only of interpretation but of arrangement as well. The vertical figures, the functional draperies, and the spacing are as admirable as the fragments that have come down to us from the late Romanesque choir-screen at Chartres. In the grouping, however, Gothic voids and Gothic compactness work together almost as impressively as in the marvellous reliefs remaining over from the 14th century *jubé* at Bourges.

72

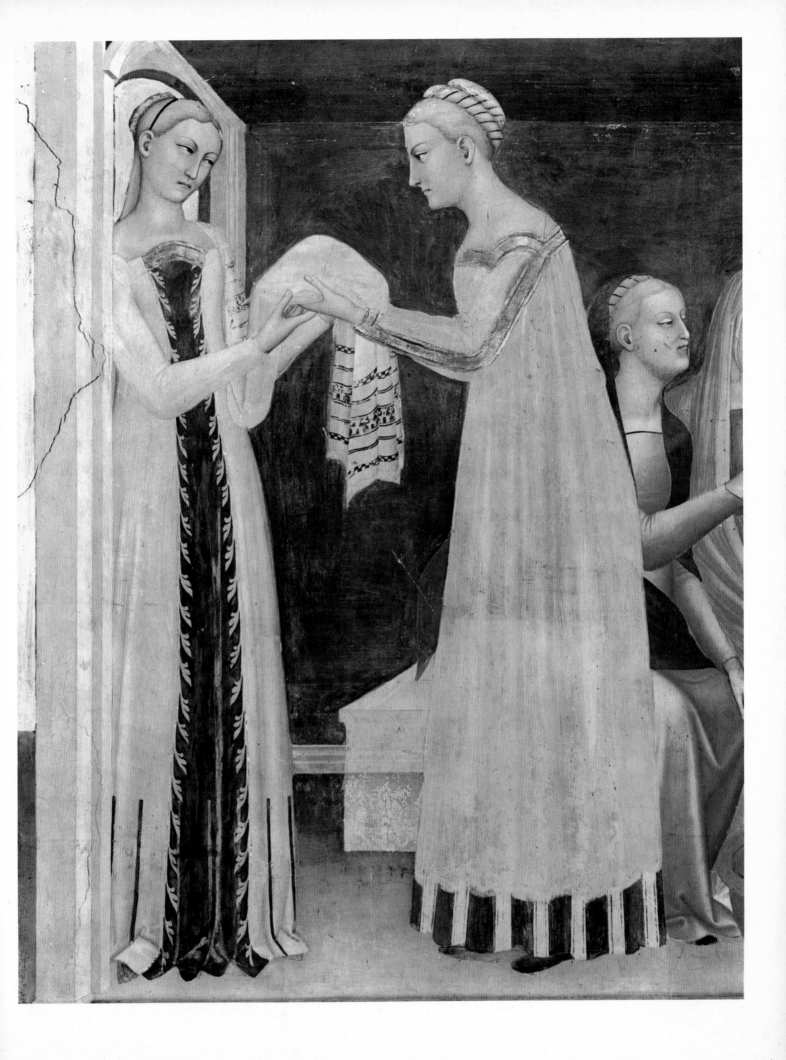

Portable Triptych

1338. National Gallery of Scotland, Edinburgh.

BERNARDO DADDI
Florence, active c. 1312–1348.
Pupil of Giotto, influenced by the Saint Cecilia Master,
Ambrogio Lorenzetti and thirteenth-century French sculpture.

"Homeless Pictures. The Florentine Trecento." 1930.
Homeless Paintings of the Renaissance.
Indiana University Press, Bloomington and London, 1970.

Daddi was the earliest of the Florentine painters deliberately to throw himself into the Gothic movement. He was, however, kept back by the severe discipline he received under Giotto and did not run to the excesses of other followers of Giovanni Pisano, but compromised upon an easy clarity, a noble graciousness, and a refined spacing reminding us more of what sculptors had done in Northern France under St. Louis. . . .

He had great technical ability, worked easily, and must have been prolific. He turned out many of those portable triptychs which served for household chapels, or were carried about on journeys. They doubtless were sold abroad and not least at the fairs of Champagne. They and their like by other Florentine painters were perhaps more efficient carriers of Tuscan art to Paris, to Picardy, to Flanders than the stationary frescoes at Avignon. . . .

The centre panel is taken up with the *Crucifixion* and the *Madonna* is shunted to one of the wings. Of course this was no caprice of the artist's but dictated by the person who ordered the painting. On another wing is the *Nativity*. Above are the *Crucifixion of Peter,* and the story of how the youthful *Nicholas* saved the three girls from shame. In the spandrels are the four *Evangelists* writing, or blowing ink from their pens. In the gable we see the *Saviour* blessing. On the base of the frame we read the date 1338, and this adds considerably to the value of this Triptych as an example of Daddi's style at a certain moment.

Nearly all his types are here, his precise draughtsmanship, his honest and praiseworthy modelling, his clear composition, his narrative skill, his dramatic power, his suavity.

74

Presentation of the Virgin

Drawing. Cabinet des Dessins, The Louvre, Paris.

TADDEO GADDI
Florence, documented since 1334, died not later than 1366.
Pupil and assistant of Giotto.

The Drawings of the Florentine Painters.
University of Chicago Press, Amplified Edition, Volume I, 1938.

The sheet in question is in the Louvre, and represents the Virgin going up the steps of the temple. It is a highly finished study for one of the frescoes in the Baroncelli Chapel at Florence. It is no great achievement, but not without interest; it tends to place Taddeo somewhat higher than the painting itself would permit. The fresco has been freed from the dirt of ages and renovated. The drawing, on the other hand, is comparatively well preserved. Yet making every allowance for difference of condition, there still remains a difference in quality. In the painting the figures tend to resemble sacks of sand settling down with their weight. In the drawing they are slimmer and better modelled, and hold themselves better.

The mastery of a Trecento artist revealed itself in the treatment of draperies; for it is by means of the draperies, and by their means only, that he attempted to model the figure and communicate the sense of its existence. Giotto here attained to a degree of excellence that has never been surpassed, not even by Masaccio or Michelangelo. But his followers from generation to generation had a dimmer and dimmer understanding of the reason for such and such and no other folds, tended more and more to think of them as ready-made patterns, and in obedience to the laws which doom the "successive copying" of a mere design to a further and further departure from the original, they ended by doing draperies almost as scrawly and as little expressive of form as were those of Giotto's uncouth precursors.

Presentation of the Virgin

1332–38. Fresco. Baroncelli Chapel, Santa Croce, Florence.

TADDEO GADDI
Florence, documented since 1334, died not later than 1366.

The Drawings of the Florentine Painters.
University of Chicago Press, Amplified Edition, Volume I, 1938.

The decline began with the great master's closest follower, namely with Taddeo Gaddi. Either he appreciated nothing in Giotto's splendid forms but their bulk, or, as is likely, he saw something more than mere bulk, but lacked the skill to convey the form he apprehended. At all events, in most of his paintings, were it not for obvious tokens of humanity like heads, hands and feet, and clothing, we should often be puzzled to decide whether a certain shape was meant to represent part of a figure, or a flour-sack; so little, as a rule, did Taddeo understand what he was doing when he drew the folds of his draperies.

The drawing before us shows him in a phase of exceptional excellence. It may be due to his having taken greater pains, or, as is probable, to his having been trained to express himself better with the pencil than with the brush. At all events, the folds in this sketch are treated far more intelligently than either in the corresponding painting or elsewhere in Gaddi's works. Look at the figures in the foreground. In the sketch the folds model the body and limbs which they cover. In the painting these same figures are not modelled at all, but are formless—now needlessly bulky, and now puffed out, like air-cushions. The drawing is superior even in conception, and shows that Taddeo's earlier and presumably more spontaneous feelings were better than reflection and elaboration made them later.

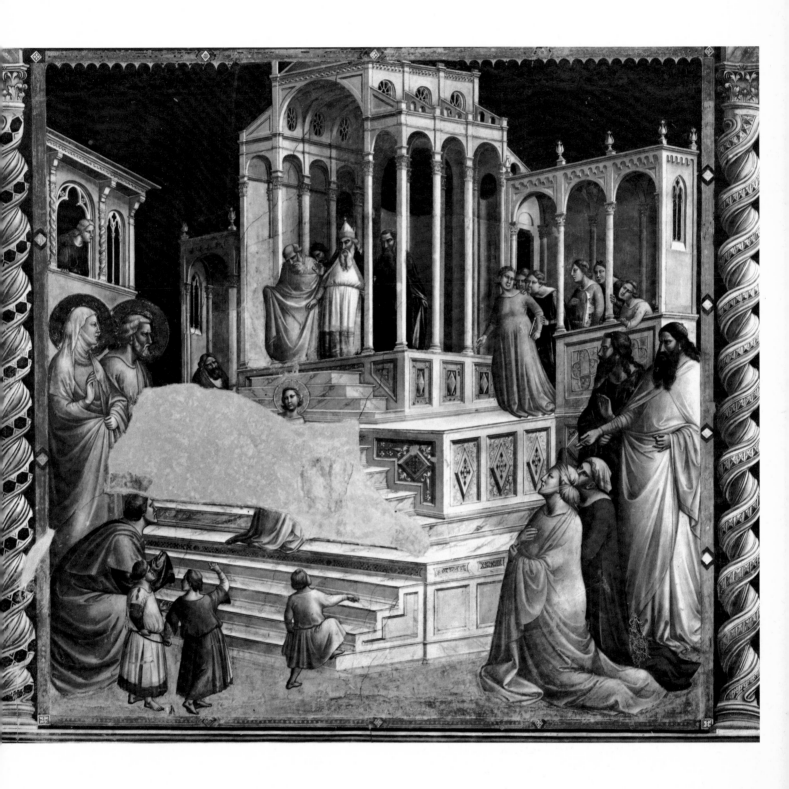

Madonna and Child with Four Angels

Detail. Museo Diocesano, Cortona.

PIETRO LORENZETTI
Siena, active 1305–1348
Probably pupil of Duccio, influenced by Simone Martini and the sculptor Giovanni Pisano.

"Ugolino Lorenzetti." 1917.
Essays in the Study of Sienese Painting.
Frederic Fairchild Sherman, New York, 1918.

I suspect that, although the Arezzo panels are the earliest paintings by Pietro of ascertained date, we possess several pictures that are still earlier. It is an inference I draw from the fact that they are stiffer, severer, and tighter, and because they are closer to Duccio. I will not dwell on the Ducciesque "Madonnas" at Castiglione d'Orcia and S. Angelo in Colle because they are ruined and not to our purpose. In Cortona, however, we have a "Madonna enthroned with Angels" which affords terms for comparison.

Nowhere else in Pietro do we see a throne so severely carpentered and angels leaning upon it or touching it in such patent Ducciesque fashion. The strip of embroidery under the Virgin's throat and crossed over her breast is paralleled nowhere else except in Duccio's *Maestas* on the figure of Pilate, before whom the Jews are accusing our Lord. The sparse geometric pattern which edges our Lady's mantle is also found only in Sienese paintings of Duccio's most immediate following.

Early in his career though it comes, and to be dated as early as 1315 perhaps, the Cortona Madonna is nevertheless markedly, unmistakably Pietro's. The types, the forms, the action are his: a Child more characteristic, ears more typical, he never painted.

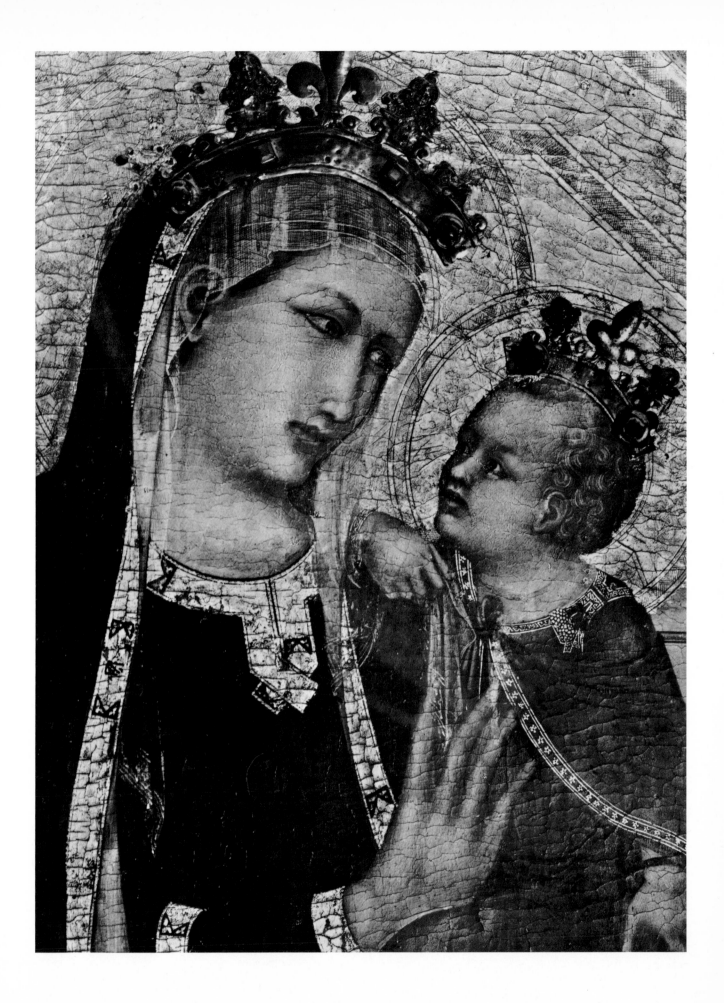

Madonna and Child Worshipped by a Monk

John G. Johnson Collection, Philadelphia.

PIETRO LORENZETTI
Siena, active 1305–1348.

Catalogue of a Collection of Paintings and Some Art Objects.
Volume I: "Italian Paintings." John G. Johnson, Philadelphia, 1913.

The Virgin is wrapped in a gold and blue embroidered mantle, and sits on a grand throne inlaid with mosaic, leaning sideways and turning to right. The Child, who wears a tunic, sits on her left knee and looks down blessing the monk who kneels below looking up with a fervent expression. The monk is designed on a much smaller scale.

This is a work in Pietro's largest style, painted not long after the Arezzo polyptych of 1320.

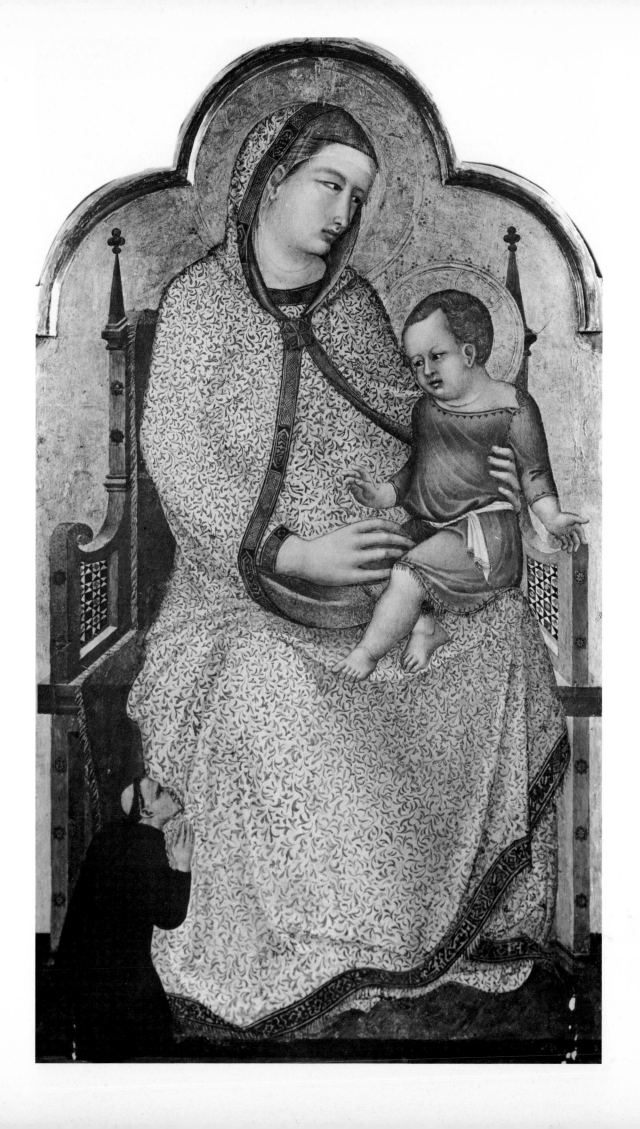

PAX: Allegory from the Good Government

1338–40. Fresco. Detail. Sala della Pace, Palazzo Pubblico, Siena

AMBROGIO LORENZETTI
Siena, active 1319–1348.
Pupil of his elder brother Pietro, influenced by the works
of Giovanni Pisano and Giotto.

Letter to Mary Costelloe.
Siena, November 22nd, 1890.

I have looked at Ambrogio Lorenzetti's frescoes representing allegories of good and bad government. Every time I have made an effort to put myself into the state of mind of a fourteenth century person. To him an allegory must have been wonderfully real, and tangible. I almost understood this for just a moment the other day, but it has gone from me again. In a higher sense it is only too natural for one to see that *"Alles Vergängliche ist nur ein Gleichnis,"* but when it comes to painting figures of peace, plenty, war, justice or what you will, it is hard to believe that there was as much as even an idea in the artist's mind to create a figure which should be really an incarnation of the spirit in the allegory.... It is hard to realize that in previous centuries especially during the middle ages the allegory was as real, probably, as angels are still to a few people. I suppose the medieval person quite likely thought there was an angel, a Dominion who was the spirit of a certain quality, and as such quite as paintable as the Archangel Gabriel or St. Michael. That much comes out not only from the art of the fourteenth century but more still from the literature, from Dante especially. Indeed the first attempts at interpretation of character in painting are to be seen in the allegorical figures, I fancy for the reason that it was easier to put expression into a face supposed capable of only one emotion, and that generally an emotion so common that the painter could not have helped noting it.... Perhaps an allegory's only function is to plunge us into a certain state of mind. On me I am sure the effect is sometimes quite like the effect of music. It does not excite intellectual activity, but opens up a world of dreams.

84

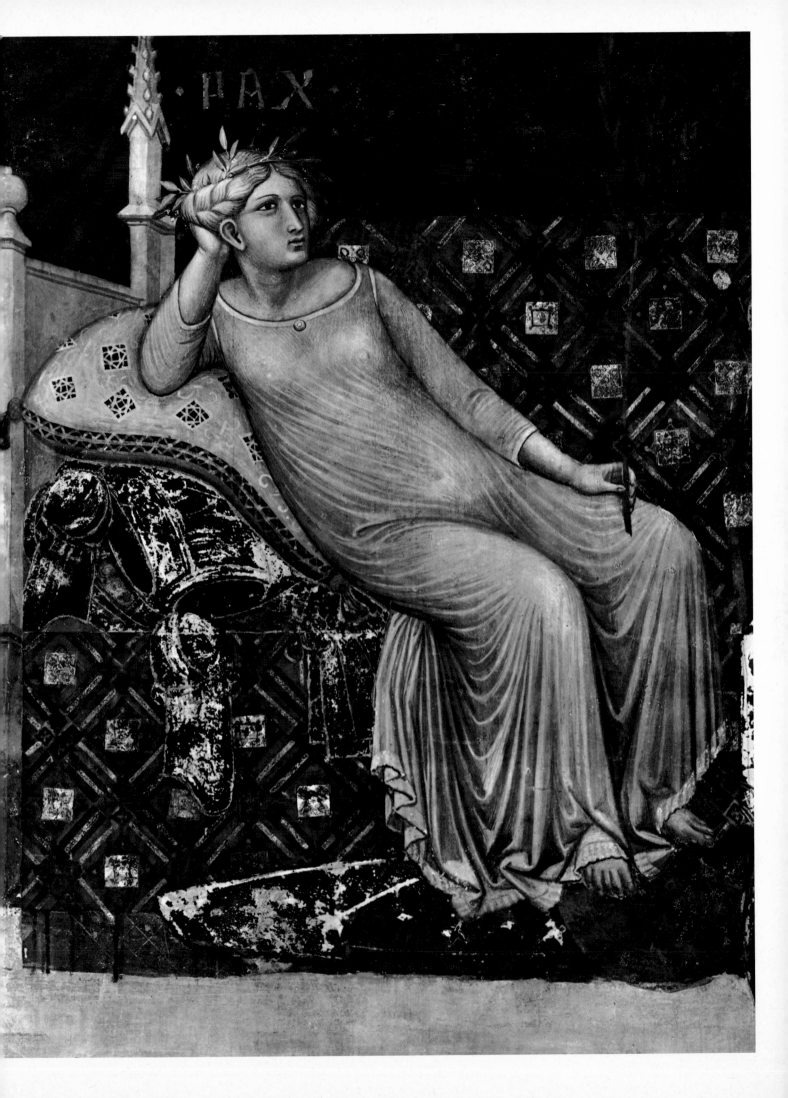

Virgil, Servius and Aeneas

Illuminated frontispiece of the Codex Virgilianus. Biblioteca Ambrosiana, Milan.

SIMONE MARTINI
Siena, c. 1284–Avignon, 1344.
Pupil of Duccio, slightly influenced by Giovanni Pisano and Giotto.

"An Antiphonary with Miniatures by Lippo Vanni." 1924.
Studies in Medieval Painting.
Yale University Press, New Haven, 1930.

In Tuscany, I affirm, paradoxical as it may sound, that a miniaturist was likely to be bolder, looser, sketchier than a tempera painter, and that the addiction to miniature painting, as then practiced, would tend to loosen and free rather than tighten and tie up an artist's hands. We happen to have an excellent example and proof of what I mean to assert in the famous frontispiece to Virgil's Eclogues, that once belonged to Petrarch and is now preserved in the Ambrosiana at Milan. This illumination is by no less an artist than Simone Martini himself. In no panel or fresco is he so unrestrained, so fluent, so sketchy, or, as the late Professor Wickhoff and his hosts of followers would have said, so "impressionistic." The practice of the craft must have led Simone to be less the devotee of the line and more the adept of the brush than as a rule he had been elsewhere. As a fact, the frescoes in St. Martin's chapel at Assisi are so much broader, looser, readier than any other frescoes of his, let alone tempera paintings, that one would expect that before going to work upon them, he had done a great deal of illuminating. Unhappily, there survives no trace of such activity. The solitary masterpiece in the Ambrosiana must be of later date.

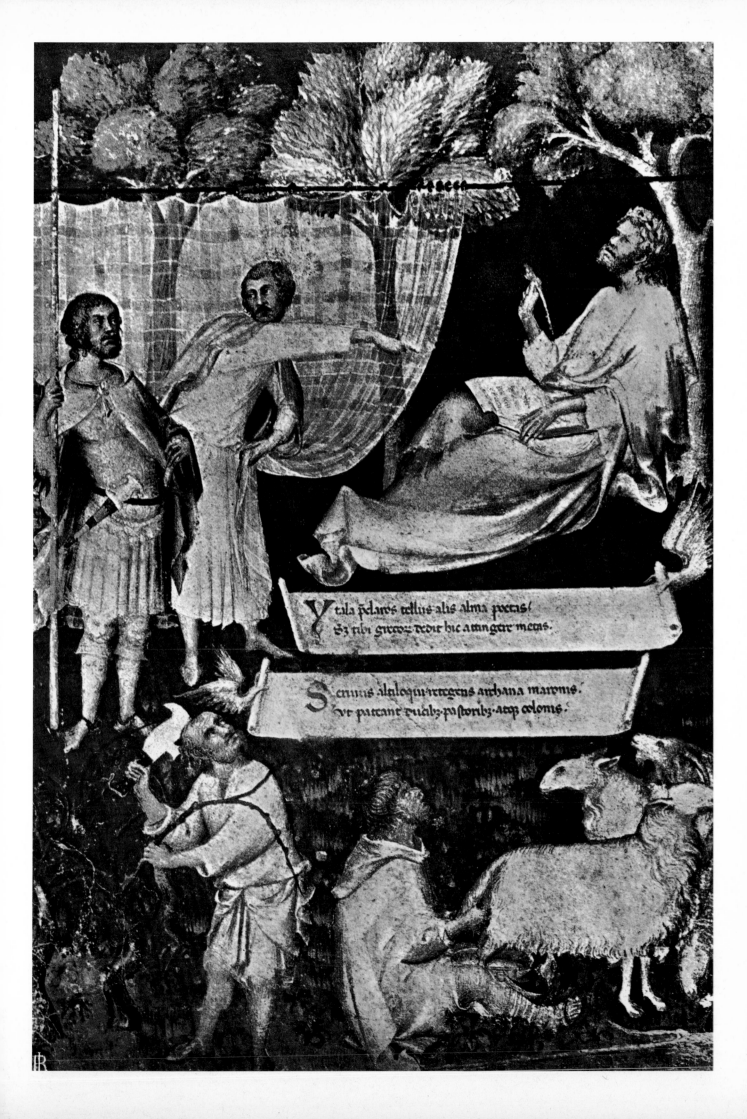

Ytala ꝑclaros tellus alis alma poetas/
Sz tibi grecoꝛ ꝛeoit hic attingere metas.

Scriuus alaloqiu retegens archana maꝛonis.
vr pateant rurib; paſtorib; atꝗ colonis.

Guidoriccio da Fogliano on Horseback

1338. Fresco. Detail. Sala del Mappamondo, Palazzo Pubblico, Siena.

SIMONE MARTINI
Siena, c. 1284–Avignon, 1344.

"The Central Italian Painters." 1897.
The Italian Painters of the Renaissance.
Phaidon Press, London, 1952.

Even when he is freed from Duccio's example, it is not as an artist with a feeling for the solemnity of actions which have almost a sacramental import that Simone reveals himself. The charm, the beauty, even the pride of life attracted him more. For him also painting was not in the first place an occasion for presenting tactile values and movement, but equally little was it an opportunity for communicating his sense of moral and spiritual significance. Simone subordinates everything — and he was great enough to have much to subordinate — to his feeling for magnificence, beauty, and grace.

Journey of the Magi

Fragment. The Metropolitan Museum of Art, New York. Maitland Griggs Bequest.

STEFANO DI GIOVANNI SASSETTA
Siena, 1395–1450.
Pupil of Paolo di Giovanni Fei; probably influenced by Masolino, Paul de Limbourg and similar Franco-Flemish artists, as well as by elder contemporary Franco-Lombard miniaturists.

A Sienese Painter of the Franciscan Legend.
Dent & Sons, London, 1909.
Epilogue, 1945 (unpublished).

For landscape as an art cannot present nature nor even represent it. It can do better: it can evoke, suggest, transport, transfigure. In these respects Sassetta was often successful not only in the Detroit "Way to Calvary" and in the "Glory of Saint Francis," but in more descriptive scenes such as the Saint Anthony Abbot panels (New Haven, Jarves Collection; Washington, National Gallery, Kress Collection; New York, Lehman Collection), the "Scenes from the Life of Saint Francis" from the back of my altarpiece (London National Gallery), and the Griggs "Procession of the Magi." Sassetta is never fantastic, as is his townsman and contemporary Giovanni di Paolo, whom I ventured to compare with Greco. He is never prosaic, as is another Sienese of his day, Domenico di Bartolo. Sassetta is highly imaginative yet never fantastic. He keeps the mean like a true classical master and is indeed as classical as the quintessentially Florentine Masolino but more inspired.

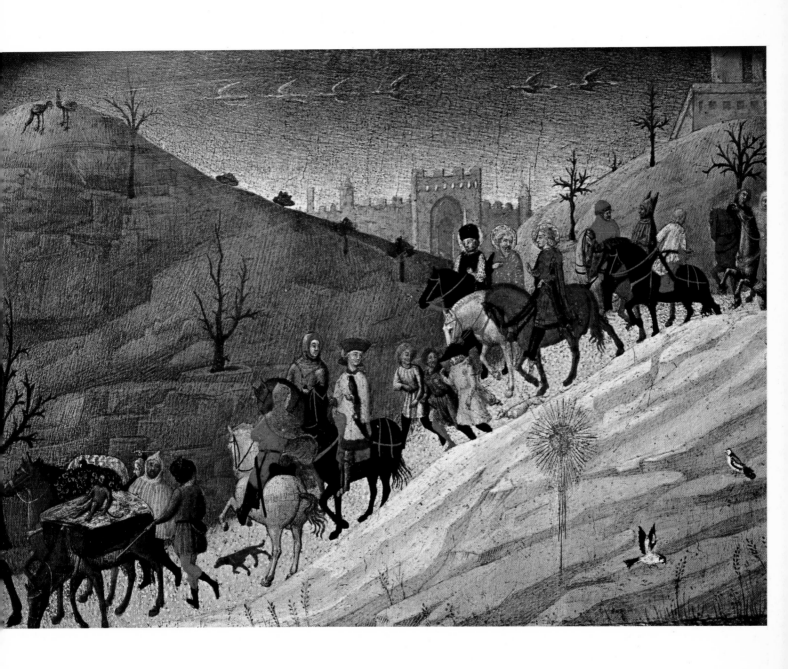

Marriage of Saint Francis with Poverty

1437–44. Side panel from the back of the San Sepolcro polyptych.
Musée Condé, Chantilly.

STEFANO DI GIOVANNI SASSETTA
Siena, 1395–1450.

A Sienese Painter of the Franciscan Legend.
Dent & Sons, London, 1909.

Here, if anywhere, was the theme for a great imaginative design.... The three virgin forms, the salutation, the disappearance — what more real and effective elements could a poetically gifted artist desire?

Stefano Sassetta, like all real poets, possessed the mythopoeic faculty of developing legend to the point where it blossoms into flowers fragrant to the soul. Neither Thomas of Celano nor St. Bonaventure speaks of a mystic marriage taking place between Francis and Poverty on the occasion of his meeting with the three maidens, nor does any other writer with whom I happen to be acquainted. But Sassetta must have seen at once what this encounter lacked to give it completeness and how self-evident and hence perfect an allegory it could thus become. Now this is what he made of it.

In the foreground of a spacious plain three maidens stand side by side. White is the robe of the first, greyish-brown of the second, rose red of the last. The one in brown is bare-footed and the most plainly clad, but it is on her hand that the ardent saint, with an eager bend of his body, bestows his ring. Then swiftly they take flight and ere they disappear in the high heavens over the celestially pure horizon of Monte Amiata they display symbols which reveal them as Poverty, Chastity, and Obedience. And when last we see them floating away in the pure ether, Lady Poverty looks back lovingly on Francis.... The figures on the ground are nearly dematerialised, the figures in the air are wafted up with their long-stoled robes fluttering like flames, the horizon is ineffably pure, and the high reaches of sky cast their transfiguring influence upon the mystery. These various instruments play upon the gentle heart, attuning it to much of all the harmony, all the "perfect blitheness" that Francis felt when he thought of his Lady Poverty.

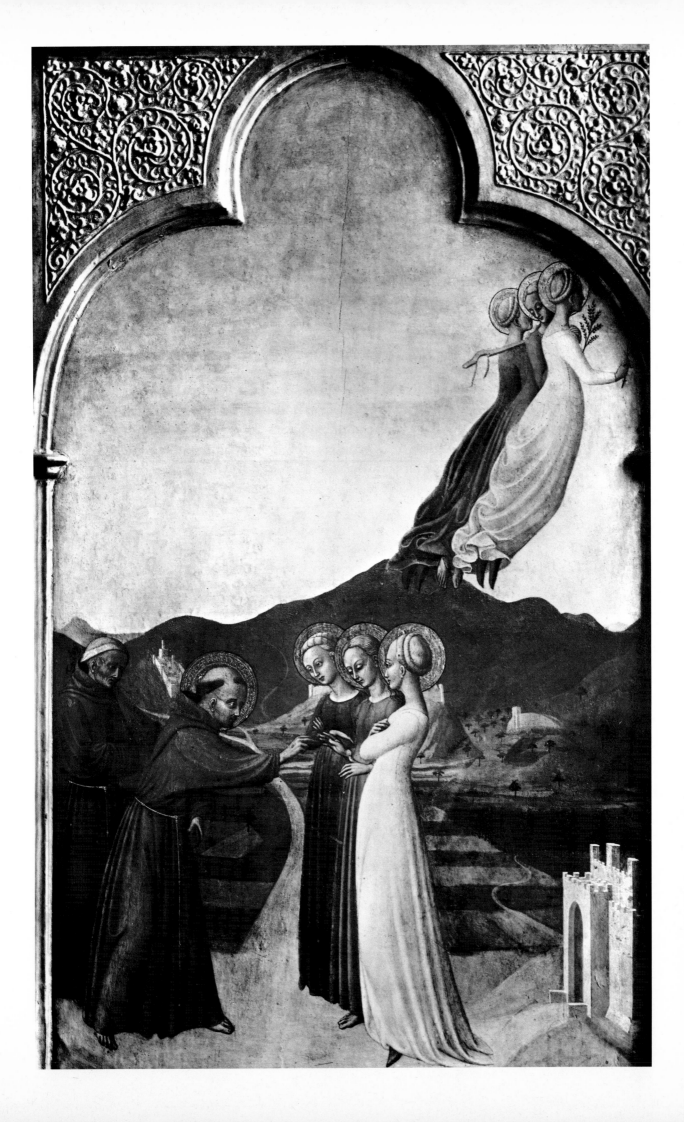

Ecstasy of Saint Francis

1437–44. Central panel from the San Sepolcro polyptych.
Berenson Collection, Florence.

STEFANO DI GIOVANNI SASSETTA
Siena, 1395–1450.

A Sienese Painter of the Franciscan Legend.
Dent & Sons, London, 1909.

Few things indeed are capable of conveying the atmosphere of worship, the sense of oneness with the universe, of ecstatic harmony with its purpose.

While it would be interesting to discuss at this point what means the art of painting has of conveying this mystic feeling, I must here limit myself to saying that the instruments at the disposal of European art for this object are nearly confined to one, and that one — space-composition — little understood and seldom employed by our artists. But the East has all the treasures of imaginative design, and Sassetta with the quasi-oriental qualities of a Sienese has left us such a design, which, as a bearer of the true Franciscan perfume of soul, has no rival.

Over the sea and the land, into the golden heavens towers the figure of the blessed Francis, his face transfigured with ecstasy, his arms held out in his favourite attitude of the cross, his feet firmly planted on a prostrate warrior, in golden panoply. Cherubim and seraphim with fiery wings and deep crescent halos form behind the saint a nimbus enframing a glory of gold and azure, as dazzling as the sky, and as radiant as the sun. Overhead, on opalescent cloudlets, float Poverty in her patched dress, looking up with grateful devotion, Obedience in her rose-red robe with a yoke about her neck and her hands crossed on her breast, and Chastity in white, holding a lily. Underfoot, beside the crowned knight in armour, obviously symbolising Violence, we see corresponding to Poverty a nun in black holding a press and money-bag, with a watch-dog by her side, as obviously representative of Avarice; and corresponding to Chastity, a pretty woman in purplish rose colour, luxuriously reclining against a black pig, and gazing into a mirror — clearly the Flesh. The almost childlike simplicity of the arrangement, the crimson and gold and azure, the ecstatic figure of the saint, the girlish figures of the radical Franciscan virtues, the more material figures of the vices, the flaming empyrean, the silvery green sea growing lighter as it approaches the silvery grey land, combine to present a real theophany, the apotheosis of a human soul that has attained to complete harmony with the soul of the universe by overcoming all that is belittling and confining, and opening itself out to all the benign influences of the spirit.

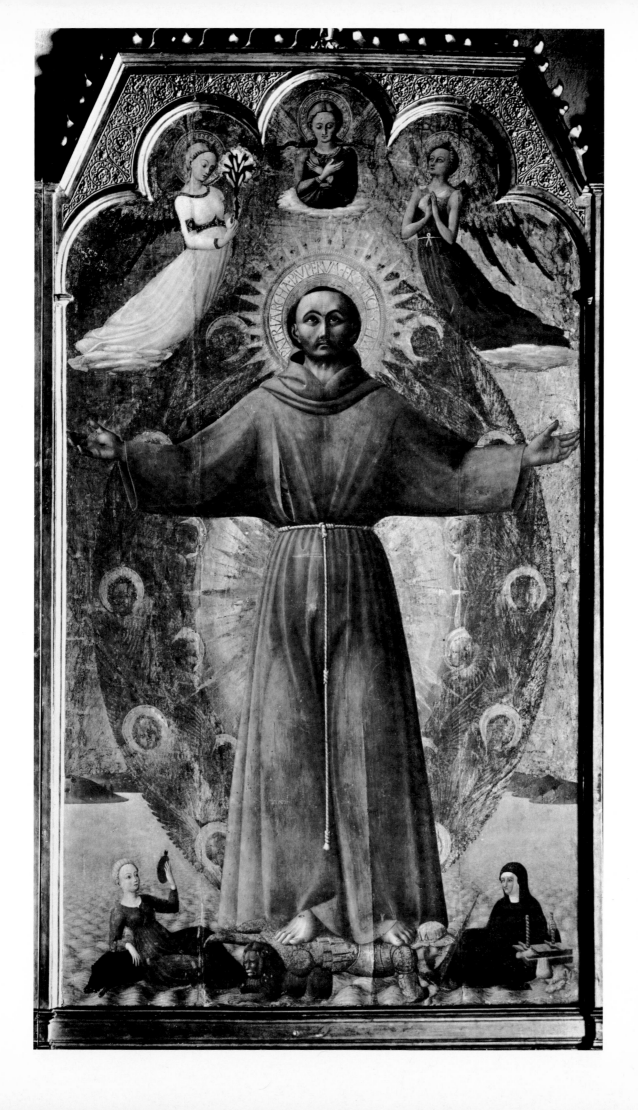

Madonna and Child with Angels and Four Saints

Signed and dated 1454. Fragmentary polyptych.
The Metropolitan Museum of Art, New York. Michael Friedsam Bequest.

GIOVANNI DI PAOLO
Siena, 1399–1482.
Pupil probably of Paolo di Giovanni Fei; close follower of Sassetta. This "Greco" of
the Quattrocento must have been in touch with contemporary Byzantine painting.

"The Catalogue of Italian Pictures in the Michael Friedsam Collection." 1926.
(unpublished).

The Virgin wears a dark blue mantle with green lining, a dark red brocaded
tunic, and a white veil over her forehead. She sits on a bench covered with
an embroidered cloth and supports the Infant Christ on a red and gold cushion
placed upon her left knee. In either corner at the base is a kneeling angel facing
the Virgin. The left one plays the harp and the other the viol; both are dressed
in damask gold robes. Two other angels stand on either side of the Virgin.
This panel is signed at the foot: OPUS. JOHANNES. MCCCCLIIII....
The Madonna and the Saints are on a marble floor. The background is of
sheet gold. The top of each panel is a gothic arch enclosed in the original
frame.
A work of the master's best years giving an adequate idea of his most
monumental phase. Its next of kin span the years from 1445, the date of the
"Coronation with SS. Andrew and Peter" at Sant'Andrea in Siena, to 1463,
the year when Giovanni painted the Altarpiece with a "Pietà" in the lunette
at Pienza. In these eighteen years he matured a manner based chiefly on Sassetta
in which he dares to paint figures as ugly and as gnarled, but as sincere and
distinguished and aloof as Chinese Lohans.

96

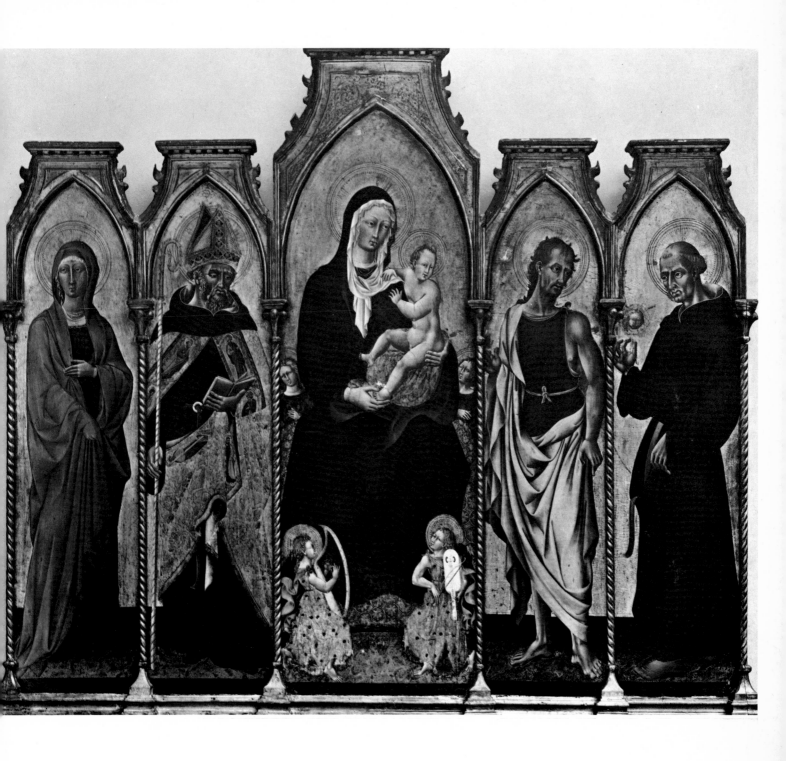

Miracle of Saint Nicholas of Tolentino

Predella panel. John G. Johnson Collection, Philadelphia.

GIOVANNI DI PAOLO
Siena, 1399–1482.

"The Catalogue of Italian Pictures in the Michael Friedsam Collection." 1926.
(unpublished).

This polyptych must have had small pictures decorating the *predella* or base, one under each panel. They must have been singularly like a "Nativity" in the Grenville L. Winthrop Collection in New York [now in Cambridge, Mass., Fogg Art Museum, G. L. Winthrop Bequest] or the "St. Nicholas Saving a Ship" in the John G. Johnson Collection at Philadelphia. Indeed it would not be surprising if these two fascinating scenes turned out to have served as a base, the one for our Madonna and the other for our St. Nicholas who in this instance was confused with his namesake of Bari, a common enough occurrence where the baptismal names were identical.

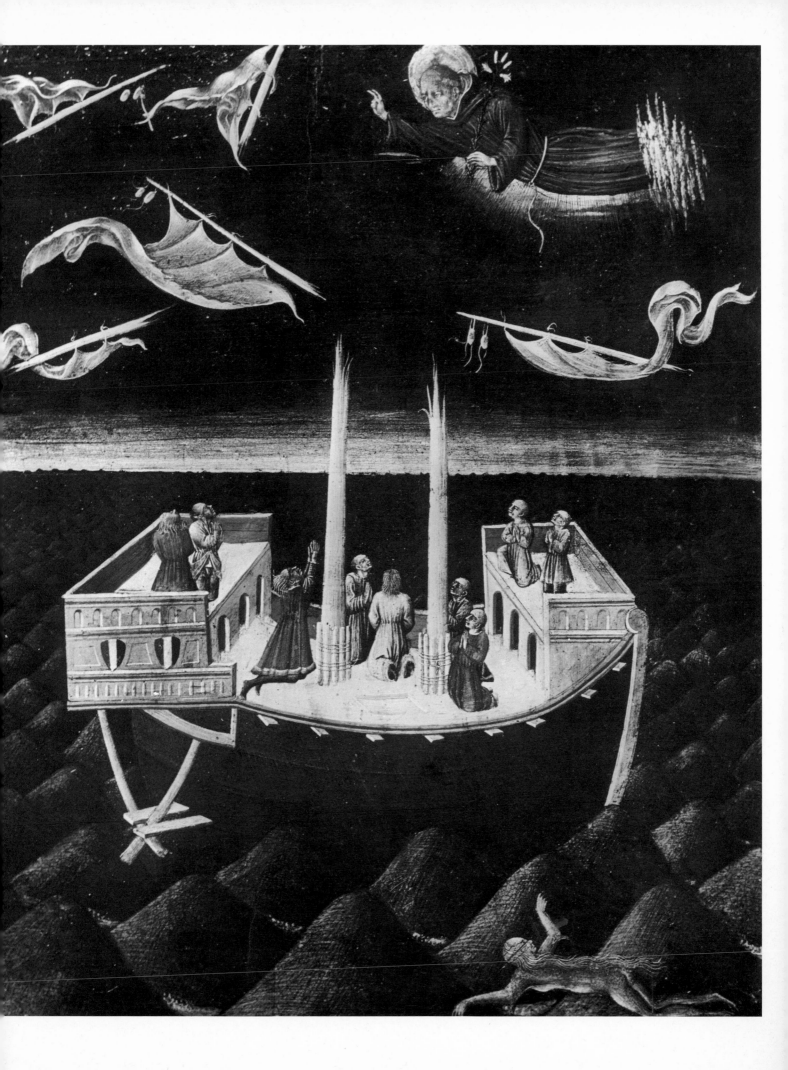

Annunciation

Predella panel. National Gallery of Art, Washington, D.C. Kress Collection.

GIOVANNI DI PAOLO
Siena, 1399–1482.

"The Catalogue of Italian Pictures in the Michael Friedsam Collection." 1926.
(unpublished).

No longer than thirty years ago at most Giovanni di Paolo was either the most unknown of artists or the most despised when known. The few pictures of his that were exhibited in public museums outside Siena were disdained. In private collections one might have come across this or that gem-like little painting, enamel-like, shown in glass cases, and ascribed to more valued artists. Now this quaint, this whimsical narrator and jeweller, with his feeling for beauty in ugliness, with his nimble movements and his ashen grey or blue tones, is a favourite even among favourites, and no private assemblage of Quattrocento Italians would be considered complete in which he was not represented.

Giovanni di Paolo has partaken of the good fortune that has befallen Sienese Fifteenth Century painting in general. Thirty years ago one went to Siena to study Sodoma and Pintoricchio, and turned away with contempt or even loathing from the exaggerations not always leaning towards prettiness of a Fei, a Giovanni di Paolo, or a Vecchietta.

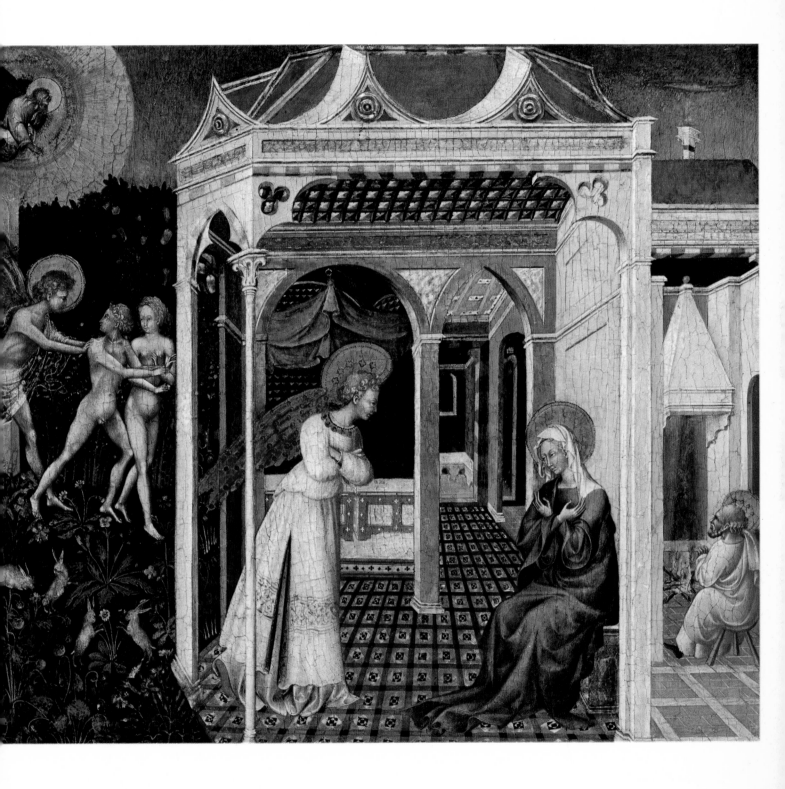

Adoration of the Magi

Signed and dated 1423. Detail. Galleria degli Uffizi, Florence.

GENTILE DA FABRIANO
Fabriano, 1370(?), documented in Venice before 1410, died in Rome, 1427.
School of Fabriano; continued tradition of Allegretto Nuzi and was subjected to Franco-Flemish influence.

"The Central Italian Painters." 1897.
The Italian Painters of the Renaissance.
Phaidon Press, London, 1952.

Umbrian art reveals itself clearly, if not completely, in its first great master, Gentile da Fabriano. To a feeling for beauty, and a sense for colour nurtured on Sienese models, to a power of construction fostered by contact with Florentine art, Gentile added a glowing vivacity of fancy, and, thus prepared, he devoted his life to recording the Medieval ideal of terrestrial happiness, clear, complete at last (as is the wont of ideals) when the actuality, of which it was the enchanting refraction, was just about to fade into the past. Fair knights and lovely ladies, spurs of gold, jewelled brocade, crimson damasks, gorgeous trains on regal steeds ride under golden skies wherein bright suns flatter charmed mountain tops.... And what a love of flowers! Gentile fills with them even the nooks and crannies of the woodwork enframing his gorgeous "Epiphany."

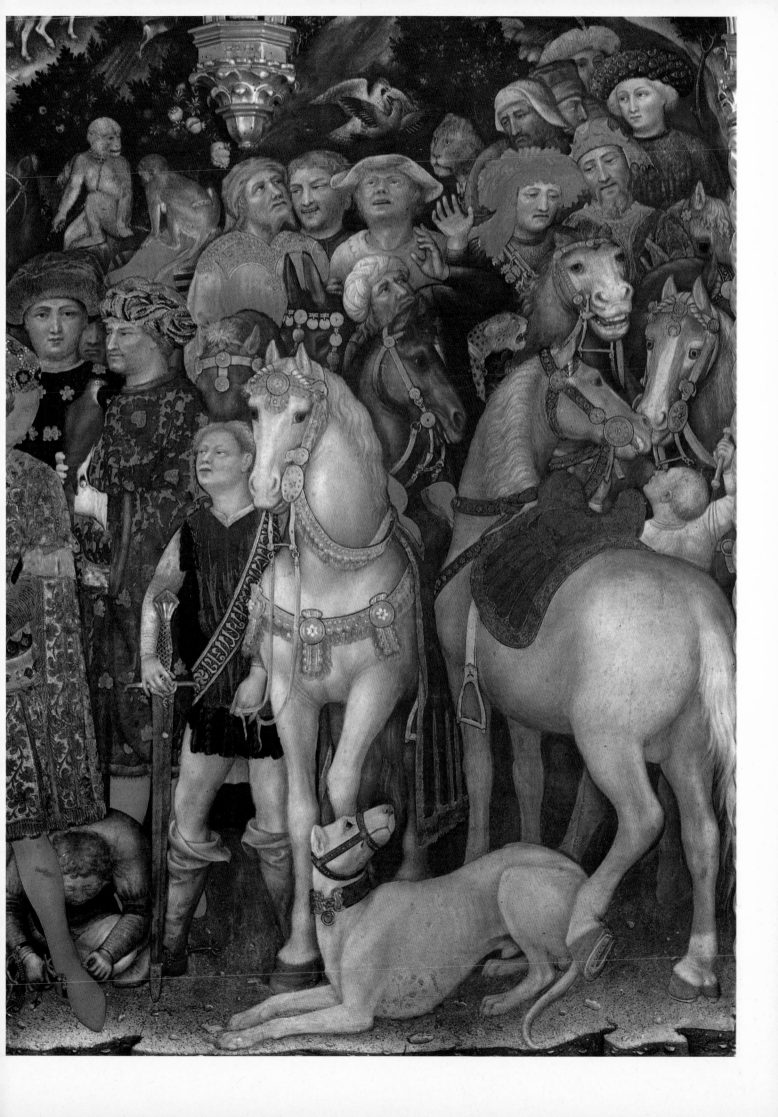

Flight into Egypt

1423. Predella panel from the Adoration of the Magi Altarpiece.
Galleria degli Uffizi, Florence.

GENTILE DA FABRIANO
Fabriano, 1370(?), documented in Venice before 1410, died in Rome, 1427.

A Sienese Painter of the Franciscan Legend.
Dent & Sons, London, 1909.
Epilogue, 1945 (unpublished).

I have seen many landscapes, landscapes of all times and climes, from Egyptian and Assyrian and Greek — as known chiefly through wallpainters' copies at Pompeii — Medieval, Renaissance and more recent centuries down to the mysticized Cézanne and Van Gogh now worshipped as if no earlier artists had ever painted or done anything worth looking at. In vacant mood and when not reduced to servitude by purposeful thinking, memory is free to open out and display what its caprice calls forth. . . . it is likely to call up even more naive representations of nature, as for instance Gentile Fabriano's "Nativity" and "Flight into Egypt." I already had seen Millets, Manets, Monets in abundance when I discovered these little masterpieces and they struck me at once as being more evocative, more transporting than the achievements of these recent artists. The night landscape of the Nativity glowing with the soft radiance of the stars, golden pinpoints in the sky lit up by the swoop of the angel down toward the reclining shepherds, the daylight scene of the Flight, the sun a golden orb in low relief, have had over me more evocative power than any *plein air* paintings, for all the cunning displayed in reproducing effects that make one blink.

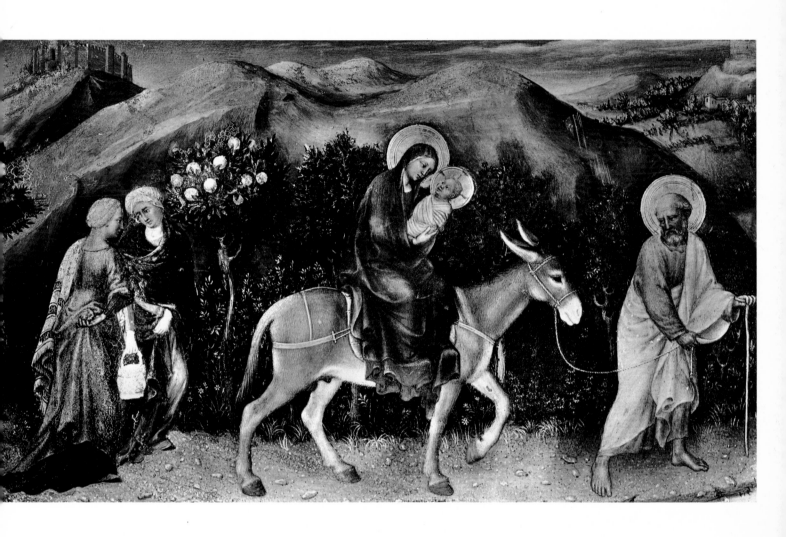

King David

1405–10. Companion to three panels formerly at Parcieux: Abraham, Noah and Moses.
The Metropolitan Museum of Art, New York.

LORENZO MONACO
Siena(?), c. 1370–Florence, 1425.
Follower of Agnolo Gaddi; influenced by Ghiberti, the Sienese, and possibly by fourteenth-century Byzantine as well as Franco-Flemish painting.

"Homeless Pictures. The Florentine Trecento." 1930.
Homeless Paintings of the Renaissance.
Indiana University Press, Bloomington and London, 1970.

In the *King David* . . . which the Cassel Gallery saw fit to render homeless, we have one of the most attractive paintings of the later Middle Ages. The prophet-poet-King — how like a French trouvère or troubadour prince of the 12th and 13th centuries! — sits gently swaying to the rhythm of the sounds he entices out of his psaltery. Conceivably, our artist had no idea of communicating this impression. He may have thought only of giving the draperies the swing to which in the years between 1405 and 1410, he was addicted. And the gracious lovely head of Jehovah's favourite is Gothic enough to crown the pattern, only that the Gothic he reminds one of is of Rheims and of the Sainte Chapelle. Looking closer at this beautiful head, one begins to wonder whether it is Gothic merely, whether it is not more like the ideal type of Byzantine manhood before the double scourge of ascetism and decay shrank and mummified it. The likeness to a *David* frescoed on the wall of the Metropolis at Mistra, soon after its foundation which goes back to 1310-11, is noteworthy, and invites attention.

After designing this masterpiece, Lorenzo seems to have fallen more and more subject to the swing and swirl of the late Gothic. I wonder at times whether our artist would have gone so far on this road if all the while he was painting in a resisting and restraining medium like tempera, instead of the more fluid one of illumination. One may be allowed also to believe that the illuminations of choir-books, to which he devoted himself for some time from about 1410 on, may have facilitated the change. Illumination was still being done in the Tuscany of that time with a technique more free, more fluid, more sketchy — more calligraphic in short — than tempera.

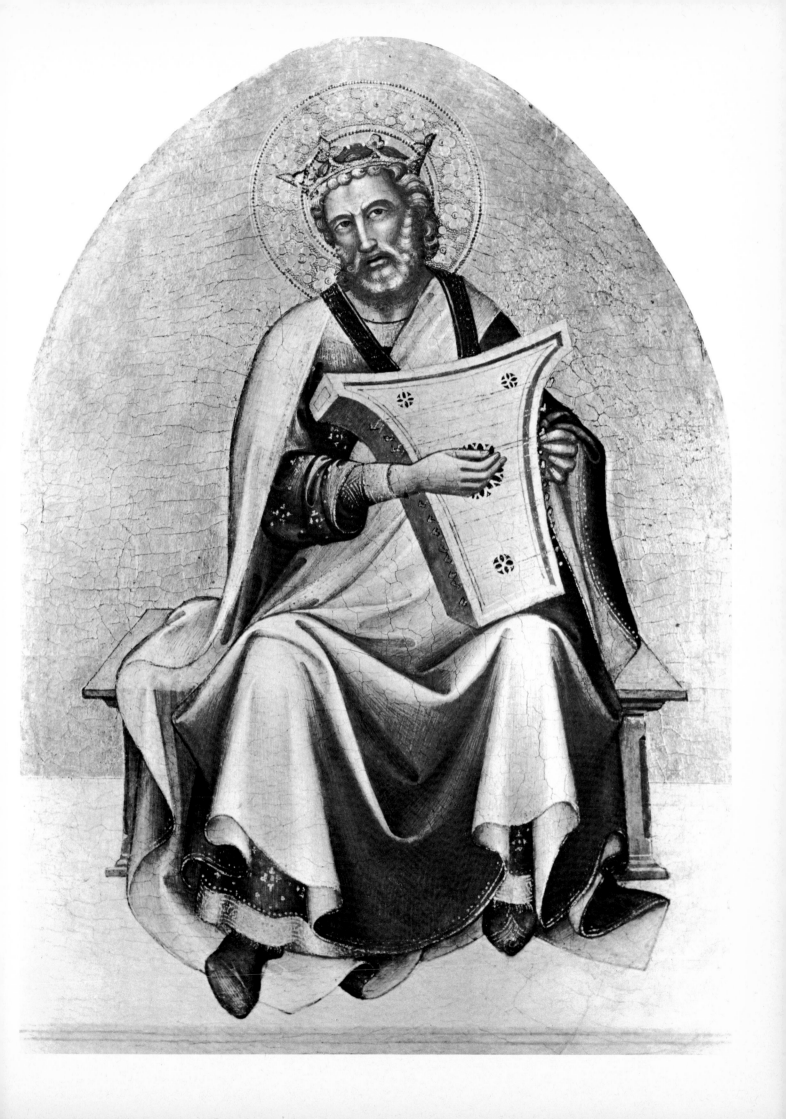

The "Goldman" Annunciation

National Gallery of Art, Washington, D. C. Mellon Collection.

MASOLINO DA PANICALE
Panicale, 1384–died after 1435.
Pupil of Ghiberti, influenced by Fra Angelico and Gentile da Fabriano.

"The Annunciation by Masolino."
Art in America, IV, February 1916.

The Annunciation is a large panel. The lovely-faced Virgin sits on the right in a hall of slender columns, while on the left kneels the flaxen-haired angel, dressed in a robe embroidered all over with golden roses. The decorative effect is so strong and so enchanting that, like the rest of Masolino's art, it scarcely finds precedents at Florence or even in Italy. The suavity, the grace, the splendour, although paralleled in Gentile da Fabriano and in Sassetta, would seem inspired rather by the ecstatic mood of Parisian painting toward 1400, with its figures of angelic candour and skies of heavenly radiance, than by Tuscan models. The Florentine and Italian, however, asserts himself in the severer rhythm of the line, in a greater softness and fusion of colour, and in the architecture, where earliest Renaissance is beginning its struggle with palsied and attenuated Gothic. Absurd as the effect may be, it is rendered delightful by the panelling, which offers a most exquisite display of wood-inlaying — the craft wherein Florence just then was rivalling the best that the Moslems in earlier centuries had achieved at Cairo. . . . Masolino's chronology is not easy to determine, for the simple reason that by the time we first encounter him, . . . he was already about forty years old and with an established style destined to undergo little change. For our keen appreciation of the absolute quality of his art must not lead us to expect of him the gifts, not necessarily artistic at all, but more often scientific, of the pioneer. He was evidently not an inventor, nor, on the other hand, was he born late enough to be carried along by the steadily rapid advance *en masse* that began only when he himself was already a most accomplished practitioner of his own manner. One is even justified perhaps in assuming a certain vague discomfort on his part in the midst of all the startling theories that were then springing up in Florence, seeing how ready he was to accept commissions elsewhere and how much he remained away.

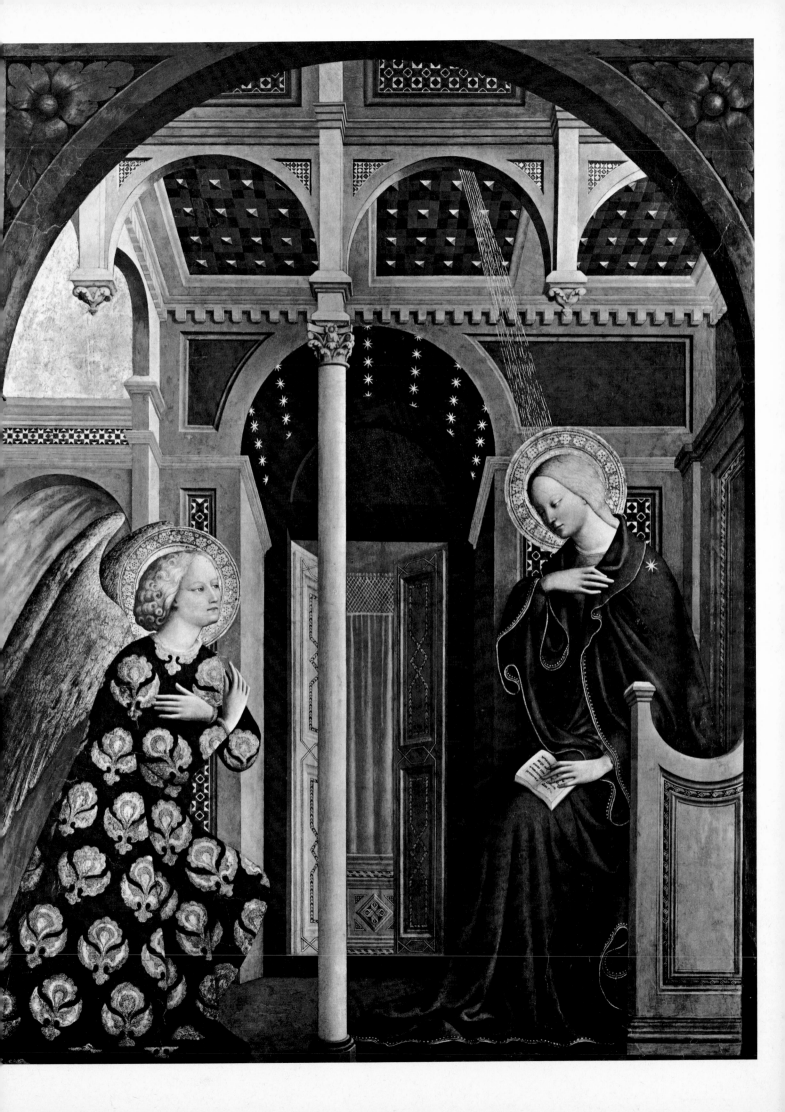

Deposition

About 1435–40. Detail. Museo di San Marco, Florence.

FRA ANGELICO DA FIESOLE
Vicchio nel Mugello, 1387–Rome, 1455.
Influenced by Ghiberti, Lorenzo Monaco and Masaccio.

"Fra Angelico." 1955.
Essays in Appreciation.
Chapman & Hall, London, 1958.

The Trecento did not look at "Nature." It improved on the Byzantine heritage and its formulas but never went beyond. The Florentine Quattrocento with few exceptions was too much absorbed in problems of perspective to give more than topographical aspects of nature, exemplified in the achievements of Baldovinetti and Pollaiuolo and admirable in their own way. Filippo Lippi painted lovely gardens and forest hillsides. Leonardo and his followers offer romantic views and mysterious distances. Of Botticelli, Leonardo wrote that all he did to paint a landscape was to throw a sponge dripping with pigment against a panel. . . .

One artist did see what I see as I look around me on my walks and even from my windows and that artist was Fra Angelico. Nobody less expected. Knowing as he must have known that the sky looked just as clear to an inhabitant of the far Valdarno as it did to him in Fiesole or in Florence, yet he painted it as he saw it, a pale greyish blue or bluish grey.

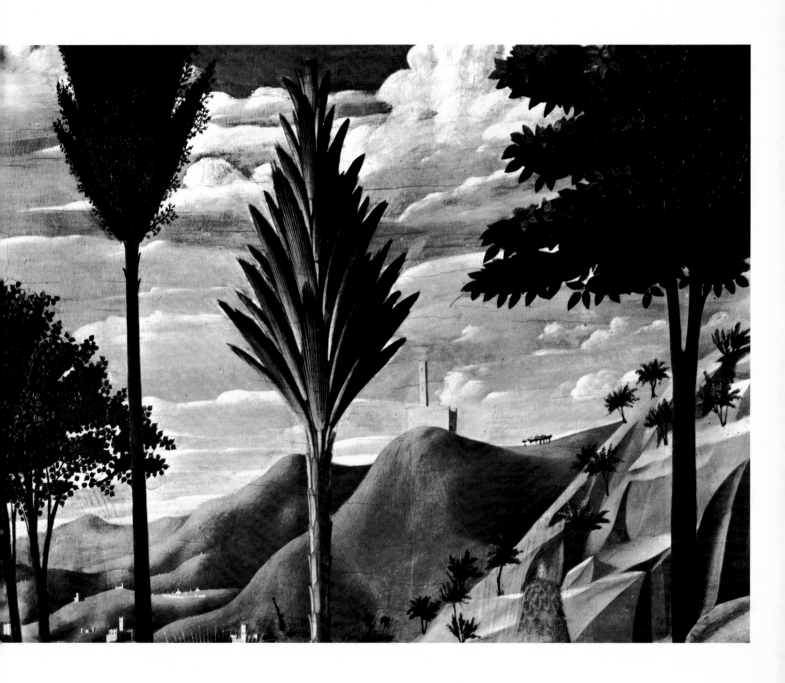

Deposition

About 1435–40. Detail. Museo di San Marco, Florence.

FRA ANGELICO DA FIESOLE
Vicchio nel Mugello, 1387–Rome, 1455.

"Fra Angelico." 1955.
Essays in Appreciation.
Chapman & Hall, London, 1958.

And equally well he knew that the white spots in the distance corresponded to homesteads, to villas, to churches and painted their geometrical shapes undetailed and looking at the whole as whitish spots in the greyish blue. To use a homely comparison, they seem like white spots of cheese appearing in the whey. One need cite no examples. If you look for them you will find them in any of Angelico's paintings that have distant views in their backgrounds.

He could paint clear skies and romantically clouded skies more evocatively, more convincingly than any of his Italian contemporaries and as well as the great Flemings.

At the same time he portrayed a city scene, the cross-section of a town in a way again unsurpassed by any of his Italian or Flemish contemporaries. His town walls, as in the "Pietà" and in the great "Deposition" (both in the San Marco Museum of Florence) are fascinating creations.

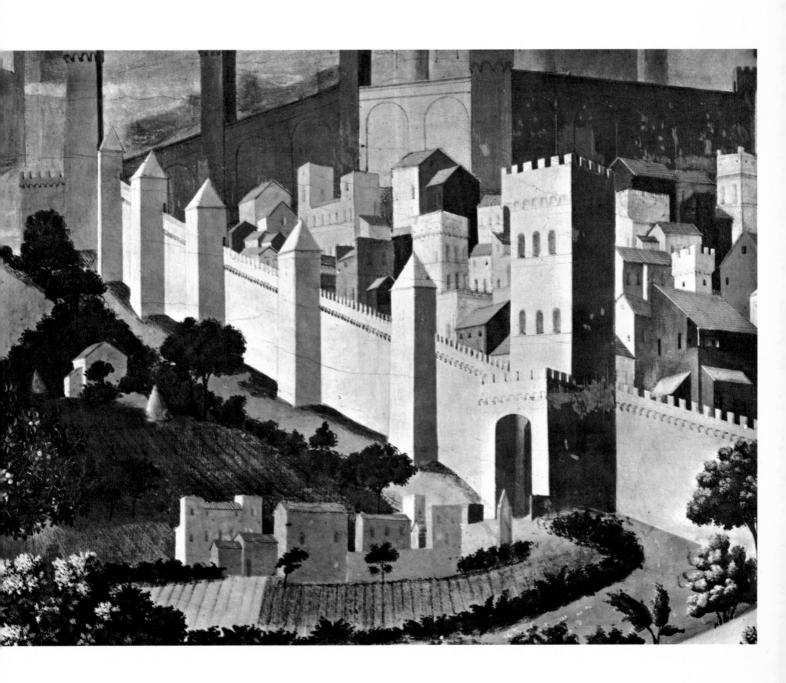

Temptation of Saint Anthony Abbot

Predella panel. Museum of Fine Arts, Houston. Edith A. and Percy S. Straus Collection.

FRA ANGELICO DA FIESOLE
Vicchio nel Mugello, 1387–Rome, 1455.

"Fra Angelico." 1955.
Essays in Appreciation.
Chapman & Hall, London, 1958.

Let it not be implied that I admire and love in Fra Angelico only the quasi-modern painter of distances, of space, of architecture and town scenes. I enjoy his celestial visions inspired to him, as to the illuminators of Byzantine and German XIIth- and XIIIth-century purple and golden codices, by descriptions in the Apocalypse of Jerusalem the Golden. I enjoy his gracious visages with their upward look of ecstasy. I enjoy his *naïveté,* his candour, even his occasional doll-like figures.

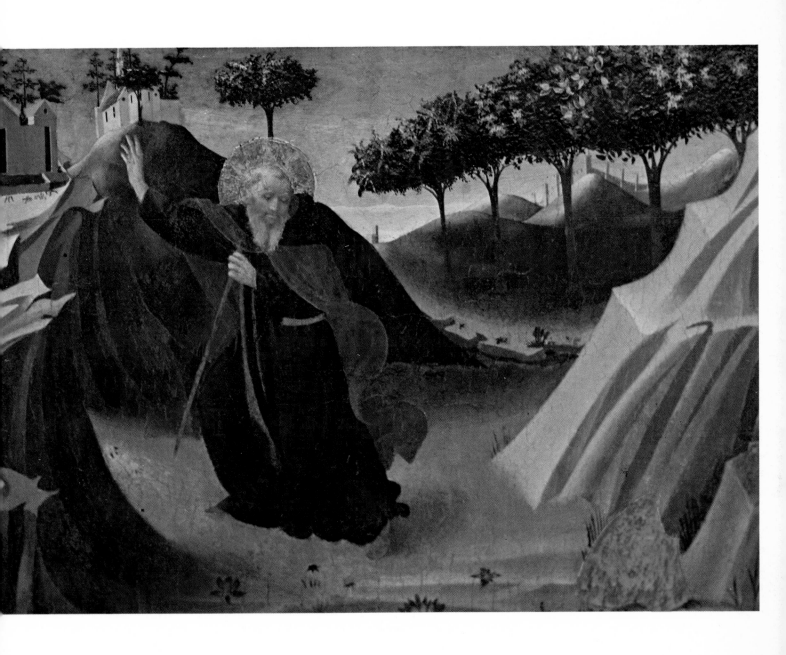

Saints Jerome and John the Baptist

Left wing of the "Miracolo della Neve" triptych in Naples.
National Gallery, London.

MASACCIO
San Giovanni Valdarno, 1401–Rome(?), 1428.
Pupil of Masolino, influenced by Brunelleschi and Donatello.

"The Florentine Painters." 1896.
The Italian Painters of the Renaissance.
Phaidon Press, London, 1952.

Types, in themselves of the manliest, he presents with a sense of the materially significant which makes us realize to the utmost their power and dignity; and the spiritual significance thus gained he uses to give the highest import to the event he is portraying; this import, in turn, gives a higher value to the types, and thus, whether we devote our attention to his types or to his action, Masaccio keeps us on a high plane of reality and significance. In later painting we shall easily find greater science, greater craft, and greater perfection of detail, but greater reality, greater significance, I venture to say, never.

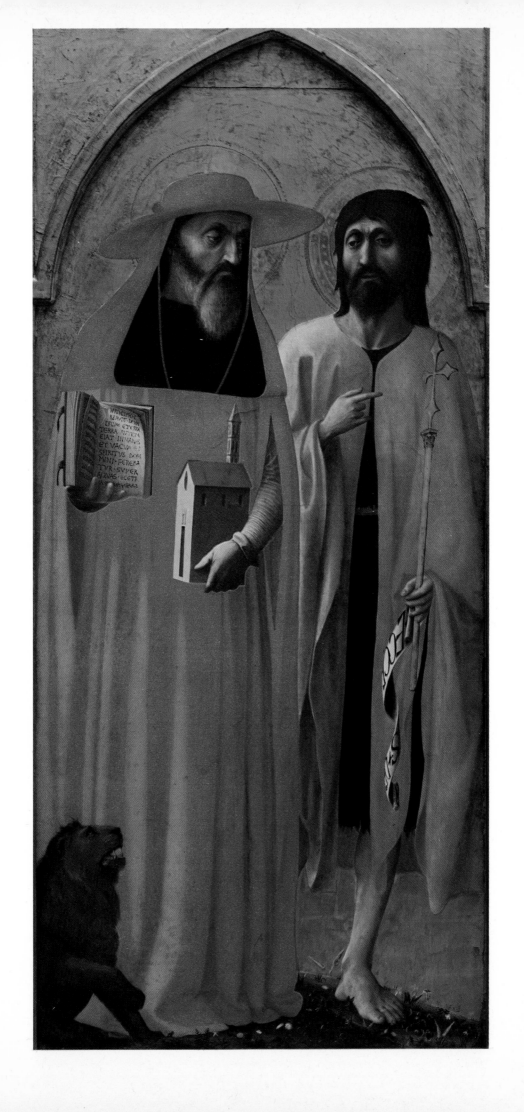

Tribute Money

1426–27. Fresco. Detail. Brancacci Chapel, Santa Maria del Carmine, Florence.

MASACCIO
San Giovanni Valdarno, 1401–Rome(?), 1428.

Letter to Mary Costelloe.
Florence, December 8th, 1890.

I spent most of the day over Masolino, Masaccio and Filippino in the Carmine.... To know Masolino, however, one must go to Castiglione d'Olona, or to San Clemente in Rome. But Masaccio can be studied here. He is very wonderful as a pioneer, much more than he is delightful to me, at least in the present condition of the frescoes. His great superiority over Masolino his master, and over such of his great contemporaries as Castagno, and Uccello is this, that with a realism, and power of articulating the human figure almost as great as theirs, he combines a power of grouping, proportioning, and composing in general which in works of the historical kind have never been surpassed. Indeed Raphael whose gift was chiefly for composition owes more than a little to Masaccio. What an impression Masaccio must have made upon him may be imagined when one bears in mind that his cartoon representing Christ taking leave of his disciples, is almost identical with Masaccio's "Tribute Money."

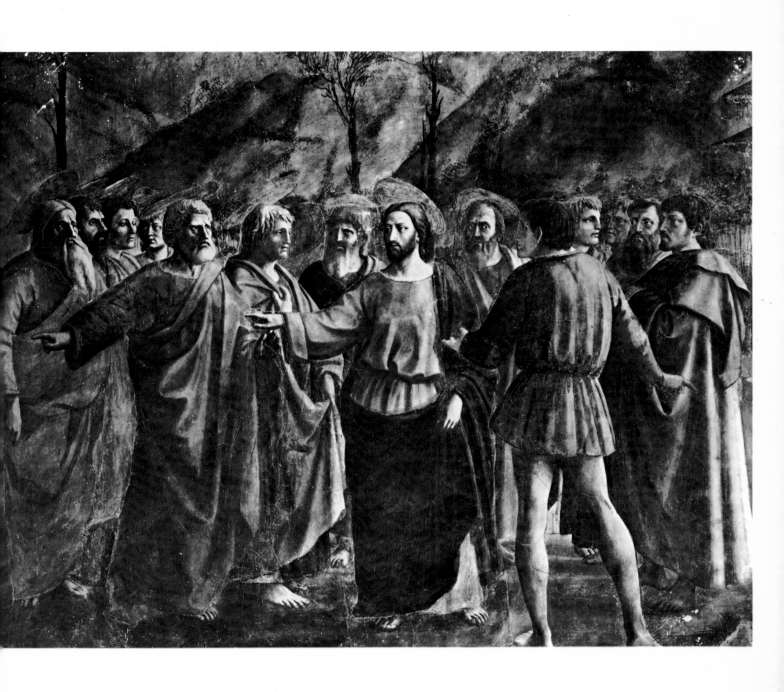

Madonna and Child with Four Angels

1426. Central panel of the Pisan polyptych. National Gallery, London.

MASACCIO
San Giovanni Valdarno, 1401–Rome(?), 1428.

"Masaccio's Pisan Madonna." 1907.
(unpublished).

The Madonna, herself more massive than any figure in the whole range of Italian painting excepting Giotto's, sits on a massive throne, from the design of which every trace of Gothic has disappeared. Her face is of almost forbidding severity with a strong nose and rather smallish eyes. The Child, sustained on her left knee, takes grapes out of her right hand. He is modelled in the round with a completeness of detachment from the background, with a perfection of spatial realization, that even Giotto had not attained. Alongside of the throne stand two angels with their hands joined in worship; below, quite in the foreground, sit two others playing on lutes. The draperies, of the Madonna especially, are heavy and ample, as unlike as possible to the ideal textures lending themselves to lovely linear motives which characterize the art of the Trecento and the Transition to the Renaissance....

In the first place, this Madonna has the almost monolithic solidity and impressiveness of the figures in the Brancacci frescoes, their largeness of planes, and their grandiose draperies with the wide sweep of heavy yet functional folds. The large powerful nose, the eyes well modelled in their sockets, and the careful rendering of the osseous structure are just what we find in the heads in Masaccio's masterpiece, the fresco of the "Tribute Money." In essentials, as a seated figure, the Virgin is practically identical with the "Peter Enthroned."... The head of the angel worshipping on the left, with knit brows and an expression almost of pain, will necessarily recall the Eve in the "Expulsion from Paradise," or some figure in the "Baptism." The ears, set far back on the side of the skull and tilted backwards, are identical with most of the ears in the frescoes. The Madonna's right hand is, with reverse of position, the same as Christ's or Peter's in the "Tribute Money." The woolly, ill-kempt hair of the lower angels can be matched repeatedly in the Brancacci Chapel. The folds are closely analogous.... Now we know from a document published recently, that Masaccio was working on the Pisan polyptych in 1426, and that it was thus his last achievement before undertaking the Florence frescoes. There is therefore a perfect harmony in the date yielded by internal evidence and the date furnished by documents for the polyptych formerly at Pisa.

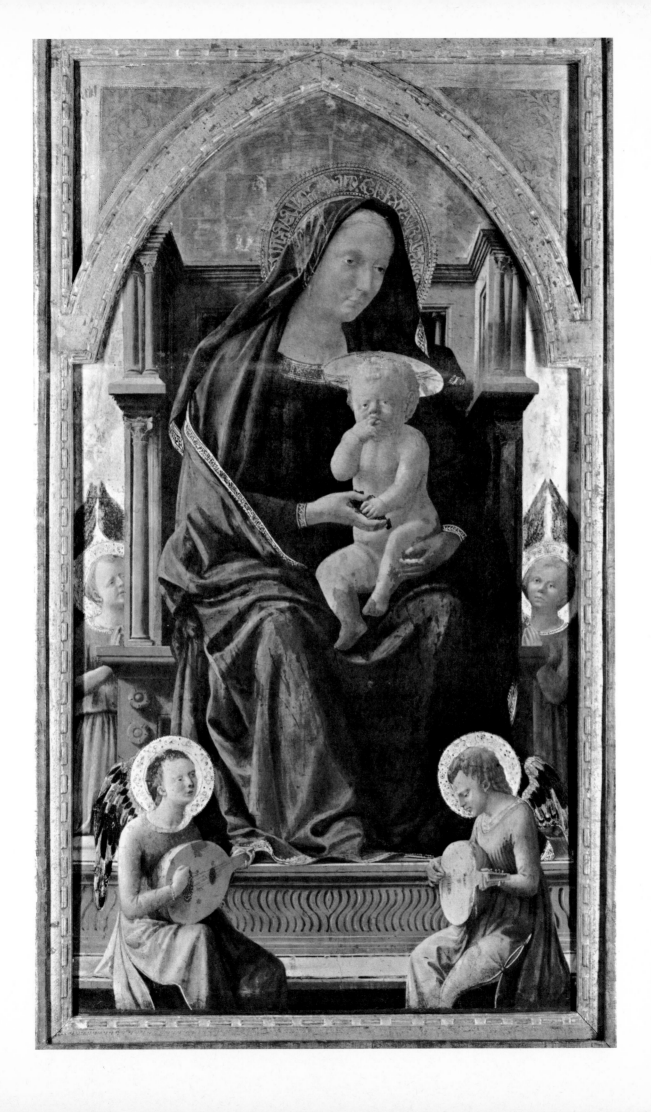

Crucifixion

1426. Upper central panel from the Pisan Polyptch.
Galleria di Capodimonte, Naples.

MASACCIO
San Giovanni Valdarno, 1401–Rome(?), 1428.

"Masaccio's Pisan Madonna." 1907.
(unpublished).

Seven other fragments exist which have been brought, with more or less questioning, into relation with the Pisan polyptych.... The largest of these panels, in which ten years ago I recognised the hand of Masaccio, has since been acquired for the Naples Gallery by Signor Venturi. More recently still it has been brought by Dr. Suida into connection with the Pisan polyptych. It offers one of the most impressive representations of the "Crucifixion" in existence. Should anyone be inclined to doubt that Masaccio painted this little masterpiece, let him note how singularly like in structure are the torsos of the Christ on the Cross and of the Holy Child in the London picture, what resemblances there are between the draperies of the Evangelist in the one and of the Madonna in the other, and how identical are the haloes in both.

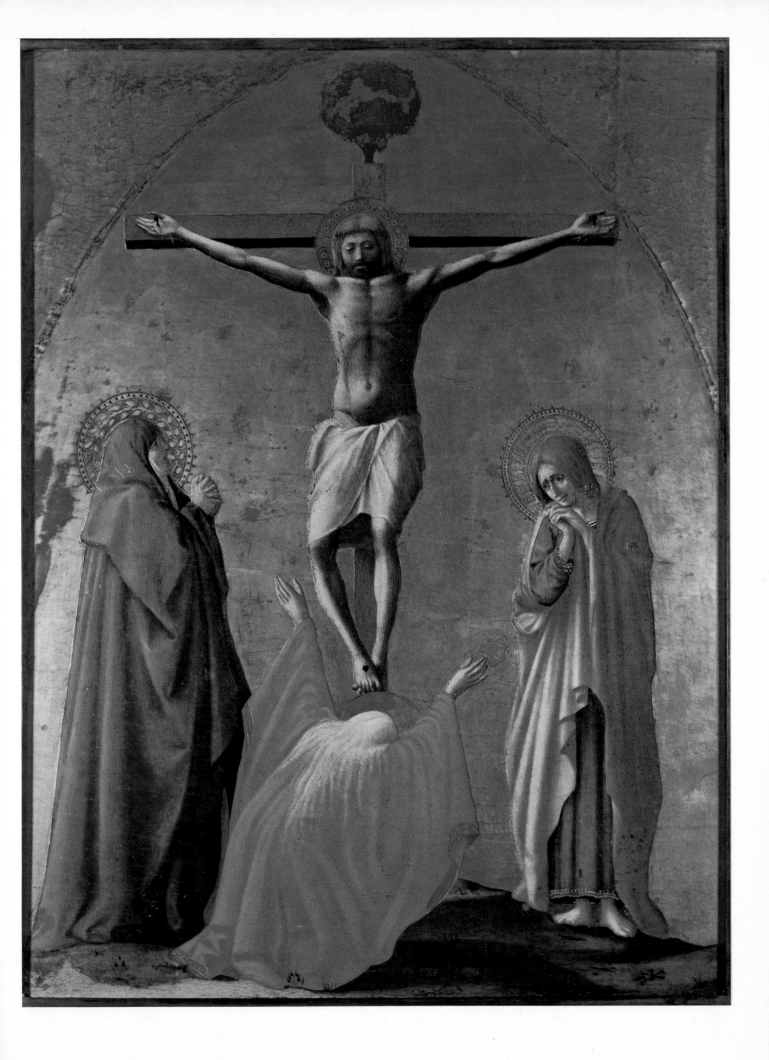

Madonna of Humility

National Gallery of Art, Washington, D. C. Mellon Collection.

MASACCIO
San Giovanni Valdarno, 1401–Rome(?), 1428.

"A New Masaccio."
Art in America, XVIII. February 1930.

This new work by Masaccio is painted on a panel little over a meter high, and represents "The Madonna of Humility." The essential of this aspect of the Blessed Virgin is that she should be sitting not on throne or chair or settee but on the ground or as here on a cushion. The Child clings to her neck, two angels hold up a brocade curtain and above and between the angels hovers the Dove. The colours are for Masaccio unusually bright and even gay. The flesh is more salmon than terra cotta coloured and the hair blonde. The Virgin's tunic is pink and her mantle is, of course, blue. Blue as well, but paler are the feathers of the dove and the raiment and wings of the angels. The cushion is bottle green with a buff pattern. The curtain is a brownish raspberry and the background gold. . . . And our own Madonna must be a mature work of Masaccio's, if the adjective can be applied to a supreme genius who, in a sense, never reached his own fullness of creative perfection, having been snatched away too soon by death. . . . It is more advanced than the Virgin with St. Anne now in the Uffizi. It is not so easy to decide whether the new Madonna is earlier or later than the one from Pisa. The last named is certainly the more overwhelming work. It is also less geometrical and abstract, more naturalistic in a sense, and perhaps these point to a slightly later moment in our artist's career. If this were painted, as is probable, in 1426, the new Madonna can scarcely be later than 1425.

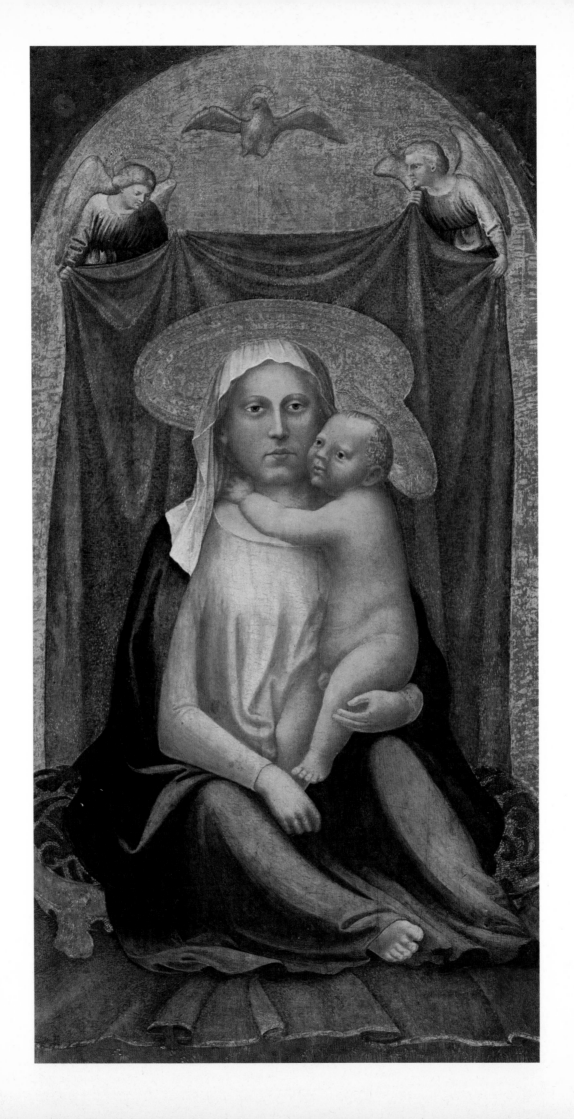

Flagellation
Galleria Nazionale delle Marche, Urbino.

PIERO DELLA FRANCESCA
Borgo San Sepolcro, 1416(?)–1492.
Pupil of Domenico Veneziano; influenced by Paolo Uccello.

Piero della Francesca or The Ineloquent in Art. 1949.
Chapman & Hall, London, 1954.

Of all Piero's paintings the one I love best, the one that satisfies me more and more every time I see it, is the Urbino Flagellation. No feeling appropriate to action expressed in face or figure, whether of the participants or of the mysterious trio in the foreground. Yet their callousness, their dumbness awe us into asking what they are made of. Not flesh and blood. Perhaps something more akin to the exquisite architecture, the columns, entablatures, ceilings, pavements, all like cut precious stones.

One is almost compelled to conclude that Piero was not interested in human beings as living animals, sentient and acting. For him they were existences in three dimensions whom perchance he would have gladly exchanged for pillars and arches, capitals, entablatures and facets of walls.

Indeed, it is in his architecture that Piero betrays something like lyrical feeling. He paints what he cannot hope to realize, his dream of surroundings worthy of his mind and heart, where his soul would feel at home. As in this Flagellation, so in the Arezzo frescoes, in the apse of the Brera altarpiece, in the cloister of the Perugia Annunciation (where he did not trouble to paint the figures), and not improbably, the view of a noble city square in an oblong panel at Urbino. At this point one may venture to ask whether it is not precisely Piero's ineloquence, his unemotional, unfeeling figures, behaving as if nothing could touch them, in short his avoidance of inflation, which, in a moment of exasperated passions like our to-day, rests and calms and soothes the spectator and compels gratitude and worship.

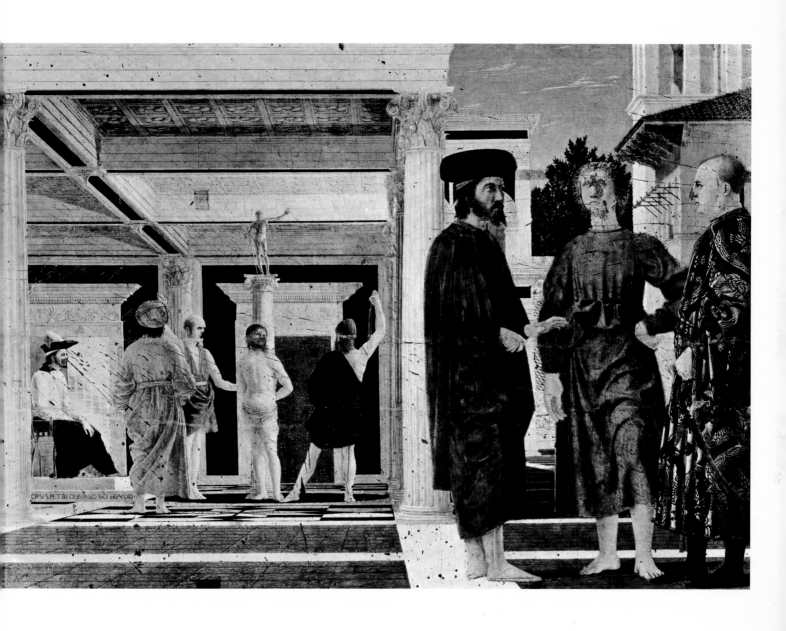

Defeat of Chosroes

1452–66. Fresco. Detail. Choir, San Francesco, Arezzo.

PIERO DELLA FRANCESCA
Borgo San Sepolcro, 1416(?)–1492.

Piero della Francesca or The Ineloquent in Art. 1949.
Chapman & Hall, London, 1954.

Some of us appreciate consciously, the placing and juncture of the planes and the way in which energy is manifested by the action of ankles and wrists, the tension and distension of muscles, the heft of a hand, the pressure of a foot. I suspect that what in these frescoed narratives impresses the seekers for aesthetic salvation is the earnestness, the gravity, the dignity of the participants, as the permanent state, the natural condition of their being, and the fact that they are so convincingly in three dimensions and full-weight. These impressions absorb the ordinary spectator enough to make him happy and leave him undisturbed by gesture and look and expression of figure and face.

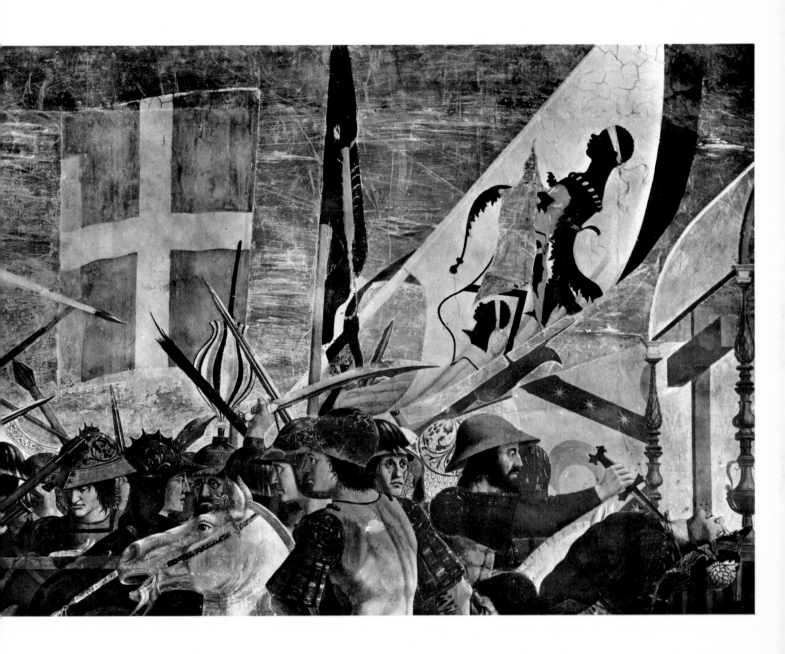

Defeat of Chosroes

1452–66. Fresco. Detail. Choir, San Francesco, Arezzo.

PIERO DELLA FRANCESCA
Borgo San Sepolcro, 1416(?)–1492.

Piero della Francesca or The Ineloquent in Art. 1949.
Chapman & Hall, London, 1954.

Piero della Francesca seems to have been opposed to the manifestation of feeling, and ready to go to any length to avoid it. He hesitated to represent the reaction which even an inanimate object would have when subjected to force, the rebound of a log, for instance, when struck by an axe. Look at the fresco of the Battle between Heraclius and Chosroes and the Decapitation of this Sassanian Monarch. No adequate action, scarcely any facial correspondence. A stiffly vertical trooper, with an immobile face, plunges a dagger into the throat of a youth. The only approach to expression, a soldier in the foreground who screams automatically when an enemy awkwardly seizes him by the hair and threatens him with a drawn sword while he, like a lay figure, jerks out an unarticulated arm.

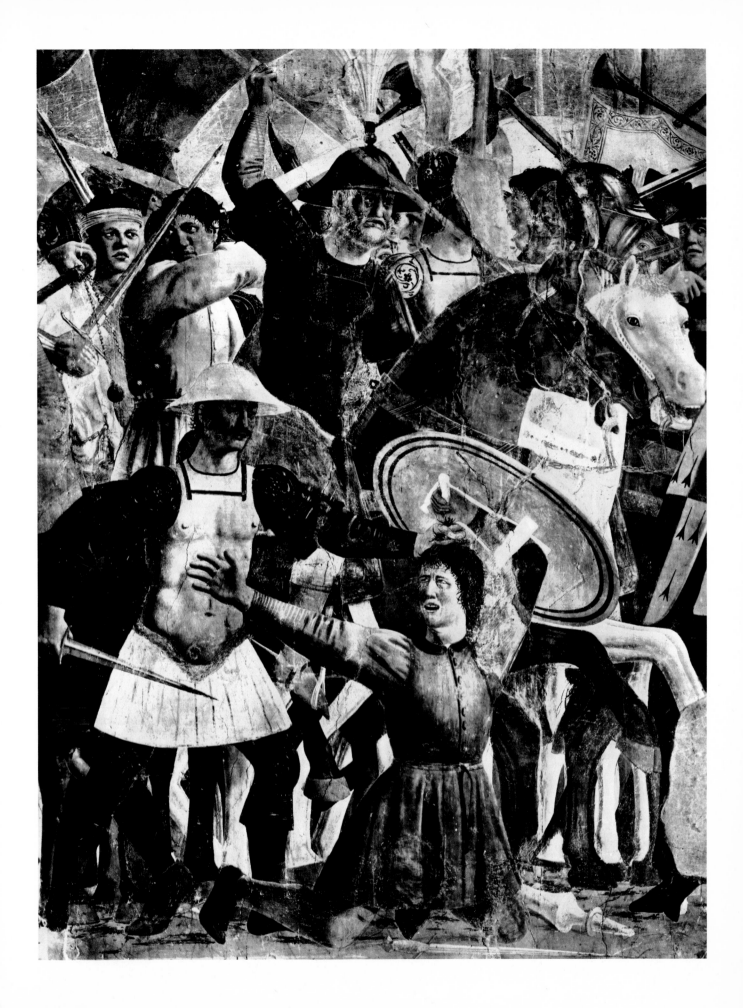

Victory of Constantine over Maxentius

1452–66. Fresco. Detail. Choir, San Francesco, Arezzo.

PIERO DELLA FRANCESCA
Borgo San Sepolcro, 1416(?)–1492.

Sunset and Twilight. From the Diaries of 1947–1958.
Harcourt, Brace & World, New York, 1963.

October 16th, Arezzo
Arezzo, Piero della Francesca's frescoes — awkward in action, almost deliberately inexpressive, they are of such a saturation of colour as in fresco is achieved, but with less discretion, only by Titian at Padua. But in sturdy tridimensionality, in the power given to the joints, the way hands grasp and feet stand, those compositions are unsurpassable. Yet the greatest achievement remains to be mentioned. It is the luminosity of the sky, which not only is reflected radiantly from the figures and objects, but is in itself as positive, as deep, as transversal, as in Cézanne and beyond. Paolo Veronese wanted such skies and tells you so in all his paintings, but does not realize, only promises. Then Piero's un-, nay, anti-romantic landscape, but so convincing. The reflection in the representation of the Tiber!

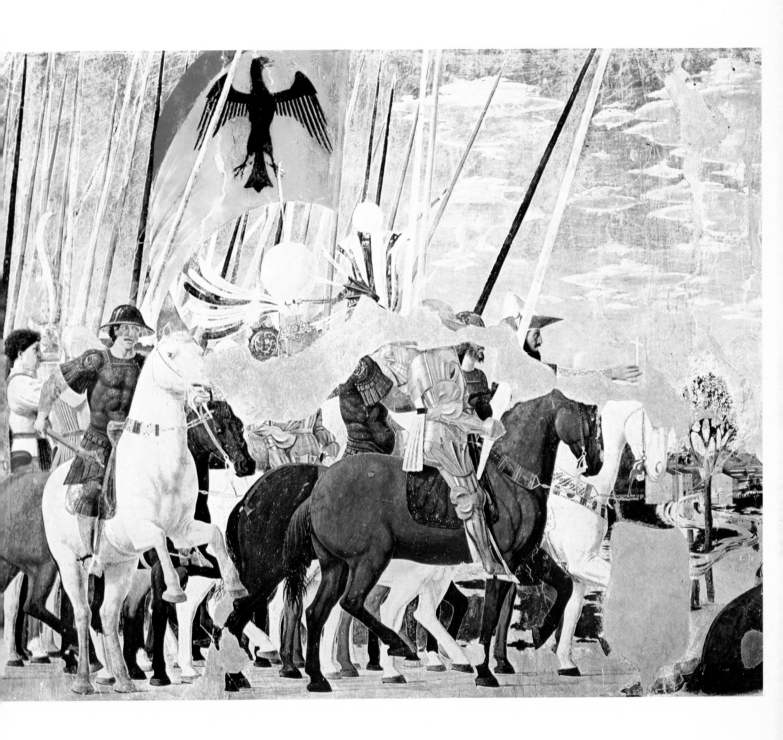

Portrait of a Young Man

National Gallery of Art, Washington, D. C. Mellon Collection.

ANDREA DEL CASTAGNO
Castagno, c. 1421–Florence, 1457.
Influenced by Donatello and Uccello.

The Drawings of the Florentine Painters.
University of Chicago Press, Amplified Edition, Volume I, 1938.

We never can have more than a fragmentary acquaintance with this highly gifted and most powerful artist, for the few paintings by him still remaining are from his last years, and tell us little about his beginnings. But this much is clear, that he was strongly influenced by Uccello, and, in turn, exerted an even stronger influence on Pollajuolo. Indeed, until recently we could still find under the latter's name important achievements of Castagno like the shield painted with the graceful figure of a David [now in the Widener Collection, Philadelphia]. The splendid Torrigiani portrait of a Florentine has been given now to one of these masters, now to the other. I considered it to be by Castagno when I published the first edition of this work. . . .

This portrait passed from the Torrigiani Collection into the hands of Mr. Rodolphe Kann of Paris; then it was acquired for the J. P. Morgan Library, New York, where it remained until recently.

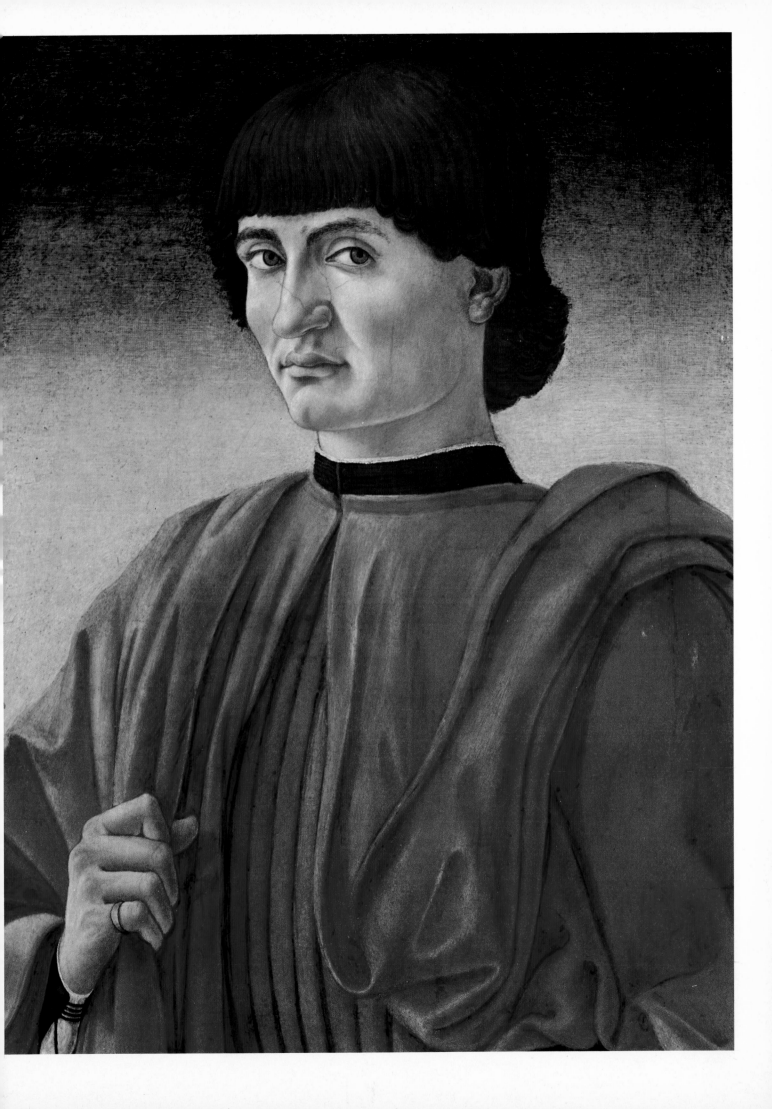

David

Painted on a leather shield. National Gallery of Art, Washington, D.C. Widener Collection.

ANDREA DEL CASTAGNO
Castagno, c. 1421–Florence, 1457.

Pictures in the Collection of P.A.B. Widener.
Volume III: "Early Italian and Spanish Schools."
Privately printed, Philadelphia, 1916.

This painting has a triple interest. It is a great work of art, apart from any consideration as to where, when, and by whom it was done. It is a masterpiece by one of the most famous painters of Florence, who, at the same time, happens to be very rare. It is painted on a shield. A word or two on each of these points. It is well composed, the figure as a pattern filling up the space quite naturally, as free from the overcrowding of the sixteenth century as from the over-bareness of the fifteenth. The action could not easily be better communicated. The expression could scarcely be more poetical, and with a poetry inherent in the movement of the entire figure, not merely painted upon the face. As a creation, too, this youthful hero is the symbol of all that is young and free, strong and gracious.

For all of which reasons this David was well calculated to decorate a shield to be borne in some joust or tourney to symbolize the aspirations of the Florentine Republic toward freedom and youth and beauty. Other shields of this nature exist, although they are rare enough; but one like this, painted by a great master, is unique.

That this master was Castagno will not be seriously questioned.... [We] find every detail, whether of face or feature, action or expression, landscape or drapery, matched. And the quality is of the same kind, substantial and strong, yet refined and gracious, almost suave, and without that mere forcefulness which takes something from our enjoyment of Castagno's earlier works.... Nowhere else does he make one so much regret his early death; for, had the creator of this figure lived, he might not only have endowed us with other masterpieces like this, but have spared his younger contemporaries many a stupid experiment, and led them along the paths to beauty that were now his own.

136

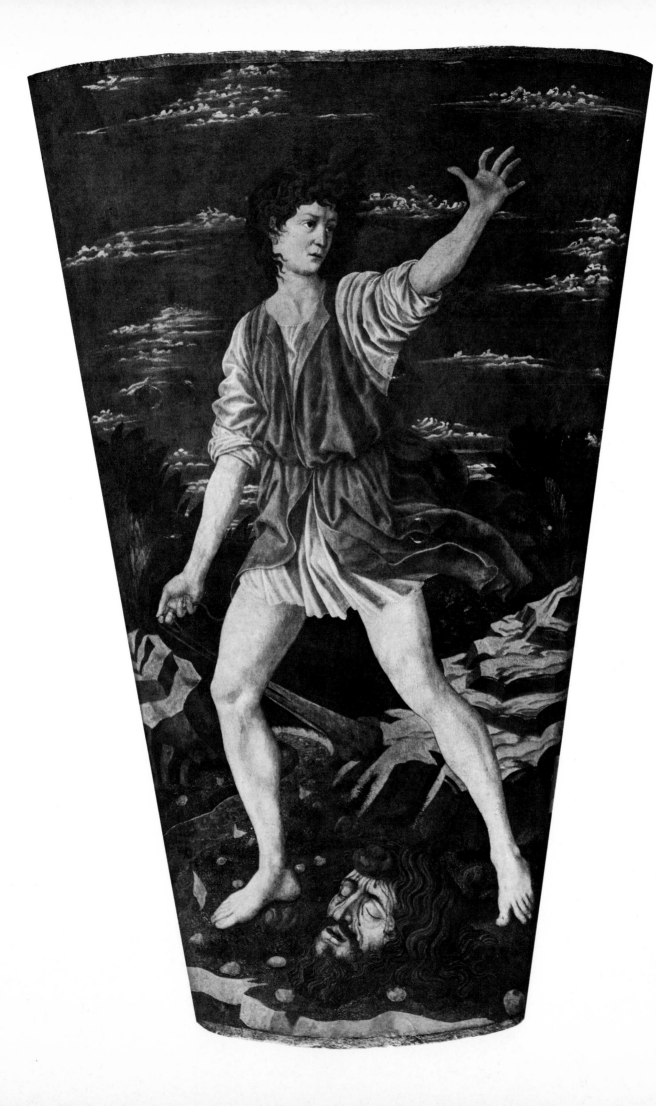

Saint Lucy Altarpiece:
Madonna and Child with Saints Francis,
John the Baptist, Zenobius and Lucy

Signed. Galleria degli Uffizi, Florence.

DOMENICO VENEZIANO
Venice, c. 1400–Florence, 1461.
A native of Venice active in Florence at least after 1438;
influenced by Pisanello, Fra Angelico, Masaccio and Uccello.

Letter to Mary Costelloe.
Florence, December 2nd, 1890.

Domenico Veneziano must have been a painter of great importance judging from the fact that Piero della Francesca worked under him for ten years. The only signed picture . . . still extant in Florence is a Madonna with four Saints in the Uffizi. The Virgin sits against a niche in a loggia the arches of which are somewhat pointed, but they rest on slender Renaissance columns. Her face is somewhat moonlike, her hair almost white. The Child stands in her lap with one arm around her neck. To the right stands a Bishop in a heavily embroidered gorgeous mantle, and mitre, and to his right St. Lucy in profile, long necked and almost white haired, an almost classical face. On the left John in skin, and short mantle points earnestly but not melodramatically at the Child. He has crisp black hair, a very expressive face, and warm eyes. Next to him stands a monastic Saint in grey, a studious person who stops as he paces the cloister, struck particularly by something in the breviary he is reading. The faces are modelled splendidly, the drapery is simple, yet lively, the colour excellent. It is a picture that takes one's thoughts to Venice. . . . Domenico Veneziano was probably a Venetian by birth, and I fancy one sees this in his picture. Certainly there is something more than Tuscan in it. A curious characteristic in this picture is that the eyes are rather heavy with a white that is very white and a warm brown pupil. That was taken over by Piero della Francesca, and from him by Fra Carnevale also. I fancy, the real reason for this sort of eye was that the painter was intent on giving it full value of perspective.

138

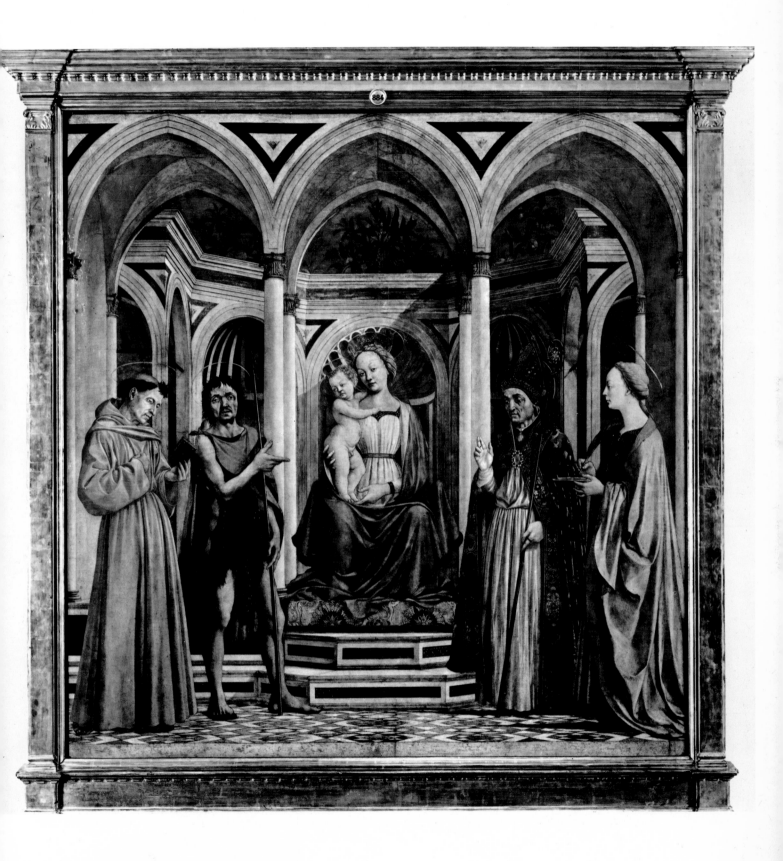

Madonna and Child

Berenson Collection, Florence.

DOMENICO VENEZIANO
Venice, c. 1400–Florence, 1461.

"Alessio Baldovinetti." 1898.
The Study and Criticism of Italian Art.
G. Bell & Sons, London, Second Series, 1902.

The influence of Domenico upon him [Alessio Baldovinetti] was still recent and strong. The force of this influence betrays itself elsewhere, up to the end of Alessio's career, in one trait and another. In all his "Madonnas" that we know, he follows Domenico's type with a fidelity even greater than that of any of this master's accredited pupils. It would be hard to find a resemblance so close between any work of Piero dei Franceschi [Piero della Francesca] and his master Domenico Veneziano, as we may descry between a "Madonna" by Alessio belonging to the present writer, and Domenico's "Madonna" in the Uffizi.

This "Madonna," until it came into the author's possession, passed for Piero dei Franceschi's. I shall not attempt here to substantiate my conviction that it is Baldovinetti's.... Yet the resemblance to Veneziano is so great that more than one critic has seriously held it to be his.

Berenson later accepted the suggestion of other critics and listed this "Madonna" as a work by Domenico Veneziano.

H. K.

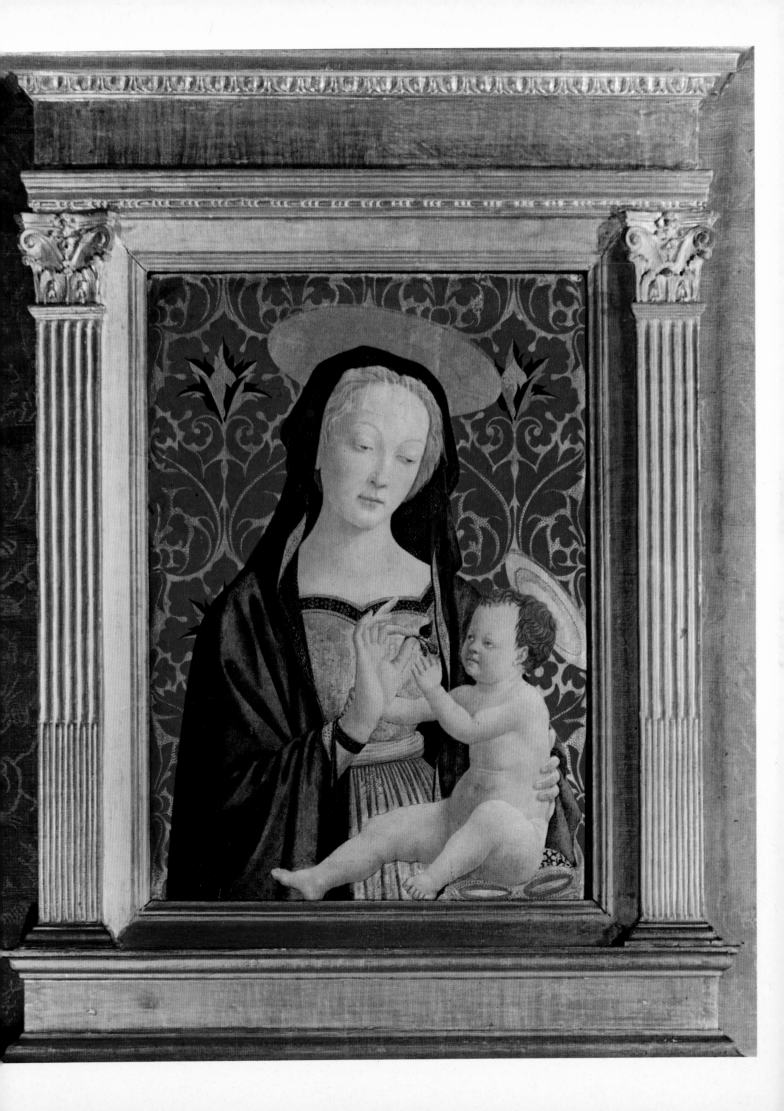

Saint John the Baptist in the Wilderness

Predella panel from the Saint Lucy altarpiece in Florence.
National Gallery of Art, Washington, D. C. Kress Collection.

DOMENICO VENEZIANO
Venice, c. 1400–Florence, 1461.

"Nine Pictures in Search of an Attribution." 1924.
Three Essays in Method.
Clarendon Press, Oxford, 1926.

To give an idea of the highest average of Florentine painters at the beginning and towards the end of the period within which our nine panels might have been painted, I reproduce two designs which happen... to represent the Resurrection of a Boy. The first of these... formed part of the *predella* to Domenico Veneziano's St. Lucy altar-piece, and is now in the Fitzwilliam Museum, Cambridge, along with the Annunciation from the same work.
I am happy to announce that all the five panels composing this *predella* still exist. Besides the two mentioned above, and the well-known Martyrdom of St. Lucy in Berlin, one representing the youthful Baptist wandering off into the wilderness is . . . in the possession of Mr. Carl Hamilton of New York, and the fifth, representing the Stigmatization of St. Francis, was recently in the hands of Herr Julius Böhler of Munich [the two last panels are now in the Kress Collection, National Gallery of Art, Washington]. I look forward to publishing them as a contribution towards our further understanding of Domenico Veneziano and of his role in Florentine art.

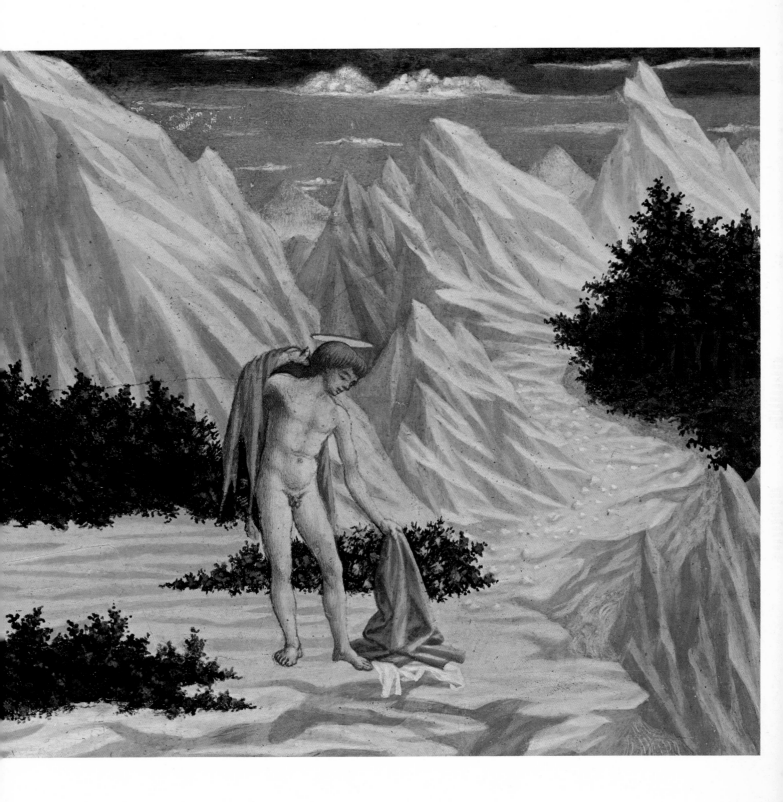

Male Head in Profile

Drawing. Gabinetto Disegni e Stampe degli Uffizi, Florence.

PAOLO UCCELLO
Florence, 1397–1475.
Trained in the studio of Ghiberti. Matured under influence of Donatello and Brunelleschi.
The first self-conscious and scientific theorist among painters since Antiquity.

The Drawings of the Florentine Painters.
University of Chicago Press, Amplified Edition, Volume I, 1938.

Relieved against a dark brown surface, washed in with bistre on a white ground, we see the profile of an iron-tempered master of life. It has not been easy for him to win the prize away from his rivals, and in the struggle his forehead has overbeetled his face, and his underlip has curled down as if to meet his chin; but he has remained master — and with the loss of such a trifle as a name, master he still is. Types so life-enhancing by the vigour of their being are not at any time offered in plenty either by life or art.

He was lucky to find an Uccello to portray him. You may wander through all the precincts of Renaissance painting without finding. a portrait superior to this profile in the qualities that are essential to a masterpiece. In directness of conception and in force of modelling it anticipates and perhaps stands at the head of the many profile portraits that were painted in Florence for generations after Uccello.

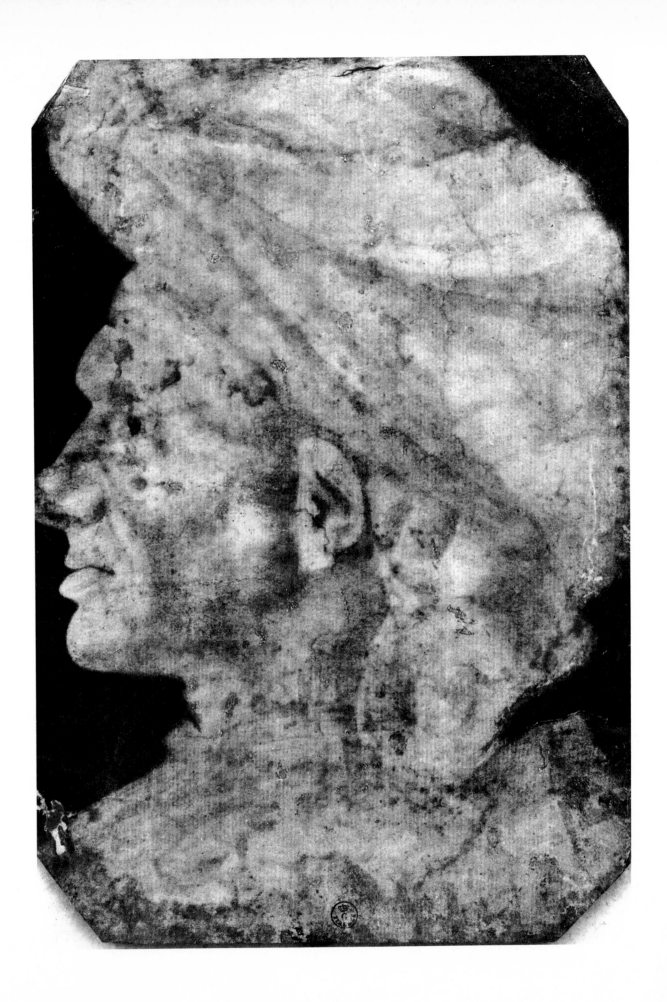

Rout of San Romano

Detail. National Gallery, London.

PAOLO UCCELLO
Florence, 1397–1475.

The Drawings of the Florentine Painters.
University of Chicago Press, Amplified Edition, Volume I, 1938.

Vasari learnt from Uccello's descendants that their ancestor had left chests full of drawings. Their number has been greatly reduced — to four or five, as far as I know. Fortunately, three are important, and two of them are masterpieces. All are in the Uffizi.

The date of one of them is so well known that this additional interest gives it the first claim to our attention, although in quality it is the least interesting. This is the sketch for the equestrian portrait in *terra verde* of Sir John Hawkwood, painted in the summer of 1436, for the Cathedral of Florence. . . . It is done in greenish wash and heightened with white on a background coloured purple. . . . Another of these drawings is also of a horseman, but no such tame performance as the first. It is, on the contrary, one of the most spirited and splendid achievements of the Florentine school. . . . Merely as an impression of colour, with its turquoise ground, its outlines in black chalk, and its telling touches of white, it is flowerlike and caressing to the eye, and worthy of Uccello in the mood when he created that masterpiece of decorative colour, his battle-piece in the National Gallery. . . .

As it is, we see in the National Gallery panel more than one group of horse and rider almost like the sketch. Closest in resemblance is the knight seen in the second rank charging ahead of Tolentino. Moreover, the horses are of the same breed as in the drawing, and are caparisoned in the same way; and the armour is of the same fashion.

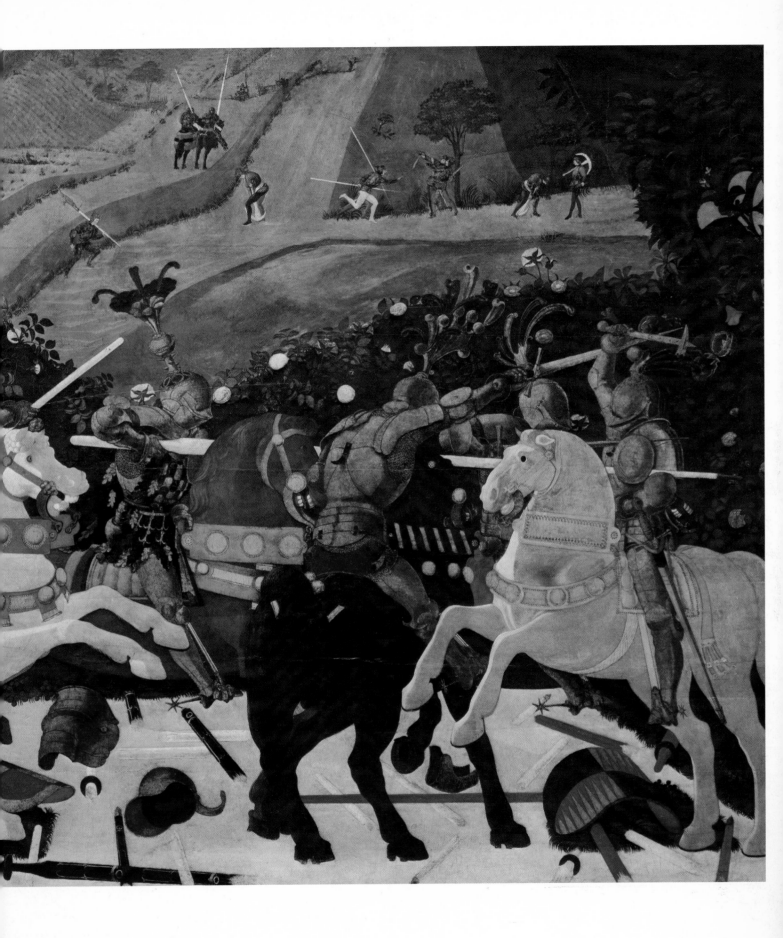

A Hunt

Cassone panel. Detail. Ashmolean Museum, Oxford.

PAOLO UCCELLO
Florence, 1397–1475.

"Homeless Pictures. The Florentine Quattrocento." 1931.
Homeless Paintings of the Renaissance.
Indiana University Press, Bloomington and London, 1970.

I challenge those who may be thinking of yet another fat volume on Angelico or Masaccio, Piero della Francesca or Signorelli, to stop and inquire whether these articles cannot wait, and whether students should not singly and corporatively take up the task of mapping out, describing and interpreting the mind and achievements of the first self-conscious and scientific theorist among painters since Antiquity. Even his artistic personality, in the narrowest sense of the phrase, remains to be defined, and I must confess to a certain disappointment when I discover in the last authoritative publications on Florentine Painting not only repetitions of my own gropings of more than a generation ago, but fresh errors due to confusing Uccello with his close yet distinct follower, the so-called "Carrand Master."

To this not too distantly future author of a satisfactory monograph on Uccello I venture to offer the advice not to neglect the tradition that he painted many *cassone*-fronts. Before it got to be the fashion to attribute these panels to Pesellino and his studio, many, if not most of them, used to be ascribed to Uccello. Nevertheless I have not seen one that I am tempted to ascribe to him, with the exception of the *Midnight Hunt* at Oxford. . . .

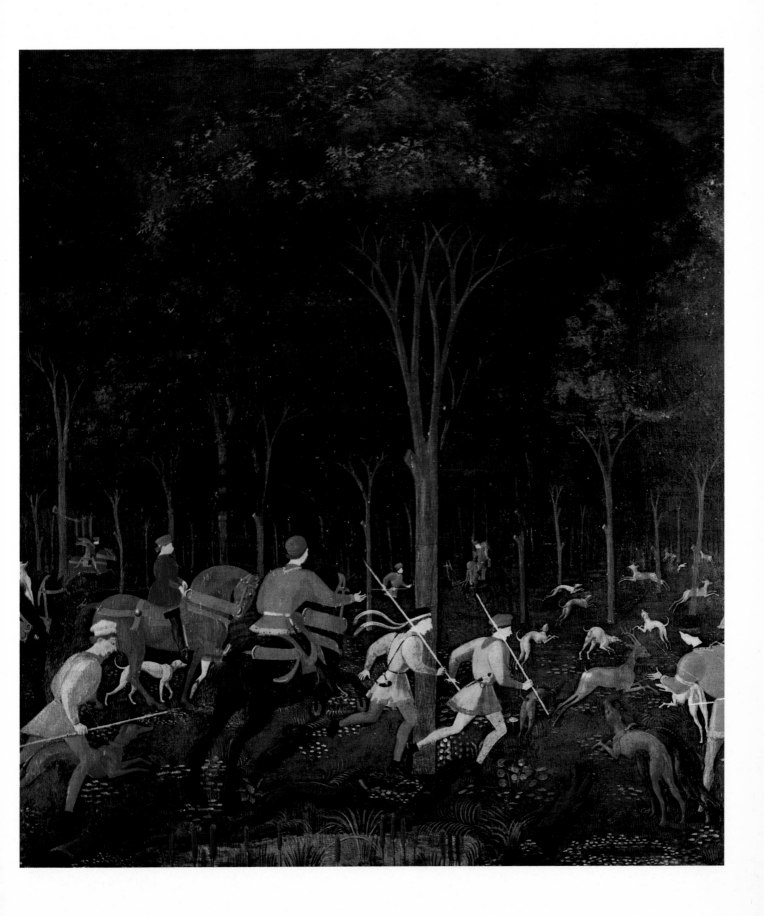

Annunciation

1455. Santa Maria Novella, Florence.

NERI DI BICCI
Florence, 1419–1491.
Pupil and close follower of his father Bicci di Lorenzo;
influenced by Fra Angelico, Fra Filippo, Domenico Veneziano and Pesellino.

"Homeless Pictures. The Florentine Quattrocento." 1931.
Homeless Paintings of the Renaissance.
Indiana University Press, Bloomington and London, 1970.

With the Florentines whose style, or manner, or mannerism was not funda-mentally affected by the Pollajuolo and Verrocchio, we must mention Neri di Bicci, who, if he was not the most popular painter in Florence — and for all we know he was — ran the busiest picture factory in a community where, through a long career, he was the contemporary of nearly all the artists who have made Florentine painting great. The son and pupil of a popular painter, he fell under the influence of Fra Angelico, Fra Filippo, Domenico Veneziano and Pesellino.... Neri, although his types are ugly, his compositions rudimentary, his colouring hot, is never stupid and seldom dull. There is a whimsicality, a heartiness, a candour about him that wins one over. And yet, and yet — that this should have been the painter whom part of the community at least loved to honour when the whole galaxy of universal genius from the Pollajuolo to Botticelli, to Leonardo, to Perugino, to Signorelli, had well passed their meridian! What a warning to be cautious in deciding what was the character of a period, and what were its popular currents....
These popular painters were apt to be more themselves and more amusing in the narrative compositions for which the *predella* masking the bases of altarpieces gave the occasion.

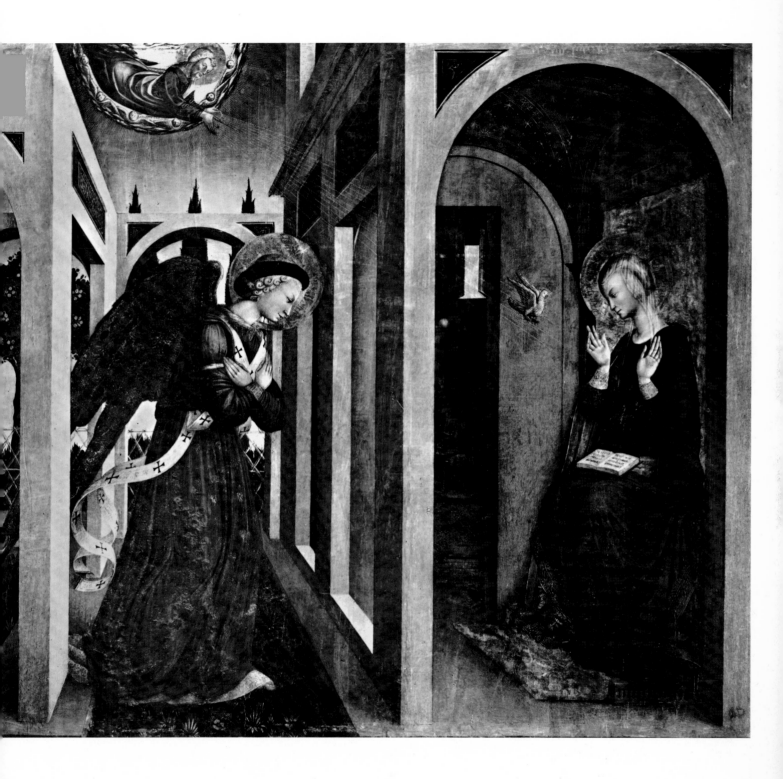

Tarquinia Madonna: Madonna and Child

Dated 1437. Galleria Nazionale, Palazzo Barberini, Rome.

FRA FILIPPO LIPPI
Florence, c. 1406–Spoleto, 1469.
Pupil of Lorenzo Monaco and follower of Masaccio;
influenced by Fra Angelico and Donatello.

"Fra Angelico, Fra Filippo, and Their Chronology." 1932.
Homeless Paintings of the Renaissance.
Indiana University Press, Bloomington and London, 1970.

In sober fact, there is no trace of Angelico in the earliest works by Filippo to reach us. What he may have done in the ten or twelve previous years of activity — in 1437 he must have been thirty — we can only infer, but the Dominican's instruction, had it affected him, would manifest itself as does Lorenzo Monaco's and Masaccio's.

The first positive date one can give to any painting by Fra Filippo is that of the *Madonna* at Corneto-Tarquinia, discovered by Professor Toesca and published in the *Bollettino d'Arte* for May–July 1917. It is inscribed with the year 1437. There is no touch in it of the suave, ecstatically smiling yet calm figures of Angelico. On the contrary, the Madonna's face is almost morose, and the Child as violently restless as in certain Lorenzettis of the Trecento, or in certain Squarcioneschi of the Quattrocento, Crivellis, Gregorio Schiavones, Benaglios, Domenico Morones, etc. And, by the way, the over-definition of the forms, and the exaggerated plasticity of the draperies legitimate the question whether the resemblances between this early Filippo and the *Veneti* just mentioned are accidental; whether he did not leave behind him at Padua works of this type which the students in Squarcione's academy did not imitate. . . .

It is not unthinkable that one fine day, when already five and thirty years old, Filippo woke up to the realization that although he had learned so much from Lorenzo Monaco who left an indelible imprint on him, and so much from Donatello and Masaccio as well, he yet had something still to learn from Angelico, both as a craftsman and as an artist.

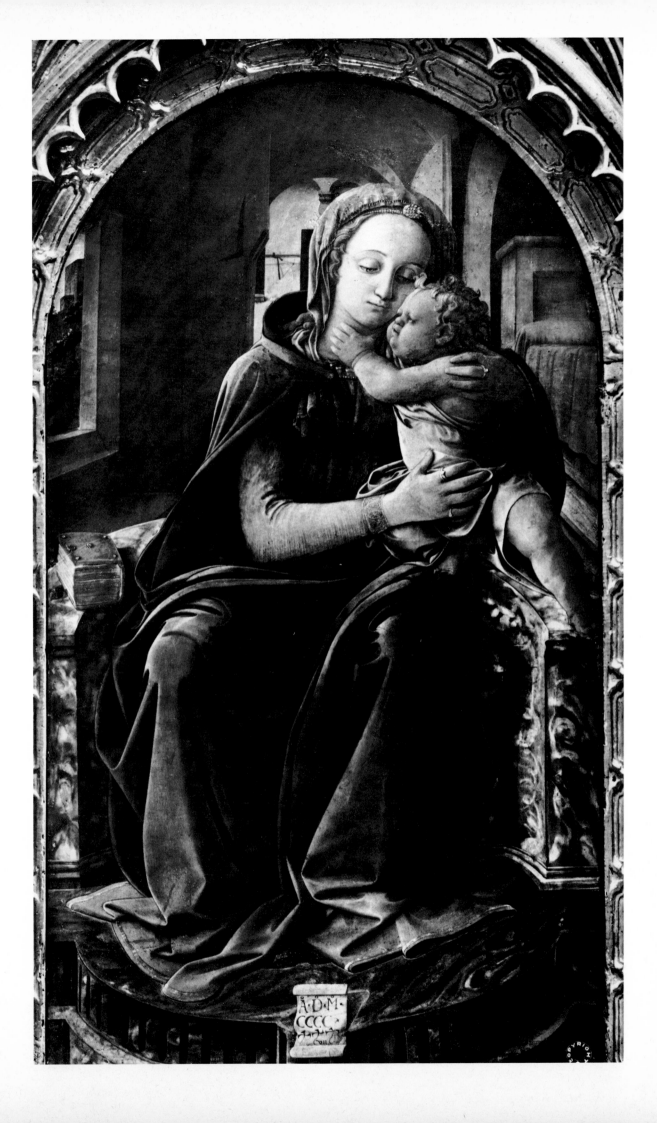

Portrait of a Young Bride of the Medici Family with Her Husband, a Member of the Portinari Family

The Metropolitan Museum of Art, New York.

FRA FILIPPO LIPPI
Florence, c. 1406–Spoleto, 1469.

"Fra Angelico, Fra Filippo, and Their Chronology." 1932.
Homeless Paintings of the Renaissance.
Indiana University Press, Bloomington and London, 1970.

The *Profile of a Lady* in Berlin . . . which Bode, when he acquired it, correctly ascribed to Filippo . . . has the exact quality of contour, and the same shark-like mouth. The folds of the draperies are thoroughly characteristic of Filippo and seem to avoid the variants made by Pesellino. The hand too has the sensitiveness of the older master, and as for the colouring, the light and shade, the atmosphere, they all are his. Be it remembered that attractive as Pesellino was, he had neither the range nor the qualities of Filippo, whose close follower, be it further remembered, he never ceased to be.
The costume of the Berlin profile is of the fifties. . . .
As there exists another profile with the same characteristics, let us glance at it here. . . . It is the *Young Woman* in the Metropolitan Museum . . . who wears the Medici diamond and three pearls, and faces the profile of a youth appearing at an opening with his fingers on the Portinari arms. Honor is due to Bode for having first recognized that this work was by Filippo. It must have been painted two or three years earlier than the Berlin one, and perhaps the hands and the bunched folds are due to an assistant.

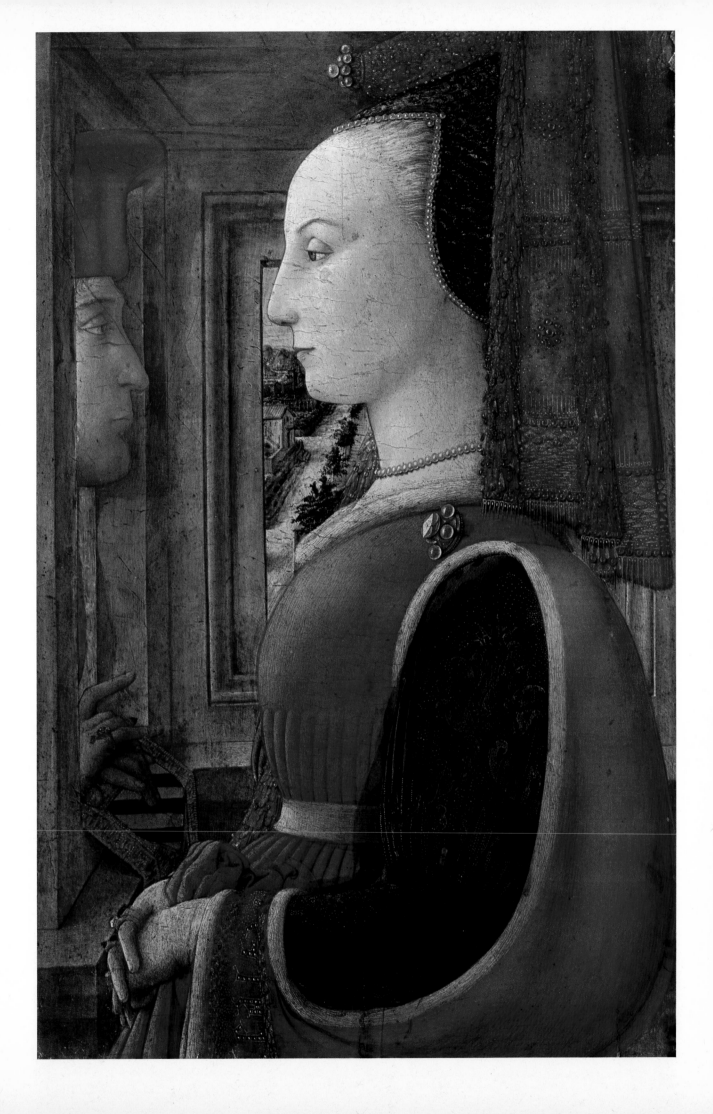

Dance of Salome

1461. Predella panel. National Gallery of Art, Washington, D.C. Kress Collection.

BENOZZO GOZZOLI
Florence, 1420–1497.
Pupil and assistant of Fra Angelico; probably influenced by
Domenico Veneziano and Pesellino.

Unpublished manuscript opinion.

The best-preserved picture by Gozzoli and the most enchanting thing of its kind ever done in Florence.

It is one of the five *predella* panels, the second from left, to the altarpiece of the "Madonna enthroned with Angels and SS. Zenobius, John the Baptist, Jerome, Peter, Dominic and Francis," commissioned to the painter by 1461 for the altar of the "Confraternita della Purificazione della Vergine" at San Marco in Florence and now in the National Gallery in London. The companion pieces are preserved in the Berlin Museum; in the John G. Johnson Collection, Philadelphia; in the Royal Collection, Buckingham Palace, London; in the Brera, Milan.

H. K.

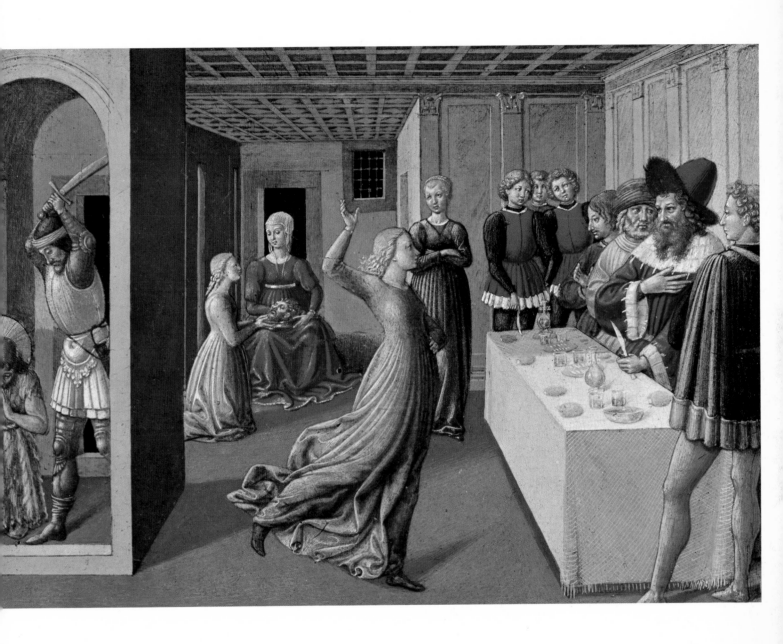

The Raising of Lazarus

National Gallery of Art, Washington, D. C. Widener Collection.

BENOZZO GOZZOLI
Florence, 1420–1497.

Pictures in the Collection of P.A.B. Widener.
Volume III: "Early Italian and Spanish Schools."
Privately printed, Philadelphia, 1916.

At the head of ten of His disciples, our Lord, with noble mien and quiet gesture, calls the shrouded Lazarus out of his tomb. The tomb is an arched vault cut into a hillside on our left. Lazarus is supported by two other disciples. At his feet are Mary Magdalen and Martha. To right and left we see groups of interested and sympathizing spectators. The scene is laid in the foreground of an elaborate, romantic landscape of fell and stream, with distant peaks, and splendid cities between. Almost over the head of our Lord rises a tall pine.

This is perhaps the most delightful work of Benozzo's later years. It is suave in tone and restful in composition, and its colour harmony is like that of autumn leaves strewing the ground.

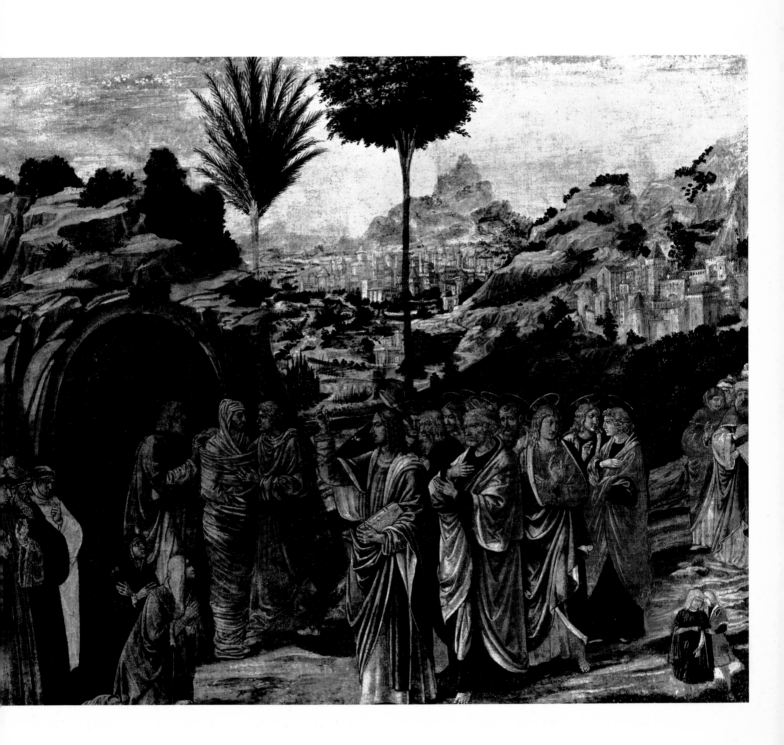

Nativity

1460–62. Fresco. Atrium, Santissima Annunziata, Florence.

ALESSIO BALDOVINETTI
Florence, c. 1426–1499.
Pupil of Domenico Veneziano; influenced by Uccello.

"Alessio Baldovinetti." 1898.
The Study and Criticism of Italian Art.
G. Bell & Sons, London, Second Series, 1902.

The splendid fresco which he executed in 1462 for the cloister at the entrance to the SS. Annunziata at Florence, [is] a fresco of remarkable beauty in spite of its present ruined state — the parts done *al secco* having long since disappeared, taking with them all the charm of colour that the faces could ever have had. Here is revealed an artist who, though he is undoubtedly sensitive to beauty of type and grace of movement, concentrates his most earnest attention upon a naturalistic rendering of detail and landscape. "He loved to paint landscapes," says Vasari, "and he drew them after nature, exactly as they are. That is why you can see in his pictures, rivers, bridges, rocks, grass and fruit trees, roads, fields, towns, castles, stretches of sand, and an infinite number of other things." Messer Giorgio no doubt had this fresco in mind while writing these lines, and they fit closely. But he forgot to mention what I find especially worthy of admiration, the art which could group in one harmonious composition these innumerable details, and — what is even more surprising — could give such an impression of height, of distance to the landscape and sky which rise and spread around the figures. We should search in vain among earlier pictures for effects of space comparable to this; and even among those who, in later times, have been the greatest masters of space-composition — Perugino, Raphael, Poussin, Claude Lorrain and Turner — very few have equalled, and almost none have surpassed this achievement of Baldovinetti.

Profile Portrait of a Lady
National Gallery, London.

ALESSIO BALDOVINETTI
Florence, c. 1426–1499.

"Alessio Baldovinetti." 1898.
The Study and Criticism of Italian Art.
G. Bell & Sons, London, Second Series, 1902.

Baldovinetti made every conceivable experiment with colour and medium; he rediscovered mosaic; he occupied himself with everything, except with painting for art's sake. For him, as for the other Florentine naturalists, painting was interesting only in so far as it offered scientific problems for solution. The few remaining fragments of the frescoes, executed by Alessio in his last years at S. Trinita, show no change in his intentions or his manner. Throughout his entire career he was faithful to the same style, to the same types, losing his original refinement and grace, in the measure that he became more and more absorbed in his craft.

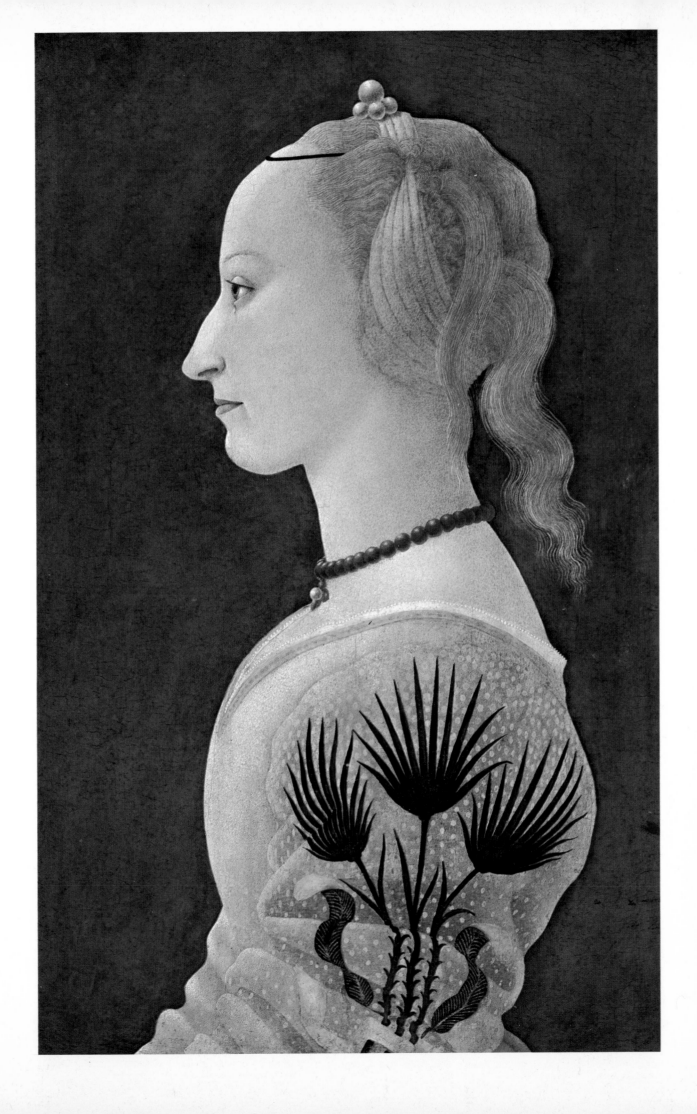

Saint John the Baptist in the Wilderness

National Gallery of Art, Washington, D. C. Kress Collection.

JACOPO DEL SELLAJO
Florence, c. 1441–1493.
Pupil of Fra Filippo; influenced slightly by Castagno's works, imitated Florentine contemporaries, especially Ghirlandajo, Botticelli and Filippino Lippi.

"Homeless Pictures. The Florentine Quattrocento." 1931.
Homeless Paintings of the Renaissance.
Indiana University Press, Bloomington and London, 1970.

Before leaving the line of Florentines descended, no matter how much influenced by others, from Filippo and Pesellino, it is convenient to speak at this point of Sellajo. We have already mentioned him as having started as the apprentice of the San Miniato Master. Later he naïvely snapped after Botticelli's loveliness and grace, and at times he attained to a charming quaintness — as, for instance, in the *Triumphs* of the Fiesole Museum, which form a striking contrast to his solemn and sulky altarpieces.

Since Morelli first discovered him, we have gleaned after him so successfully that Sellajo may now rank as one of the best represented painters of the Renaissance . . . what views of hill and dale, sea and shore, and what daintily trimmed gem-like trees! Happy the saints for whom deserts changed into paradises! . . . Blessed the moment when third-rate artists like Sellajo could so ably follow the lead of their betters so as to produce furniture pictures of this loveliness!

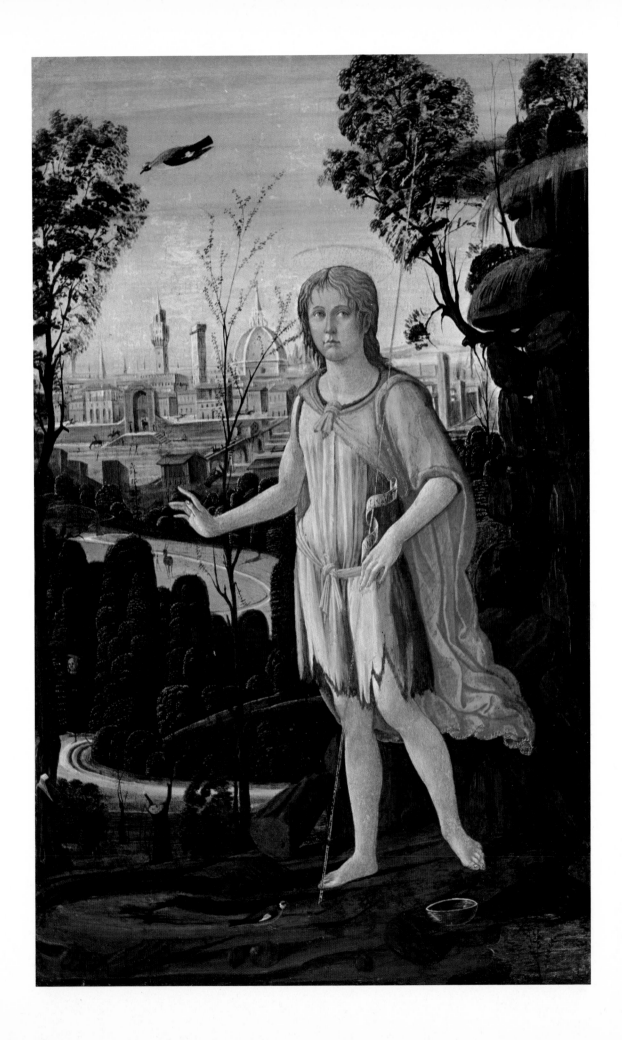

David

John G. Johnson Collection, Philadelphia.

JACOPO DEL SELLAJO
Florence, c. 1441–1493.

Catalogue of a Collection of Paintings and Some Art Objects.
Volume I: "Italian Paintings." John G. Johnson, Philadelphia, 1913.

A landscape consisting of bluish green jagged rocks, winding roads and streams. In the foreground a youth stands panting astride over a giant's head which he contemplates. His right hand holds a sling, his left rests on his hip. His hair is red and he wears a pale yellow tunic, a fluttering pink mantle, and greenish blue belt and buskins.

The action of this boyish figure, all but spent with the excitement of his victory, is so admirable that one may scarcely credit with its invention such a wielder of the scissors and paste-pot as Sellajo. It may not be too hazardous a conjecture that we have here an echo of a masterpiece by Castagno.

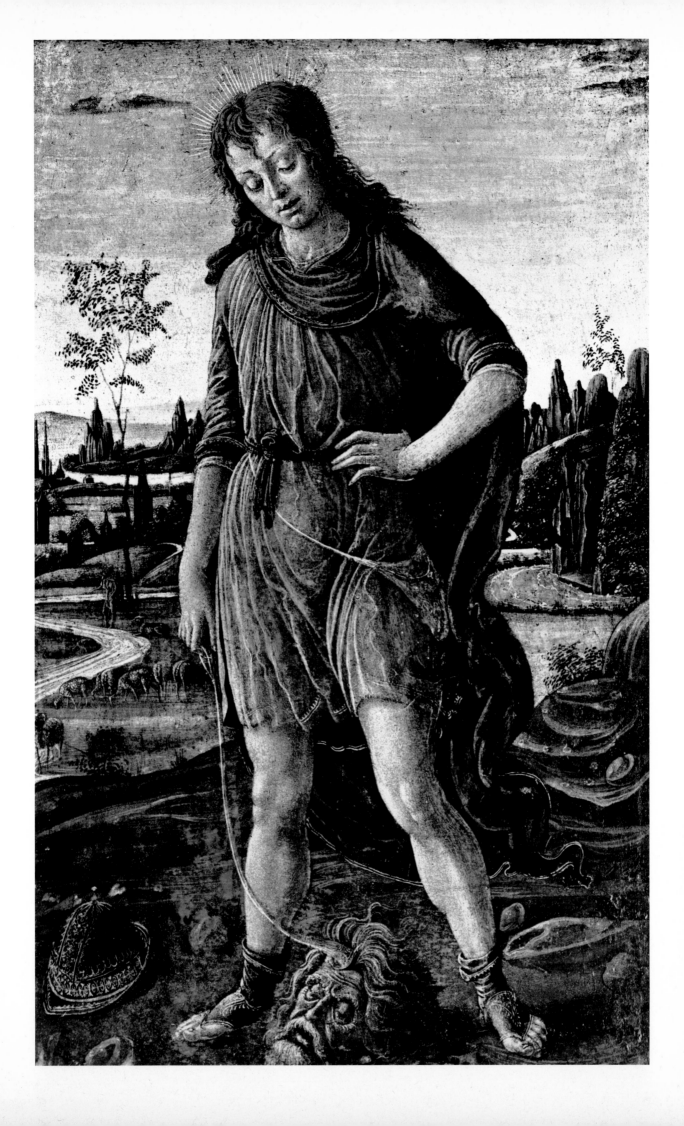

Tobias and the Archangel

Galleria Sabauda, Turin.

ANTONIO POLLAJUOLO
Florence, 1429–Rome, 1498.
The elder brother, Antonio, sculptor, goldsmith and painter, developed under the influence of Donatello, Andrea del Castagno and Baldovinetti.

The Drawings of the Florentine Painters.
University of Chicago Press, Amplified Edition, Volume I, 1938.

In sifting Antonio's productions from those of his brother, we have, besides the sculptures which are his beyond dispute, the little paintings of Hercules and Antaeus, and Hercules and the Hydra, universally accepted as his, and the engraving representing the Combat of the Nudes, signed by him, as well as the twenty-seven embroideries recounting the life of the Baptist, executed after his designs with such perfection that, as Vasari observes, you seem to see not the embroiderer's needle but the master's touch. These works bear out, and more than bear out, the reputation Antonio enjoyed among his contemporaries and their descendants, revealing him as one of the greatest masters of movement that there has ever been, and one of the ablest manipulators of the human body as a vehicle of life-communicating energy, and exultant strength. Against this magnificent achievement of his elder brother, Piero has no perfectly authenticated works to show save the S. Gimignano altar-piece. . . .

Vasar ascribes . . . to both the brothers, the Tobias and the Angel, painted for Orsanmichele, and now in the Turin Gallery. For the deep tones of its golden brown colouring, for the splendid movement of the figures, for the penetrating charm of the landscape, and for the decorative harmony between the background and the figures, it is one of the masterpieces of Florentine art. Here Piero's share must have been small. Perhaps there is something of his hand in the face of the archangel, a merest touch in the face of the Tobias. Otherwise the colouring points to Antonio's execution, and the movement and swing certainly to his finished cartoons.

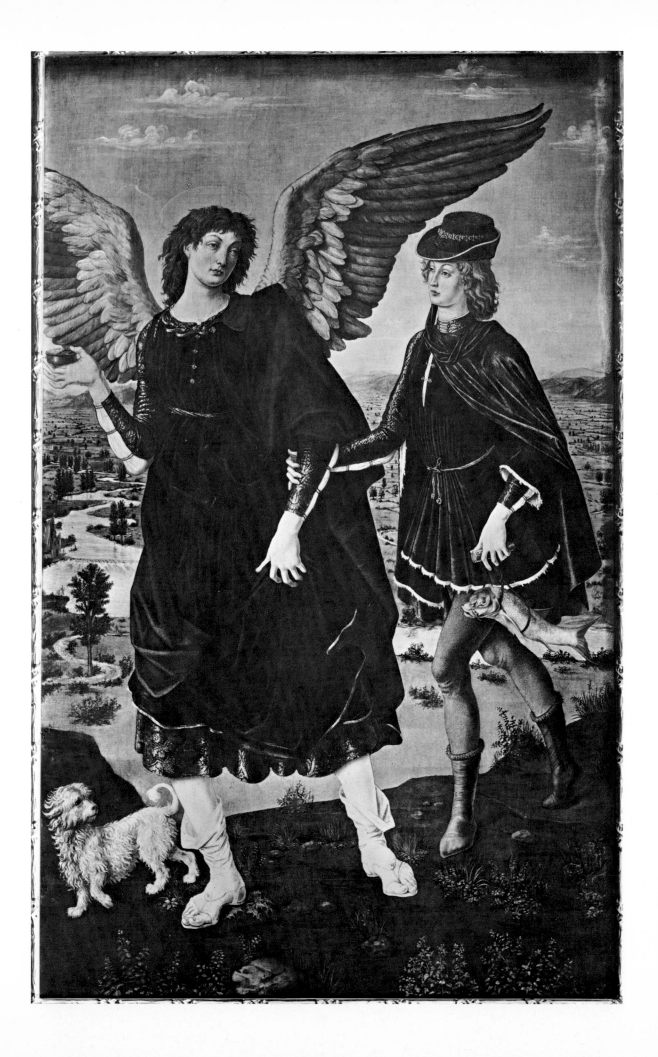

Annunciation

Staatliche Museen, Berlin.

PIERO POLLAJUOLO
Florence, c. 1441–Rome, 1496.
The younger brother, pupil of Baldovinetti, chiefly worked on Antonio's designs.

The Drawings of the Florentine Painters.
University of Chicago Press, Amplified Edition, Volume I, 1938.

A painting of about the same date [1466], conceivably somewhat earlier, is the Annunciation in Berlin. It is a design in which, again, the figures are inferior to the surroundings, which in idea surpass and in execution do not fall below the settings of the finest Annunciation ever executed by Van Eyck's best followers. The Madonna and Gabriel are in a hall of precious marbles and bronzes, partitioned off by a wall into two chambers, one of which stretches away to a loggia overlooking a plain, and the other to a window opening out on the same plain. It is the landscape... of Alesso Baldovinetti: Verrocchio endowed it with more fancy; and then it was ready for Leonardo's transfiguring imagination. In this Berlin Annunciation we see more clearly than elsewhere that it is nothing else than the Valdarno; for if you walk to the window, you will behold Florence zoned by her splendid walls and crowned with Brunellesco's dome.... the figures point so distinctly to Piero. The Madonna has his characteristic full oval and pinched features. She is over-blond, her draperies are comparatively flowing, her hands lifeless. Gabriel is somewhat better... his hands and the impasto of his face betray Piero's touch, as also does the charming group of angels, whose music comes to us from the loggia.

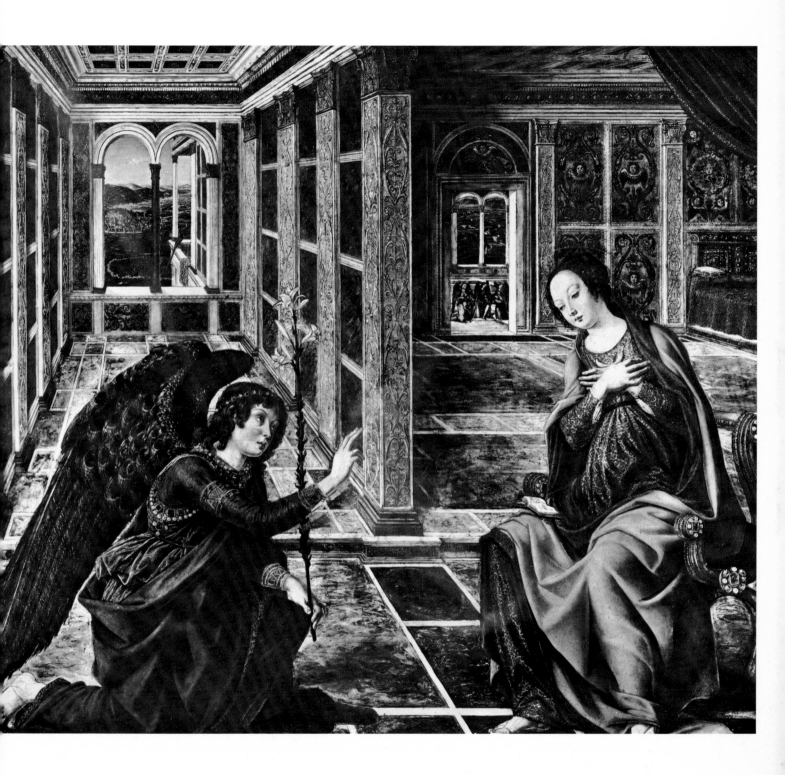

Dancing Nudes

After 1470. Fresco. Detail. Torre del Gallo, Arcetri (Florence).

ANTONIO POLLAJUOLO
Florence, 1429–Rome, 1498.

The Drawings of the Florentine Painters.
University of Chicago Press, Amplified Edition, Volume I, 1938.

Fortunately, no doubt can cross one's mind as to which of the Pollajuolo executed the matchless fragment representing five nude figures dancing in Bacchic frenzy, discovered in 1897 under whitewash in a small villa close to the Torre del Gallo outside Florence. The swing and the power of the movement, the masterly modelling in contours, the grouping, reveal the dazzling presence of an artist of the most exalted rank. There can be no talk here of the assistant's hand, for the outlines seem breathed onto the wall rather than painfully executed. Here, therefore, we have perfect proof not only that Antonio was a painter, but with leisure to decorate; for a mere accident has brought this to light, and many others like it may have existed. As this painting must have been executed before Botticelli's Primavera, and as in type the figures agree with those in the embroideries of S. Giovanni, drawn, as we remember, somewhat before 1470, and as in structure they recall the figures in one of the bas-reliefs on the triumphal arch in the Martyrdom of St. Sebastian, we may safely assign it to a year following soon after this last date. . . .

(It would be interesting to know whether Henri Matisse was acquainted with these nudes before painting some strangely like them.)

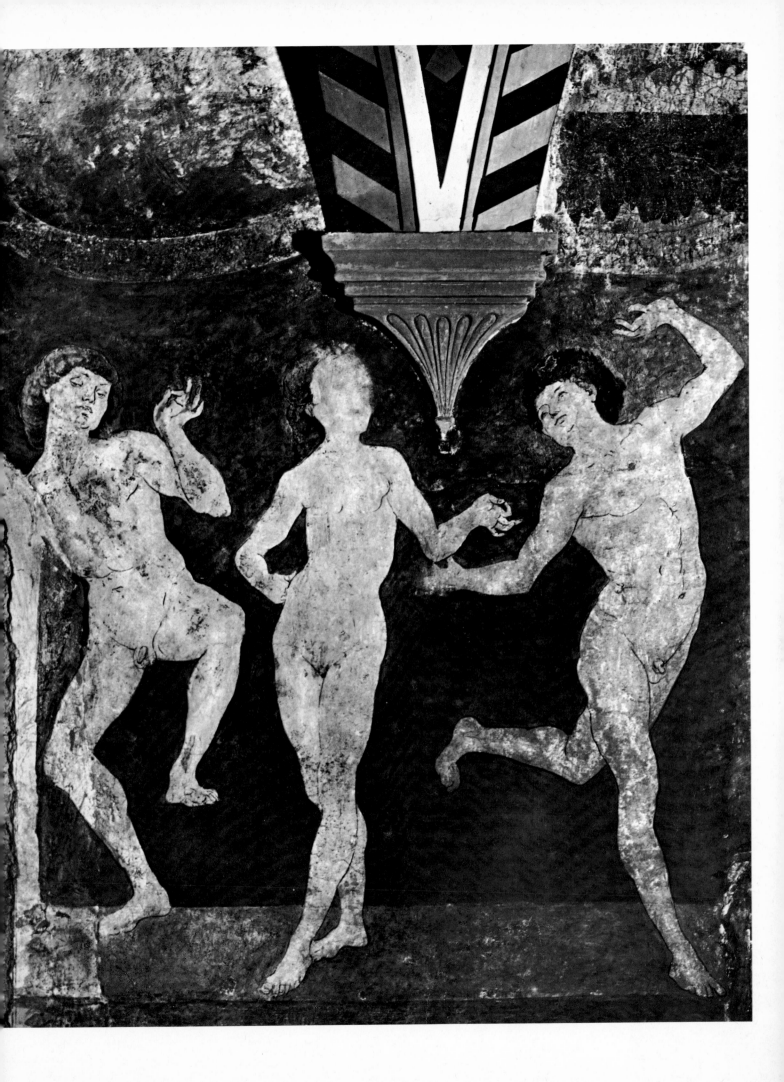

Pan and the Gods

Signed. Formerly Staatliche Museen, Berlin (destroyed 1945).

LUCA SIGNORELLI
Cortona, c. 1450–1523.
Pupil of Piero della Francesca;
influenced by Antonio Pollajuolo, Perugino and Francesco di Giorgio.

The Drawings of the Florentine Painters.
University of Chicago Press, Amplified Edition, Volume I, 1938.

Signorelli had the range and variety of an artist who in a single lifetime passed through successive stages of development. Greater as draughtsman than as painter, it is, as we shall have further occasion to note, in his drawings that he most fully revealed his genius. His command of the human figure not only made him the precursor of Michelangelo and even of Tintoretto, but enabled him to be the poet, the prophet even, who created the Berlin Pan, the angels in the sacristy ceiling at Loreto, and the Apocalypse at Orvieto....

Our artist was perhaps the only one who as draughtsman travelled on his own legs the whole long way from Pollajuolo and the crystalline Naturalism of mid-Quattrocento to the heroic proportions of Michelangelo, the almost too poignant accents of Andrea del Sarto, and the subtle rhythms of Tintoretto. His nudes are even more pictorial than Tintoretto's. As we saw in the Harewood demons and elsewhere, they almost shimmer with their own light.

In the frescoes and other paintings only the proportions of the figures remain. Both in modelling and in lighting they are less pictorial than the drawings. Signorelli was, in short, a great illustrator and an even greater draughtsman, but not so great a painter, and, we must add, an indifferent composer.

One is tempted to ask whether the wonderful sketches he made and did not use were discarded because they did not please his patrons, or because he felt instinctively that he could not bring them to port on wall or panel without damage.

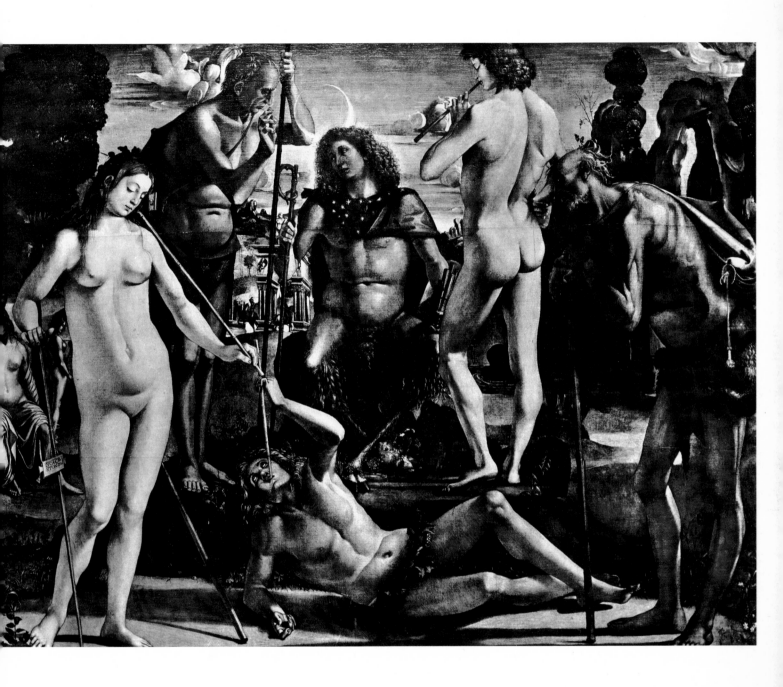

Madonna and Child with Nudes in Background
Tondo. Detail. Galleria degli Uffizi, Florence.

LUCA SIGNORELLI
Cortona, c. 1450–1523.

"A Possible and an Impossible 'Antonello da Messina'." 1923.
Three Essays in Method.
Clarendon Press, Oxford, 1927.

Later on in the fifteenth century, in Florence to begin with and then elsewhere, in answer to a craving for a more compact and therefore more pyramidal grouping, [the Madonna] bends not only her head but her torso as well, and it is naturally towards the spectator and never away from him. I doubt whether a single exception to this rule will be discovered before 1500. . . .
As luck would have it, we possess a record of this exact problem. It goes back to an eager student of the human body in action, namely to Signorelli, who in his *Tondo* in the Uffizi . . . places the Mother of our Lord, as if she were the Magna Mater of Phrygia, against a background of nudes, suggesting Pan and other sylvan deities, and gives her body an unusual twist, as she sits playing with the Child. Michelangelo took up this motive, as he did more than one other invented by Signorelli, his closest precursor, and developed, or rather distorted it, into what we see in his famous Doni *Tondo*. . . .

Profile Portrait of Camillo Vitelli

Berenson Collection, Florence.

LUCA SIGNORELLI
Cortona, c. 1450–1523.

The Drawings of the Florentine Painters.
University of Chicago Press, Amplified Edition, Volume I, 1938.

His finished paintings never anticipate the future as the drawings do, not only in proportion and in action, but in lighting as well.

The discrepancy between spontaneous drawing and finished painting is not confined to Signorelli. It is, on the contrary, almost universal, and nothing is rarer than the case of an artist, like Ingres, who draws as he paints and paints as he draws.

Among the many reasons for this which in an adequate treatment of the subject would have to be considered, two may be mentioned, but not more than mentioned here.

One is the differing degree of advance in technique. Drawing in Signorelli's hand could achieve anything he wanted it to do. It is doubtful whether in the technique of painting Signorelli was master of the most advanced practices of the Flemings and Venetians of his own day. And even if he were, these practices could not yet cope with the problem of light as solved later by Correggio and his close contemporaries.

Then, the finished painting is in art something like what a dress parade is in military drill. It must come up to the expectation of the authorities. Originality, anticipations, must be suppressed, or at least kept well in hand. The authorities, in the artist's case his employers, would not appreciate a serious departure from the average.

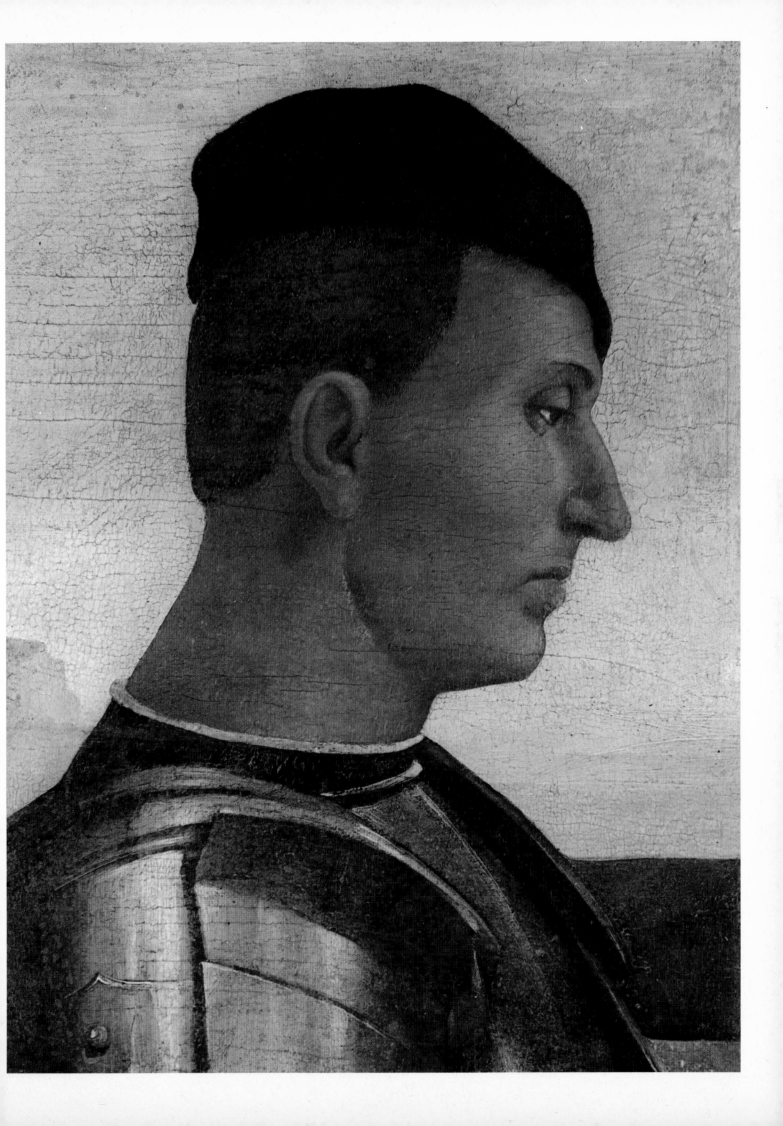

Madonna and Child

Staatliche Museen, Berlin.

ANDREA DEL VERROCCHIO
Florence, 1435–Venice, 1488.
Pupil of Donatello and of Baldovinetti; influenced by Pesellino.

The Drawings of the Florentine Painters.
University of Chicago Press, Amplified Edition, Volume I, 1938.

Andrea del Verrocchio remains one of the most enigmatic figures among the great masters of Florence. His contemporaries seem to have bestowed upon him a fluctuating esteem. Venice chose him from among the many sculptors of Italy to erect the equestrian statue to Colleoni; on the other hand...Ugolino Verini, writing in 1502 or 1503, insists rather upon Verrocchio's qualities as a teacher than as an artist. Fifty years later Vasari, while duly appreciating the subtle hard-won beauty of this or that work by Andrea, records his general impression that Verrocchio was more industrious than gifted and adds that, to the vulgar, he seemed both affected and tame, although he did not fail in gaining the admiration of the few.... It remains a moot point whether the expansion of a man's influence be necessarily in relation of cause and effect to his personality; it certainly stands quite apart from the intrinsic value as art of his own work. Touching his rank as an artist, we should confine ourselves strictly to an estimate based on a study of his works....

The most archaic, the most sculptural and probably the earliest of all Verrocchio's pictures is the monumental Madonna in Berlin. She is seated sideways against a quiet bit of Florentine landscape, rugged and yet intimate. In no other painting is Verrocchio so entirely himself, so unaided, so uncontaminated. Only the terra-cotta relief from S. Maria Nuova, now in the Bargello, is so certainly the master's own.... It may be noted, by the way, that the face and the hand of this Madonna, or of another like her, made so deep an impression upon Domenico Ghirlandajo's memory that, in his earliest years at least, the faces of his own Madonnas and the hands of most of his figures remind us of this or similar works by Verrocchio. As Ghirlandajo was born in 1449, he may have seen this kind of picture being painted in 1467, when he was eighteen.

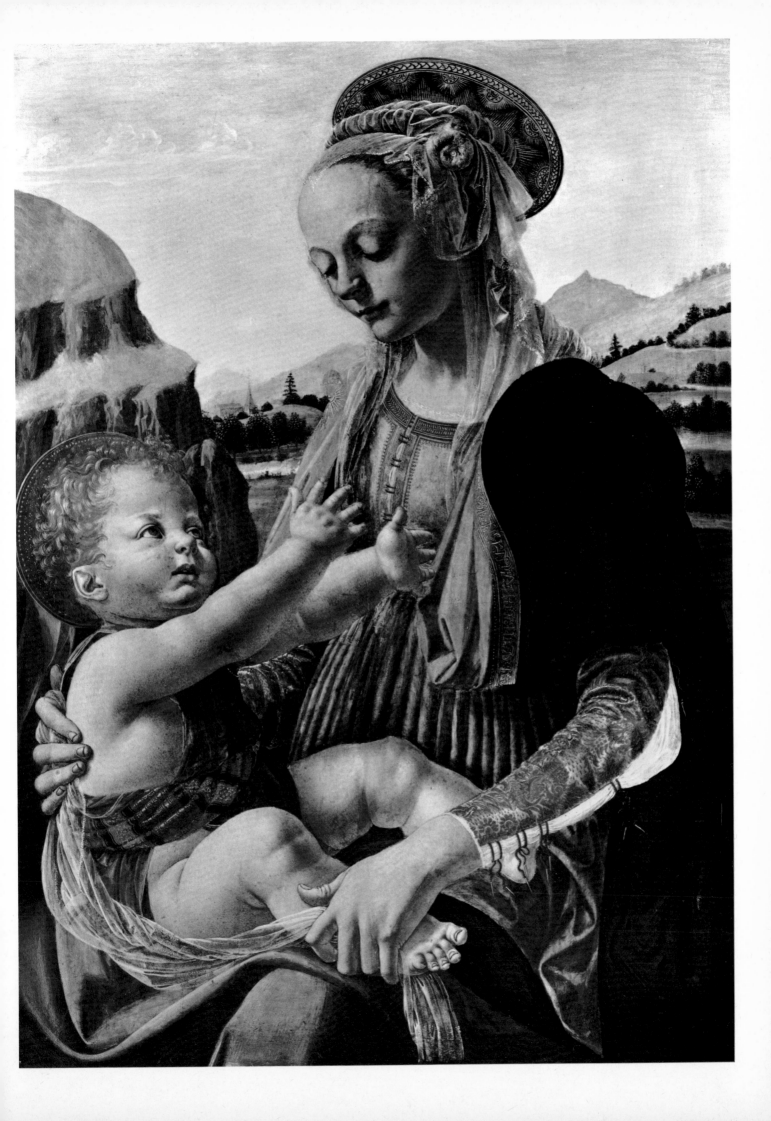

Birth of Venus
Detail. Galleria degli Uffizi, Florence.

SANDRO BOTTICELLI
Florence, c. 1445–1510.
Pupil of Filippo Lippi; influenced by Pollajuolo, Andrea del Castagno and Verrocchio.

Letter to Mary Costelloe.
The Selected Letters of Bernard Berenson.
Houghton Mifflin, Boston, 1964.

Florence January 1892
Wednesday evening
I looked at Botticelli's Venus, and never before did I enjoy it so much. I enjoyed it as I expected to enjoy it when I used to dream about it in Boston, reading Pater's description. In that picture Florentine art touched bottom, created something which invites no comparison, asks for no explanation, is complete in itself as Degas, or Hokusai, or our friend who did the door of Spoleto. To bring us close to life is in one shape or another the whole business of art, and Botticelli in the Venus does bring us close to life.... You have it in the toss of the drapery, in the curl of the flower, in the swing of the line — life full of power, and not afraid to spend itself.

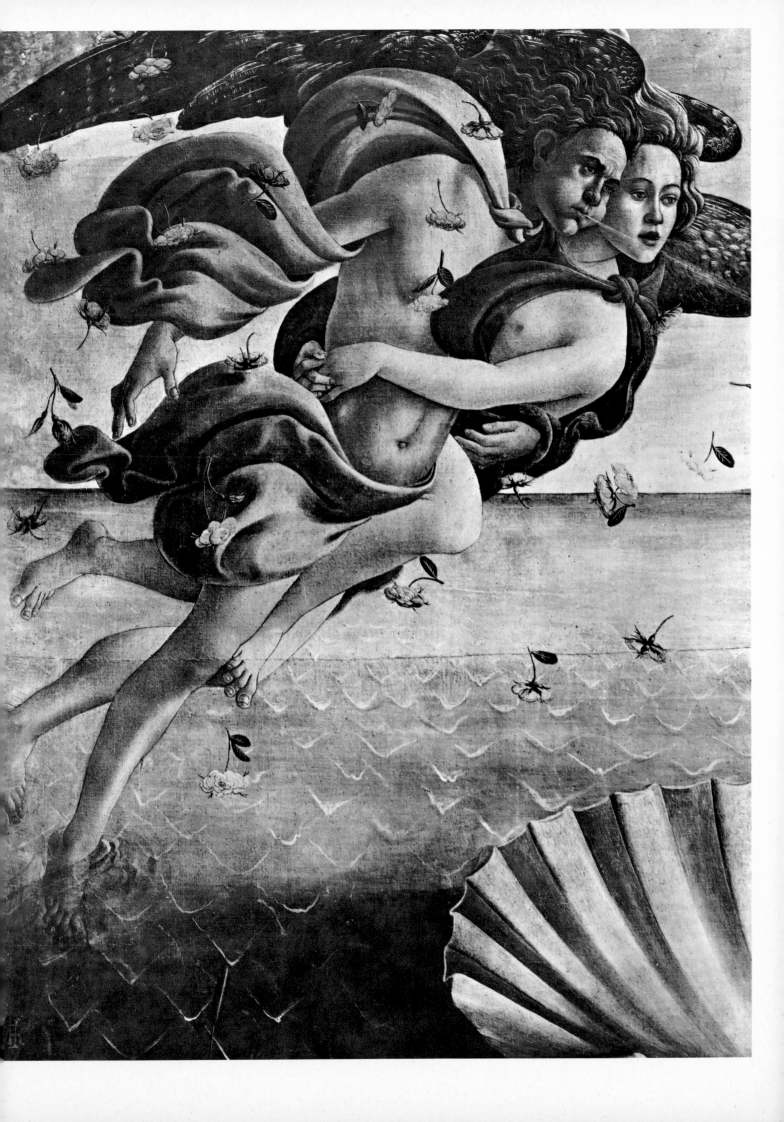

Saint Augustine in His Study

1480. Fresco. Ognissanti, Florence.

SANDRO BOTTICELLI
Florence, c. 1445–1510.

The Passionate Sightseer —from the Diaries of 1947–1956.
Harry N. Abrams, New York, 1960.

June 1956, Florence
Yesterday to the Ognissanti Church. Looked at Botticelli's "St. Augustine." No picture of an intellect engaged on the highest problems compares with this, not even Dürer's, Michelangelo's or Rembrandt's. Realized plastically as draughtsmanship, modelling in colour, all in a most communicative way. Appurtenances painted with accuracy and understanding of what a thinking writer wants near him. And yet how little known, even to a cultivated public, and how unappreciated! Curious, considering that Botticelli is among the favourites of the presumable art lovers. Until Rossetti and Ruskin and English Pre-Raphaelites, and particularly Pater, discovered him he was scarcely known. Even Burckhardt gave him scant attention, and other writers of nearly a hundred years ago, if they mentioned him at all, spoke of him as inferior to Ghirlandaio. Owing no doubt to Pater, I loved him at sight though it took decades before I understood him.

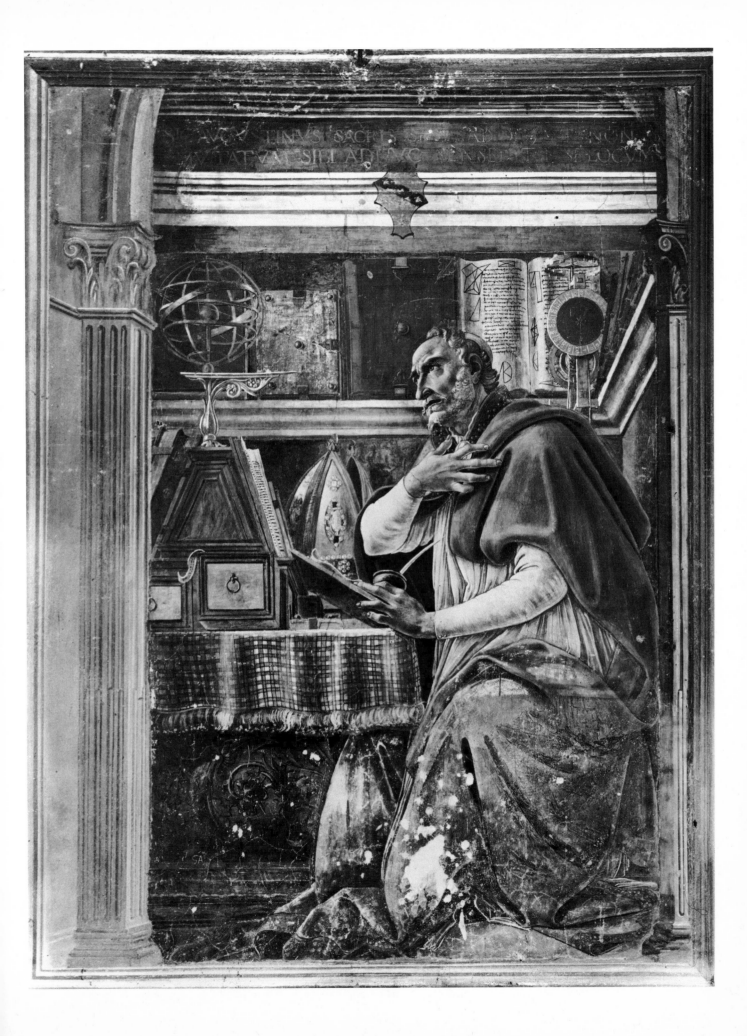

Last Communion of Saint Jerome

The Metropolitan Museum of Art, New York. Altman Bequest.

SANDRO BOTTICELLI
Florence, c. 1445–1510.

The picture is documented as having been painted by Botticelli on commission of Francesco di Filippo del Pugliese, the Florentine merchant, collector and patron of leading artists. It is mentioned in his first will of 1502–03 and again in his final testament of 1519.

The painting illustrates the scene as described in Buonacorsi's *Life of Saint Jerome,* published in Florence in 1490, the *terminus ante quem* for the execution of the work.

A pen and wash drawing of the "Communion of Saint Jerome," smaller in size, in the Robert Lehman collection in New York, is published by Berenson as a "faithful contemporary copy of Botticelli's picture now in the Metropolitan Museum."

H. K.

186

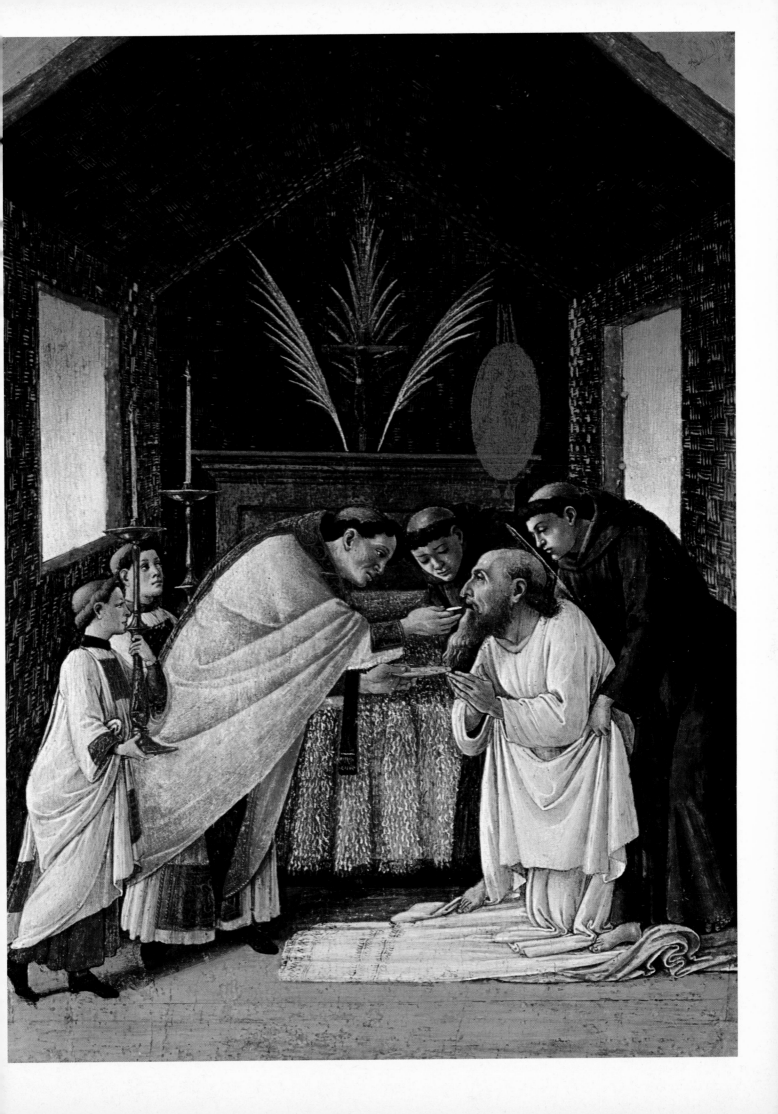

Portrait of Francesco Sassetti and His Son Teodoro

The Metropolitan Museum of Art, New York. Bache Collection.

DOMENICO GHIRLANDAJO
Florence, 1449–1494.
Pupil of Baldovinetti; influenced strongly by Verrocchio and to some degree by the young Leonardo and Botticelli. In nearly all his frescoes and in many of his panels assisted by his brothers Davide and Benedetto and his brother-in-law Mainardi.

"A Catalogue of Paintings in the Collection of Jules S. Bache." 1929.
(unpublished).

Three-quarter length, standing figures, slightly under life-size; Francesco Sassetti faces the observer, and wears a purple skull-cap and a long, red, pleated doublet trimmed with fur at the collar and sleeve; around the waist is a black cord from which hangs a pouch; his right hand rests on a balustrade; his eyes look downward to his son, Teodoro, who stands at the right, in profile, looking up, with his hands crossed before him; he wears a scarlet cap, and a tunic of grey brocade trimmed with white fur, over a green undergarment, the sleeves alone of which are showing; through a window occupying the entire width behind, is seen an inlet of the sea, with mountains and various buildings; inscribed at the top of the window-frame: FRANCISCUS SAXETTUS THEODORUS QUE F.

Francesco Sassetti, born in Florence, March 9, 1420, was a partner of Lorenzo de' Medici in his bank at Lyons, and died in 1491.... His son was born March 11, 1479, and is depicted about eight or ten years of age, which fixes the date of the picture as 1487–1489. Teodoro, who died in 1546, was grandfather of Filippo Sassetti, well-known through his travels in India.

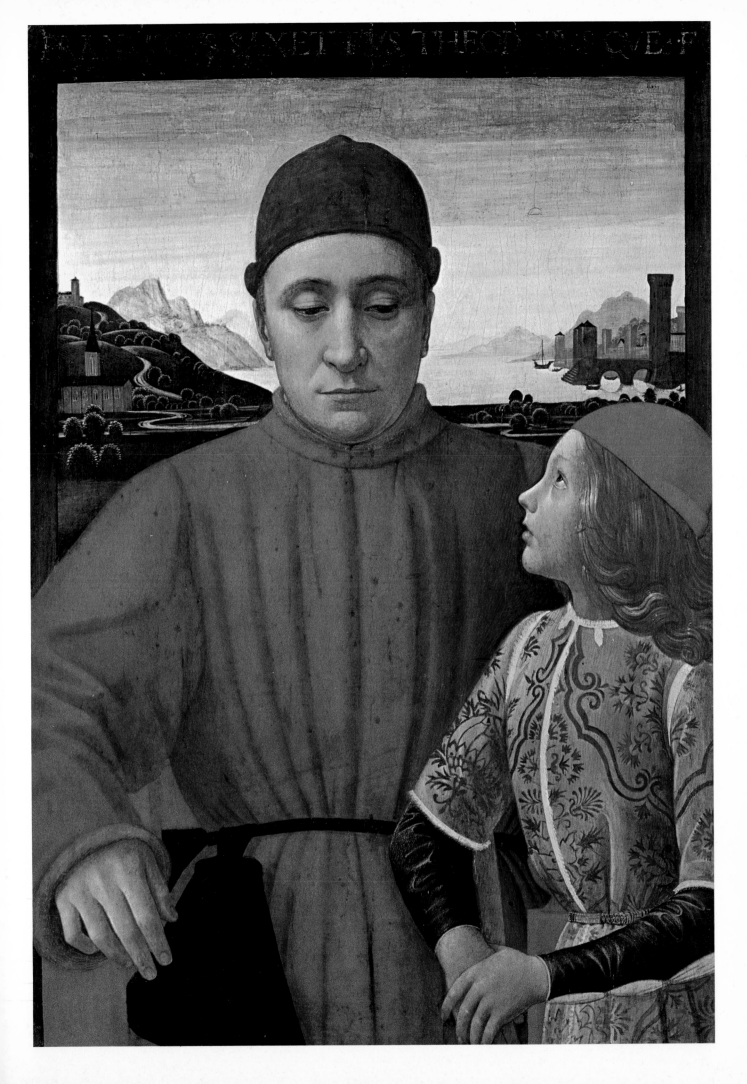

Head of an Old Man

Drawing. Print Room, Nationalmuseum, Stockholm.

DOMENICO GHIRLANDAJO
Florence, 1449–1494.

The Drawings of the Florentine Painters.
University of Chicago Press, Amplified Edition, Volume I, 1938.

The almost unique case of a drawing which although itself of Ghirlandajo's best, is nevertheless surpassed by the painting for which it was made. It is a life-study done in silver-point and white of the head of an old man with eyes and mouth tight shut as if fast asleep. The forehead is large and cliff-like. The hairs on the crown and sides grow with a vigour expressive of the entire mask, of which the striking, the startling feature is a burgeoning nose ruffled and furrowed like a quince or like a potato that has started budding. Yet this singular deformity does not repel, does not detract from the dignity of the face.

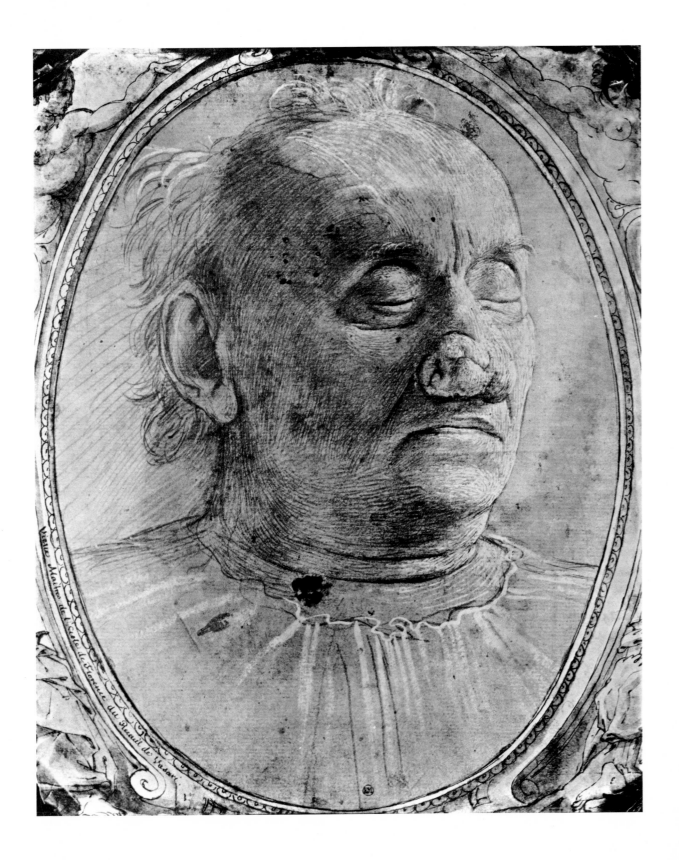

Portrait of an Old Man and a Boy
The Louvre, Paris.

DOMENICO GHIRLANDAJO
Florence, 1449–1494.

The Drawings of the Florentine Painters.
University of Chicago Press, Amplified Edition, Volume I, 1938.

Now let us see what Ghirlandajo has done with it. The finished work in the Louvre represents an old man holding a little boy at arm's length, feeding his eyes on him before lifting him up to kiss. There is no more human picture in the entire range of Quattrocento painting, whether in or out of Italy. With what contented affection the old man looks down at the child and how trustfully, how eagerly the child strains up for the elder's embrace! It was a stroke of genius to represent the old man not as two or three generations later the Flemings and Venetians would have done, in the midst of sons and sons' sons, with wives and daughters, and infants in swaddling clothes, but as the departing generation happy in the sight of the on-coming one. Here, without the least sentimentality, the good essence of family relations is presented with the economy, simplicity, and directness of a Greek masterpiece. There is nothing finer even in Athenian funerary reliefs.

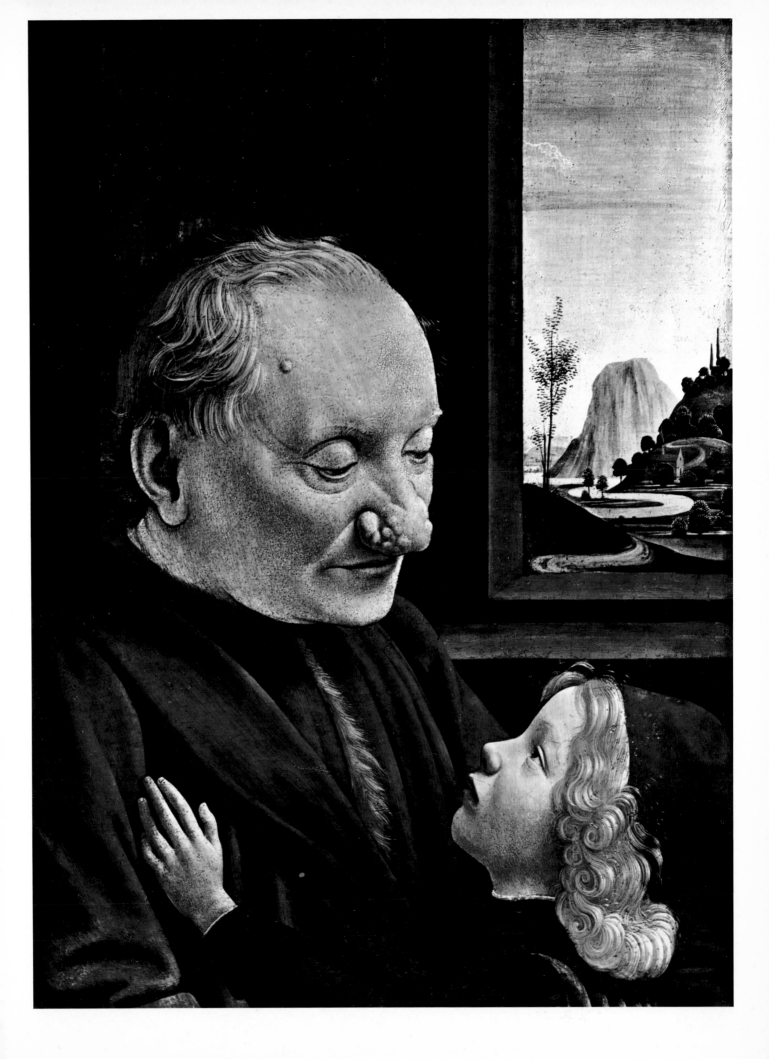

The "Palmieri" Assumption with Saints and the Angelic Hierarchies

Before 1475. Detail. National Gallery, London.

FRANCESCO BOTTICINI
Florence, 1446–1498.
Pupil of Neri di Bicci. Follower of Andrea del Castagno and Cosimo Rosselli;
worked with Verrocchio; influenced by Botticelli, and, after 1480, by Filippino Lippi.

The Drawings of the Florentine Painters.
University of Chicago Press, Amplified Edition, Volume I, 1938.

We know from Neri di Bicci's diary that Botticini, when twelve years old, became his pupil, in 1459. The earliest dated work of those which on internal evidence can be assigned to him, is the Crucifixion with Tobias and the Angel and Saints at Berlin, executed in 1475. This shows clearly that Botticini, after leaving Neri di Bicci, must have worked chiefly under Cosimo Rosselli, that later he must have studied Castagno, and that just about 1475 he was turning his attention to Verrocchio, whose assistant he must have actually become soon afterwards....

A tolerable craftsman, easily submitting to minds stronger than his own, must have appealed to a man on the outlook for someone to slavishly execute his own ideas. Matteo Palmieri certainly employed Botticini and not Botticelli to paint for him that elaborately thought-out Assumption of the Virgin in the National Gallery which the suspicion of heresy soon rendered famous. The date of its execution can scarcely be later than 1475, the year of Palmieri's death and more probably is soon after 1470. This would allow ample time for the planning and execution of the picture which is in the first place a sort of frontispiece to Palmieri's *Città di Vita,* finished early in 1464.

The manuscript of this famous poem, dated 1473, which Palmieri handed over to the Guild of Notaries, is now in the Laurentian Library at Florence. Here and there it contains coloured figures of angels, and at the end, what is more to our purpose, a medallion in pen and ink of Matteo Palmieri, all, as Horne pointed out to me, by Botticini.

Exorcism of the Temple of Hieropolis

1502. Fresco. Detail. Strozzi Chapel, Santa Maria Novella, Florence.

FILIPPINO LIPPI
Prato, 1457–1504.
Pupil and follower of Botticelli.

Letter to Mary Costelloe.
Florence, December 12th, 1890.

[Filippino] is the product of two generations. In Filippo it was character, in Botticelli thought, in him grace. You feel as if a movement had reached its culminating period in him. Another step and you would have over daintiness, over grace, and over elegance. But as it is he has a flow of lines, a charm of colour, figures full of elegance and grace with drapery fluttering, beautifully, their bodies a trifle bent forward, yielding and clinging. The women look a bit ailing. Their refinement is almost that of the ideal Parisian. He is so different from Botticelli whose people look so bored and despondent at times. Filippino's all seem to say *"vivamus dum vivimus"* for *"di doman non c'è certezza."* His decorative sense was of the greatest. He lets ribbons flutter out over his paintings, strews them with roses, puts in edifices that anticipate the very flower of Baroque style, the Zwinger of Dresden for instance. His flesh tints, especially in women is delicately transparent, and pure, his hair flaxen, soft, and clinging, his stuffs velvety. White, light ultramarine, and vermilion he paints in a way all his own. In landscape too he stands by himself. One can see that here as in many other things he has drawn upon Botticelli's, but the spirit is so different. . . .
Scarcely anything I know is more complete than this chapel. You have no allowances to make, and can resign yourself to unalloyed enjoyment. Around the window are painted angels strewing flowers, and below them an allegory of music, such a fascinating maze of lines, and tragedy and comedy in amical conversation. On one of the walls St. John is represented compelling a pestilential dragon to quit an altar and curing a young prince who has fainted. This prince is the sweetest creature imaginable, and the way he swoons into the arms of his companions is simply perfect.

"Warren" Tondo: Holy Family with Infant Saint John and Saint Margaret

Museum of Art, Cleveland.

FILIPPINO LIPPI
Prato, 1457–1504.

"An Unpublished Masterpiece by Filippino Lippi." 1900.
The Study and Criticism of Italian Art.
G. Bell & Sons, London, Second Series, 1902.

It is a *tondo* with figures under life size. . . .

It would be difficult to find a more fascinating composition. The figures are in perfect harmony with the surrounding space: they neither lose themselves in stretches of sky and land too vast for them to hold their own in, as the figures do in a number of fifteenth-century pictures; nor are they crowded and stifled, as in the *tondi* of Signorelli, or the "Madonna della Seggiola" of Raphael. The Madonna dominates the whole. The other figures only serve to complete the harmonious rhythm of lines and contours, which give to the composition the suggestion of a pyramidal silhouette that, inclosed in a circle, never fails to produce an agreeable impression on the eye; nor is the action less ably rendered. We see Filippino here at the very happiest moment of his career, as far from the almost rigid immovability of his Virgin in the Uffizi altar-piece or of the Madonna in the "Vision" of the Badia, or even of the one in the Corsini *tondo*, as from the aimless and nervous agitation of his last paintings. . . . Rarely if ever has the Leonardesque *motif* of the two holy children embracing each other, been rendered with greater naturalness and freedom from affectation. Worthy of note also is the way the right arms of the female figures and the children are entwined, so as to form a semicircle within the *tondo*.

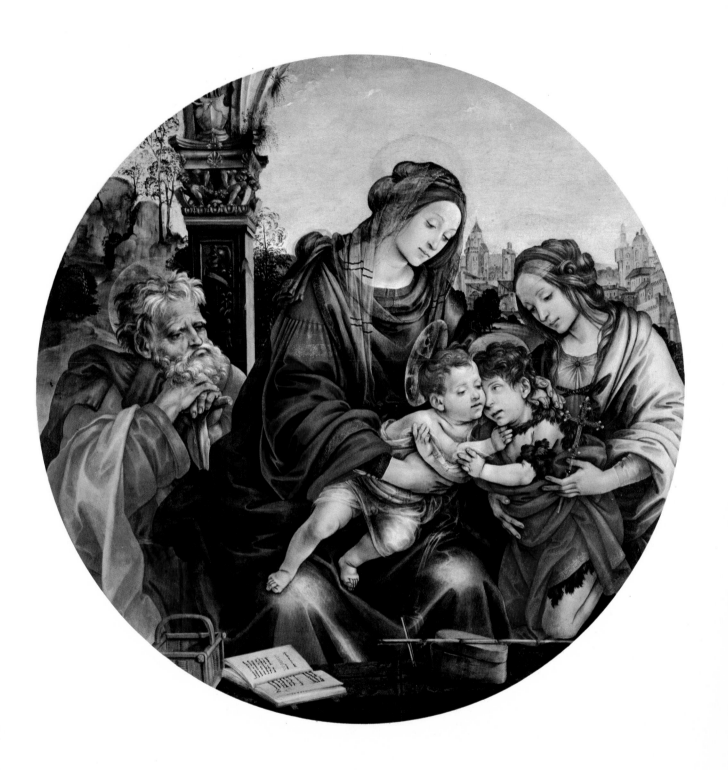

Saint Michael

Signed 1499. Left panel from the lower register of the Certosa di Pavia polyptych.
National Gallery, London.

PIETRO PERUGINO
Città della Pieve, 1445–Fontignano, 1523.
Formed by Verrocchio; influenced slightly by Francesco di Giorgio and Melozzo da Forli.

"The Central Italian Painters." 1897.
The Italian Painters of the Renaissance.
Phaidon Press, London, 1952.

Perugino...produces his religious effect by means of his space-composition. Of his figures we require no more than that they shall not disturb this feeling, and if we take them as we should, chiefly as architectonic members in the effect of space, they seldom or never disturb us. Their stereotyped attitudes and expressions we should judge, not as if they were persons in a drama, but as so many columns of arches, of which we surely would not demand dramatic variety.

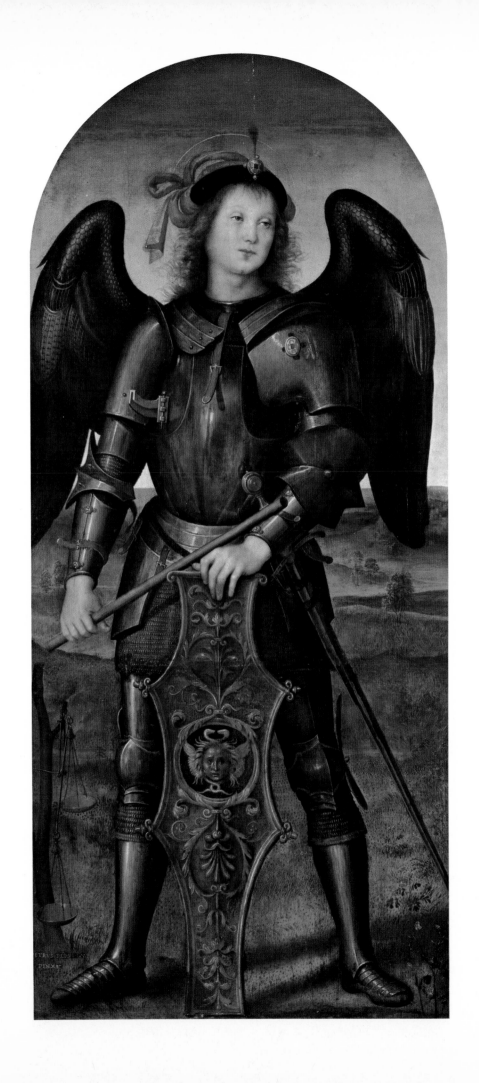

Portrait of a Man

Brooklyn Museum, New York. Michael Friedsam Bequest.

PIETRO PERUGINO
Città della Pieve, 1445–Fontig

"The Catalogue of Italian Pictures in the Michael Friedsam Collection." 1926.
(unpublished).

Bust of a man with dark complexion, brown eyes, and long black hair coming from under a black hat, wearing what is apparently the garb of a cleric, dark brown with small white collar, and black at the armpits. His right hand holds a paper. Blue background.

This self-possessed and quietly humorous countenance so admirably composed, so supple in its contours and so crisp in execution can be the work of no one but Perugino. Its resemblance to the early portrait by Raphael in the Borghese Gallery is startling, but this head, fine as it is, lacks something of the freshness of the other, and besides, the hand is as good as a signature, and should be compared with the hand of "Francesco dell'Opere" in the Uffizi. The shape of the hat furnishes the date of the painting as between 1505 and 1510.

When the present writer first saw this portrait it was scarcely considered as Perugino's. The truth is that Perugino, like Botticelli and others, is being re-valued, and his career traced back further than used to be done thirty years ago. At the same time, he is being more clearly distinguished from other Florentine and Perugian artists. He emerges as one of the greatest masters of the Renaissance, which indeed corresponds with the estimate in which he was held by his contemporaries down to Ariosto.

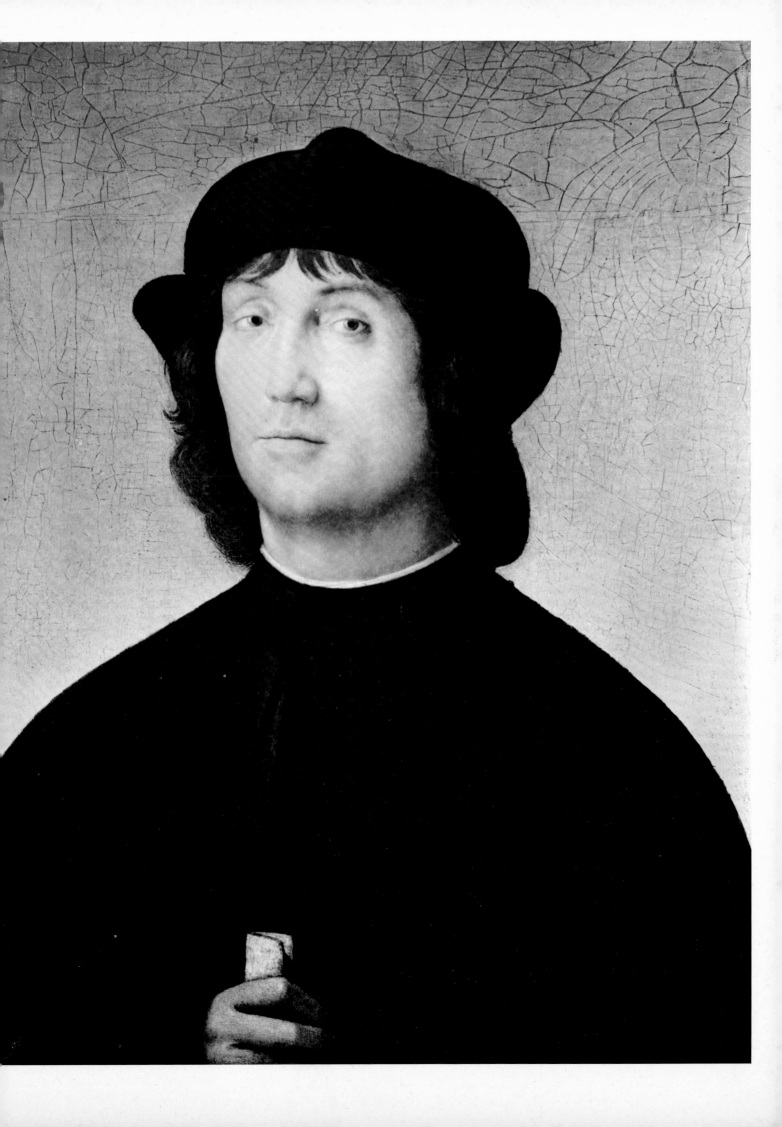

Self-Portrait

Inscribed and dated 1488. National Gallery of Art, Washington, D.C. Widener Collection.

LORENZO DI CREDI
Florence, c. 1459–1537.
Pupil and assistant of Verrocchio; strongly influenced by the young Leonardo.

Pictures in the Collection of P.A.B. Widener.
Volume III: "Early Italian and Spanish Schools."
Privately printed, Philadelphia, 1916.

He is seen turned slightly to our left, but looking straight out, with the head tossed back a little. He wears a cap over a shock of hair which tumbles down to his shoulders and is swept away from his face in wisps that stand out boldly against the sky. Background of cliffs and pools and distant hills.
Inscribed on the back in a cursive, nearly contemporary hand:
LORENZO DI CREDI PITTORE ECC....TE
1488 AETATIS SUE 32, VIII
This is not only Credi's masterpiece as painting and portraiture, but it is a very interesting picture for other reasons as well. In the first place, it reveals a character far more alert and determined than one would have expected from an acquaintance with his other works. Then, as design, it is obviously the kind of pattern — invented, no doubt, by Verrocchio — which leads up through Perugino and Pintoricchio to Raphael, particularly in the treatment of the hair. Finally, it furnishes what we lacked previously, the date of Credi's birth. It is in all probability the work mentioned by Vasari as belonging to Credi's pupil, Gianiacopo, in Florence.

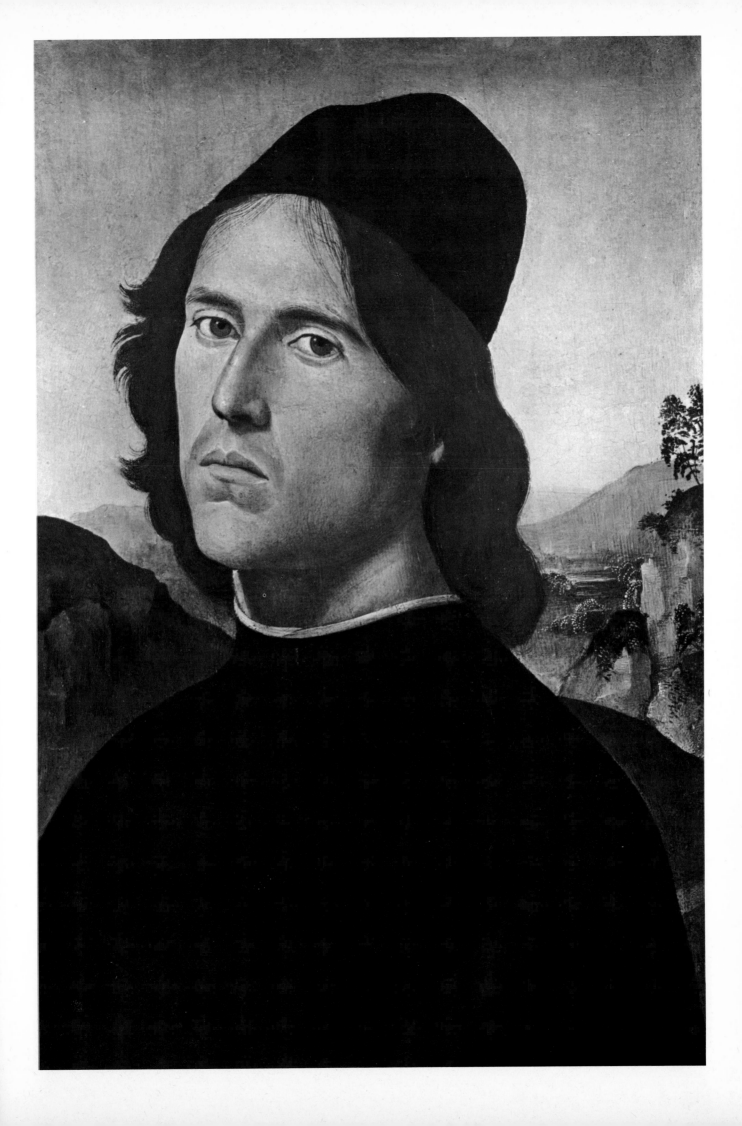

"Pratt" Madonna and Sleeping Child

National Gallery of Art, Washington, D. C. Kress Collection.

COSME TURA
Ferrara, c. 1430–1495.
Court painter of the Estes till 1486. Studied in the School of Squarcione at Padua;
strongly influenced by Donatello, Castagno, and other Florentines;
possibly also by Tavernier and other miniaturists of the Burgundian Court.

"The North Italian Painters." 1907.
The Italian Painters of the Renaissance.
Phaidon Press, London, 1952.

Of the young men who flocked to Padua, none brought greater gifts, none drank deeper of Donatello's art, and none had a more remarkable destiny than Cosimo Tura. He founded a line of painters which flourished not only in his native town of Ferrara, but throughout the dominions of its Este lords and the adjacent country from Cremona to Bologna. It was destined that from him should descend both Raphael and Correggio.

Yet nothing could be more opposed to the noble grace of the one, or the ecstatic sensuousness of the other, than the style of their Patriarch. His figures are of flint, as haughty and immobile as Pharaohs, or as convulsed with suppressed energy as the gnarled knots in the olive tree. Their faces are seldom lit up with tenderness, and their smiles are apt to turn into archaic grimaces. Their claw-like hands express the manner of their contact.... His landscapes are of a world which has these many ages seen no flower or green leaf, for there is no earth, no mould, no sod, only the inhospitable rock everywhere. He seldom finds place even for the dry cornel tree which other artists, trained at Padua, loved to paint.

206

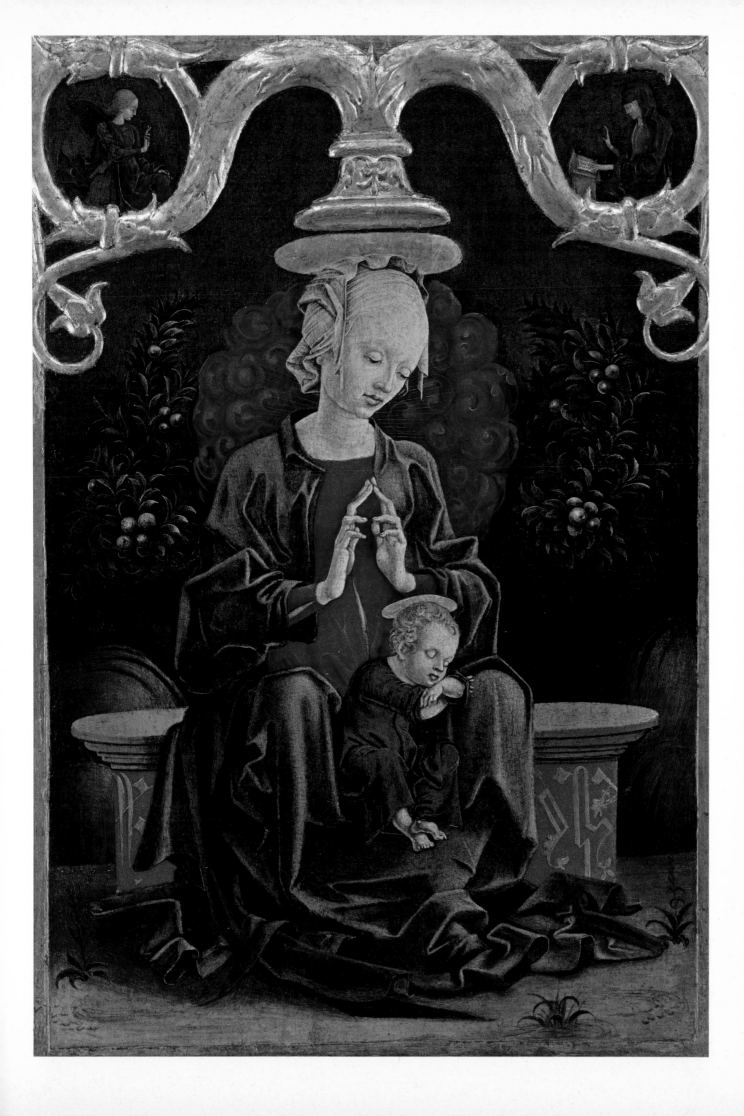

Miracles of Saint Vincent Ferrer
(opposite and following pages)

1472–73. Predella to the Griffoni polyptych. Detail.
Pinacoteca Vaticana, Rome.

FRANCESCO DEL COSSA
Ferrara, 1435–Bologna, 1477.
Pupil of Tura; strongly influenced by Domenico Veneziano, Castagno and Baldovinetti;
and to some extent by Benozzo Gozzoli.

ERCOLE DE' ROBERTI
Ferrara, c. 1450–1496.
Studied at Padua. Pupil of Tura; influenced by the Bellini, Mantegna and Antonello.

"A Ferrarese Marriage-Salver in the Boston Museum of Fine Arts." 1918.
Essays in the Study of Sienese Painting.
Frederic Fairchild Sherman, New York, 1918.

The truth is that no artist south of the Apennines has so much in common
with the Quattrocento painters of Ferrara as Matteo di Giovanni. . . . [As] to the
parallels and resemblances between Matteo and Tura and Cossa, they are indeed
close and startling. All, to begin with, are in dead earnest about form, but not
very serious, for did they deserve this last epithet, they would, like the
Florentines, have cultivated form for its own reward. . . .
All three artists, Matteo as well as Tura and Cossa, arrest their interest in form
directly they can achieve hardness of substance and trenchant precision of
outline. They tend therefore to depict a world mineral, metallic, and lunar,
such as might be evoked by the Sagas of the Berserkers rather than by the
peopled earth that we dwell in, we who are the heirs of Mediterranean
civilization, with its infinite tenderness as well as its appalling madness. Tura,
and Cossa and Matteo have nevertheless left pictures not devoid of sweetness
and charm, although these qualities are not the flower of their art, but outside it.
Matteo in particular, the least gifted of them, it must be added, can not resist
the Sienese taste for loveliness. But when most himself, although he has neither
the vigour nor the rigour of the others, he, too, presents figures contorted with
vehemence, claw-handed and haughty, in landscapes as jagged as the debris of
an avalanche, or in a setting of massive, crowded, piled-up architecture.

Annunciation

1468–69. Organ-shutters. Museo dell'Opera del Duomo, Ferrara.

COSME TURA
Ferrara, c. 1430–1495.

"A Ferrarese Marriage-Salver in the Boston Museum of Fine Arts." 1918.
Essays in the Study of Sienese Painting.
Frederic Fairchild Sherman, New York, 1918.

Take, for instance, his four versions of that singularly popular theme in Sienese painting, the "Massacre of the Innocents." All strike us by the exasperation of ferocity and suffering, the tragic cruelty, the contorted features, iron hands, and flinty figures that are so familiar to us now in Tura and Cossa and Ercole Roberti. The modelling, although much flatter, means to be as unyieldingly firm, and succeeds in being almost as hard; the definition as cutting, and the colour, as among certain followers of Cossa and Tura...has a curious resemblance to tarnished old brass. The architecture might almost be Ferrarese, flint-edged and over-loaded, deeply recessed, richly coffered, encrusted with bas-reliefs and charged with grotesque decoration, — in brief, a delightful but puerile revel of orders and ornaments, very unlike the severely intellectual building of other Tuscans. It will suffice to ask the reader to compare these four designs of Matteo with Tura's altarpieces in the London National Gallery, and in Berlin, with his "Annunciation" in the Ferrara Cathedral best of all, for our purposes, or with Cossa's works at Bologna and in the Vatican, and with Ercole's in the Brera.

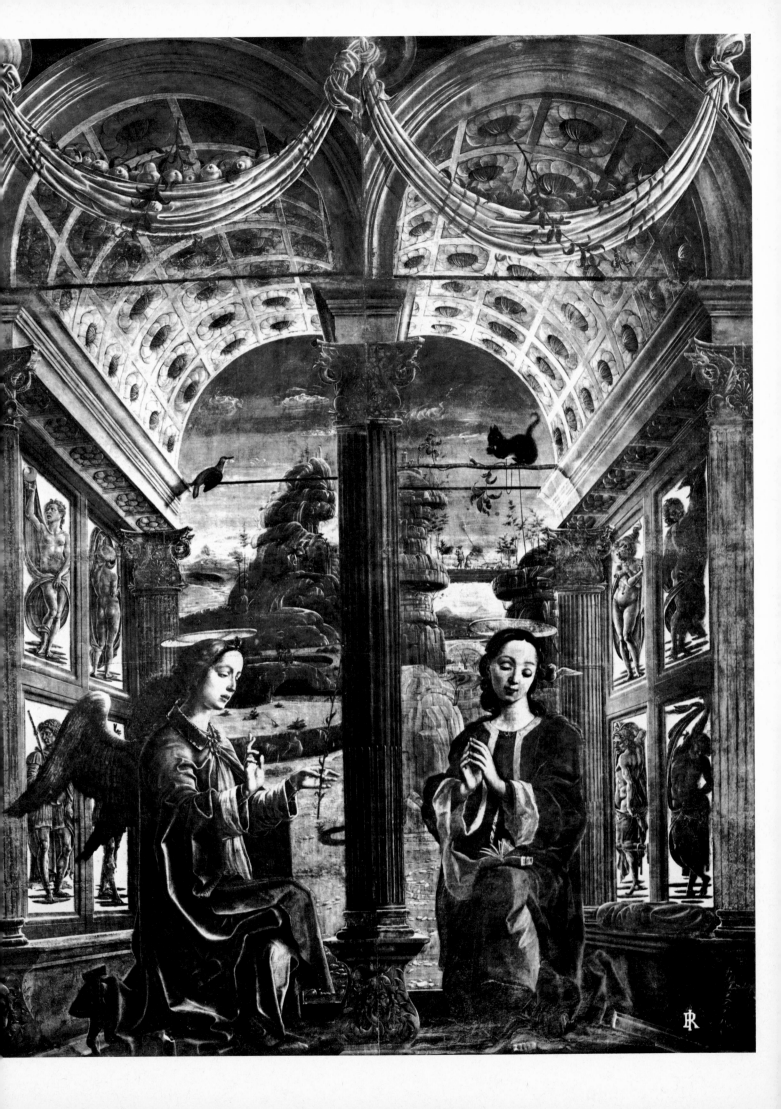

Massacre of the Innocents

1481. Marble intarsia. Pavement. Detail. Cathedral, Siena.

MATTEO DI GIOVANNI
Borgo San Sepolcro(?), first mentioned 1452–53, died in Siena, 1495. Pupil possibly of
Domenico di Bartolo; strongly influenced by Vecchietta, and, later, by Pollajuolo and Girolamo
da Cremona.

"A Ferrarese Marriage-Salver in the Boston Museum of Fine Arts." 1918.
Essays in the Study of Sienese Painting.
Frederic Fairchild Sherman, New York, 1918.

These parallels and resemblances . . . between Matteo and his Ferrarese contemporaries are not necessarily the result of mere accident. They may be due to more than the hazard of kindred temperaments in similar stages of development, for, as we remember, all these painters were striving, if not to be realists, naturalists and scientists themselves, at least to profit by the efforts of the artists who were. It is possible that Matteo had come into personal touch with Tura and Cossa, for even in the Fifteenth Century people were not quite as limited in their movements as pumpkins. What at any rate is fairly secure, is that they all came under the influence of the great Florentines, whether Donatello and Castagno and Pollajuolo, or Uccello and Piero della Francesca. It is not necessary to prove this statement in so far as the Ferrarese are concerned, for it has been amply and even more than amply acknowledged. As for Matteo, his indebtedness to Pollajuolo, who in a sense resumes his own and his preceding generation, is not only manifest more or less everywhere, but in his greatest achievement, the "Massacre of the Innocents" on the pavement of the Siena Cathedral, the friezes in the cornice, if we had them separately and unclassified, would by miracle only have escaped attribution to the Florentine.

214

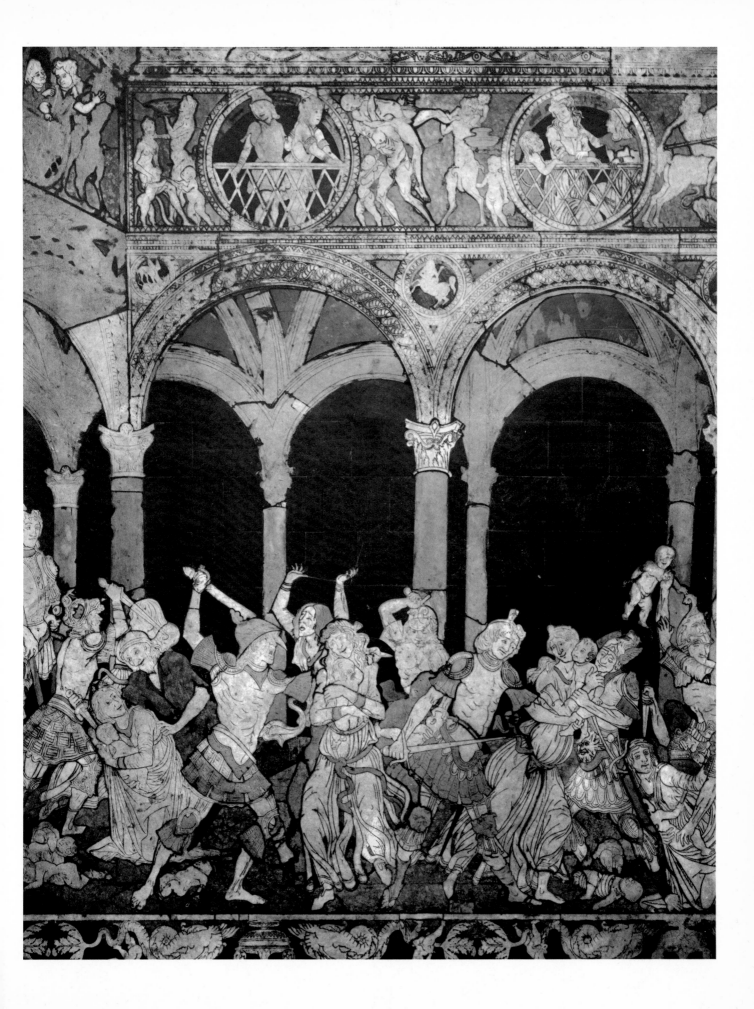

Madonna Suckling the Child

c. 1490. John G. Johnson Collection, Philadelphia.

VINCENZO FOPPA
Brescia, c. 1427–1515/16.
Founder of the School of Milan, but himself a Brescian. Studied at Padua in School of Squarcione; influenced by Giovanni Bellini and later by Mantegna and Bramante.

Catalogue of a Collection of Paintings and Some Art Objects.
Volume I: "Italian Paintings." John G. Johnson, Philadelphia, 1913.

The Blessed Virgin is seen nearly down to the knees, seated against a curtain of yellow brocade with a pleasant landscape showing on the right. She looks towards our right and suckles the Child Whom she holds to her left breast. She wears a dark grey-blue mantle over a light vermilion dress. The Child is in yellow with a close fitting red cap. The flesh is silvery grey, the landscape rather brown. The halo has a pattern of Roman letters trying to look Cufic.

Massive, grave, yet homely, much more on the plane where we encounter Giovanni Bellini in his earlier years, than on that of the "painted lilies" which usually come to our minds when we hear mention of Milanese art. But no one can breathe provincial air with entire impunity. In the case of Foppa it merely arrested his growth. Here we have a picture designed towards 1490, that is to say from his ripest maturity. At that time Bellini had already created his Frari Triptych and the S. Giobbe Altarpiece; and yet they started pretty even.

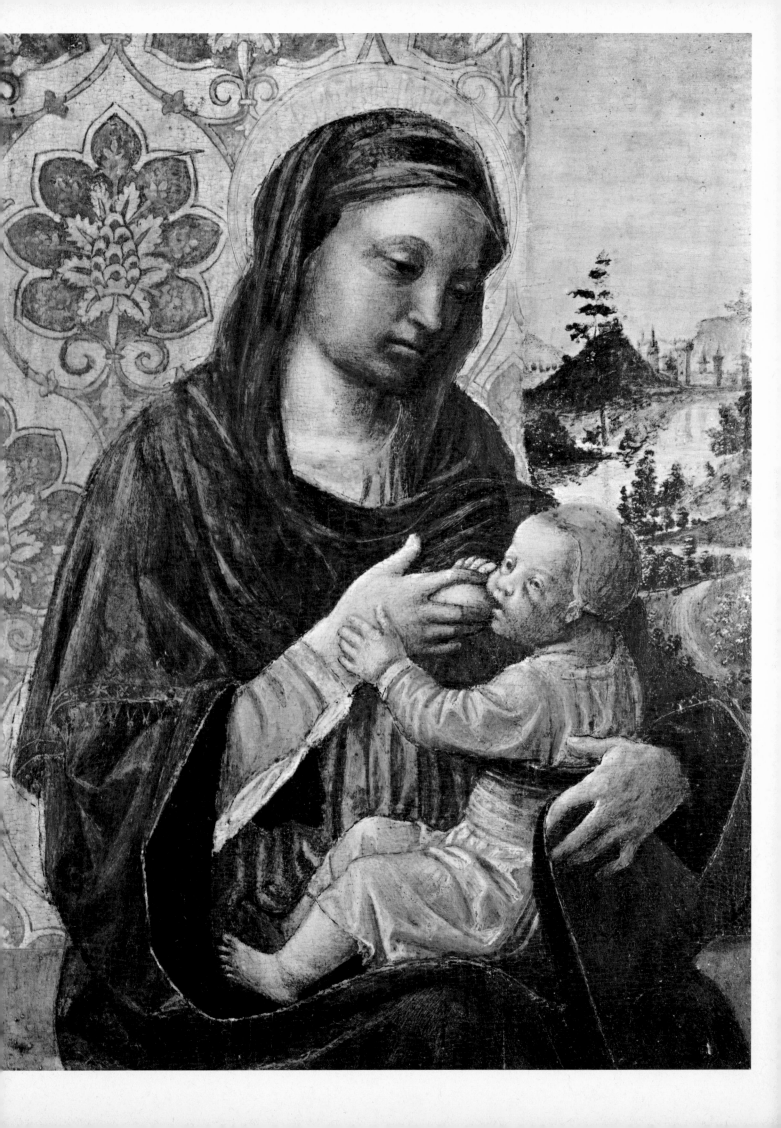

Profile of Bianca Maria Sforza

c. 1493. National Gallery of Art, Washington, D. C. Widener Collection.

AMBROGIO DE PREDIS
Milan, active 1472–1506 and probably later. He may have been the pupil of Foppa and was certainly the assistant and close follower of Leonardo da Vinci.

Pictures in the Collection of P.A.B. Widener.
Volume III: "Early Italian and Spanish Schools."
Privately printed, Philadelphia, 1916.

His is the version of [Leonardo's] "Virgin of the Rocks" in the National Gallery, and his, too, are some of the best known portraits ascribed to the greater artist. She is seen to just below the waist, in profile, looking to our left. She has brown hair, wears a golden brown dress of rich brocade, and is very elaborately decked with jewels. In her head-dress appears the well-known Sforza motto, MERITO ET TEMPORE, which may be translated as "Do your best and bide your time."

Bianca Maria Sforza was a daughter of the tyrannical Duke of Milan, Galeazzo Maria. She was born April 5, 1472, and died December 31, 1510. She was first affianced to Filbert of Savoy, who died before their marriage could take place. Another engagement to John Corvinus, son of the King of Hungary, was broken for her by her uncle, Ludovico the Moor, because it suited his policy to marry her to the Emperor Maximilian. This wedding took place on November 30, 1493. Bianca was a woman of childish but affectionate character, who bored her husband but was devoted to her friends. . . . This portrait was, in all probability, painted before Bianca's marriage.

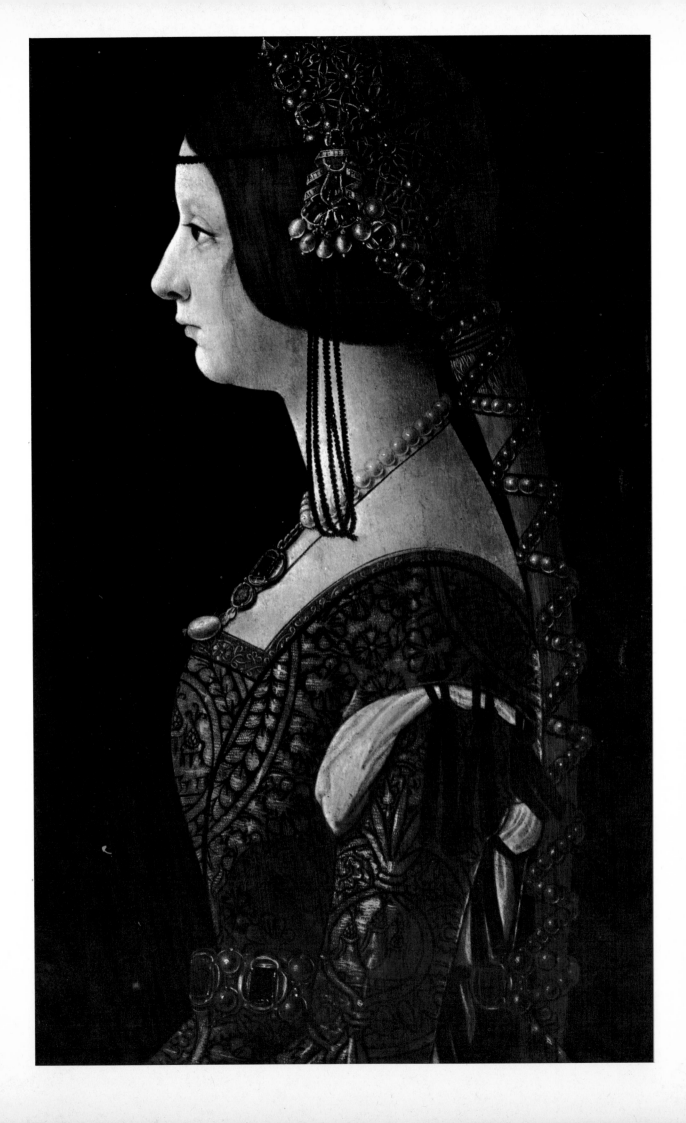

Bust of Alessandra Piccolomini

National Gallery of Art, Washington, D. C. Widener Collection.

NEROCCIO DI BARTOLOMMEO LANDI
Siena, 1447–1500.
Painter and sculptor. Pupil of Vecchietta, and for some years partner of his fellow-pupil, the architect, painter and sculptor, Francesco di Giorgio.

Pictures in the Collection of P.A.B. Widener.
Volume III: "Early Italian and Spanish Schools."
Privately printed, Philadelphia, 1916.

She is about twenty-five years old, seen not quite to the waist, above a parapet, against an enchanting landscape. Her rather long face is turned slightly to our left, and her hair, which is almost straw-coloured, is very elaborately dressed. Each hair is spun out or daintily curled, and the whole flows down in a mass over her bare neck and throat to her shoulders, clinging fairly close to the temples but puffed out over the ears, and crowned on the back of the head with a jewelled cap. She wears a double string of pearls around her neck, with an oval pendant, and lower down over her throat and bosom a larger string with a cruciform jewel. Her dress, which is beautifully embroidered, is cut low and square and is set with pearls. The landscape consists of graceful trees watching over silent pools and romantic castles.

The whole parapet is occupied by a tablet with a triangular handle at each end. On the tablet is the following elegiac distich:

QUANTUM · HOMINI · FAS · EST · MIRA · LICET · ASSEQUAR · ARTE:
NIL AGO: MORTALIS · EMULOR · ARTE · DEOS ·

On one of the handles of the tablet we read the letters NER, which we can safely assume to be the abbreviated signature of Neroccio. On the other handle are the letters A. P....

Even if the signature were not here, there could be no question about the authorship of this unique head, so redolent of Renaissance romance. It is, unhappily, not so certain who this fascinating great lady was. We may safely assume that she must have belonged to one of the ruling families of Siena, and at the time Neroccio is likely to have painted this portrait (before rather than after 1490), no family would have answered that description better than the Piccolomini....

Among other prominent families at Siena, there is no easily accessible record of a woman living in the last quarter of the 15th century to whom the initials A. P. could apply.

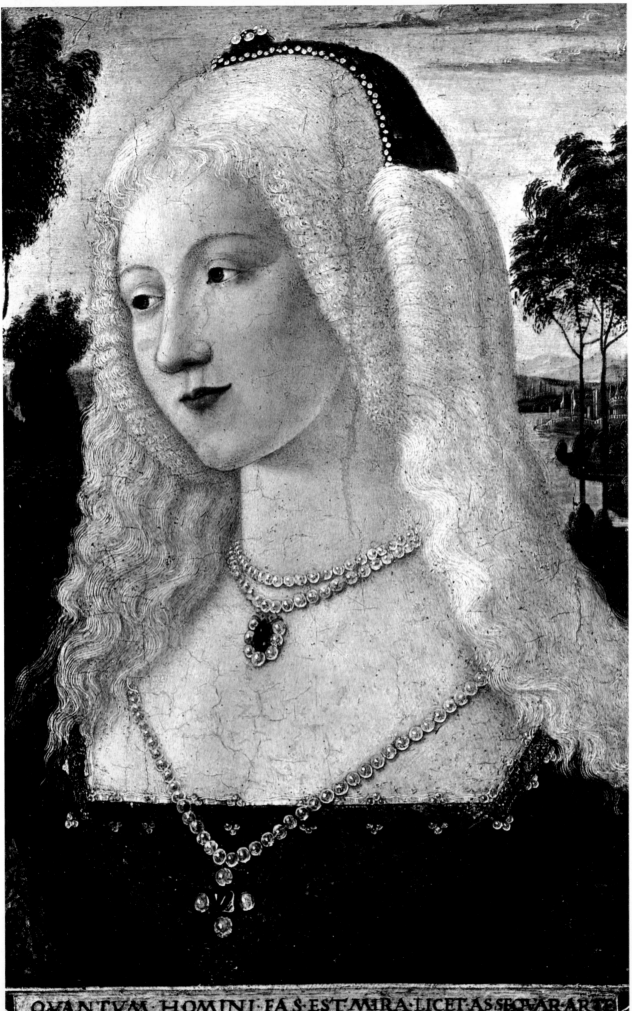

QVANTVM·HOMINI·FAS·EST·MIRA·LICET·ASSEQVAR·ARTE
NIL·AGO·MORTALIS·EMVLOR·ARTE·DEOS·

Vestal Claudia Quinta on a Pedestal

National Gallery of Art, Washington, D. C. Mellon Collection.

NEROCCIO DI BARTOLOMMEO LANDI
Siena, 1447–1500.

"Missing Pictures of Fifteenth Century Siena." 1931.
Homeless Paintings of the Renaissance.
Indiana University Press, Bloomington and London, 1970.

It would seem that somebody wanted to furnish a room with a series of panels each painted with the figure of an heroic or allegorical personage. The employer would seem to have been in a hurry for the work had to be farmed out to be done piece-meal as it were, although it would seem — I use this locution for the third time — that the commission for the whole was given to Signorelli. He did not paint a single panel entirely with his own hands, but he designed four of them. . . . For all of these the great master probably designed the cartoon but painted less and less of the figures, and nothing of the backgrounds. He left landscape and all other details to a Sienese assistant, brought up in the traditions of Neroccio and Benvenuto, whom we may best designate as the Griselda Master. . . . Of the three remaining panels of this series, the *Vestal Claudia* of the former Dreyfus Collection is by Neroccio. . . .

Miniature Portrait of a Turkish Youth

1479–80. Isabella Stewart Gardner Museum, Boston.

GENTILE BELLINI
Venice, 1429–1507.
Pupil of his father, Jacopo; influenced by the Paduans.

According to a letter written by Sami Boyar of Istanbul to the Director of the Isabella Stewart Gardner Museum in 1938, it is strongly probable that this is a portrait of Sultan Djem, who was a great poet and man of letters even at an early age.

H. K.

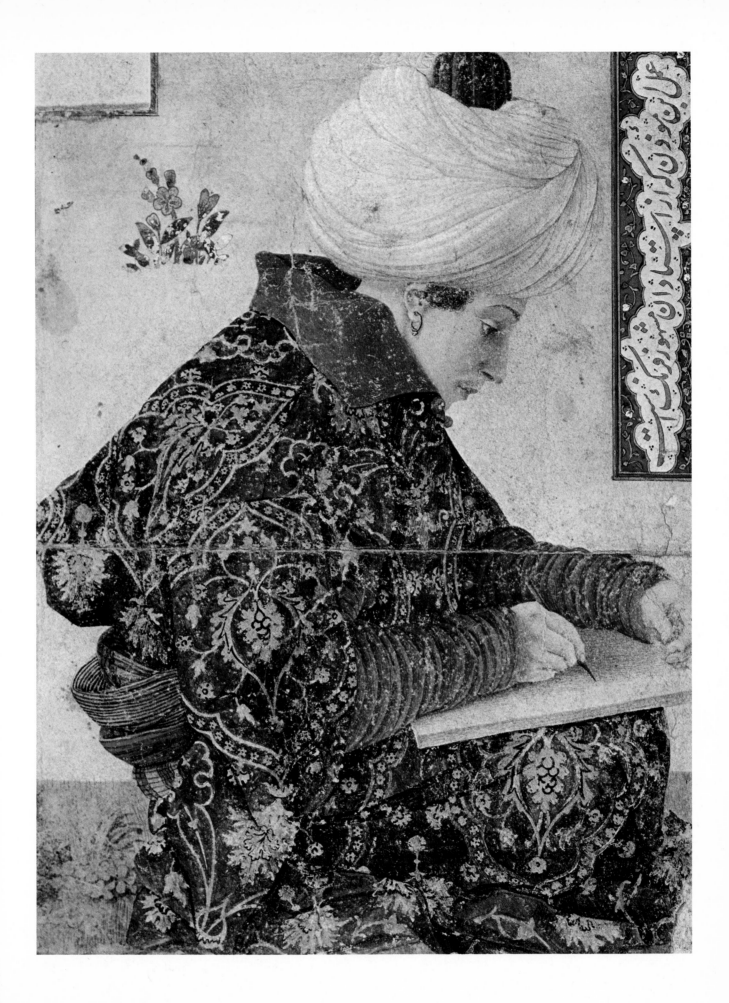

Portrait of Caterina Cornaro

Museum of Fine Arts, Budapest.

GENTILE BELLINI
Venice, 1429–1507.

Letter to Mary Costelloe.
Budapest, October 28th, 1890.

I must tell you at any rate about the greatest thing all in all that there is in this gallery. It is Gentile Bellini's portrait of Catherine Cornaro. It is a bust seen three-fifths. What English poet is it that celebrated Catherine?... Whoever the poet, he would find little poetry in the portrait of this corpulent female. She is gorgeously dressed in gold brocade, wears a diadem of gold and rubies, and chains of pearls all over her, and a stomacher set with rubies. She looks as if she found it hard to keep her eyes open, as if good dinners had told upon her . . . and very much like a Venetian fishwife of to-day. Yet she must have been very wonderful in her youth, as Queen of Cyprus, and later as the great lady of Asolo with the most dazzling wits of Italy, Bembo among them, to keep her company. Perhaps it was their humanistic wit that makes her eyelids so heavy. As painting, as portraiture nothing could be better. Gentile here shows himself the greatest portrait painter up to his day.

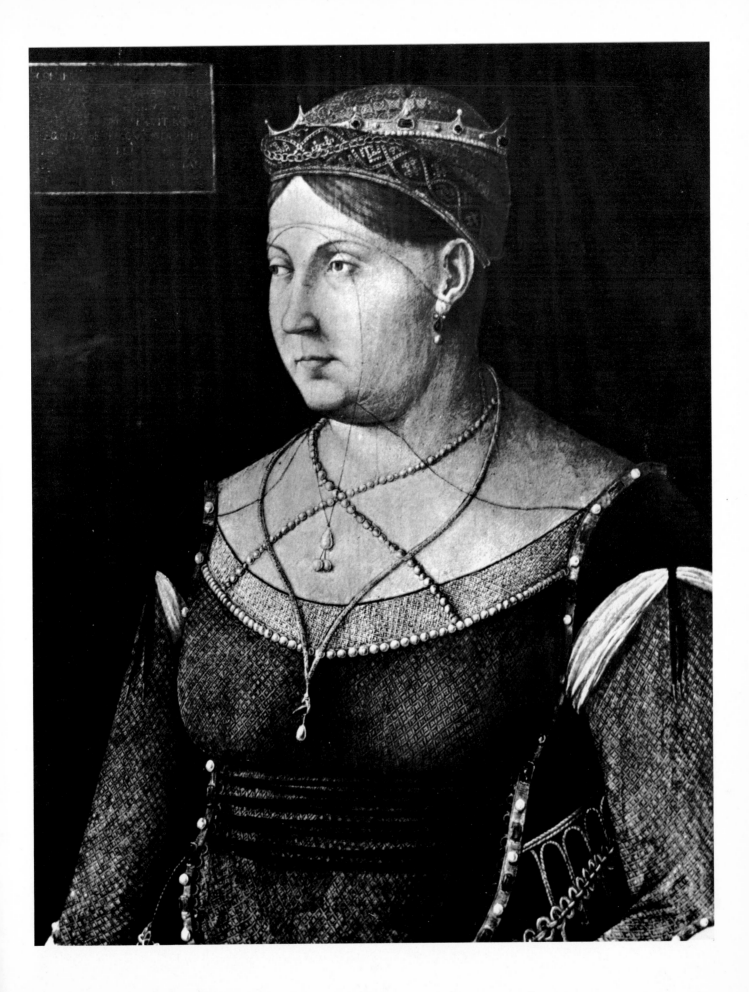

Epiphany (following pages)

National Gallery, London. Layard Bequest.

GENTILE BELLINI
Venice, 1429–1507.

"Nine Pictures in Search of an Attribution." 1924.
Three Essays in Method.
Clarendon Press, Oxford, 1926.

Gentile is one of the many victims of time. It has devoured nearly all the offspring of his genius, so that it has become hard to frame an idea of his quality, let alone to construct a history of his career. The few works of his maturity that remain probably give but a one-sided notion of his talent, for they are ceremonial pictures that afford small scope for what is not stately and processional. . . .

But great masterpieces like this Epiphany are produced by great masters only; and of such, at any given moment, there are not many. When Cézanne towards the end of his days said to a critic, "You know perfectly well that I am the only painter now in Europe," he was somewhat tainted with senile conceit — for Degas and Renoir were still alive; but after all he was not so very far wrong in his calculations. Take away the three Bellinis and Carpaccio, take away Giorgione, Titian and Tintoret, and what remains of Venetian *Quattrocento* and *Cinquecento* painting? As for the rest of Northern Italy, who are its great masters during these two centuries if you leave out of account Mantegna, Paul Veronese, and Correggio?. . .

Although Gentile Bellini's career is like a stream that we must cross by jumping from stepping-stone to stepping-stone, it is nevertheless saner to find a place for this masterpiece among his works than among those of any other artist. The unique intimacy with Oriental costume, the head of the oldest Magus, which recalls the signed portrait of Doge Barbarigo at Nuneham, the hands of the Blessed Virgin and of St. Joseph, the folds of the draperies, the precise, economical, and crisp draughtsmanship, all point to Gentile, and compel us to accept as his the unexpected elements, notably the landscape and the rather silvery, browny colouring — due, perhaps, to God knows what disintegrations and repairs. For reasons we have not the space to discuss, the picture must have been designed about 1485.

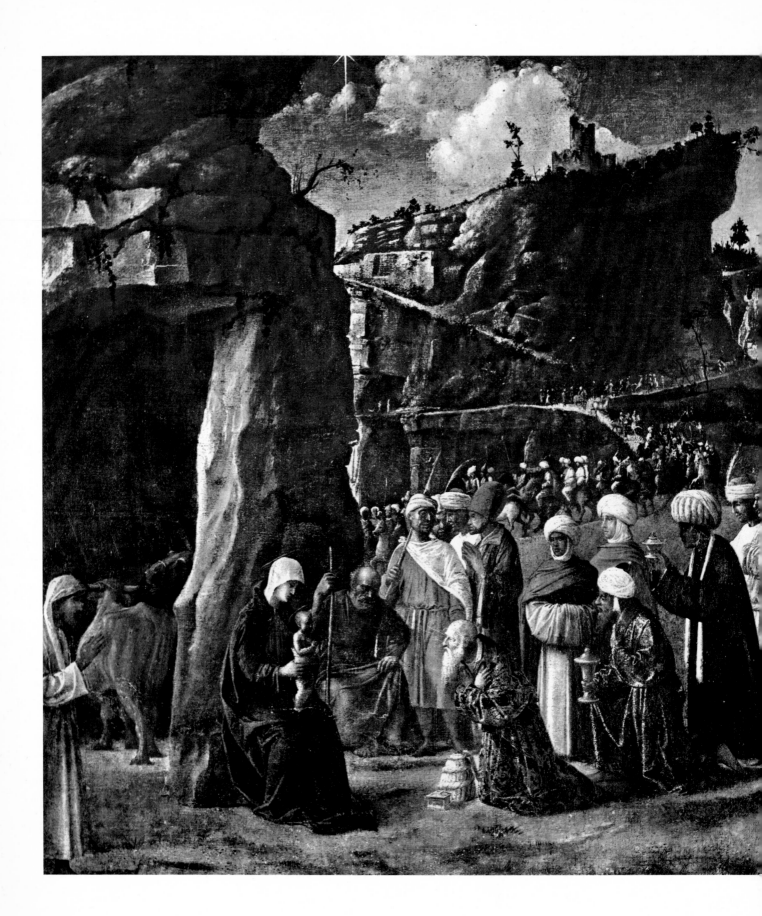

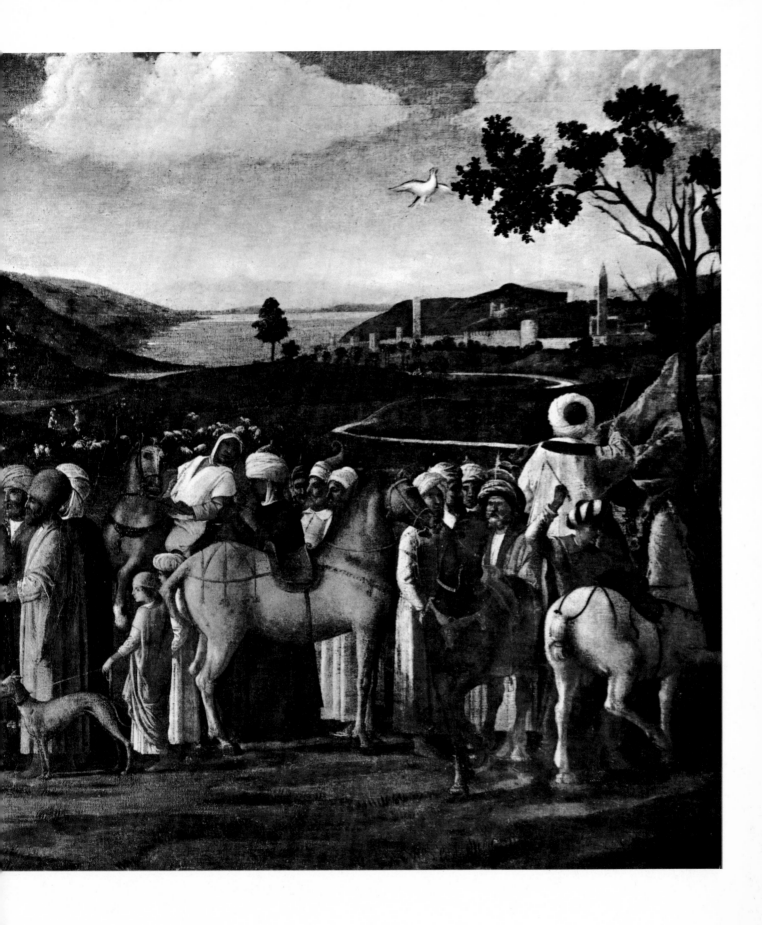

Saint George and the Dragon

Isabella Stewart Gardner Museum, Boston.

CARLO CRIVELLI
Venice, 1430/35–Fermo, 1495.
Pupil of some follower, perhaps Catalan, of Roger van der Weyden; formed by the Paduans.

Venetian Painting in America. The Fifteenth Century.
Frederic Fairchild Sherman, New York, 1916.

In Carlo Crivelli the Byzantine painting of the West reached its culmination and fullest fruition. Crivelli no doubt owed much to the Paduans, but his gorgeous polyptychs, filled with a sensuous splendour of decorative detail, suggesting the *iconostaseis* of Greek churches, are still in essence medieval Greek. There is, however, in his art a quality of genius which the Byzantine world never produced, and, without Renaissance leaven, probably never could have produced. The stirring of the Quattrocento spirit, which in Florence, and under the influence of Florence, was so prolific, produced, when in union with Eastern methods and tradition, no signal offspring but Crivelli. . . .

Here is not an attitudinizing page-boy, but the ever youthful defender of eternal right against regardless might. His face of beauty and passion and his slim body are outlined against the golden sky, while he bestrides a gorgeously caparisoned steed, himself in shining armour that can never lose the purity of its luster. He is now hacking away at the Dragon, already transfixed by his lance. The young knight, too, is nearly spent, but his victory is sure. Under the bastion towers of the undevastated city kneels in prayer the Princess for whom he is fighting. Stately trees stand dark against the sky. What a pattern — and what an allegory!

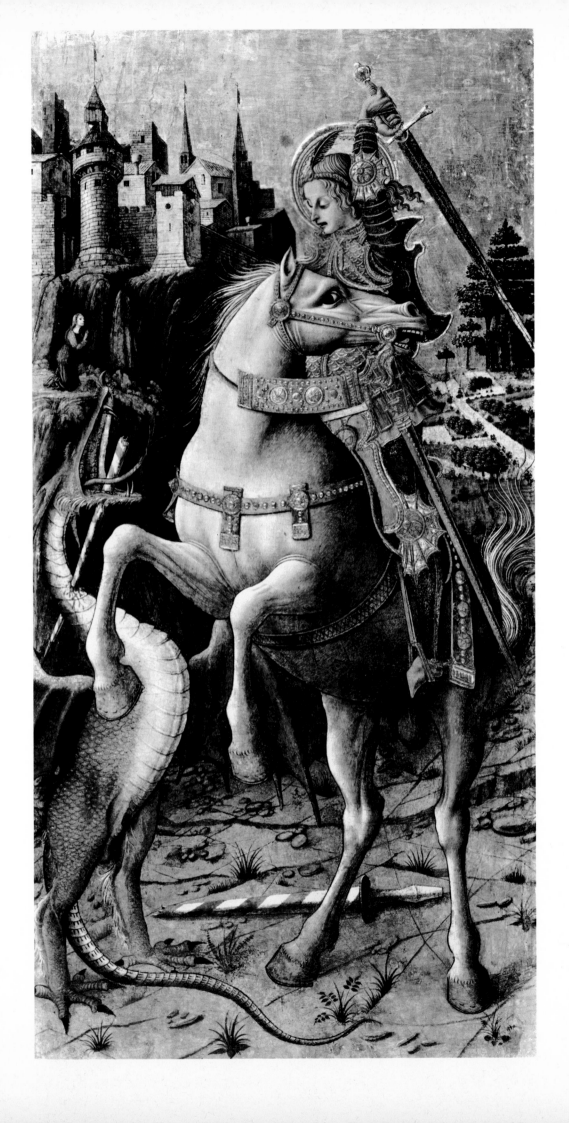

Madonna and Child

Signed. The Metropolitan Museum of Art, New York. Bache Collection.

CARLO CRIVELLI
Venice, 1430/35–Fermo, 1495.

"A Catalogue of Paintings in the Collection of Jules S. Bache." 1929.
(unpublished).

Half-length figure of the Madonna, standing behind a sculptured balustrade, in a blue mantle richly decorated with gold embroidery, lined with green, and a white head-dress fastened with a string of pearls and a jewel; she holds the Child in front of her, as He sits on a violet cushion on the balustrade, holding a gold-finch in both hands; the nimbi are gilt and decorated with gems; behind a lilac curtain, over which is suspended a festoon of fruit and leaves; a wooded landscape in the background; on the balustrade, at the left, is a very naturalistic fly; on a yellow satin cloth spread over the balustrade is a *cartellino* with the inscription: OPUS·KAROLI·CRIVELLI·VENETI. The large fruits are characteristic of Crivelli; the apple representing the sin of Eden, and the gourd the Resurrection which redeemed the world from its consequences.

234

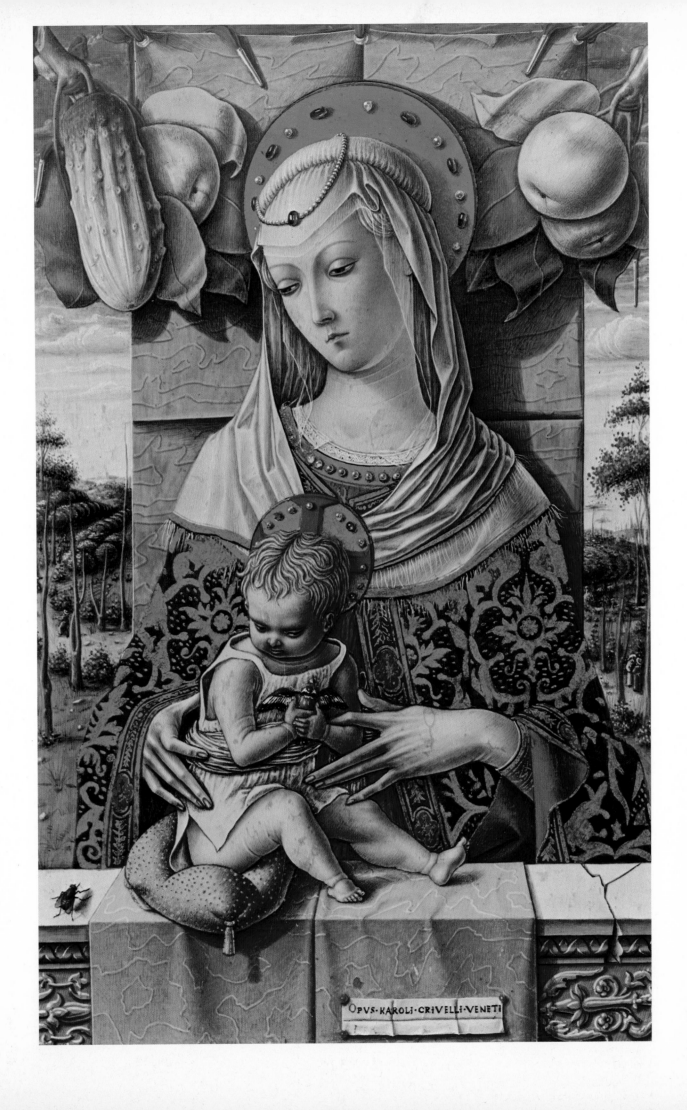

Woman Reading

National Gallery of Art, Washington, D. C. Kress Collection.

VITTORE CARPACCIO
Venice, c. 1455–1526.
Pupil and follower of Gentile Bellini; influenced by Giovanni Bellini and Giorgione.

"Venetian Painting, Chiefly Before Titian...." 1895.
The Study and Criticism of Italian Art.
G. Bell & Sons, London, First Series, 1901.

We do not see him here in his most characteristic capacity, that of a *raconteur,* but as the author of one figure of a saint, and of a couple of drawings. The saint is a charming representation of a woman, dressed in the gay costume of the time, seated by a lakeside, reading, perhaps, the fragment of some "Santa Conversazione."
The identical figure recurs in a "Birth of the Virgin" at the Lochis Gallery in Bergamo, there ascribed to Carpaccio, by whom it was not painted, although designed.

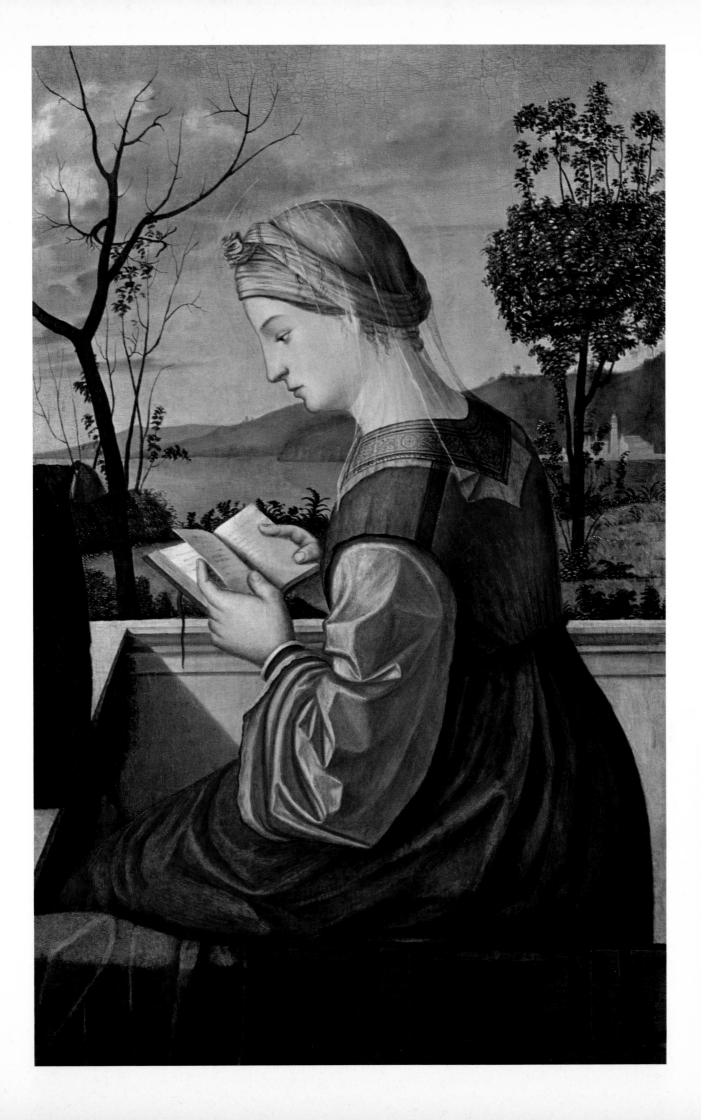

Meditation on the Passion:
Dead Christ in Rocky Landscape with
Saints Onophrius and Jerome

Signed. The Metropolitan Museum of Art, New York.

VITTORE CARPACCIO
Venice, c. 1455–1526.

Venetian Painting in America. The Fifteenth Century.
Frederic Fairchild Sherman, New York, 1916.

Like his master, Gentile Bellini, Carpaccio seems to have been first and foremost an historical painter, a master of narration, and compositions from his hand of the easel picture type are infrequent. For this reason his works out of Venice are exceedingly rare. . . .

While he was at work upon the fascinating designs at *S. Giorgio degli Schiavoni,* where his genius still retains nearly all its freshness, and exuberance and buoyancy, and where his touch at times is as exquisite as one will ever see, he found the leisure to design, if not to execute, the series now scattered of the "Life of the Virgin," and to do with his own hands canvases like the spacious and sumptuous "Nativity" belonging to Lord Berwick [now in Lisbon, Gulbenkian Foundation], and the "Repose of the Dead Saviour" acquired not too long ago for the Berlin Gallery, and furthermore the arresting, impressive *"Pietà,"* more recently purchased by the Metropolitan Museum of New York. The dead Saviour, although His body has every accent and touch of Carpaccio, is yet the element of this work which makes one think most of Giovanni Bellini. Quite naturally, for the feeling and action were both inspired by some such a *"Pietà"* of Bellini's as the one now at Berlin. . . .

The Saint who faces Jerome is in every probability Onofrio. He frequently appears as a pendant to the great Church Father when the latter is represented as a desert anchorite. . . . The volutes and curves on the shattered throne wherein Our Lord reclines may be seen most conspicuously in the "Marriage of the Virgin" (Brera), a painting of the same date as the last of the *Schiavoni* compositions. This canvas, too, contains in a tablet Hebrew inscriptions identical with some of those in the New York picture. . . .

The square block on which Onofrio sits contains, just above the false signature of Mantegna, the genuine signature of Carpaccio. Although in Hebrew letters wayward and much disguised, I read the possible equivalent of VICTOR SACARPAT.

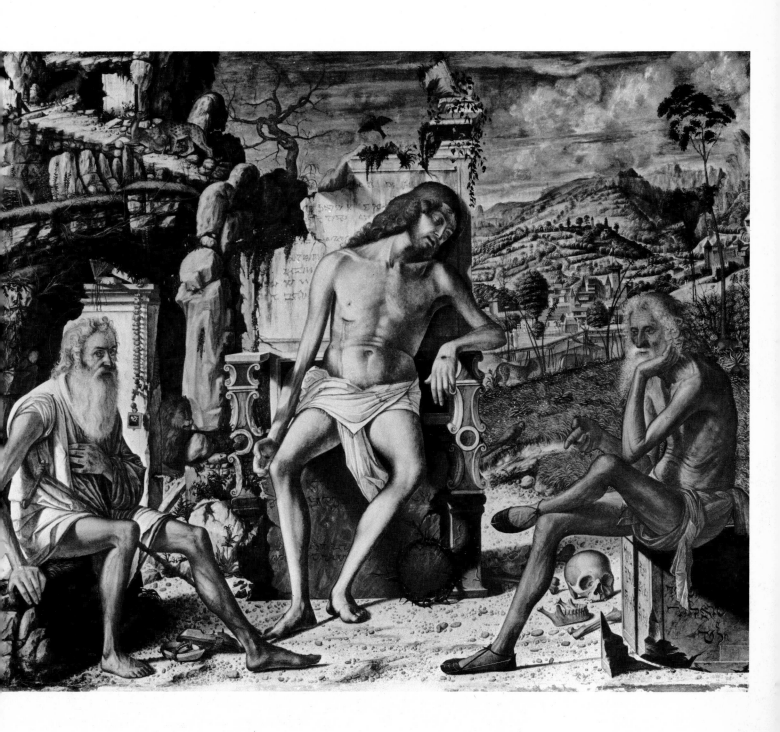

Sacra Conversazione

c. 1485. Isabella Stewart Gardner Museum, Boston.

ANDREA MANTEGNA
Isola di Cartura (Padua), 1431–Mantua, 1506.
Brought up in the workshop of his adoptive father, Squarcione. Influenced by his future
father-in-law, Jacopo Bellini, and even more powerfully by Donatello, and Pizzolo, during a
probable first apprentice-ship. Impressed probably by Uccello, Castagno and Fra Filippo Lippi.

Venetian Painting in America. The Fifteenth Century.
Frederic Fairchild Sherman, New York, 1916.

It is a singular, elaborate, rather puzzling work, highly finished — over finished, even — touched up in the high lights with silver, executed for his Gonzaga patrons. One is tempted to fancy that the painter contrived it deliberately as an epitome of his entire career up to that point; and doubtless it pleased them, for it remained with them until it was acquired by that exquisite dilettante, Charles I....

On a level space, overshadowed by two cliffs which frame in a hillside with a town nestling under the sky line, the Blessed Virgin is seen in the midst of six other holy women, all sitting low or on the ground. The Holy Child, resembling an infant Apollo, stands against His Mother's [left] knee and addresses Himself to the Infant Baptist. The elderly woman next to Our Lady is probably St. Elizabeth, but I have no clue to the identity of the others, or to their function in the symbolical or allegorical economy of the picture. Nor is it our concern. It can not be too firmly maintained that a work of art can pretend, as a work of art, to no meaning, broadly human or narrowly artistic, beyond what is spontaneously suggested to the cultivated mind.... It is enough to see what Venetian art lovers, at the highest moment of Venetian art, called a *"Sacra Conversazione,"* that is to say, a social gathering of holy persons. These ladies have come together to adore, to worship, to meditate and to pray. To my recollection, this is the first instance of a motive destined to acquire so wide a vogue a generation or two later.... It is possible that in a court, whose first lady, when Mantegna arrived there, was a Brandenburg Princess, such a favourite subject of German art as "Die Heilige Sippe" — the Holy Family in the most comprehensive sense — was known and liked, and that Andrea took his cue from a German painting of this theme, simplifying and classicizing it according to the dictates of his genius.

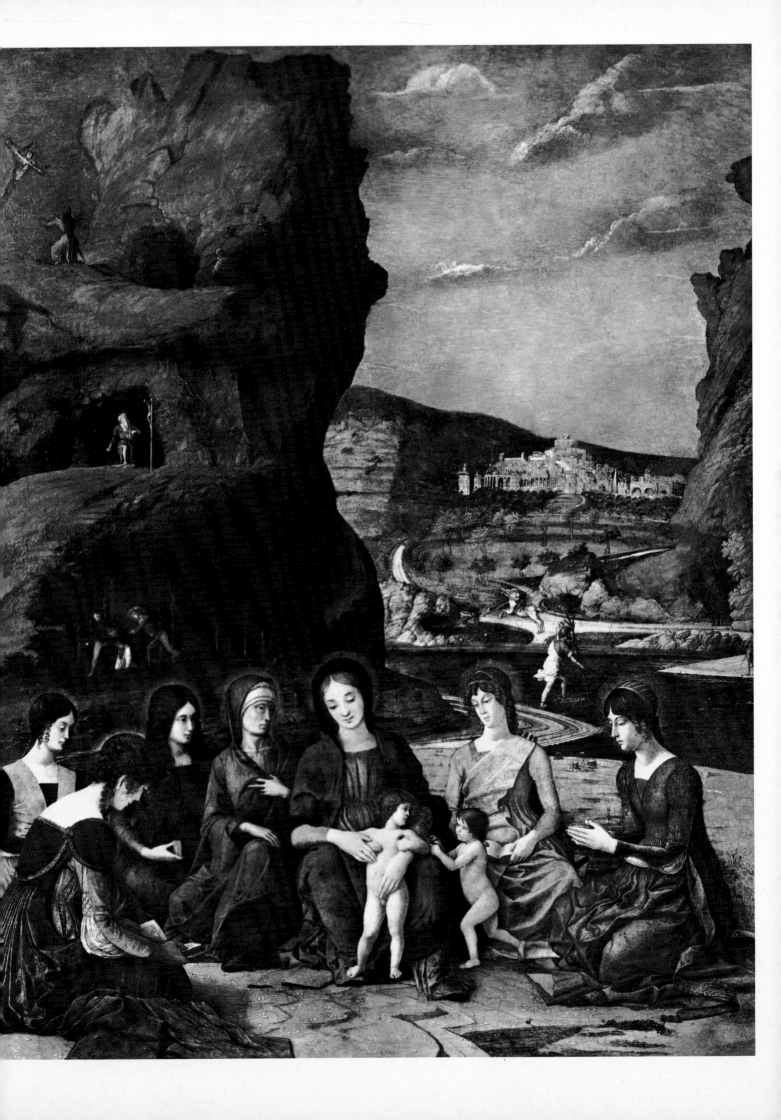

Martyrdom of Saint Christopher

1457. Fresco. Detail. Ovetari Chapel, Church of the Eremitani, Padua.

ANDREA MANTEGNA
Isola di Cartura (Padua), 1431–Mantua, 1506.

"Nine Pictures in Search of an Attribution." 1924.
Three Essays in Method.
Clarendon Press, Oxford, 1926.

In Venetia there was, from about 1400 at least, a marked tendency towards accentuating the horizontal in every kind of composition, but especially in architecture. The vertical is only tolerated on condition that, if it projects above the sky-line, it should serve to accentuate and embellish the horizontality of that line. The diagonal must be avoided at all costs. It is never to be put up with except symmetrically, as in a flattened pediment, or, as the all but vertical side of an obelisk. It must never sprawl indecorously, like a ballet-dancer kicking out with her toes, nor must it appear even as mere asymmetry, like the roof-lines of the Gothic tradition.

The tendency just defined will have been recognized, despite the inadequacy of the description, as the universally classical one, from the earliest architecture of Egypt and Babylon down to ourselves, their direct cultural descendants. Venetia simply anticipated this return to classicism after the medieval interruption, by two or more generations.... Mantegna not only took up with these tastes, but purified them from the excrescences and childish absurdities to which his father-in-law too often gave way.

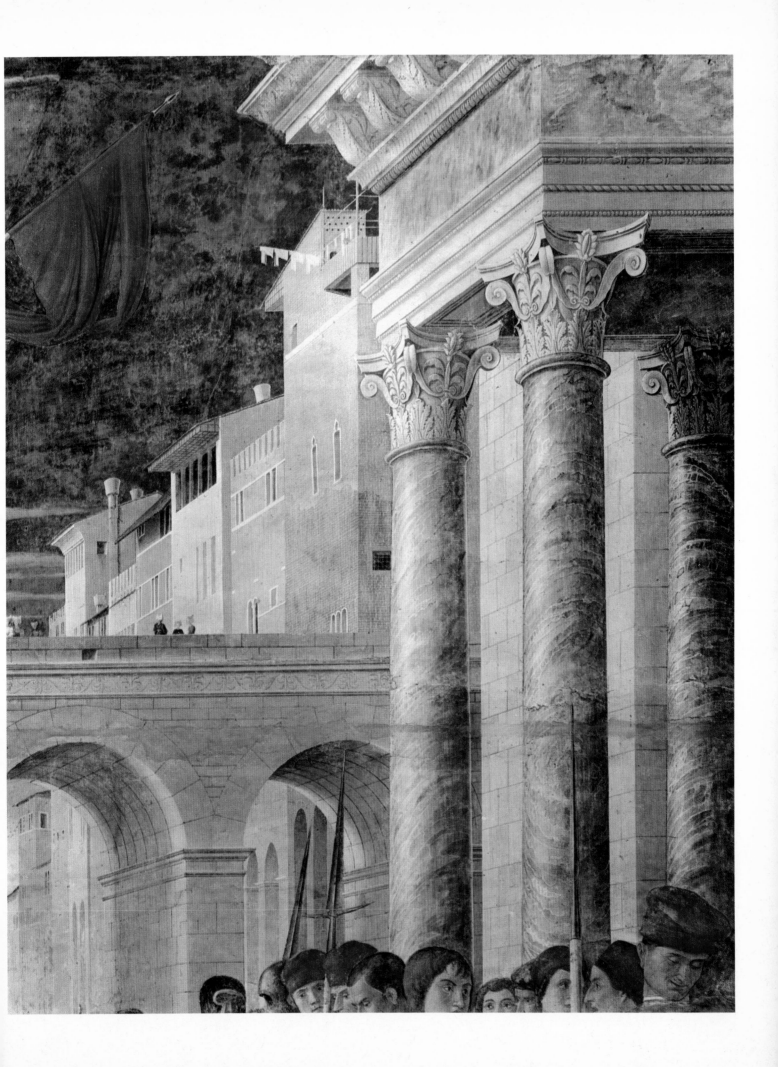

Transfiguration

Between 1470–90. Galleria di Capodimonte, Naples.

GIOVANNI BELLINI
Venice, c. 1430–1516.
Pupil of his father, Jacopo; formed in Padua under the influence of Donatello and of his own brother-in-law, Andrea Mantegna.

Venetian Painting in America. The Fifteenth Century.
Frederic Fairchild Sherman, New York, 1916.

The Naples "Transfiguration," dating from toward the end of this period, presents a scene not only of silent, solemn, subduing feeling such as the subject demands, but one filled with well-managed episodes, and shows unexpectedly a much greater interest than hitherto in cloud and plant. In the "St. Francis" all these tendencies culminate, and never again do we find Bellini revelling, as he does here, in detail, whether it be of twig or leaf, pebble or wattled knot. Directly afterwards, he began to generalize nature, and to subordinate it to those effects of coloured atmosphere which, because of his invention and teaching and example, became the dominant note of Venetian painting for the rest of its history.

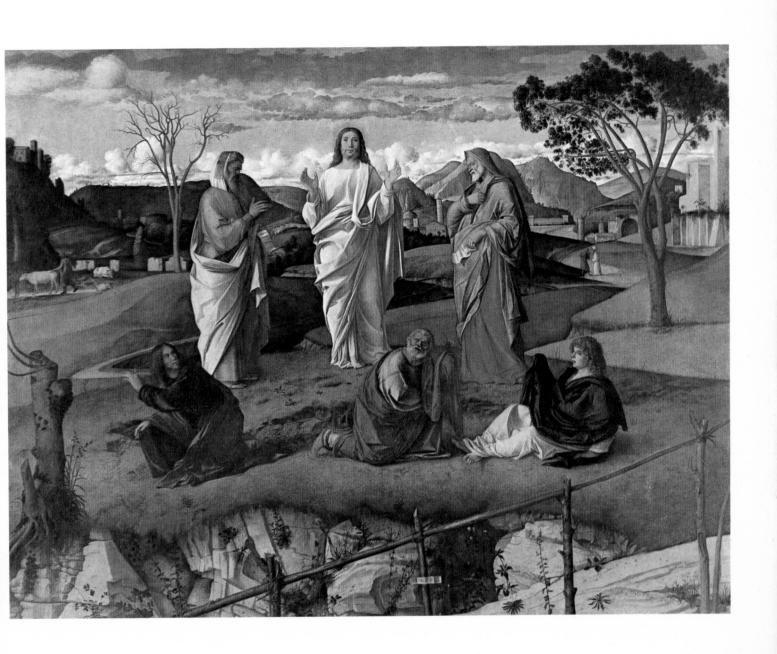

Saint Francis Receiving the Stigmata

c. 1481. The Frick Collection, New York.

GIOVANNI BELLINI
Venice, c. 1430–1516.

Venetian Painting in America. The Fifteenth Century.
Frederic Fairchild Sherman, New York, 1916.

Doubtless Bellini, as well as his patron Messer Zuan Michiel who ordered this picture, meant it to be a landscape, but European man had not yet made sufficient advance toward nature to compose a landscape without some pretext of a religious, legendary, or at least romantic subject. The white man's world was still man-centered. The pretext here was St. Francis receiving the Stigmata. It is not unusual in Venetian Painting for Francis to stand rather than kneel while receiving the Stigmata, and it does not surprise us that Bellini conceives him as an ascetic, but at the same time virile and intellectual personality. But how different it all is from the Florentine or even the Sienese treatment of the subject! Here there is no passive ecstasy and no horrid wilderness, but a free man communing with his Ideal, and in surroundings completely humanized, humanized to the point of a certain noble homeliness. The Saint need not retire to the wilderness to find His God. He can find Him close to the haunts of men. . . .

From his earliest years as an independent artist, Giovanni Bellini betrays in his landscape a most unusual delight in quiet, sober forms which he had taken straight from nature and recombined for his purposes under a unifying light tending to produce the emotion he wished to stir. . . . Just because of its fidelity to the ordinary aspects and moods of nature this scene is not only transporting but convincing. Now it is fairly easy to be transporting, and one can with gifts and effort be convincing. To be both requires genius.

Bellini's interest in landscape seems to have intensified as well as expanded more and more as he found himself, and particularly during that most formative decade of his career, the years between 1470 and 1480.

246

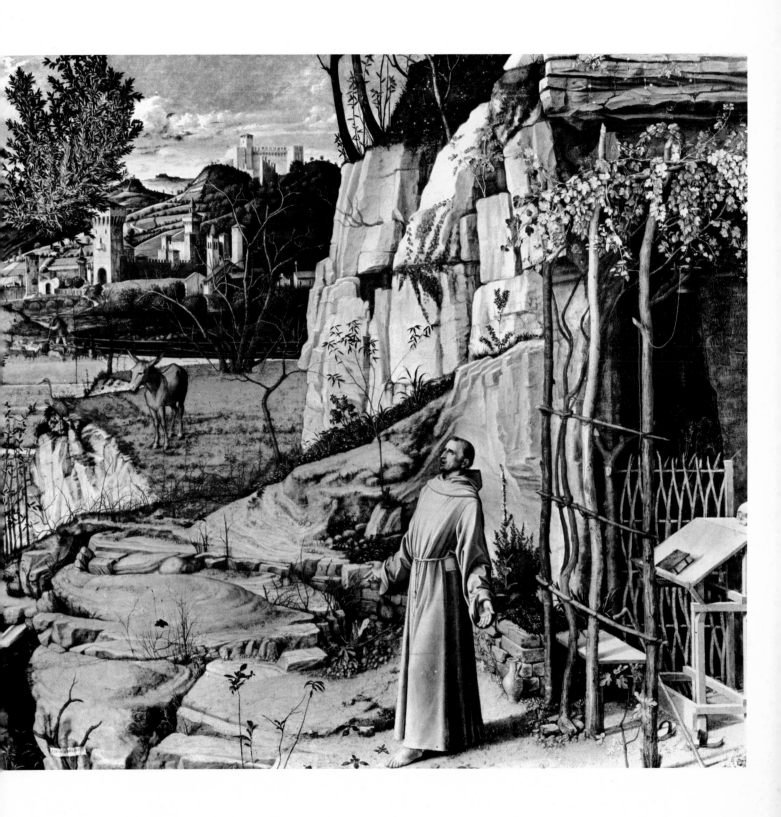

Saint Sebastian

Gemäldegalerie, Dresden.

ANTONELLO DA MESSINA
Messina, c. 1430–1479.
Formed under the influence of Catalan and Flemish contemporaries, particularly Petrus Christus;
he had contact with Domenico Gaggini and Francesco Laurana, and matured in Venice, where
he was mentioned 1475–76.

Letter to Mary Berenson.
Dresden, September 3rd, 1922.

The Antonello and the Vermeer... satisfy one's hunger for seeing in three
dimensions in a way that almost no other painters do at all, excepting always
Piero, and Antonello more even than Vermeer. The Saint Sebastian yesterday
seemed the one entirely complete reconstruction of space in existence. In the
same hall... there are the Giorgione, and Titian, and Palma, and the great
Cossa, but it was hard to look at any of them, so absorbing was the Antonello.
Piero beats him at volume, but he [beats] Piero at space. Vermeer alone can
place objects in their places as well as Antonello, although I doubt whether he
sees as completely in the round. The way you see round and round the Sebastian,
the way the Sebastian's arm invites you to glide around it, are simply unique.

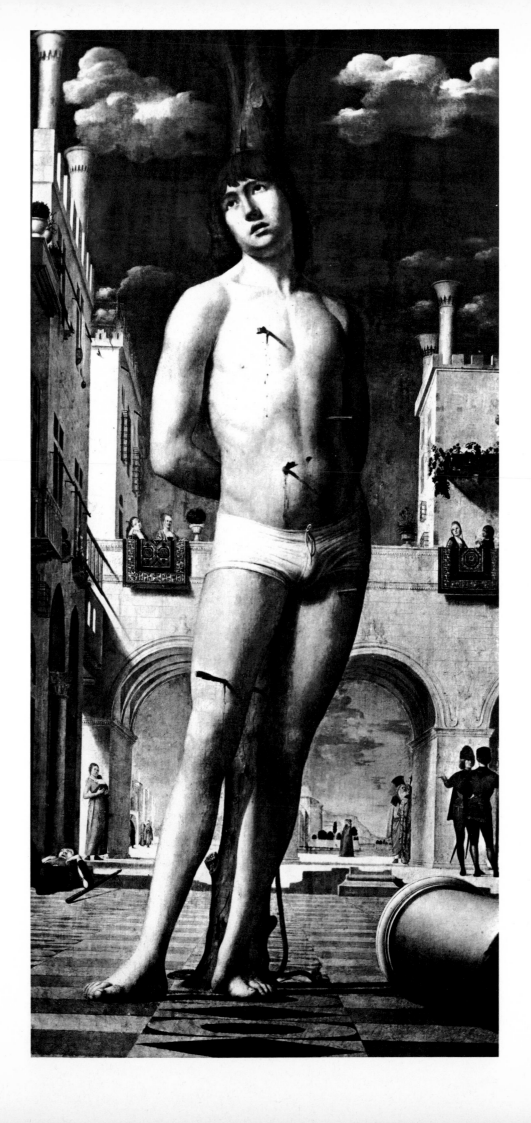

Crucifixion

Signed and dated 1475. Musée Royal des Beaux-Arts, Antwerp.

ANTONELLO DA MESSINA
Messina, c. 1430–1479.

Venetian Painting in America. The Fifteenth Century.
Frederic Fairchild Sherman, New York, 1916.

Antonello, while great in portraiture, was no less great in composition. Much as we admire his heads, we admire even more such subjects as the Syracuse "Annunciation," the Antwerp "Crucifixion," the Correr *"Pietà"* and the National Gallery "St. Jerome." Like the portraits, they hold the attention by the inexhaustible stimulus of the essential art values, and they add to these, symphonic effects of orchestration, as it were, that relax and repose. . . .

In the first place, Antonello was not an imaginative artist. As was the case with Piero della Francesca and Velasquez, his greatness consisted in presenting objects more directly, more penetratingly, more connectedly and more completely than we could see them for ourselves, and not in making a dramatic or moving arrangement of his vision that might make a further appeal to our emotions. He was more bent upon extracting the corporeal than the spiritual significance of things, and while he at times, and not very successfully (as in the "Ecce Homo" at Piacenza, and the other in Baron Schickler's Collection [New York, Metropolitan Museum]), attempted to portray the emotion of others, he invariably refrained from conveying his own or trying directly to affect ours. Call to mind his Antwerp "Crucifixion." The crucified figures to right and left, although suggested by Franco-Flemish models intended to evoke a strong emotional response, have in his hands become the occasion for the painting of firm, supple, youthful nudes in attitudes singularly suited to display tactile values and movement. The Mother of Our Lord and the Beloved Disciple appeal for no sympathy in their grief. . . . The landscape does not transport us, but rather, like all objective works of art, unobtrusively draws us into itself.

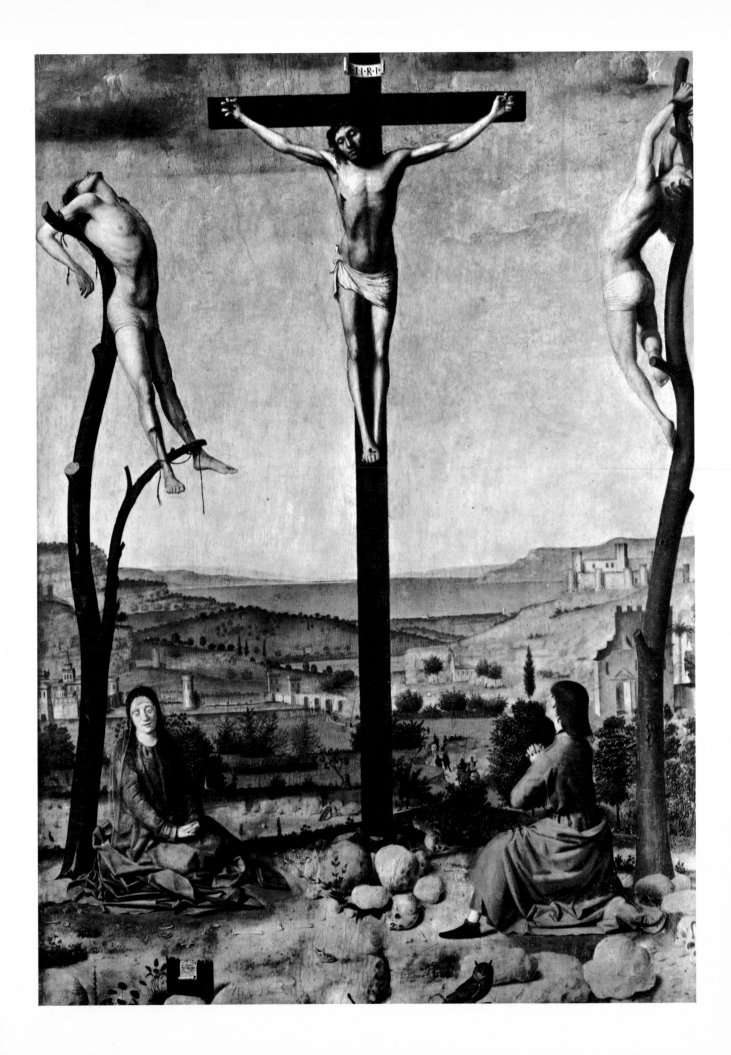

Bust of a Young Man

The Metropolitan Museum of Art, New York. Altman Bequest.

ANTONELLO DA MESSINA
Messina, c. 1430–1479.

Venetian Painting in America. The Fifteenth Century.
Frederic Fairchild Sherman, New York, 1916.

The Altman "Portrait"... is of a youth with a Luinesque face and a look and smile saved from being like Luini's by the sobriety and self-restraint of the painter. It is probably only the resistance a pretty face like this opposes to artistic values that accounts for the slight inferiority of this painting to Mr. Johnson's picture....

The likeness in contour and plastic treatment to the Johnson "Head" need not be insisted on. From all these indications, we can be fairly certain that the Altman "Portrait" dates from Antonello's maturest period. We get further support for this view from the closer resemblance in the hair to the so-called "Humanist" of the Milan Castello (certainly a late picture) than to any other of Antonello's portraits, as well as from the curious Luinesque aspect of the sitter. Is it too fanciful to suppose that this pretty type of face really existed in the Milan of that time, before Leonardo went there, and before Luini was born? If the youth were Milanese, then we could assume that he sat for Antonello during the artist's sojourn in Milan in 1476.

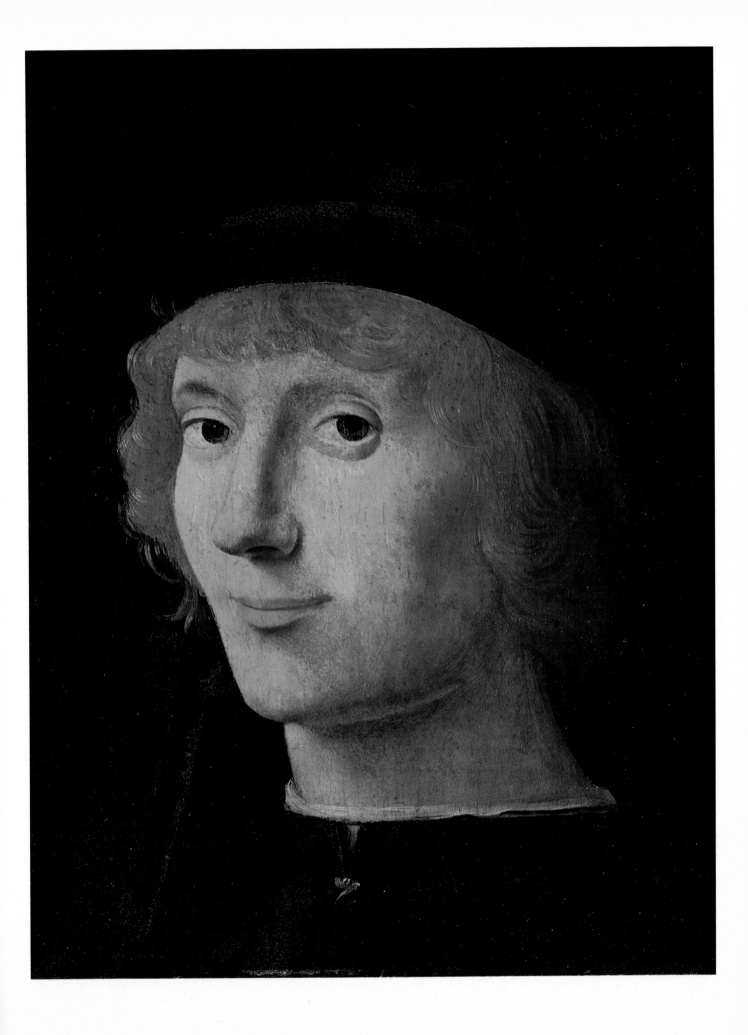

Saint Jerome in the Wilderness

Signed. National Gallery of Art, Washington, D. C. Kress Collection.

CIMA DA CONEGLIANO
Conegliano, c. 1459–c. 1517.
Pupil probably of Alvise Vivarini, but formed under Antonello and Bellini, and later influenced by Giorgione.

Venetian Painting in America. The Fifteenth Century.
Frederic Fairchild Sherman, New York, 1916.

After Giovanni Bellini and Carpaccio and before Giorgione, the best beloved painter of Venice remains Cima da Conegliano. No wonder, for no other master of that time paints so well the pearly hazes that model the Italian landscape with a peculiar lightness and breadth. He calls up memories of hours spent among the foothills of Alps and Apennines, cool and covered with violet grey mist. His castles, his streams and his foliage have the same gift of recalling and even communicating pleasant states of body and mind. His figures are severe and chaste but seldom morose, and occasionally they have quivering nostrils and mouths of surprising sensitiveness

So much for Cima's character as an illustrator. Judged by the requirements of decoration, he stands only under Bellini. He is a draughtsman of strenuous and exquisite precision, with a sense of line scarcely surpassed in Venice. His colouring is transparent, cool, pearly, and nevertheless seldom if ever cold or harsh. . . . Yet he has neither the abandon of a Carpaccio nor the intimacy of a Giovanni Bellini. He remains more external, more schematic, as if he constructed rather than created his figures; and in this, as in certain other respects, resembles Mantegna.

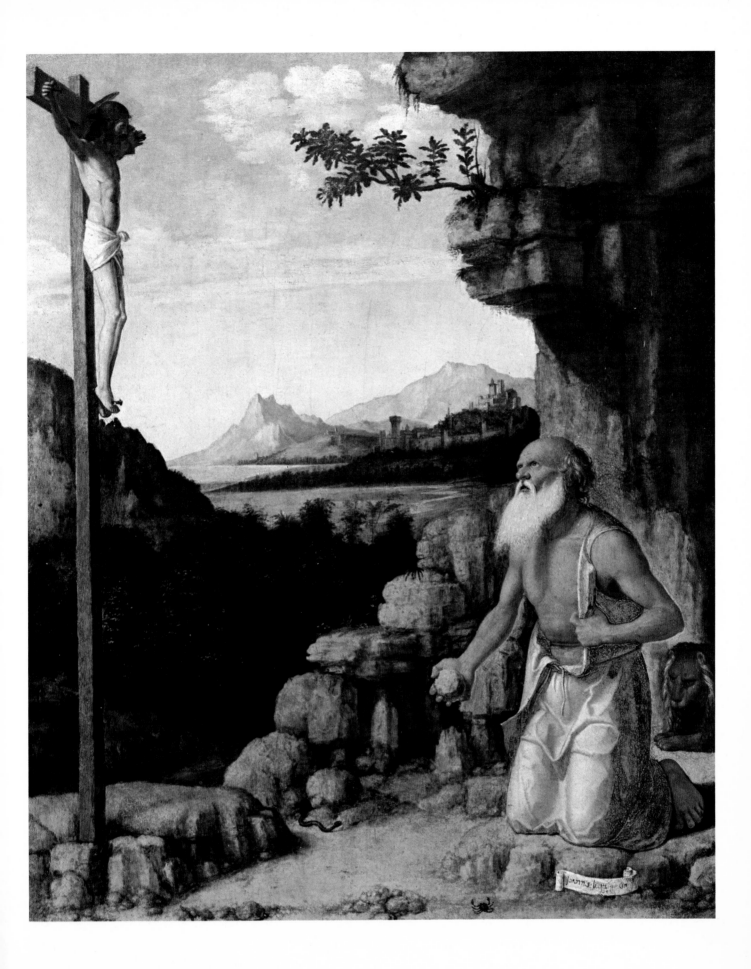

Madonna under Trellis between
Saints James and Jerome
Signed and dated 1489. Museo Civico, Vicenza.

CIMA DA CONEGLIANO
Conegliano, c. 1459–1517.

Venetian Painting in America. The Fifteenth Century.
Frederic Fairchild Sherman, New York, 1916.

His earliest dated work, the altarpiece of 1489 at Vicenza, reveals, as is scarcely the case with the earliest work of any other master, the talent, the character and the quality of a whole career. It is true that he was about thirty at the time, but then we have no painting more youthful by any other of the great Quattrocento Venetians. Quite likely none of the extant panels by Giovanni Bellini were designed before he was thirty, but what a gulf between them and his masterpieces of about 1487; whereas the differences between the Cima of 1489 and the Cima of the last important picture, the Brera "St. Peter" of 1516, are relatively slight, altho' the same number of years had elapsed.

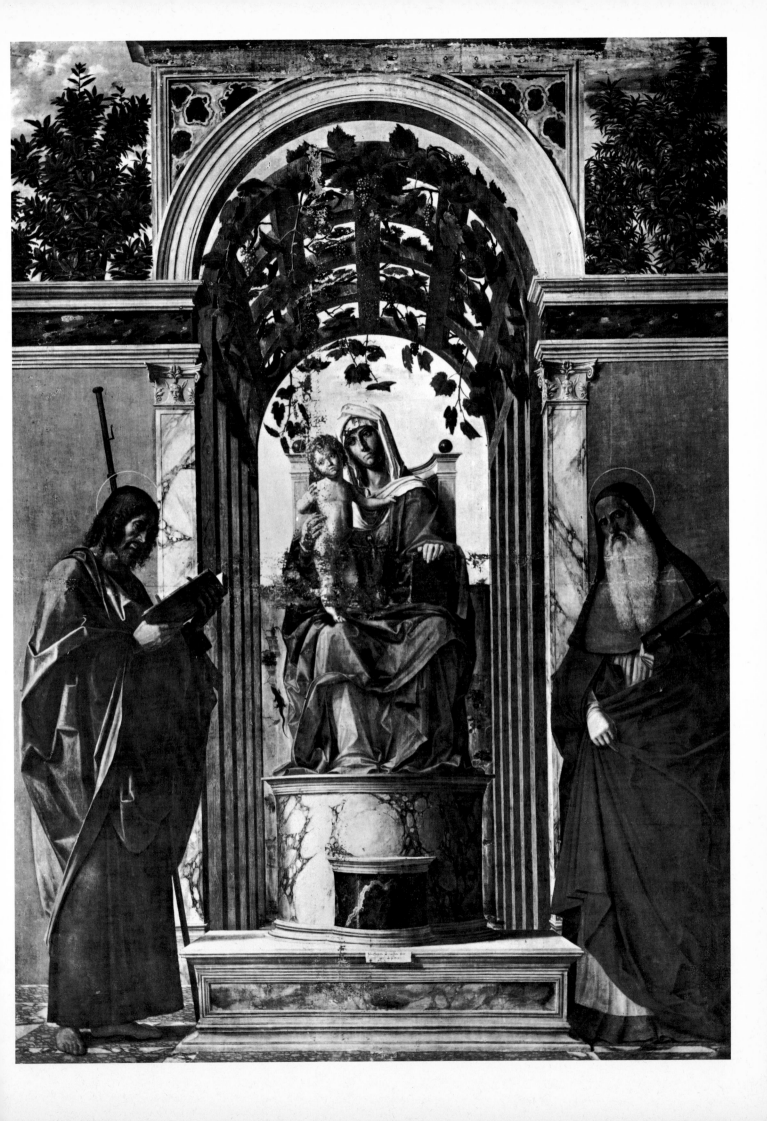

A Lady of Rank as Saint Giustina of Padua

c. 1504–6. The Metropolitan Museum of Art, New York. Altman Bequest.

BARTOLOMMEO MONTAGNA
Orzinuovi (Brescia), c. 1450–Vicenza, 1523.
Pupil perhaps of Domenico Morone or Benaglio at Verona; formed by Giovanni Bellini, strongly influenced by Antonello da Messina and somewhat by Alvise Vivarini, Bellano and Carpaccio.

Venetian Painting in America. The Fifteenth Century.
Frederic Fairchild Sherman, New York, 1916.

The more interesting of his two portraits in American possession is the one of a lady represented as St. Giustina of Padua with a dagger in her breast, in the Altman Bequest of the Metropolitan Museum. In the Hainauer Collection whence it came it was ascribed to Lorenzo Costa, but I do not fear that my attribution to Montagna will be disputed. . . . The costume and hair are of the first decade of the XVIth Century, but I am inclined to think not quite Venetian. Now everything in this panel connects it with Montagna's paintings at Verona of 1504–1506, and I suspect we shall not be far out if we assume that it was painted there during those years.

It was not uncommon to let one's self be portrayed under the guise of some saintly person. Here, however, the disguise was merely perfunctory and superficial, for the elaboration of the costume and hair and the jewels contradict the knife and the palm. Those of us, however, who are intimately acquainted with Montagna's types from toward 1500 for some six or seven years, may well ask what, after deducting all that is specifically characteristic of him, remains of the sitter. But if that question were asked before every portrait, modern as well as ancient, surprisingly few would leave more of a residue of objectivity than this.

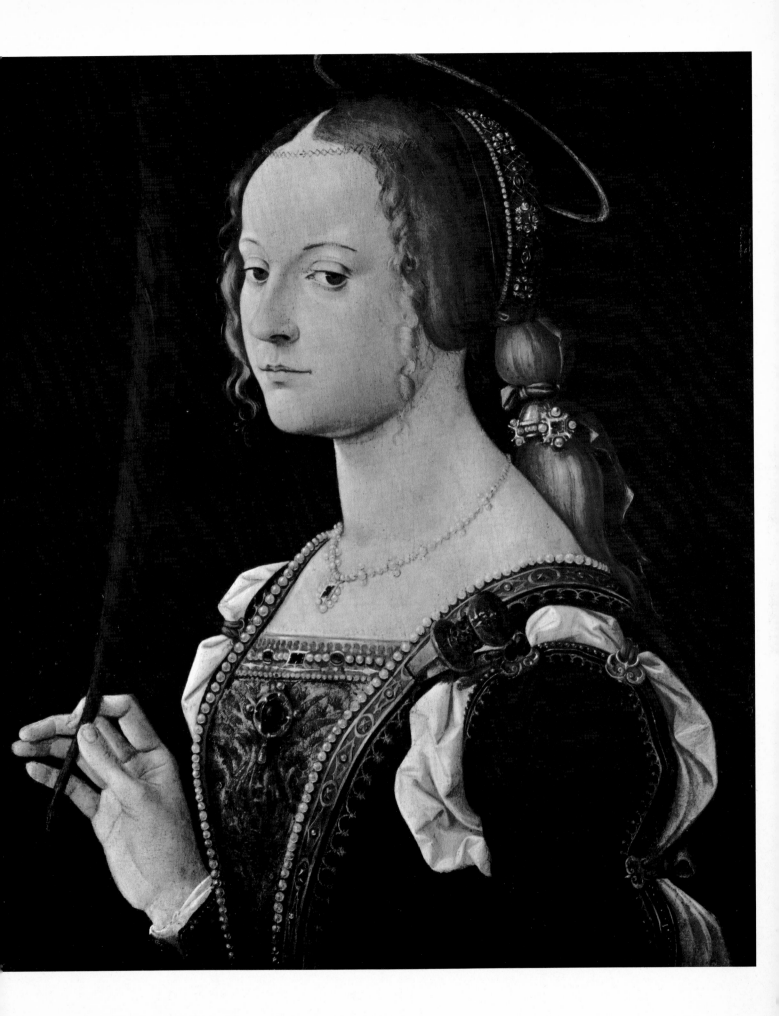

Gipsy and Soldier: "La Tempesta"

Detail. Accademia, Venice.

GIORGIONE
Castelfranco, c. 1477–Venice, 1510.
Pupil of Giovanni Bellini.

"Notes on Giorgione." 1954.
Essays in Appreciation.
Chapman & Hall, London, 1958.

The attribution to Giorgione of the Old Woman with the words "Col Tempo" is now beyond need of proof. It would be enough to place it side by side with the Gipsy of the *Tempesta* for the trained eye to see that they were by the same artist.

I should like to say a few words of another kind about the two. It is my belief that they were painted at about the same time, as indeed is manifested by the identical folds of kerchief and tunic in both. I would go further and fancy that the artist imagined how the woman who had served as model for the Gipsy would look *col tempo* as an old woman. Nearly the same dome-shaped cranium, nearly the same high forehead, same parting and dropping to sides of the hair, features, eyes, nose, cheeks, chin sufficiently alike. All has undergone a sad change. The brow and cheeks are furrowed and wrinkled, the eyes bleary and gummy, the mouth oozing through broken teeth, the throat leathery, the expression one of physical discomfort, of distress even.

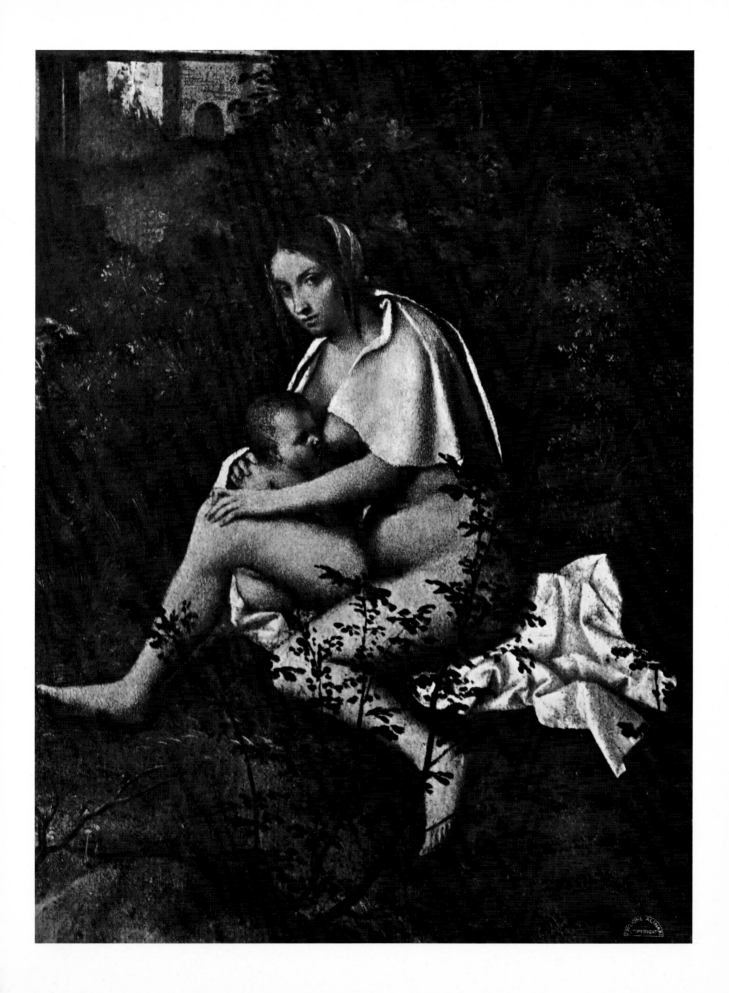

Bust of Old Woman: "Col Tempo"

Accademia, Venice.

GIORGIONE
Castelfranco, c. 1477–Venice, 1510.

"Notes on Giorgione." 1954.
Essays in Appreciation.
Chapman & Hall, London, 1958.

Giorgione was certainly under thirty when he painted this old woman and probably five or six years younger. Even if he had a model for accurate rendering of details, a concept of old age so complete, so convincing, could have been entertained only by a creative imagination of the highest order.

I feel tempted to let my fancy run free, and to weave the plot of a romance around these two pictures, the *Soldier and Gipsy* or *Tempesta* and the *Old Woman "Col Tempo."* The soldier would be the young Giorgione himself looking on while the somewhat more mature woman was giving suck to his and her child. She may be suffering a revulsion of feeling against him for having brought her to this pass, and he painted her as she would look when old, as an admonition to gather roses while she might for time was aflying.

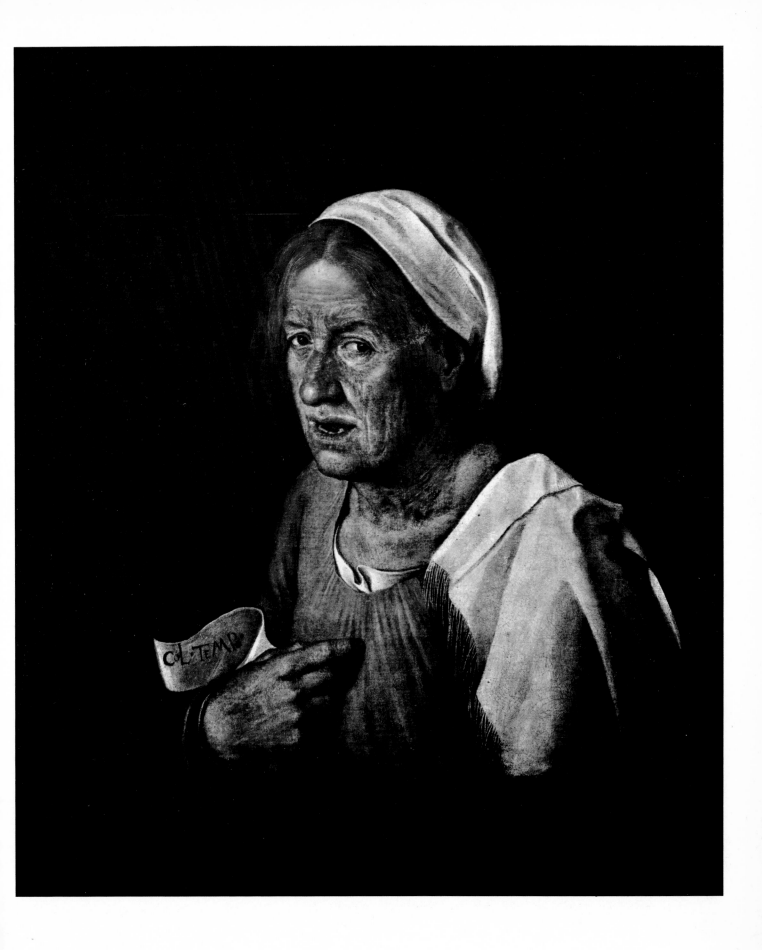

Bust of a Courtesan

Städelsches Institut, Frankfurt.

BARTOLOMMEO VENETO
Cremonese-Venetian, active 1502–after 1530.
Pupil of the Bellini along with Previtali, Francesco di Simone da Santacroce and other
Bergamasks; influenced by the Giorgionesques, Lotto, Solario and Boltraffio.

Venetian Painting in America. The Fifteenth Century.
Frederic Fairchild Sherman, New York, 1916.

It is, however, as a painter of portrait heads, or what amounts to that, even when a wheel or some other label of apotheosis is attached, that Bartolommeo Veneto is of interest to us. If we may draw inferences from the dress and the character of his sitters, he must have worked chiefly in Lombardy, and to some degree under Lombard influence.... Bartolommeo was much given to painting fancy heads to which, by means simple enough, generally by the arrangement of the hair and the costume, or by some look, he gives, when the effect is successful, an air of fascination. The successes are rare, the best of them being the enchanting "Bust of a Courtesan" at Frankfort.

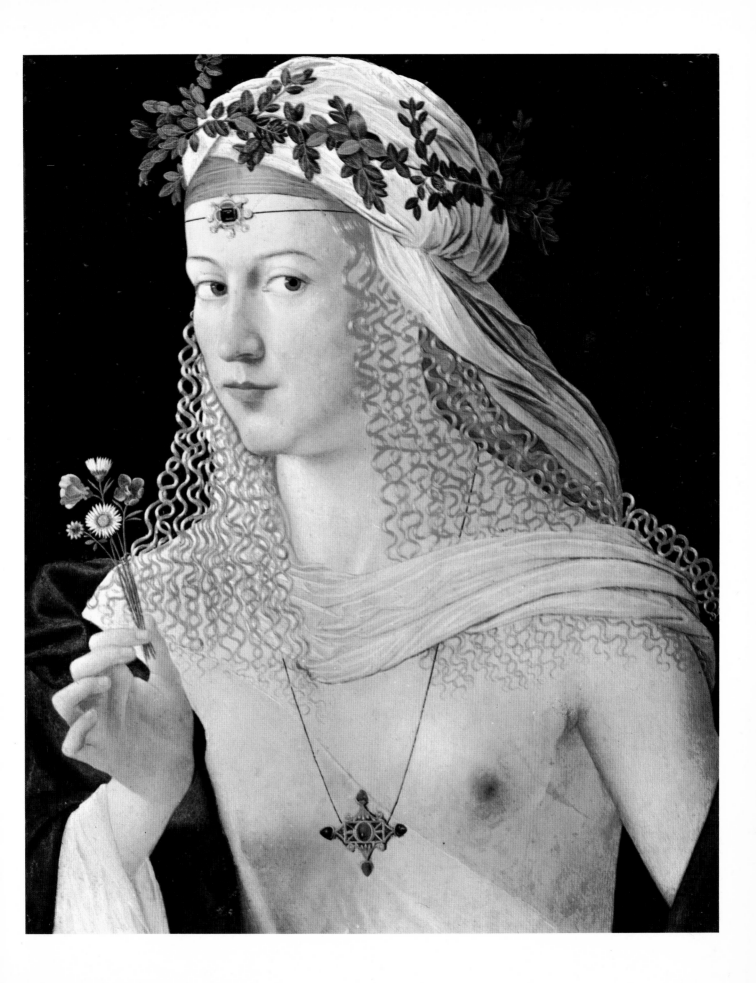

Portrait of a Young Lady

Museum of Art, El Paso. Kress Collection.

VINCENZO CATENA
Venice, active c. 1480–1531.
Pupil perhaps of Cima; strongly influenced by Giovanni Bellini, and Giorgione,
and somewhat by Raphael.

"The Venetian Painters." 1894.
The Italian Painters of the Renaissance.
Phaidon Press, London, 1952.

Early in the sixteenth century, when people began to want pictures in their own homes as well as in their public halls, personal and religious motives combined to dictate the choice of subjects . . . and the portrait crept in half hidden under the mantle of a patron saint. Its position once secure, however, the portrait took no time to cast off all tutelage, and to declare itself one of the most attractive subjects possible. Over and above the obvious satisfaction afforded by a likeness, the portrait had to give pleasure to the eye, and to produce those agreeable moods which were expected from all other paintings in Giorgione's time. . . . Giorgione and his immediate followers painted men and women whose very look leads one to think of sympathetic friends, people whose features are pleasantly rounded, whose raiment seems soft to touch, whose surroundings call up the memory of sweet landscapes and refreshing breezes. In fact, in these portraits the least apparent object was the likeness, the real purpose being to please the eye and to turn the mind toward pleasant themes. This no doubt helps to account for the great popularity of portraits in Venice during the sixteenth century.

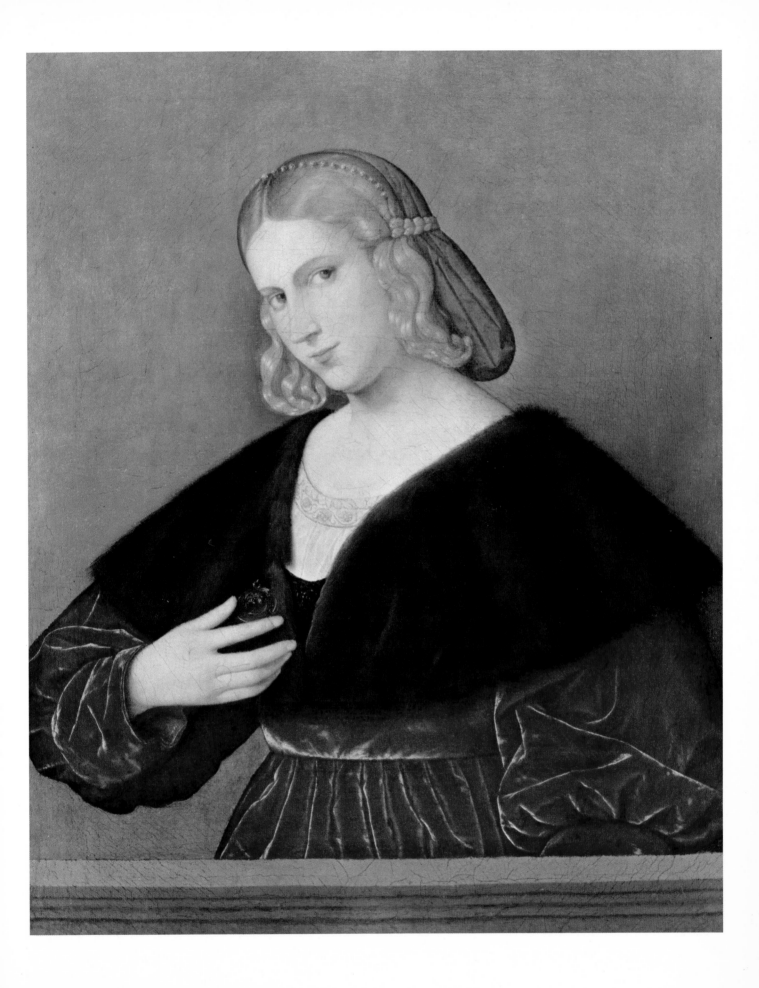

Portrait of Doge Andrea Gritti

c. 1517. The Metropolitan Museum of Art, New York. Davis Bequest.

VINCENZO CATENA
Venice, active c. 1480–1531.

Venetian Painting in America. The Fifteenth Century.
Frederic Fairchild Sherman, New York, 1916.

Perhaps as late as 1517, our author may have designed one of his grandest portraits, the "Bust of a Venetian," in the collection of the late Mr. Theodore M. Davis of Newport, Rhode Island.

It is the presentation of a vigorous personality, powerful both physically and morally, direct and energetic — as a nature and as a character. If Catena could portray in this fashion — and it is certain that he could — we understand better than ever why his contemporaries admired him, appreciating, no doubt, effects of design so bold and large obtained by means so simple and with the least possible abuse of chiaroscuro.

A problem is raised by the question as to the identity of the person represented. For many years I have taken it for granted that he was Andrea Gritti, and I still can not help thinking that it must be he. The difficulty is that in 1517, which is about the date I would assign to the portrait on internal evidence, Gritti, not yet Doge, was in his sixty-second year. We should scarcely give that age to the head before us. On the other hand we must bear in mind that Gritti lived to be eighty-four and may have been unusually well preserved. It is hard to believe, however, that he could have been as well preserved as this, and one of two conclusions follows. Either the portrait is not of Gritti, which I should find it disagreeable to admit, or it was done after a likeness representing him at an earlier age.

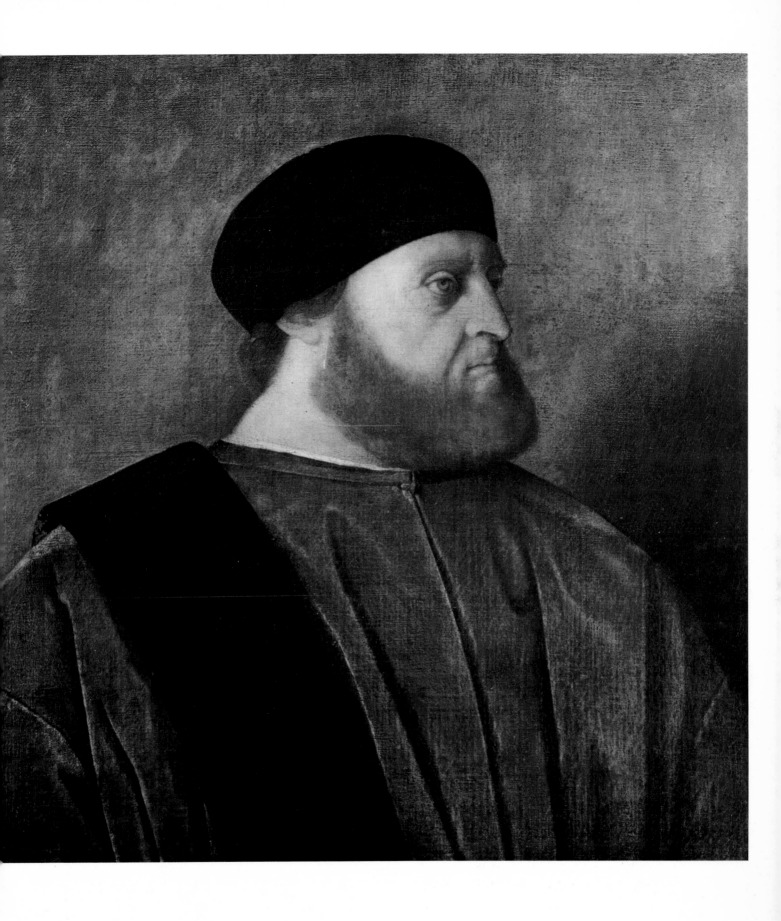

Noli me Tangere

Dated 1517. Fresco. Chapel, Santa Maria Maddalena Convent, Caldine (Florence).

FRA BARTOLOMMEO
Florence, 1475–1517.
Pupil of Cosimo Rosselli and Piero di Cosimo; collaborated with Albertinelli. Influenced by Leonardo and Michelangelo; and, after a trip to Venice in 1508, by Bellini and Giorgione.

Letter to Mary Costelloe.
Florence, December 17th, 1890.

Fra Bartolommeo is already a person of another generation. Although he entered as a child the workshop of Cosimo Rosselli the influence that one sees in him was already of Piero di Cosimo to begin with, of Filippino just a trifle, of Leonardo, and Raphael, and of Michelangelo. The list of names almost sounds as if Fra Bartolommeo could have had nothing in himself. This is not at all true. His style is very distinct, his ideal of beauty extremely personal, and his qualities as a draughtsman and painter are of the best. I love his landscapes particularly. He takes up Piero di Cosimo's and makes them finer, hazier, so that often you can't tell where sky and horizon meet. But toward the end of his short life he was seized by a passion for doing big, and from that period the Florentine galleries have saints and apostles of a Herculean sort, full of bravura, and more impressive than delightful. He had in turn an influence on Raphael, and still greater on Andrea del Sarto.

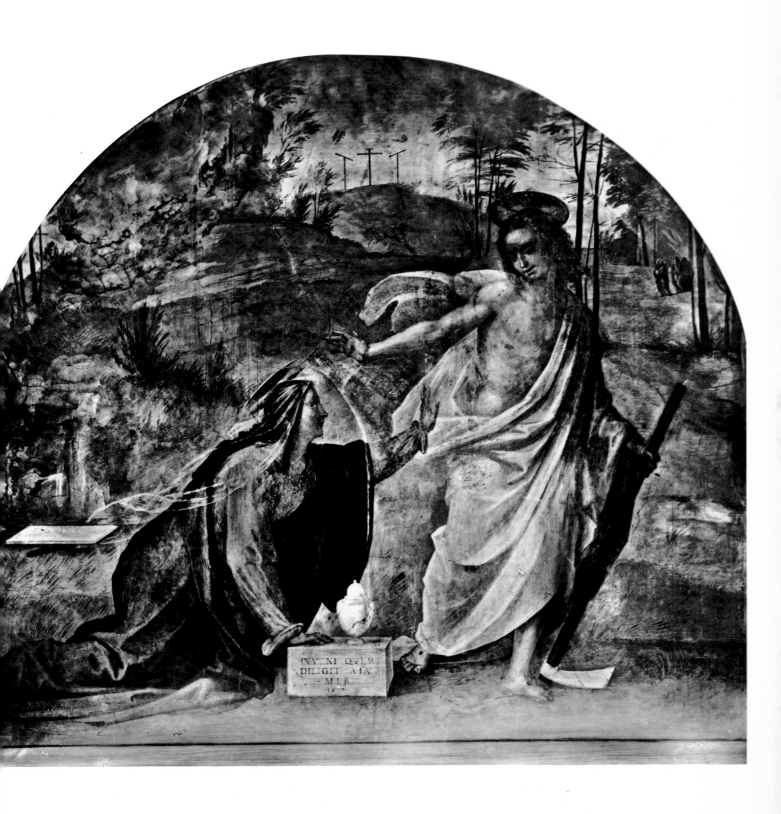

Pietà

c. 1517. Museo Civico, Viterbo.

SEBASTIANO DEL PIOMBO
Venice, c. 1485–Rome, 1547.
Pupil of Giovanni Bellini, Cima, and Giorgione; influenced later by Michelangelo.

The Drawings of the Florentine Painters.
University of Chicago Press, Amplified Edition, Volume I, 1938.

This easy-going, pictorially minded, sensuous Venetian tried to put on the armour and wield the weapons of a Michelangelo, to convert his flickering, shallow, sparkling vision into the firmly fixed, inexorably outlined mighty images of the most abstract of all artist-seers! What violence he must have done to his nature, what battles must have been waged between temperament and purpose!...

[It is in] the sublime masterpiece at Viterbo where, if at all, the project has been realized of combining Florentine grandeur of design with the glamour of Venetian colour. How much there is in this painting of Michelangelo we see in the reposeful figure of the Saviour, and in the action and even in the type of the Madonna. Yet, as we could have inferred from our study of the sketches for the Raising of Lazarus, and as indeed we know from the correspondence that passed between Michelangelo and Sebastiano, it was not the latter's intention merely to colour cartoons prepared by the former. All that he seems to have wanted was a general scheme followed by more or less guidance and correction while preparing his own cartoons, that is to say, while striving to come as close as he could to Michelangelo without ceasing to be Sebastiano.

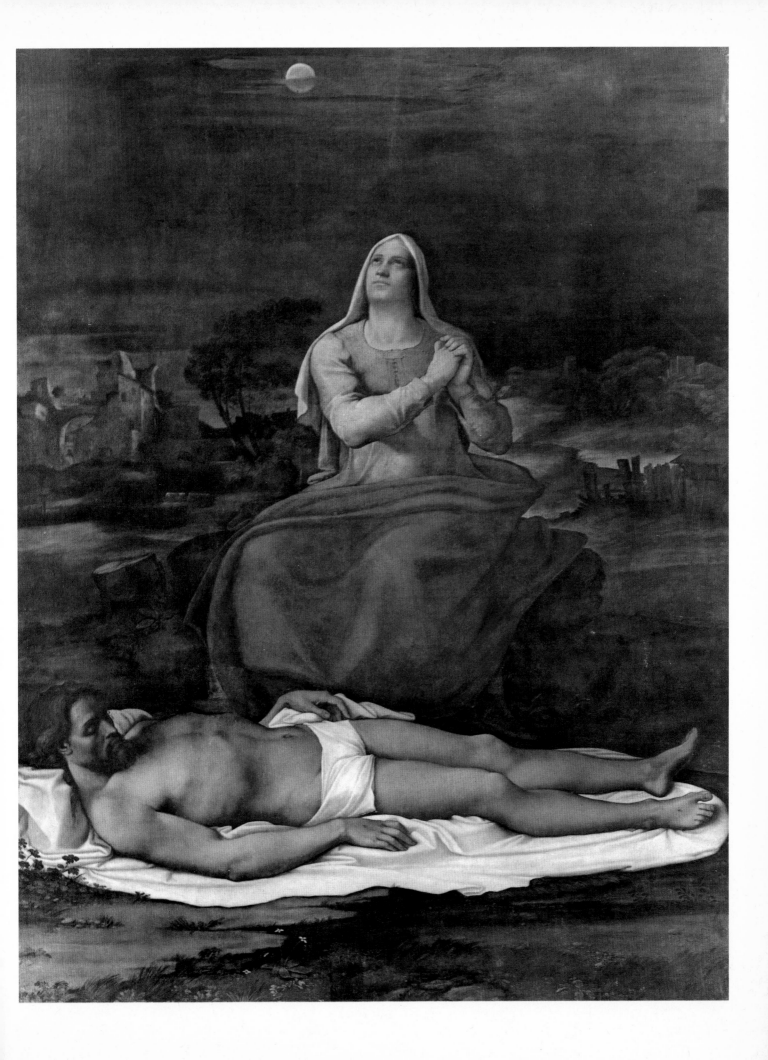

The Battle of the Centaurs and Lapiths:
Death of Cyllarus
Detail. National Gallery, London.

PIERO DI COSIMO
Florence, 1462–1521.
Pupil of Cosimo Rosselli; influenced by Verrocchio, Signorelli, Filippino Lippi and Lorenzo di Credi.

The Drawings of the Florentine Painters.
University of Chicago Press, Amplified Edition, Volume I, 1938.

The real patriarch, however, of the Florentine painters belonging to the so-called Golden Age was not Cosimo Rosselli himself, but his pupil Piero di Cosimo, who seems to have lingered on for a long while in his master's studio as foreman. He was a feebler version of Leonardo on the fanciful side of that many-facetted genius (just as Baldovinetti had been on the side of scientific experiment with vehicles), and we should expect him to have left a large number of designs in which he had noted down his strange and capricious visions. But nothing of the sort remains. Even the book of sketches after various animals which Vasari saw in the collection of Duke Cosimo has disappeared. The few drawings which can still be mustered are studies for portraits, or for sacred subjects or landscapes, and exhibit Piero in no transfiguring light as an artist, nor in any signally imaginative phase, but reveal him as, on the whole, a mediocre draughtsman, and confirm the impression his paintings give, that he was an eager eclectic.

274

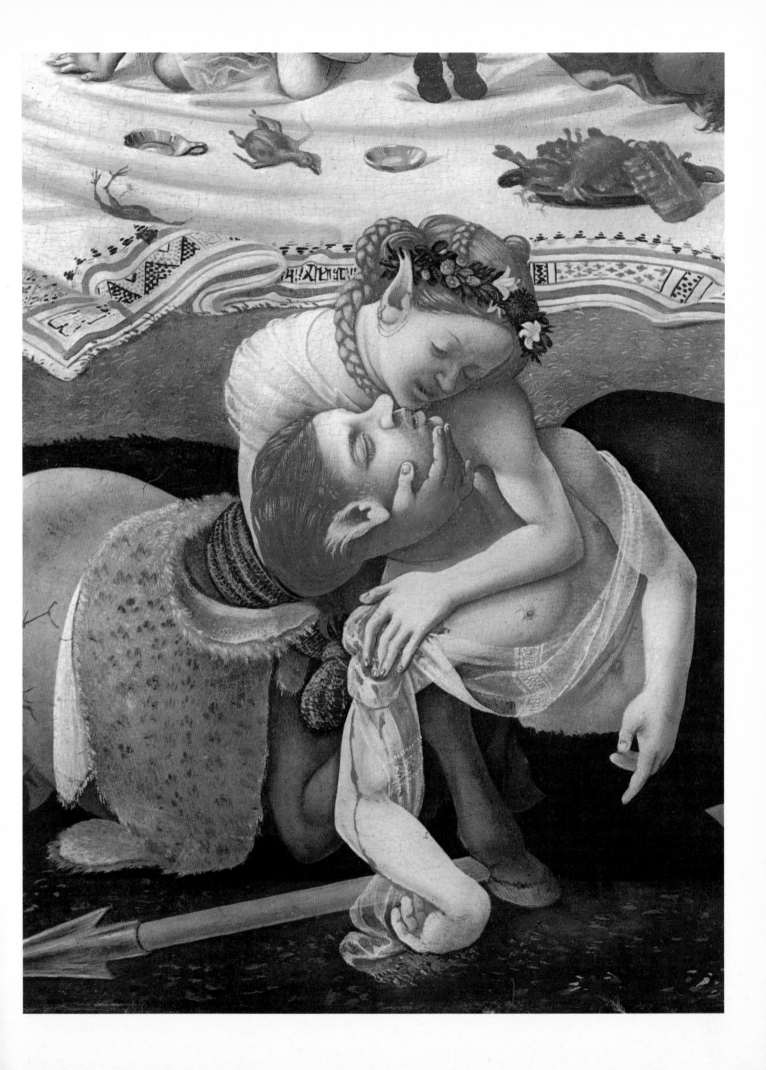

The Immaculate Conception

Galleria degli Uffizi, Florence.

PIERO DI COSIMO
Florence, 1462–1521.

Letter to Mary Costelloe.
Florence, December 4th, 1890.

Piero must have been quite young when he painted the picture in the Innocenti although I believe that he had already painted the "Vierge à la Colombe" of the Louvre, the "Venus and Mars" of Berlin, and the "Cyllarus" of the National Gallery. As he advances, his painting becomes less and less dry, there is softer modelling and increasing skill in the treatment of light and shadows. A few years must have elapsed between the painting of the picture in the Innocenti, and the "Conception of the Virgin" in the Uffizi. The Virgin stands on a pedestal on which is a bas relief representing the Annunciation, curiously suggestive of Fra Bartolommeo. She looks heavenward in joyful ecstasy, her face glorified, and illuminated by the flood of light coming from the dove that hovers over her. To [the] right stands Anthony with eyes lost in a dream of the infinite and Peter. To [the] left you see Phillip Benizzi. Such a healthful person, and a rather over graceful John the Evangelist. The landscape consists of a hazy plain, between two palm-crowned heights. On the one to the left the Virgin is seen adoring the Child, and on the right, Joseph bent in twain is toiling up the path leading the mule that bears the Virgin and Child. They are climbing up to a village of fantastic chalets, identical with the village in one of his two portraits in the Hague. All in all this Conception is one of the great pictures of all schools, and times, but in the Florentines its rival for out and out beauty, and colour would be hard to find.

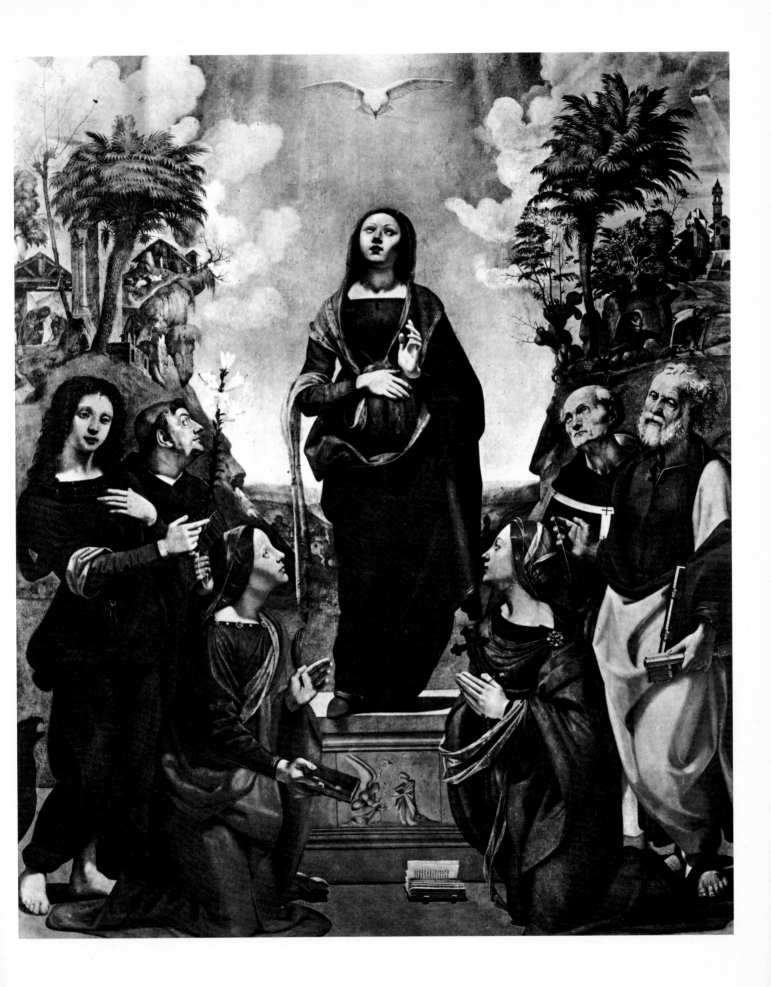

Madonna and Child with Saint Anne

Cartoon. National Gallery, London.

LEONARDO DA VINCI
Vinci, 1452–Amboise, 1519.
Pupil of Verrocchio. Left Florence for Milan in 1482 and returned to Florence only from 1500
to 1507.

The Drawings of the Florentine Painters.
University of Chicago Press, Amplified Edition, Volume I, 1938.

It is more than likely that for every considerable work Leonardo executed a cartoon. Only one remains, the famous one... for the Virgin and St. Anne.... One will scarcely find draped figures conceived in a more plastic fashion, unless one travels back through the centuries to those female figures that once sat together in the pediment of the Parthenon. In Italian art we shall discover nowhere else a modelling at once so firm and so subtle, so delicate and so large as that of the Virgin's head and bust here. We should look in vain, also, for draperies which, while revealing to perfection the form and movement of the parts they cover, are yet treated so unacademically, are yet so much actual clothing that you can think away.

Although we are in the presence of a cartoon as elaborated, for all we know, as any that Leonardo ever executed, we see no such attempts as other Florentines made at high finish for its own sake. The artist treats it as merely preparatory work, as he seems to have treated all the rest of his drawings. The chalks have evidently been used with the greatest rapidity, and for the mere drawing he was contented with little more than the outlines. It was the modelling which chiefly absorbed his attention, and he seems to have carried it as far as his materials would permit, seeking even in the preparatory stages that completely realized relief which caused him to dwell for years upon the painting of a picture.

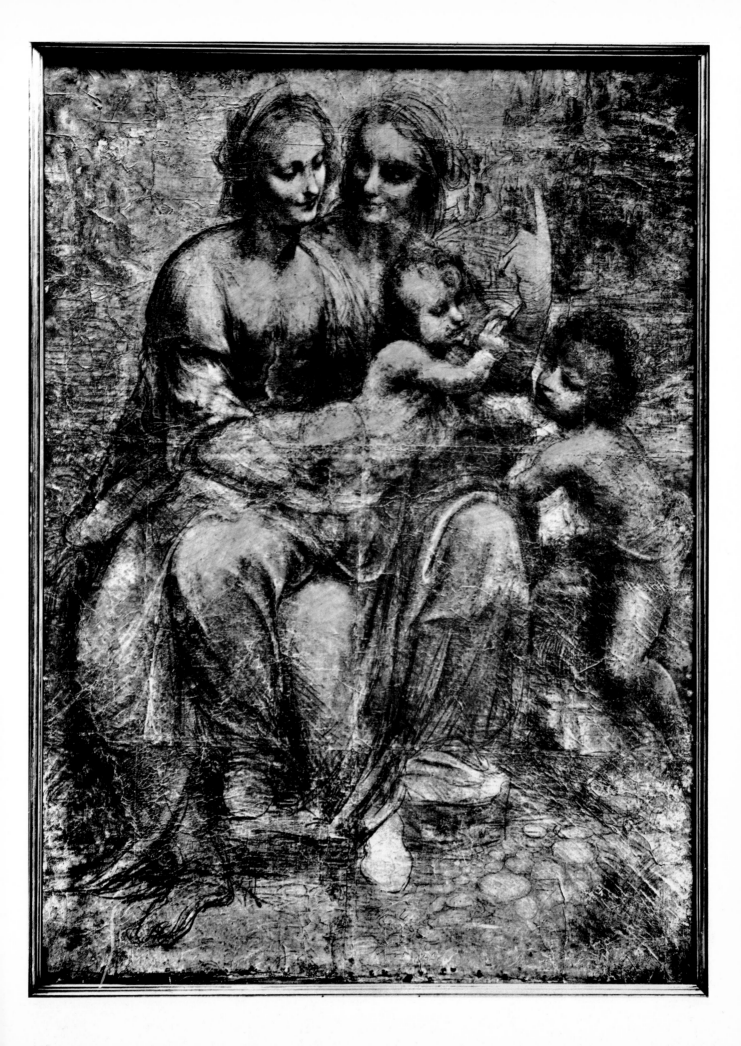

Madonna and Child with Saint Anne

The Louvre, Paris.

LEONARDO DA VINCI
Vinci, 1452–Amboise, 1519.

The Drawings of the Florentine Painters.
University of Chicago Press, Amplified Edition, Volume I, 1938.

Why Leonardo deserted this cartoon to engage upon another version of the same subject (on which he was working at Florence in 1501) it would be hard to determine. Certain reasons may, however, be suggested, as, for example, that the first cartoon was lacking in clearness of arrangement, or that the painter was so enamoured of a pyramidal grouping that ultimately he could not remain contented with any other. Symbolism may also have had its part in the change, for, to judge by his writings, no great artist delighted more in allegorical fancy and representation than he. In the Venice Academy there is a sketch... — one of his finest pen-drawings — for the altered version. Here Leonardo was still undecided just how to arrange the heads, and it had not yet occurred to him to make the Virgin bend down in such a way that hers would come under her mother's. What searchings must he not have gone through before he attained to the perfectly proportioned grouping, the exquisite balance of masses, the harmonious rhythm of expression rippling from face to face, that we admire in the great picture at the Louvre!...

His triumph is that despite the realism, and despite the greater homeliness, he none the less makes the figures exist for us, under their relatively modern garb, as much as any of Giotto's or Masaccio's majestic apparitions — more, perhaps, than any of Michelangelo's.

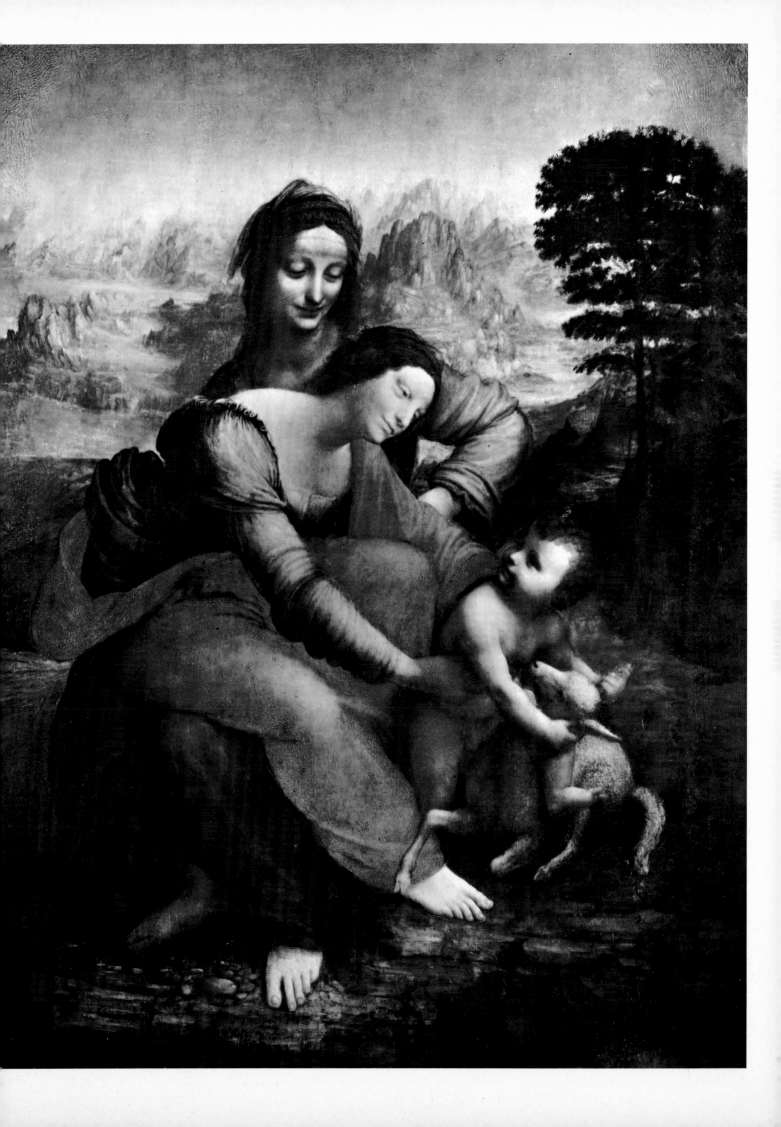

Portrait of Ginevra dei Benci

National Gallery of Art, Washington, D. C.

LEONARDO DA VINCI
Vinci, 1452–Amboise, 1519.

Letter to Mary Costelloe.
Vienna, October 21st, 1890.

After lunch we went to the Liechtenstein Gallery, one of these collections you feel that a prince has gathered together because he is a prince, and which he never looks at. It contains some of the finest Rembrandts, van Dycks, and Rubens in the whole world, a great Frans Hals, something to make a modern painter give up the ghost for envy, and a few Italians, among them two portraits of the sort that a wicked and malicious providence seems to have created to torture us poor *Kunsthistoriker*. . . . But the portraits. One of them is the head of a woman seen full face, beautifully modelled, rather chalky carnation with a warm rich landscape background. What is very certain is that Verrocchio carved a bust of the same woman which is now in the Bargello. The Germans are perfectly convinced that this portrait is by Leonardo. Richter thinks it is by Ridolfo Ghirlandaio, and thinks wrong. Frizzoni believes that it is by Lorenzo di Credi, which seems merely likely. As to what I think, I scarcely have a right to an opinion.

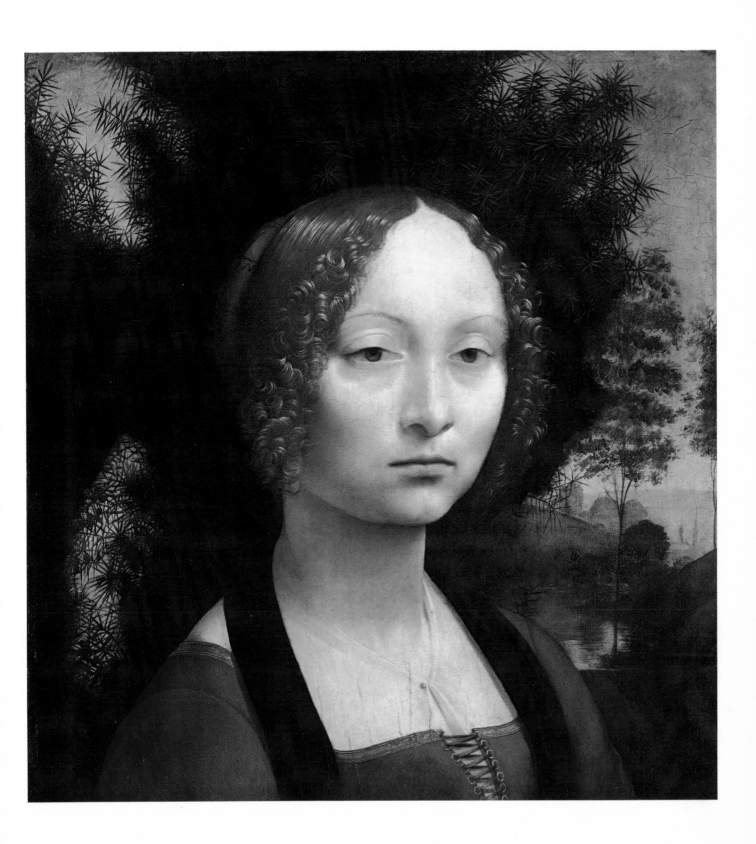

Portrait of a Man Called the "Sculptor"

Signed. National Gallery, London.

ANDREA DEL SARTO
Florence, 1486–1530.
Pupil of Piero di Cosimo; influenced by Leonardo, Fra Bartolommeo and Michelangelo.

"The Florentine Painters." 1896.
The Italian Painters of the Renaissance.
Phaidon Press, London, 1952.

Andrea del Sarto approached perhaps as closely to a Giorgione or a Titian as could a Florentine, ill at ease in the neighbourhood of Leonardo and Michelangelo. As an artist he was, it is true, not endowed with the profoundest sense for the significant, yet within the sphere of common humanity who has produced anything more genial than his "Portrait of a Lady" with a Petrarch in her hands? Where out of Venetia can we find portraits so simple, so frank, and yet so interpretive as his "Sculptor," or as his various portraits of himself— these by the way, an autobiography as complete as any in existence, and tragic as few?

Madonna of the Sack: "Madonna del Sacco"

Dated 1525. Fresco. Chiostro dei Morti, Santissima Annunziata, Florence.

ANDREA DEL SARTO
Florence, 1486–1530.

The Drawings of the Florentine Painters.
University of Chicago Press, Amplified Edition, Volume I, 1938.

The last of Andrea's frescoes is the Madonna of the Sack, painted in 1525, a work which for the splendour of mere physical existence and beauty of colour reminds one, as Andrea so frequently will remind one, of Veronese. Is it only coincidence, by the way, that the latter's Madonna in the altar-piece of the Venice Academy is of an air and carriage so like to this "of the Sack"? The *Madonna del Sacco,* painted, let us remember, just after that failure, the Scalzo Visitation, although it cannot, like the Madonna of Porta a Pinti, be said to be more or less a copy after Michelangelo, is due only in a less degree to that "divine one." "But how" it may be asked, "can a scene like this be traced back to Buonarroti?" Nothing easier. The source, the deep, broad, although unrecognized, apparently even unstudied, source of much of the *quasi-genre* in Florentine and perhaps in all Italian Cinquecento painting, is to be found in the spandrels and lunettes of the Sixtine Ceiling, with their scenes of brooding, exquisite tenderness, domesticity and repose. Now look carefully at the Madonna of the Sack, and what is it but a composition in a lunette, varied upon some of the triangular compositions in the Ceiling? It was thence surely that directly or indirectly Andrea derived the idea of this particular composition, the sack and the seated figure on the ground [going back to Quattrocento Rests in the Flight]....

The space at command does of itself dictate that the figure shall not stand or sit high, yet Michelangelo was the first to perceive this fact; and Andrea follows him, although . . . it was at the start not easy for him to realize clearly why the lunette requires figures sitting low.... By placing the figures low, the artist has been able to make them as erect as the monumental style requires, while yet leaving ample space above them.

The Small "Cowper" Madonna and Child

c. 1505. Detail. National Gallery of Art, Washington, D. C. Widener Collection.

RAPHAEL SANZIO
Urbino, 1483–Rome, 1520.
Pupil possibly of Timoteo Viti of Urbino; formed by Perugino, influenced by Leonardo, Fra Bartolommeo and Michelangelo.

Pictures in the Collection of P.A.B. Widener.
Volume III: "Early Italian and Spanish Schools."
Privately printed, Philadelphia, 1916.

There perhaps never was an artist with a greater gift of assimilation.

Our Lady sits on a stone bench in the open air, in a quiet landscape. She holds the naked Child in her left hand, while he thrusts his left foot against her right hand and throws his arms around her neck, at the same time following her sweet, steady gaze at the worshippers assumed to be present just outside the picture. The hair of both is blond; the eyes warm, deep brown; the Blessed Virgin's dress red and her mantle blue lined with green. The flesh is radiantly golden, and the sky a pearly blue as it broods over the yellow green of the landscape. On our right there is a country church on a hill, and on our left a stream. The church is almost certainly San Bernadino, a Franciscan convent, a charming stroll from Urbino.

It is unanimously assumed that this perhaps most completely characteristic of Raphael's earlier Madonnas was painted in 1505. It would seem to be just later than the "Granduca," but opinion oscillates as to whether it was painted just before or just after the "Madonna del Prato" (Vienna), which is dated 1505 or possibly 1506. The Virgin's right hand is so much like the one in the Louvre drawing for Maddalena Doni's portrait that we may assume that Raphael was undertaking the latter as he was completing the former, for the finished picture shows a more advanced type of hand.

Portrait of a Lady: "La Donna Velata"

Galleria Pitti, Florence.

RAPHAEL SANZIO
Urbino, 1483–Rome, 1520.

"The Central Italian Painters." 1897.
The Italian Painters of the Renaissance.
Phaidon Press, London, 1952.

The type of beauty to which our eyes and desire still return is Raphael's — the type which for four hundred years has fascinated Europe. Not artist enough to be able to do without beauty, and the heir of the Sienese feelings for loveliness, too powerfully controlled by Florentine ideals not to be guided somewhat by their restraining and purifying art, Sanzio produced a type, the composite of Ferrarese, Central Italian, and Florentine conceptions of female beauty, which, as no other, has struck the happy mean between the instinctive demands of life and the more conscious requirements of art. And he was almost as successful in his types of youth or age — indeed, none but Leonardo ever conceived any lovelier or more dignified.

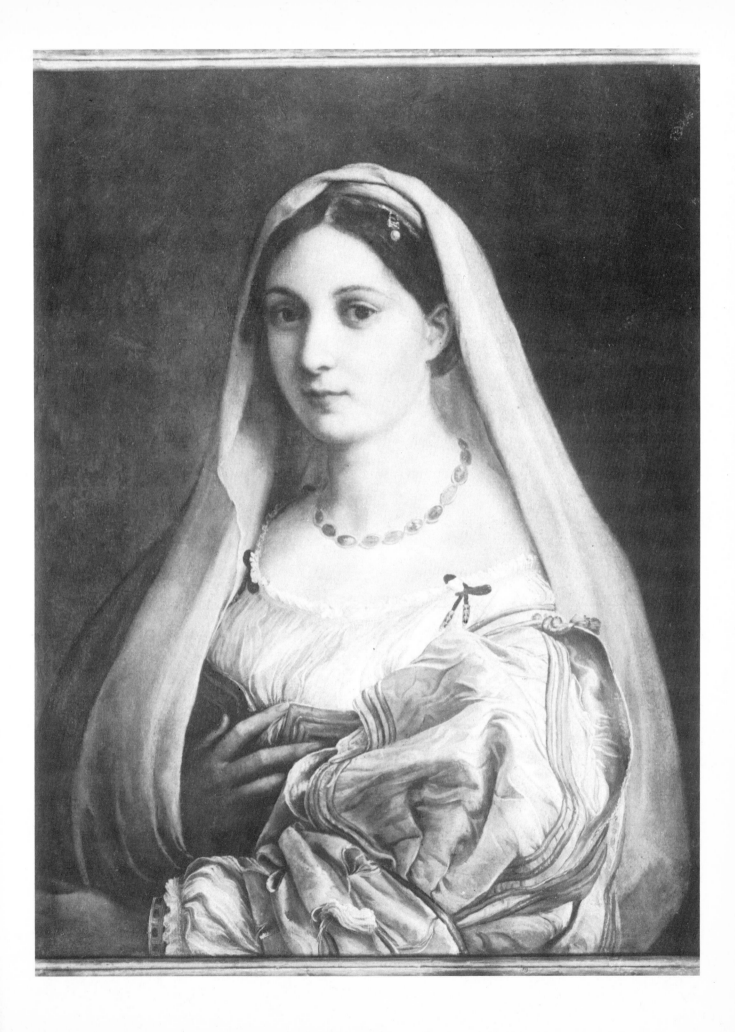

Saint George and the Dragon

National Gallery of Art, Washington, D. C. Mellon Collection.

RAPHAEL SANZIO
Urbino, 1483–Rome, 1520.

"The Caen 'Sposalizio'." 1896.
The Study and Criticism of Italian Art.
G. Bell & Sons, London, Second Series, 1902.

Raphael profited by Perugino's teaching in only one thing. The painter of Urbino, the artist who, among all the artists of the world, has attained the most marvellous effects of space, owed the revelation of this quality, which is his supreme quality, to Perugino, who before him was the most successful master of space composition. I doubt if a painter brought up entirely in the school of Ferrara-Bologna could have composed an effect of space... which gives one so penetrating a sense of well-being that... we have a pleasure such as pure spirits disencumbered of their bodies might feel. What breadth there is in his middle distances, pure and cool, filled with an air so soft and fresh! What repose in the delicate vapours at the horizon!

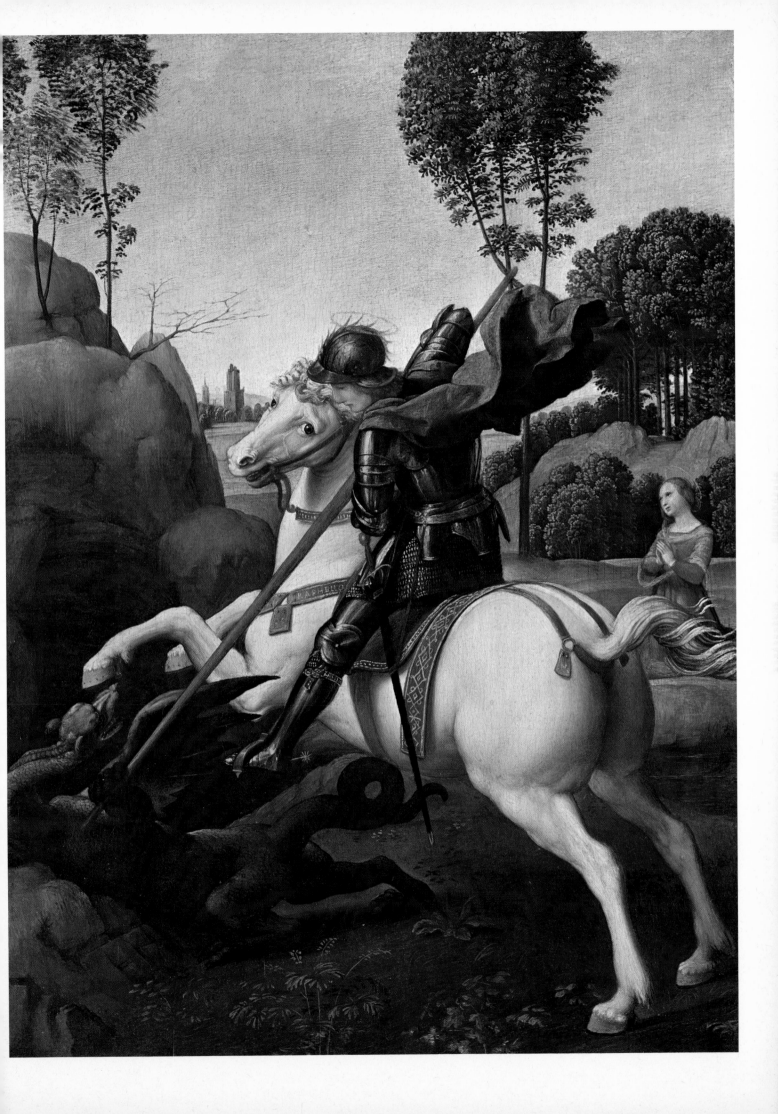

The Flood

1508–12. Fresco. Detail. Sistine Chapel Ceiling, Vatican, Rome.

MICHELANGELO BUONARROTI
Caprese, 1475–Rome, 1564.
Pupil of Ghirlandajo and Bertoldo; influenced by the antique, by the Pisani and Jacopo della Quercia, by Donatello and Signorelli.

The Arch of Constantine or The Decline of Form. 1951.
Chapman & Hall, London, 1954.

Like a torrent swollen with the melting snows and brooking no barriers, his genius was bound to pour itself forth, if not in the Tomb of Julius, then into the Sixtine Ceiling, into the New Sacristy, on and ever on, into the Last Judgement, and at the end, spent and wearied, into the Pauline Chapel and his last efforts. For him, whose creative impulse was ever toward the nude in action, a course had been laid which had no windings. Run it must, and, if well, a delight to himself and to us. Had we the Tomb of Julius, we should have different visual shapes, and different arrangements from those presented by the Sixtine Ceiling, or the Medici Marbles. It is probable, moreover, that, functioning to his heart's desire over a work toward which his whole soul leapt up with joy, he would have attained to a degree of perfection that the other children of his brain, begotten on less loved mothers, do not show. But it may be doubted whether the essential revelation would seem different, whether we should have done much more than exchange the Tomb for the Ceiling. It is hardly conceivable that he could have carried both works to completion. We might have had a Michelangelo of the Tomb, but although a happier, and perhaps more enjoyable, he would not have been a different Michelangelo from the one we know, the Michelangelo of the Ceiling.

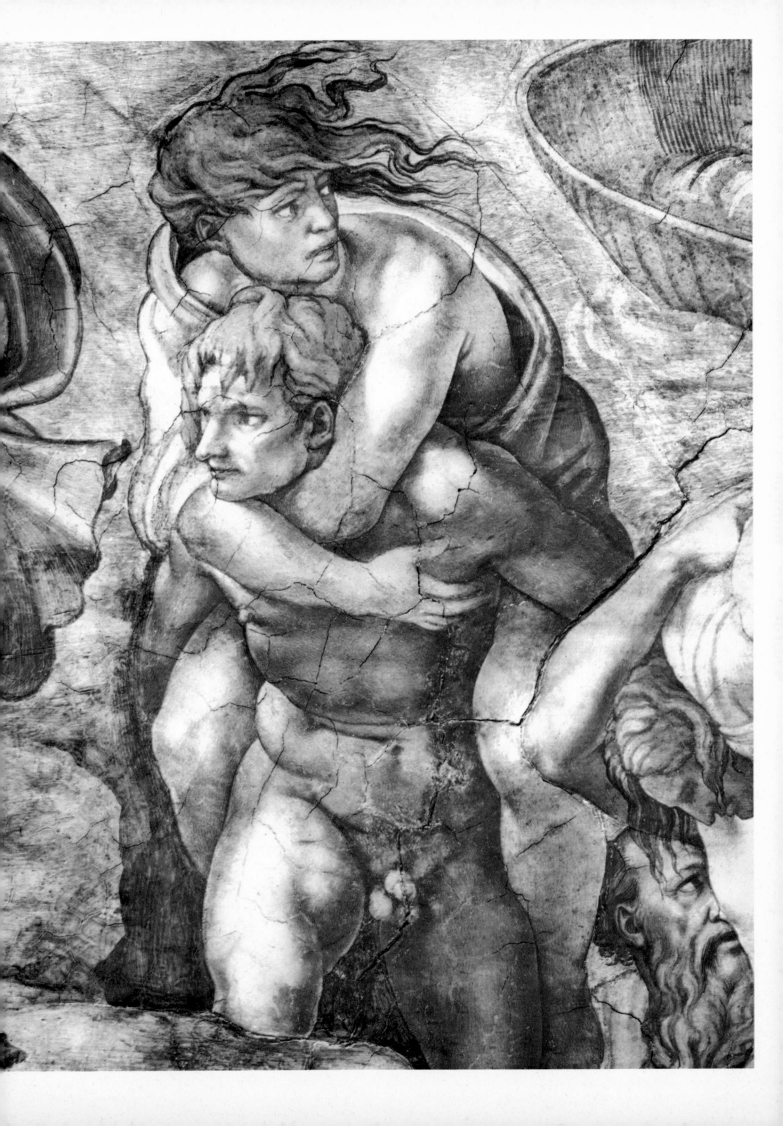

The Last Judgment: Saint Sebastian

1534–41. Fresco. Detail. Sistine Chapel Altar Wall, Vatican, Rome.

MICHELANGELO BUONARROTI
Caprese, 1475–Rome, 1564.

The Drawings of the Florentine Painters.
University of Chicago Press, Amplified Edition, Volume I, 1938.

A style cannot be manufactured by taking thought. Its origin, emergence and formation are due to many causes, and call into play the mental and moral energies of a people for previous centuries, besides the technical activities of its artists. The factors are too many for an equation and besides most of these factors remain unknown. What produced the Attic style of the Vth century, what the French style known as Gothic, what the Baroque? Certainly no one person nor any number of known individuals. The individual may create marvels and leave scarcely a mark on the style of his period, as was the case with a genius almost out of the blue like Piero della Francesca; or be like Michelangelo whose activity as a figure artist led to the fading out of Tuscan painting and to the reduction of its sculpture to jewellery (even when, as with Cellini, it was life-size or over) and who can be regarded, particularly in architecture, as a precursor of the Baroque. Yet, while at work, he did not bother about consequences. Only as an old man, on his last visit to the Sistine Chapel, he looked at his Judgement and cried out: "What horrors this will lead to!" If he handed on so much more to his successors than Piero, was it not because the latter appeared out of the blue, as we said, while Michelangelo brought to a head tendencies inherent in several generations of technical experimenters?

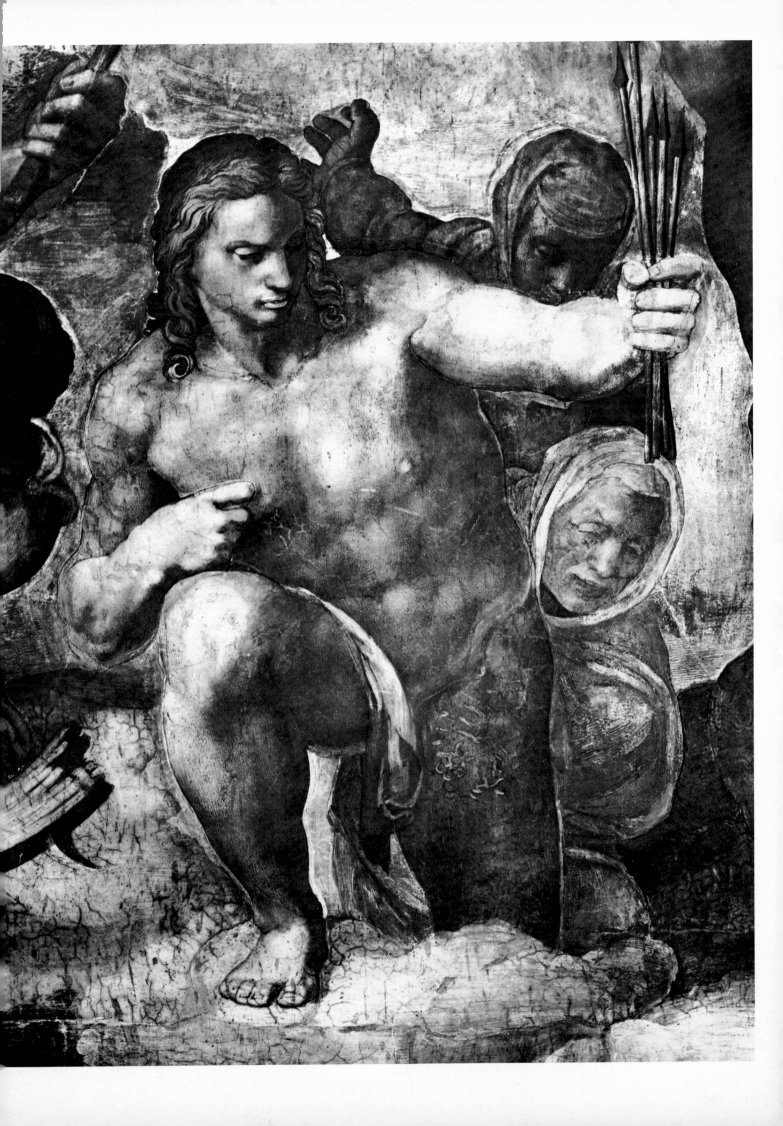

"Doni" Tondo:
Holy Family with Nudes in Background
Galleria degli Uffizi, Florence.

MICHELANGELO BUONARROTI
Caprese, 1475–Rome, 1564.

The Drawings of the Florentine Painters.
University of Chicago Press, Amplified Edition, Volume I, 1938.

I yet incline to believe that the Doni *tondo* must have been painted after and not before the Cartoon [of the Bathers for the "Battle of Cascina"]. My chief reason is the one I assign for shunting the marble Matthew to the same years — that figures like these, so colossally conceived, in attitudes so strained, and yet so well arranged to communicate, as an ideated offering, all the strength of their mighty limbs — that these figures, I say, could not have succeeded directly upon the David, and the Bruges Madonna, but must have been prepared for by the fierce struggles for self-discovery and self-expression necessitated by the Cartoon. Other arguments not trivial if less high-sounding may be brought forward. Thus, the decorative nudes in the *tondo* differ in growth but slightly, in actual shape scarcely at all, from the earliest in the Ceiling, those in the Flood, for instance. An Uffizi leaf... with copies of various early sketches by Michelangelo shows us one nude which might have been a study either for the nude in the *tondo* leaning in profile to left against the wall on the right, or for the nude in a similar attitude on the extreme right in the vast tub adrift on the waters of the flood.

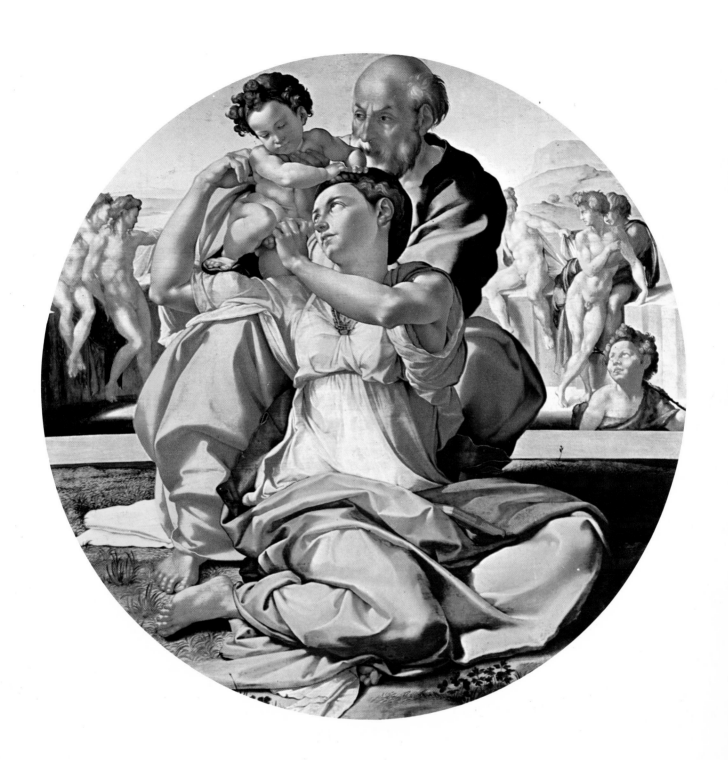

Visitation

1528–30. San Michele, Carmignano (Florence).

JACOPO PONTORMO
Pontormo, 1494–Florence, 1556.
Pupil of Andrea del Sarto; influenced by the graphic art of Dürer and by Michelangelo.

The Drawings of the Florentine Painters.
University of Chicago Press, Amplified Edition, Volume I, 1938.

With his temperament and his training, Pontormo, in his early, vigorous years, could not adopt the abstract or synthetic, highly intellectual methods of Michelangelo. When finally, as we shall see, he did surrender to them, it was to become little more than a distorted and blurred image of the master in his decline. He remains interesting even then, because his confusion was sincere perplexity, because he gained something visionary, because he ended by creating images which remind us of William Blake....

On the other hand, Pontormo was nimble-witted, brilliant, and playful. His task was not a thing to be paid for and have done with, but a road from which branched off numerous and enchanting lanes, every one of which he had to explore before he could go further. He thus seldom came to an end, and when he did, it was not always to the great satisfaction of his employer, or indeed to his own glory as an artist. What did he care? He had been so charmingly entertained by the way! He had drawn the figures, not only in the few attitudes strictly required by his subject, but in almost every conceivable pose. What sport it all was to wreak his sprightliness upon his models, contorting their bodies into the most ridiculous positions, or denuding them of all flesh and letting them hop about as grinning skeletons! Very pleasant all this, not only for Pontormo but for us spectators as well....

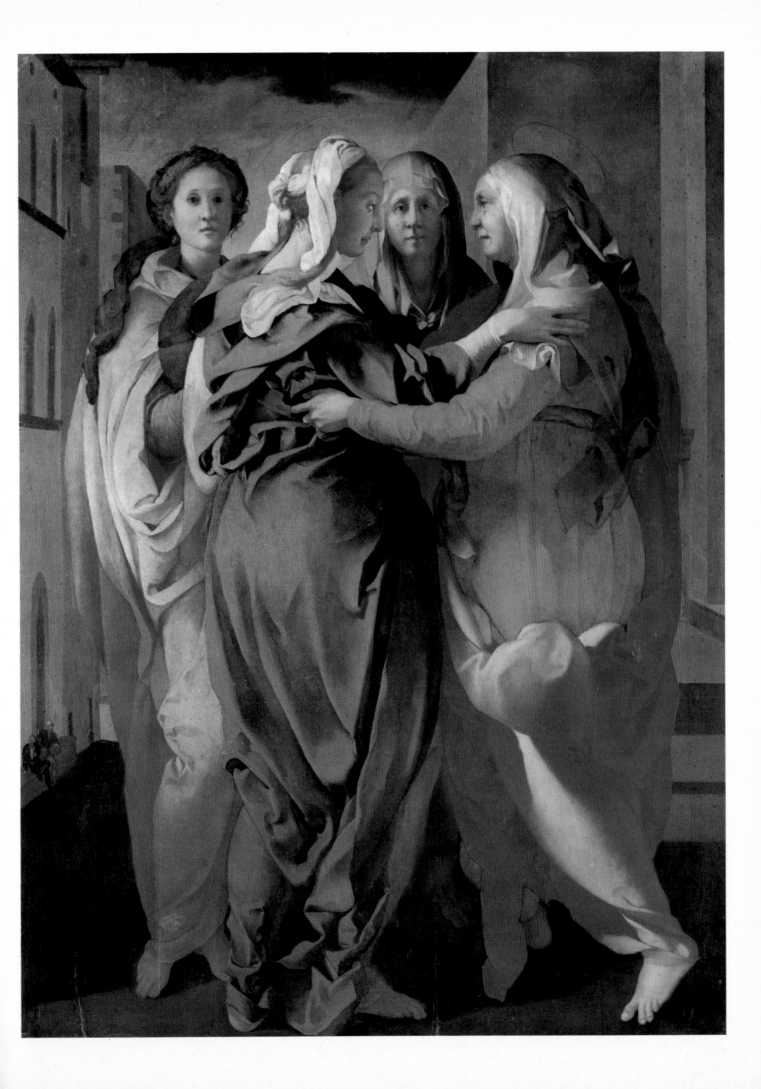

Deposition

1526–28. Capponi Chapel, Santa Felicita, Florence.

JACOPO PONTORMO
Pontormo, 1494–Florence, 1556.

The Drawings of the Florentine Painters.
University of Chicago Press, Amplified Edition, Volume I, 1938.

The Pietà in its various phases is a subject which occupied Pontormo's attention at different periods of his career. It was a theme so often imposed upon artists at that time, and so admirably treated by the best of them, that it was well calculated to absorb Pontormo and to arouse his emulation. Of his various paintings of this subject mentioned by Vasari, two only are known to be extant, the one in the Academy and the other at S. Felicita. . . .

The altar-piece of S. Felicita is free from absurd extravagances, and indeed one does not quite understand Vasari's sweeping censures of it, if one is to take them in earnest, as perhaps they should not be taken. He seems to find in this work a flagrant instance of Pontormo's continuous search for newness of arrangement and strangeness of treatment. For my part, I feel myself irresistibly attracted towards this Pietà. The blond colouring, and the insufficient contrasts of light and shade which Vasari blames are pleasant to me, and give a freshness to the tone and a luminosity to the substances which remove them into another sphere of reality. The feeling is intense, yet delicate, and the arrangement and action unhackneyed, yet not far-fetched. The composition consists of two groups and two crowning figures. The principal group comprises the dead Christ supported by two men behind Him, and by another in front, who, in nearly kneeling posture, sustains the burden on his shoulders, as well as a young woman who stoops pityingly over the Saviour's head. The other group is of the Virgin, who is about to faint away, a woman who runs up to sustain her, and another who looks on. The two groups complete one another spatially, are united intimately by the play of the hands, and joined at the top by two beautiful figures who look on and sympathize. But a head at the right, although fine in itself, were better away, for it takes no part in the action and is not otherwise needed. It is a portrait head which Pontormo was probably required to insert.

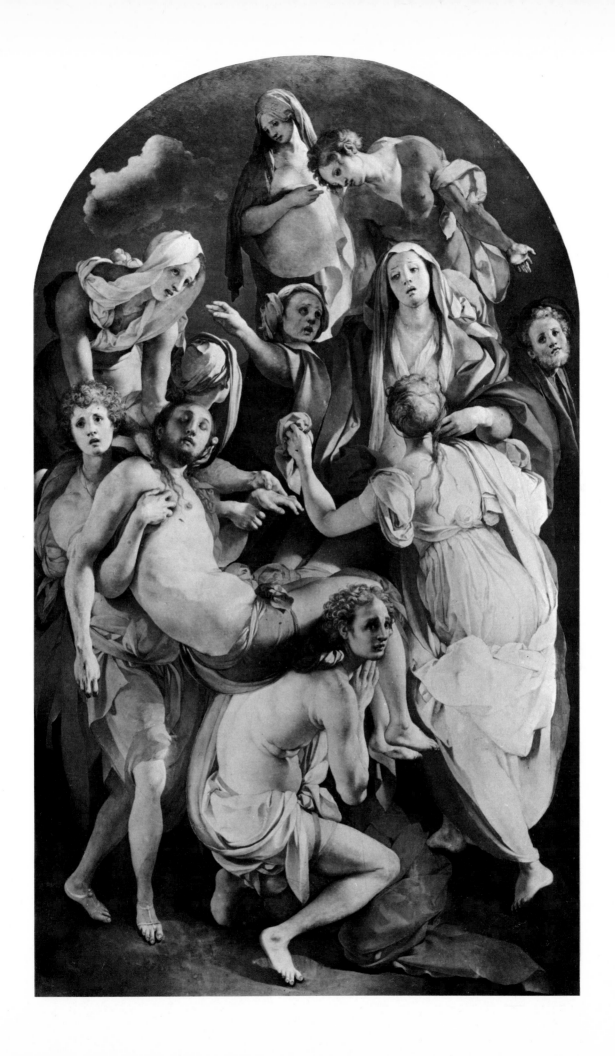

Deposition

Signed and dated 1521. Pinacoteca Comunale, Volterra.

ROSSO FIORENTINO
Florence, 1494–Paris, 1540.
Pupil of Andrea del Sarto, influenced by Pontormo and Michelangelo.

The Drawings of the Florentine Painters.
University of Chicago Press, Amplified Edition, Volume I, 1938.

Rosso Fiorentino was born in the same year as Pontormo, but a whole artistic generation appears to lie between them, and Rosso's art seems based as much upon Pontormo's as Pontormo's upon Andrea's. This is not the place to try to account for the phenomenon, of which many plausible explanations might be offered. Here it must suffice to record that Rosso had far less power of direct vision than even Pontormo, and that, as the latter saw the world in the contours of Andrea, so Rosso seems to have seen it in terms of Pontormo. But it may be questioned whether he saw the world at all, whether he had ever seen more than Pontormo's presentation of it. He had the disadvantage of being acquainted only with a second-hand instead of a direct transcript of nature, and he was further handicapped by lacking the impulse from within which characterized Pontormo, and the latter's gift for communicating values of energy and of life. . . .

Yet he had qualities which captivated his contemporaries, and in weaker moments please one still.

They are alluring rather than sterling qualities — great ease of handling, sparkle, dash, the *bravura* Vasari speaks of, fresh colouring, striking light and shade, and a certain daintiness, gracefulness, even elegance of type.

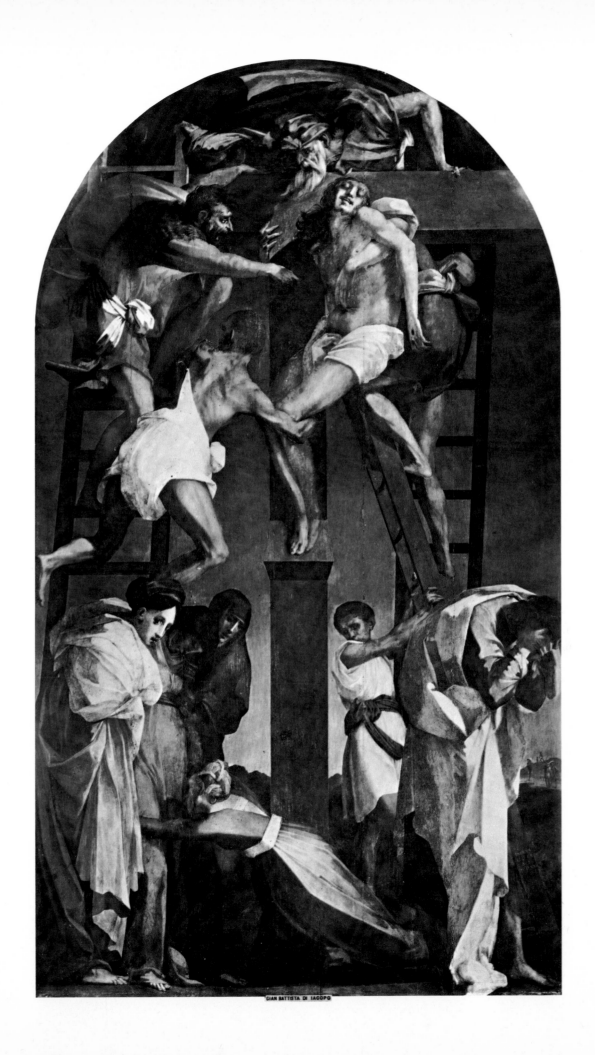

GIAN BATTISTA DI IACOPO

Moses Defending the Daughters of Jethro

Galleria degli Uffizi, Florence.

ROSSO FIORENTINO
Florence, 1494–Paris, 1540.

The Drawings of the Florentine Painters.
University of Chicago Press, Amplified Edition, Volume I, 1938.

I may shock the grave reader if I confess that I derive from Rosso's works a pleasure not unlike that which certain phases of recent French art have given me — the picture-posters of Chéret, for instance.

The mention of French art reminds me of an historical reason for allowing Rosso a certain place in our esteem. He was, more than any other artist, the founder of the school of Fontainebleau, and thus started French painting, which thereupon broke completely with Northern tradition, on the career which has never since been seriously interrupted. But Rosso perhaps achieved even more. He and Cellini may be held responsible for that elegance and grace of carriage and manner which have ever since distinguished the French....just before the time we are now considering, the French were scarcely less ungainly and provincial in aspect and dress than other Northern peoples. I repeat that the rapid and triumphant change must have been due in the first place to Rosso and Cellini, who introduced representations of pride, of distinction, of elegance, which they in their turn had derived both directly and indirectly from Michel-angelo.

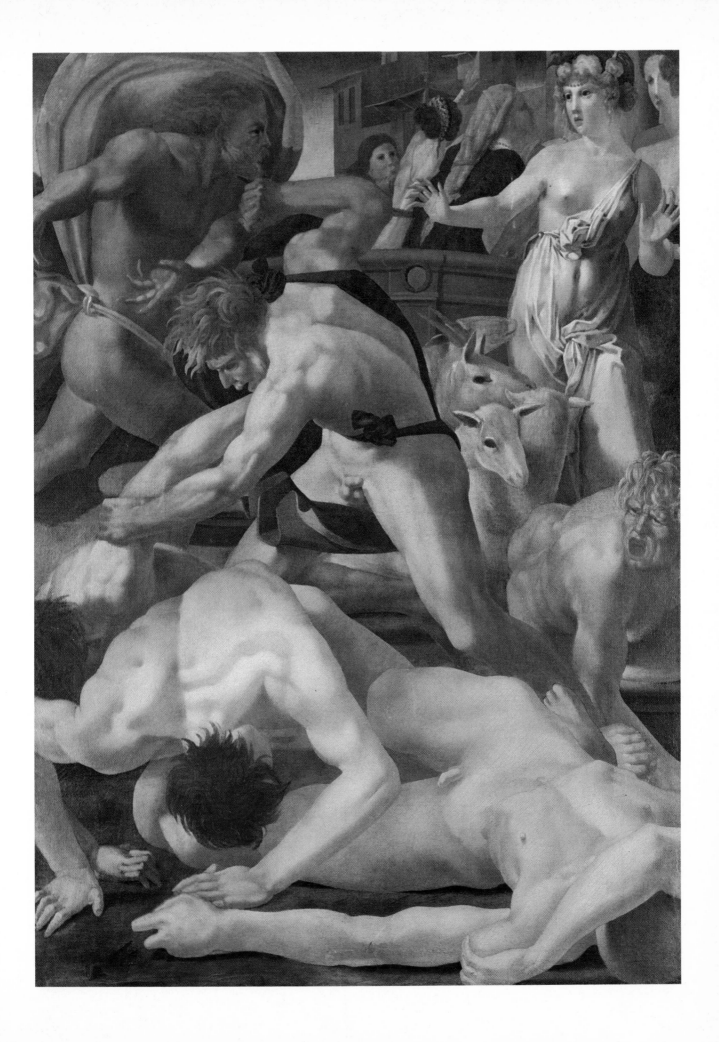

Allegory

*Inscribed: "LAURENTIUS LOTTUS P./CA. JUL. MDV." Cover to Portrait of Bishop
Bernardo de' Rossi di Berceto (Naples).*
National Gallery of Art, Washington, D. C. Kress Collection.

LORENZO LOTTO
Venice, 1480–Loreto, 1556.
*Pupil of Alvise Vivarini; follower of Giovanni Bellini; influenced by Raphael, Palma Vecchio,
Giorgione and Titian, and possibly by Dürer and other contemporary Germans.*

Lorenzo Lotto.
Phaidon Press, London, 1956.

The basic meaning of the allegory is clearly a moral warning of good and evil
based on the virtues and vices; but to explain the significance of each item is
beyond my competence and my curiosity. Visual representations like this are
the equivalent of "Lieder ohne Worte" — songs without words — in music.
The satyr looking so deeply into the vase reminds me of a similar motive in
the Pompeian Villa dei Misteri, and the child with the geometrical and musical
objects recalls Caravaggio's Berlin "Cupid." As neither Lotto nor his inspirers
knew the Villa dei Misteri, and as it is unlikely that Caravaggio would have
seen this panel, one cannot help wondering how this comes about? Could some
antique symbolism have traversed the ages by hidden ways down to the
sixteenth century?

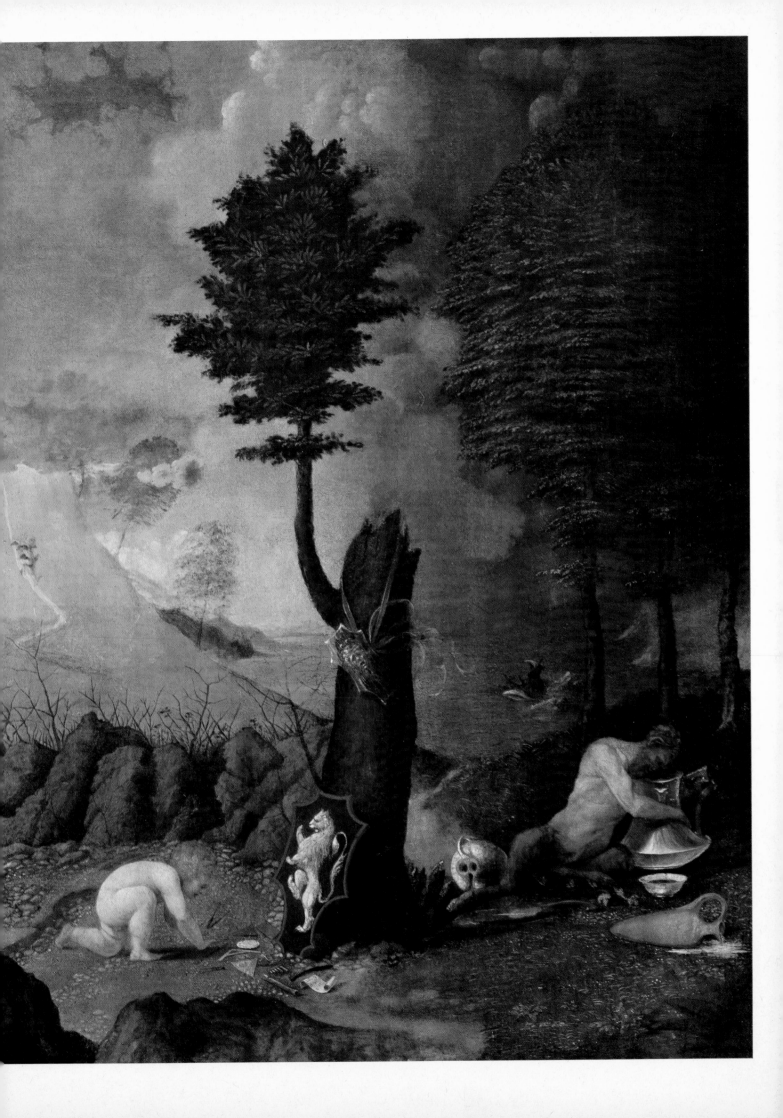

Crucifixion

Signed and dated 1531. Santa Maria in Telusiano, Monte San Giusto (Macerata).

LORENZO LOTTO
Venice, 1480–Loreto, 1556.

Lorenzo Lotto.
Phaidon Press, London, 1956.

The great *Crucifixion*... signed and dated: "Lotus 1531" is the masterpiece by Lotto of the following year.... The stroke of the brush is of masterly firmness and breadth, surpassing not merely all that Lotto himself had ever accomplished before, but even Titian's achievements up to this date. If it were as great in the structure of the single figure as it is in conception and execution, it would, as a work of art, rival Titian's greatest masterpieces. It may be separated into two groups — into foreground and middle distance. The foreground is almost a complete picture by itself, of splendid dramatic effect. The Virgin, partly supported by one of the Marys, faints into the arms of St. John. To the right, the Magdalen, with flaxen hair, expresses her grief in frantic gestures. In front of her kneels another Mary, in profile, with her eyes turned to the Cross, while she holds the arms of the fainting Madonna. John, perhaps a portrait, turns abruptly to look at the donor Niccolo Bonafede, Bishop of Chiusi and Vice-Legate of the Marches, who kneels to the extreme left. Beside the bishop, an angel with arms eloquently outstretched, explains the scene. In the middle distance rise three tall crosses. The upper part of the picture is veiled in clouds, while the figures at the foot of the cross stand out clearly against the pale, green sky. Horsemen surround the scene on each side, one on the right bearing a yellow standard, while the one next to him has his arm around the thief's cross. Two robust lancers stand at the foot of the middle Cross, and beyond them, men are seen hurrying down the hill. At the foot of the cross to the left, Nicodemus, on a white horse, starts back, letting fall his lance. Several soldiers surround him, pointing up, and gesticulating. The white draperies of the crucified figures stream out against the clouds. Nothing can be simpler or more free from entanglement, clearer or grander in action, than is this entire picture. Rarely, if ever, has the Crucifixion been treated so much in the spirit of a Greek tragedy. To an even heightened sense of beauty, Lotto adds here a mastery of construction such as we have never found in him before.

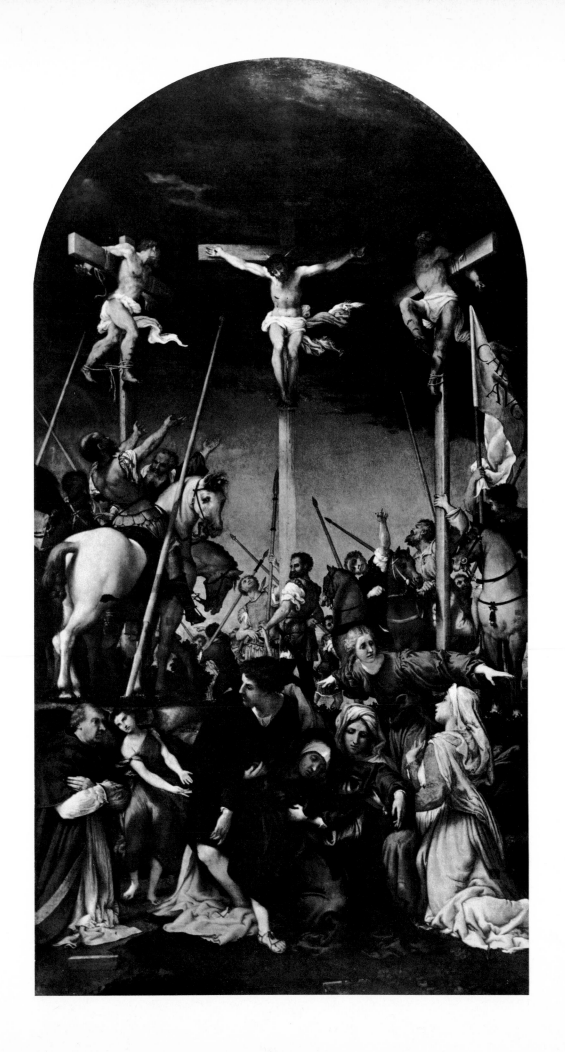

Portrait of Andrea Odoni

Inscribed: "Laurentius Lotus 1527." Royal Collections, Hampton Court.

LORENZO LOTTO
Venice, 1480–Loreto, 1556.

Lorenzo Lotto.
Phaidon Press, London, 1956.

Lotto's psychological interest is never of a purely scientific kind. It is, above all, humane and makes him gentle and full of charity for his sitters, as if he understood their weaknesses without despising them, so that he nearly always succeeds in winning sympathy for them. This is true even when they were evidently antipathetic to him, as in the portrait of Andrea Odoni, at Hampton Court, where the painter seems as much as to say: "What can you expect from a man of this temperament?" Not that Lotto could not, if necessary, be a severe judge, as in one of his latest portraits, that in the Brera of an old man whom life seems to have turned to flint. Even when he has sitters to whom no other painter of the time would have managed to give a shred of personality, Lotto succeeds in bringing out all that is most personal in them; all that could possibly have differentiated them from other people of their age and station.... Never did it happen, before or after Lotto, that a painter should have brought out on the face of his sitter so much of his inner life. If few of his portraits leave us indifferent, most of them offer the interest of private confessions. His analysis is so searching, his diagnosis so complete, that he seems to combine the ideal physician's sympathy with the ideal priest's tenderness.

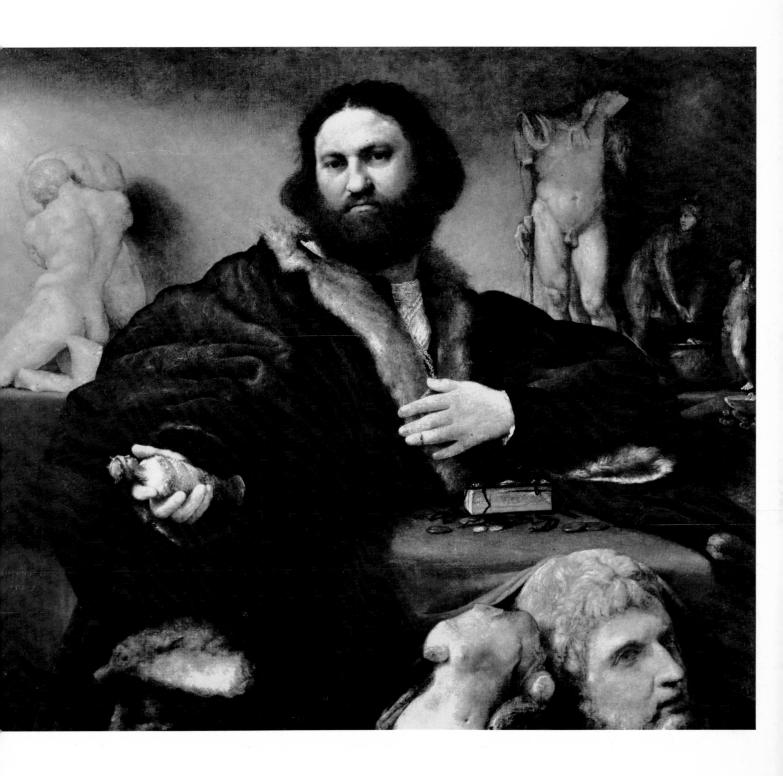

So-called Portrait of Gaston de Foix

National Gallery of Art, Washington, D. C. Kress Collection.

GIROLAMO SAVOLDO
Brescia, c. 1480–after 1548.
Possibly pupil of Francesco Bonsignori; influenced by Giovanni Bellini, Giorgione, Scorel, Palma, Lotto.

Letter to Mary Costelloe.
Vienna, October 23rd, 1890.

[Savoldo] painted a portrait of Gaston de Foix. The one in the Louvre, it was always supposed, was this portrait. I never could believe it. I saw absolutely no resemblance to the beautiful effigy of his by Bambaja (Agostino Busti) which is now in the Museo Sforzesco at Milan. . . . But no sooner did I see the portrait to-day than I recognized it at once for Gaston de Foix. How beautiful it is! I did nothing for two hours but look at it. So absorbed in a picture I have not been for a long time. Gaston de Foix sits in a chair draped in a mustard-coloured cloth. He wears a breast plate over a deep crimson tunic. He holds a broken staff in his hand to signify an early death of course. . . . His face is turned slightly to the right. The eyes are large, soft and indescribably beautiful, the nose straight, the mouth firm and sweet. A severer, and more loveable face I never have seen. In the middle distance a battle is going on, and the sea continues the distance. The colouring is very saturated, almost greasy as always in Savoldo, the tone somewhat sombre.

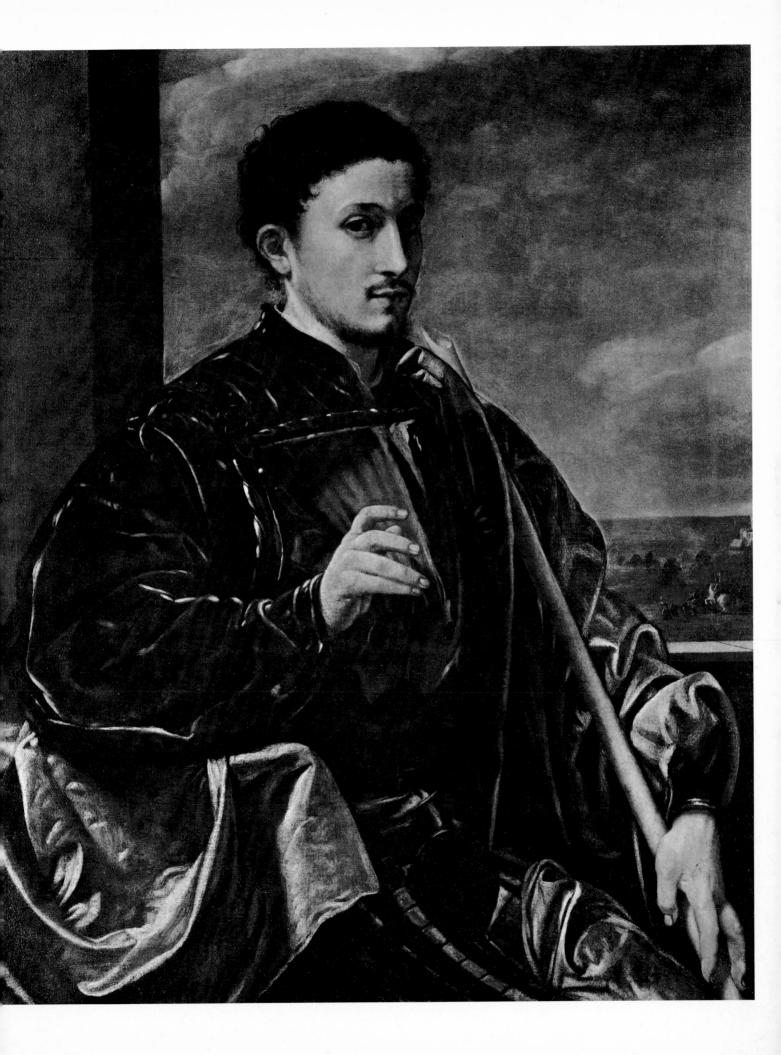

Portrait of an Old Man with a Skull: "Trionfo della Morte" (following page)

Companion to New Orleans portrait. Staatliche Kunstsammlungen, Cassel.

Portrait of a Young Man with a Lute: "Trionfo d'Amore" (second following page)

Companion to Cassel portrait. Delgado Museum of Art, New Orleans. Kress Collection.

BACCHIACCA (FRANCESCO UBERTINI)
Florence, 1494–1557.
Pupil of Perugino; influenced by Andrea del Sarto, Michelangelo and the graphic art of Lucas van Leyden and Dürer.

Letter to Mary Costelloe.
Berlin, September 25th, 1890.

In spite of the many influences he betrays, Bacchiacca is quite easy to recognize. The prevalence of types, costumes, and whole episodes taken from Lucas van Leyden, the way of painting the hair a sort of blue and then varnishing it with yellow, the waxen flesh painting, a certain series of folds on the sleeve and the trees, stiff pines with smooth tall trunks are in combination extremely characteristic of Bacchiacca.... This is a portrait of a smooth faced man in a diamond shaped cap, and loose black robe confined at the waist. He faces three fourths to the right, is very bony, and earthy in complexion. He is seated on a parapet, and to his right, on the same parapet stands an hour glass, and under it the inscription: — Neque praeterite hora redire potest. The hour glass and the inscription go well with the cadaverous complexion. The slope back of the old man rises to a clump of pines with smooth trunks, and heavy foliage. In the middle distance to the left Bacchiacca has put in Time on his car drawn by Lions, crushing poor humanity under his wheels. Back of this, one sees the enclosure of a villa. This is the sort of picture that makes a cold shiver run down one's spine. Mr. Charles Butler of London has a portrait by Bacchiacca in which the composition and manner of painting is much like that of the portrait before us, only that Mr. Butler's portrait [now in New Orleans, Delgado Museum of Art, Kress Collection] is not at all unpleasant. It represents a metaphysical youth playing the mandolin.

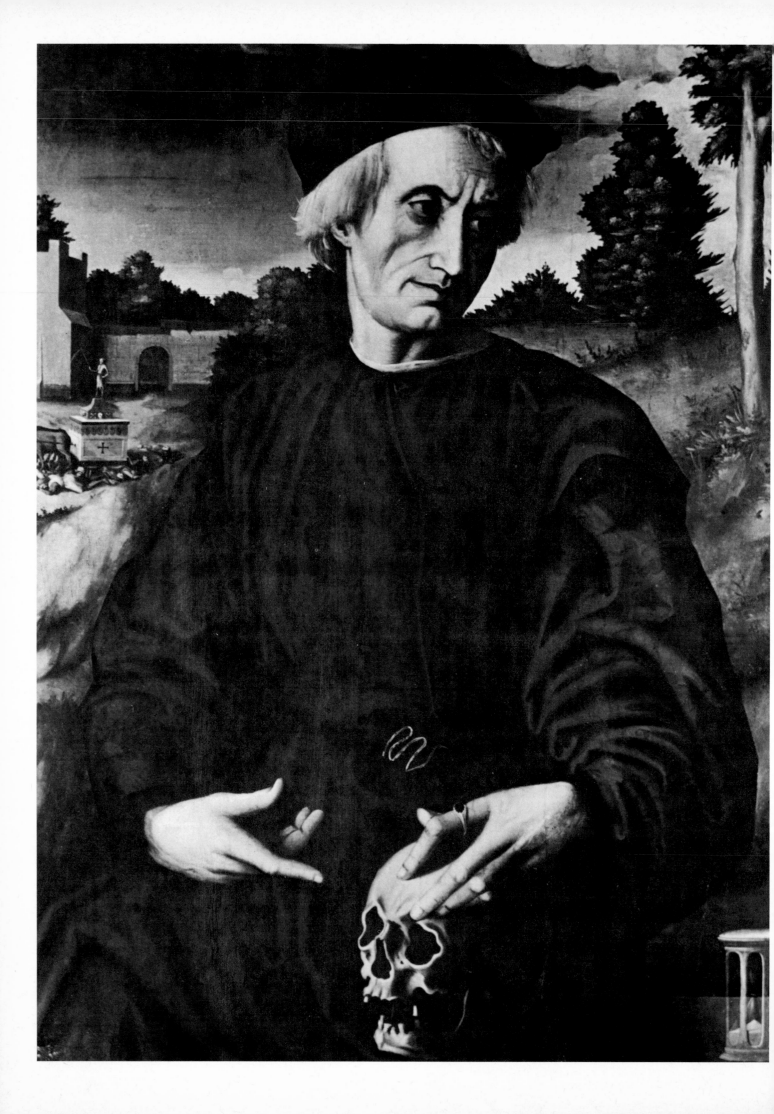

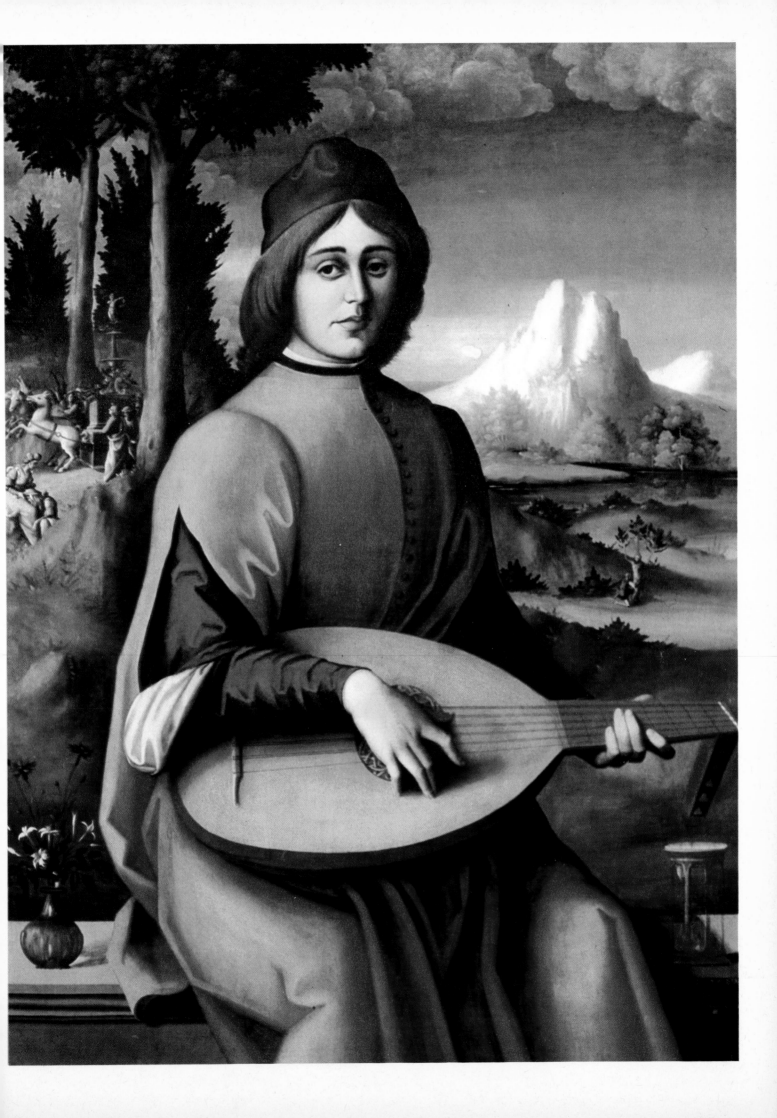

Circe or the Sorceress Alcina

National Gallery of Art, Washington, D. C. Kress Collection.

DOSSO DOSSI
Documented at Mantua, 1512, died in Ferrara, 1542.
School of Ferrara. Developed under the influence of Giorgione, Titian and Raphael.

"Some Comments on Correggio in Connection with His Pictures in Dresden." 1892.
The Study and Criticism of Italian Art.
G. Bell & Sons, London, First Series, 1901.

In 1511 Dosso Dossi was thirty-two years old, and nearly at the height of his genius. It was just before he became the court painter of Alfonso of Ferrara and Lucretia Borgia, his wife. Ariosto speaks of him in his "Orlando" along with Giorgione and Leonardo and Michelangelo. The court poet and the court painter were remarkably alike in the essence of their genius. They were both lovers of "high romance," and both had the power to create it — the one in verse, the other in colour — with a splendour that perhaps many other Italians could have equalled, but with a fantasy, a touch of magic, that was more characteristic of English genius in the Elizabethan period than of Italian genius at any time. Real feeling for the fantastic and magical has not often been granted to the well-balanced Italian mind. It is all the more delightful, therefore, to find an artist who has not only the strength and self-possession of an Italian, but the romance and sense of mystery of the great English poets.

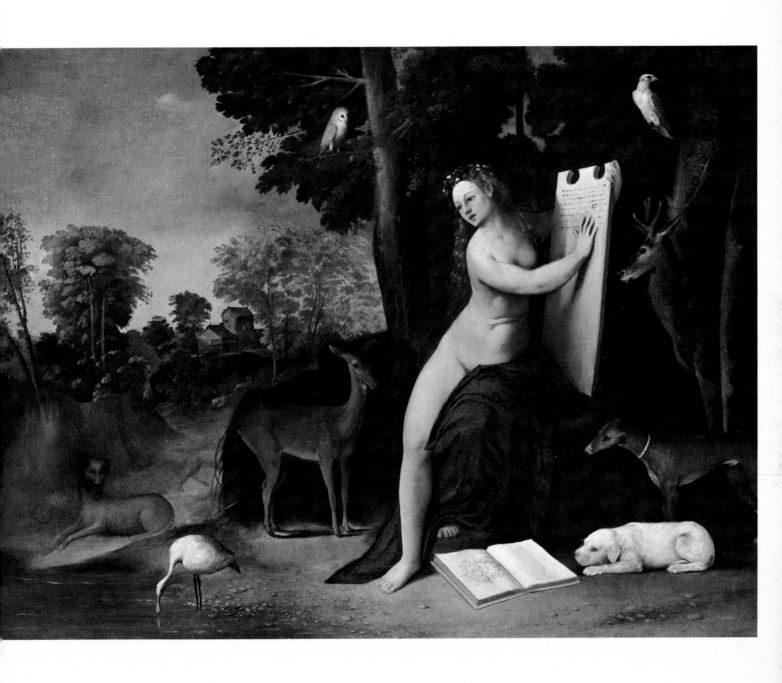

Circe or Melissa

Galleria Borghese, Rome.

DOSSO DOSSI
Documented at Mantua, 1512, died in Ferrara, 1542.

"Some Comments on Correggio in Connection with His Pictures in Dresden." 1892.
The Study and Criticism of Italian Art.
G. Bell & Sons, London, First Series, 1901.

If Marlowe had written about Circe, he would have presented us with one like Dosso's, as she may be seen in the Borghese Gallery: an enchantress clothed in crimson and emerald, sitting under balsamic trees where olive green lights are playing, with the monsters about her feet, their real natures made visible by her arts. Rather than Greek she is Arabian. She does not permit us to ask whether the lines of her form are classical, or whether her form is statuesque. Before her we lose ourselves in a maze of strange lights and mysterious colours which make us sink deeper and deeper into a world which is as entrancing as it is far away. Marlowe and Shakespeare would have taken that delight in her which we can well imagine Ariosto took.

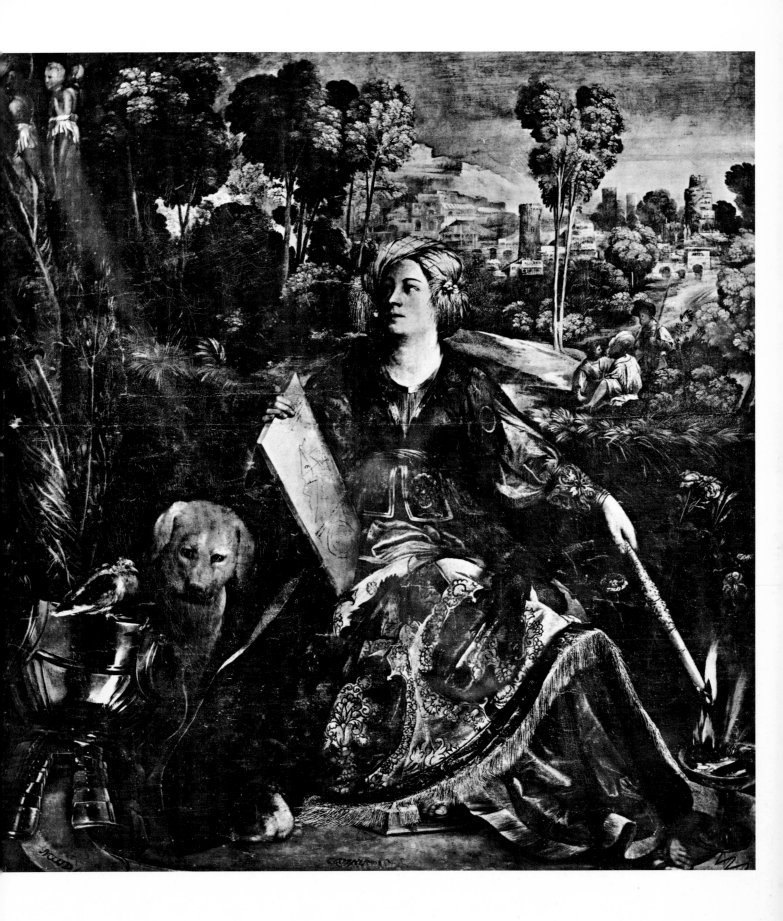

Orpheus

Marble intarsia. Pavement. Detail. Cappella di Santa Caterina, San Domenico, Siena.

DOMENICO BECCAFUMI
Siena, 1486–1551.
Pupil of Pacchiarotto; influenced by Sodoma, Fra Bartolommeo and Raphael.

"Missing Pictures of Fifteenth Century Siena." 1931.
Homeless Paintings of the Renaissance.
Indiana University Press, Bloomington and London, 1970.

From Peruzzi, Beccafumi, the most gifted of the later Sienese, may have got his impulse to the classicism in spacing and relating figures in architecture which led straight to Poussin.... One of the first achievements in this order was Peruzzi's picture in the Pace in Rome which I recommend to the future historian of the classical, the Virgilian, the heroic landscape, or, to be more accurate, the out-of-doors in art.

Beccafumi owed little to Sienese traditions. What he got from Peruzzi was Roman, and he himself got his technique and his world of images from Fra Bartolommeo, Andrea del Sarto, Raphael, and perhaps from Pierino del Vaga. As a painter he reminds us of Lotto, of Rosso, of Parmigianino. It should moreover be remembered that he was not only one of the most spirited precursors of the Mannerists and Tenebrists, but also the author of one of the most attractive designs in the whole world, the polychrome floor mosaic of the chapel of St. Catherine in the church of S. Domenico at Siena....

It can be said without exaggeration that, after all, in him the Sienese school died *en beauté*.

Antiope or Terrestrial Venus

The Louvre, Paris.

CORREGGIO (ANTONIO ALLEGRI)
Correggio, 1494 or earlier–1534.
Pupil of Bianchi, and of Francia and Costa; was well acquainted with the works of Mantegna,
Raphael, Leonardo, and Michelangelo. Probably had personal contact with Dosso and the
Venetians.

"The Fourth Centenary of Correggio." 1894.
The Study and Criticism of Italian Art.
G. Bell & Sons, London, First Series, 1901.

This intense and rapturous emotion might have become cloying in the end if Correggio had not always been as unstudied and as unconscious as he was emotional. In his mere craftsmanship, too, he seems to have been the most unconscious of artists, never dreaming that he would be admired or blamed for his astonishing foreshortenings, or for his broad, almost modern, treatment of light and shadow. In this, indeed, he had scarcely a rival, even among the later Venetians. None of them, not even Tintoretto, treated effects of diffused light with such success as he. In his ripe years he loved effects of broad daylight and landscapes sparkling with sunshine, as if he could not have light enough to bring Nature into complete harmony with his own rapture. His landscapes seem therefore to pulsate with joy under the full sunlight, and he gives fields and trees that look of gaiety which they have in the early summer.

His colouring was throughout on a level with the intense joyfulness of his feeling and with his sunny landscapes. Distinct from the Venetians, he was in no way inferior to them, except that colour and brushwork did not with him, as it did with the Venetians, become a distinct instrument of expression. But where he is unrivalled, either by them or perhaps by any other Italian painters, is in the flesh painting of the one or two perfectly preserved pictures which we still have. Flesh that looks so real as that of the "Antiope" in the Louvre, it would, perhaps, be hard to find anywhere else.

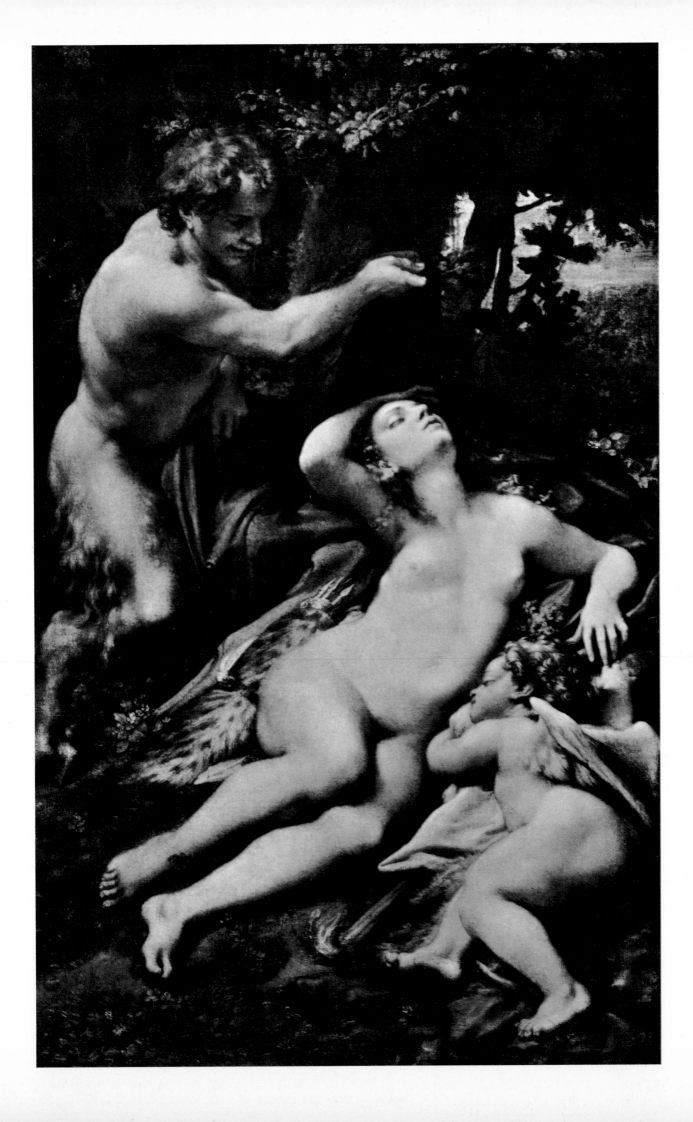

Rape of Europa

Signed "TITIANUS P." 1559–62. Isabella Stewart Gardner Museum, Boston.

TITIAN
Pieve di Cadore, c. 1480–Venice, 1576.
Pupil of Giovanni Bellini; formed by Giorgione;
slightly influenced first by Raphael and later by Michelangelo.

Letters to Isabella Stewart Gardner;
Archive of the Isabella Stewart Gardner Museum, Boston.

One of the few greatest Titian's in the world is the "Europa" which was painted for Phillip II of Spain, & as was known from Titian's own letter to the king, despatched to Madrid in April 1562. Being in every way of the most poetical feeling & of the most gorgeous colouring, that greatest of all the world's amateurs, the unfortunate Charles 1st of England had it given to him when he was at Madrid negotiating for the hand of Phillip the Fourth's sister. It was then packed up to await his departure. But the negotiations came to nothing, & Charles left Madrid precipitatedly. The picture remained carefully packed — this partly accounts for its marvellous preservation — & finally came in the last century into the Orleans collection. When that was sold some hundred years ago, the Europa fell into the hands of a lord whose name I forget, then into Lord Darnley's. . . . No picture in the world has a more resplendent history, & it would be poetic justice that a picture once intended for a Stewart should at last rest in the hands of a Stewart. . . .

Rome, May 10th, 1896

I hope you have now received her, & had your first honeymoon with her. What a beauty. Titian at his grandest, Rubens at his strongest, you have both matchless artists' dominant notes singularly combined in this one picture. No wonder Rubens went half mad over it. I beseech you look at the dolphin, & at the head of the bull. There is the whole of great painting.
How I wish I might see you in your first raptures over her!

North Berwick, August 2nd, 1896

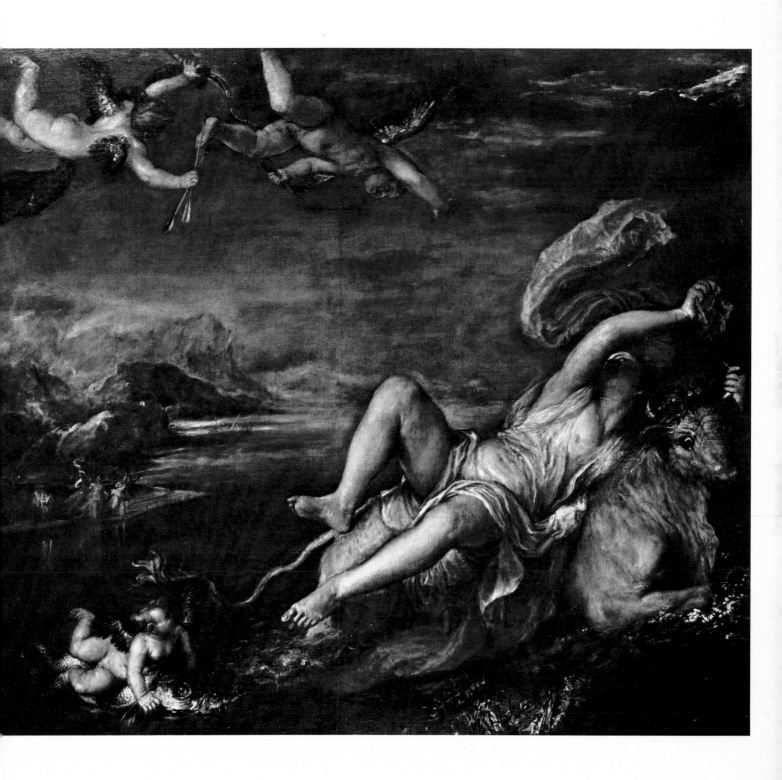

Shepherd and Nymph

Detail. Kunsthistorisches Museum, Vienna.

TITIAN
Pieve di Cadore, c. 1480–Venice, 1576.

"The Venetian Painters." 1894.
The Italian Painters of the Renaissance.
Phaidon Press, London, 1952.

In painting...a greater effect of reality is chiefly a matter of light and shadow, to be obtained only by considering the canvas as an enclosed space, filled with light and air, through which the objects are seen. There is more than one way of getting this effect, but Titian attains it by the almost total suppression of outlines, by the harmonizing of his colours, and by the largeness and vigour of his brushwork. In fact, the old Titian was, in his way of painting, remarkably like some of the best French masters of the end of the nineteenth century. This makes him only the more attractive, particularly when with handling of this kind he combined the power of creating forms of beauty such as he has given us in the "Wisdom" of the Venetian Library of San Marco or in the "Shepherd and Nymph" of Vienna.

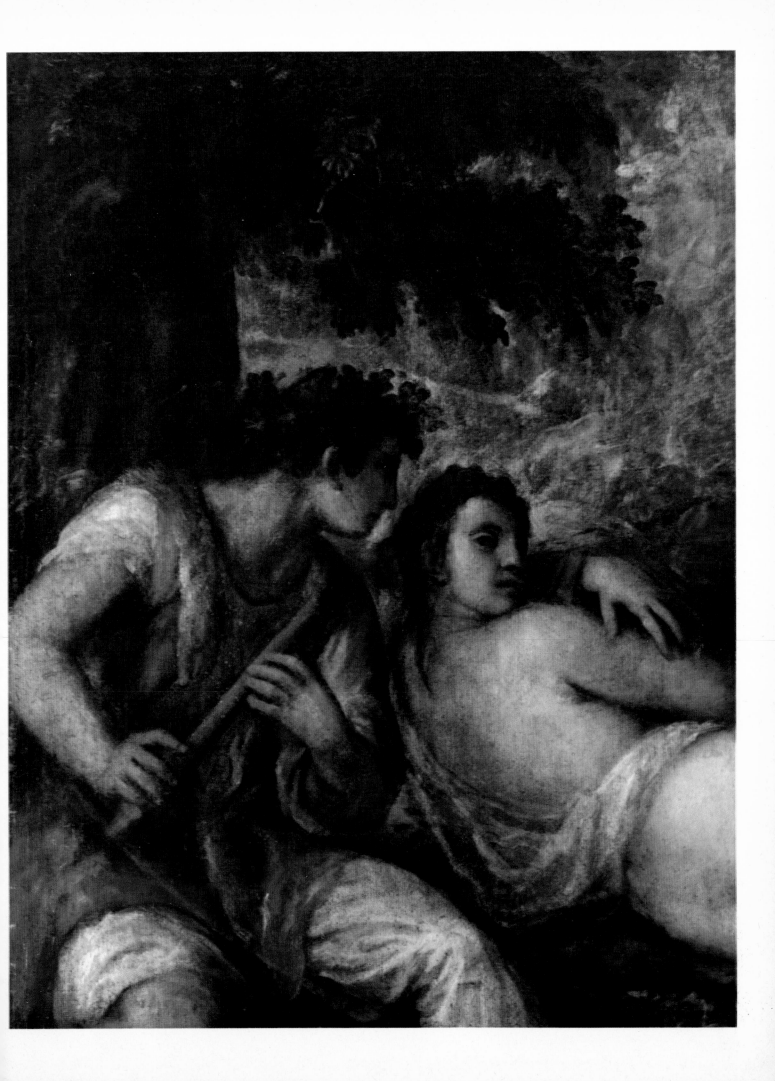

Christext on the Lake of Galilee

National Gallery of Art, Washington, D. C. Kress Collection.

JACOPO TINTORETTO
Venice, 1518–1594.
May have been pupil of Bonifazio Veronese; influenced by Titian, Michelangelo,
Parmigianino and Lotto.

Sunset and Twilight. From the Diaries of 1947–1958.
Harcourt, Brace & World, New York, 1963.

February 8th, I Tatti

Last few weeks have given an hour or more every morning to looking at photos of Tintoretto and Veronese. The pleasure they give me is different in kind from what I receive from looking at photos of earlier works, even when by Titian. They give me a fullness of satisfaction, as if the whole of me was engaged, sensually as well as sentimentally and intellectually. Tintoretto with his penetrating and persuasively convincing portraiture, as well as interpretation of sacred and profane story, and Veronese with his fullness of life as one would live it. Tintoretto's only rival as interpreter is Rembrandt, and Veronese is scarcely paralleled by any till we come to Tiepolo and the French eighteenth-century painters. But they all are on a less vital level, at times bluffing.

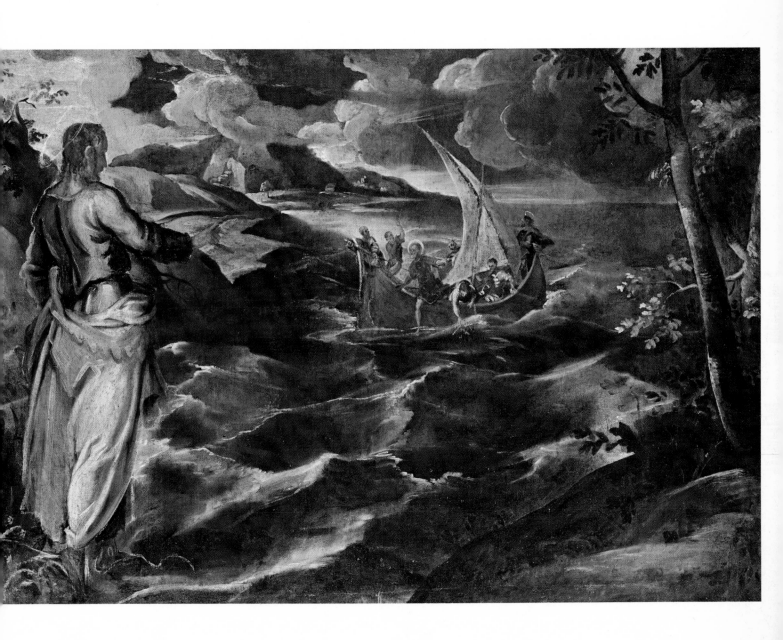

Portrait of an Old Man and a Boy

Kunsthistorisches Museum, Vienna.

JACOPO TINTORETTO
Venice, 1518–1594.

Letter to Mary Costelloe.
Vienna, December 22nd, 1890.

In spite of all Ruskins's ravings Tintoretto is nothing like appreciated as yet. He never will be when regarded merely as literature, although scarcely another Italian painter lays himself out to literary interpretation as he does. But as a painter he takes you to the seventh heaven. A fine sense of interpreting events beautifully, and even romantically he had to an incomparable degree. But even in such paintings as those of the Scuola di San Rocco, Tintoretto is to my mind not so great as he is in portraiture. In this art he combines the stateliness of Titian, the delicacy of complexion of Bordone, and the veracity of Velasquez, not all in the same subject, but as he finds occasion. His doges, his senators, his captains, what a world of magnificent men. Women he scarcely painted at all. Of the many portraits that are here I think I prefer one of an old man with the life almost as extinct as his eyes seem quenched, and a boy beside him. There is scarcely any colour in this portrait. It seems done in five minutes. It has most of the good qualities of Velasquez, and something more — a *Weltanschauung*, if you will. Is it not curious that nothing shows a painter's *Weltanschauung* so well as the portraits he paints.

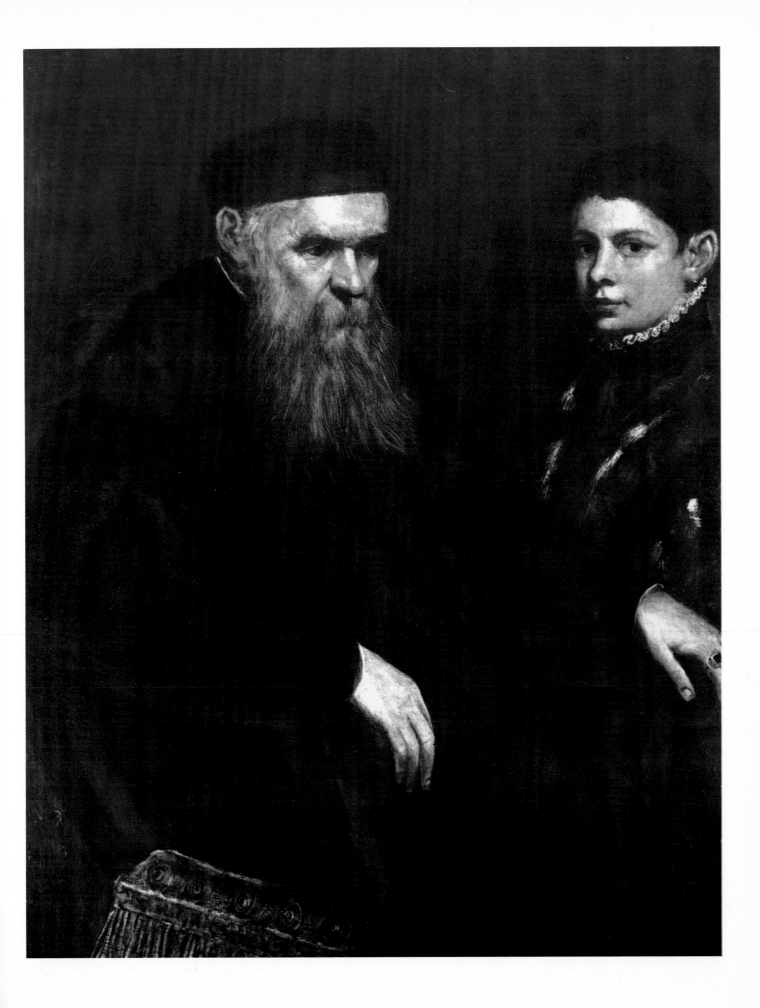

Flight into Egypt

1583–87. Ground floor, Scuola di San Rocco, Venice.

JACOPO TINTORETTO
Venice, 1518–1594.

The Passionate Sightseer—from the Diaries of 1947–1956.
Harry N. Abrams, New York, 1960.

May 18th, Venice
Scuola di San Rocco. Sumptuous, magnificent, spacious this club-house of a Venetian guild. As for Tintoretto's paintings, they compare with Rembrandt for interpretation and as craftsmanship. In one composition, the "Christ before Pilate," he surpasses all other artists who have attempted the same theme. In the "Temptation" Satan is a combination of grossness, impudence and challenging arrogance. The landscapes are among the most romantic ever created, evocative, transporting, nostalgic. In brief, Tintoretto here is as great an illustrator as painting has produced. His colour now is rich and strange, yet satisfying. When these paintings left his hands, they were as dazzling, fresh and radiant as Renoir, as we can see in a bit that was folded back and thus saved from sun and dirt. I am not sure that I don't prefer them toned and mellowed to the condition they are in now.

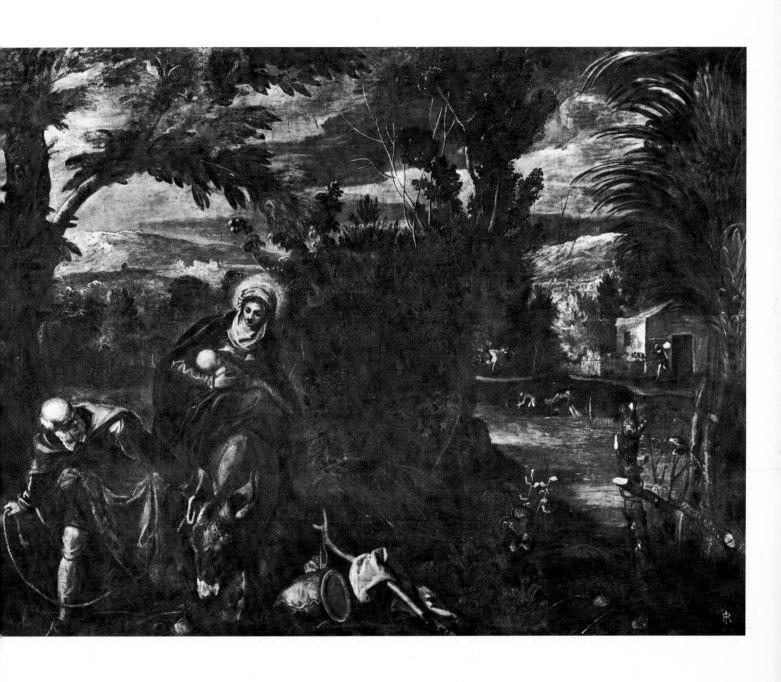

Baptism of Christ

National Gallery of Art, Washington, D. C. Widener Collection.

PARIS BORDONE
Treviso, 1500–1571.
Pupil and follower of Titian, influenced later by Michelangelo.

Pictures in the Collection of P.A.B. Widener.
Volume III: "Early Italian and Spanish Schools."
Privately printed, Philadelphia, 1916.

He was the pupil of Titian during the latter's most Giorgionesque phase, and was greatly influenced by the study of Giorgione's work at first hand. It is evident, too, that, to a somewhat greater extent than most of his Venetian contemporaries, he was acquainted with the types, proportions and composition of Michelangelo.

Christ stands ankle-deep in the Jordan, with hands folded in prayer, turning and bending slightly to our right to receive the water which the Baptist, who stands on the bank, pours over his head from a shallow bowl. On the other bank is an angel in the shape of an adolescent clad in a garment of crushed strawberry, pink and yellow, with his head in profile to our right. All this in the foreground of a lush romantic landscape with a storm gathering in the sky. High up on our left, child angels float in the clouds.

A characteristic achievement of this most opulent and sensuous of Venetian painters. Few works surpass it for luscious saturation of colour and fascinating play of light. Unhappily, it is almost wholly without spiritual content. It was the sumptuous, ceremonial and sensual side of the world that Bordone was born to evoke, and not its indwelling soul.

This canvas must belong to the middle years of his career, but is earlier than the Michelangelesque "Baptism" in the Brera at Milan.

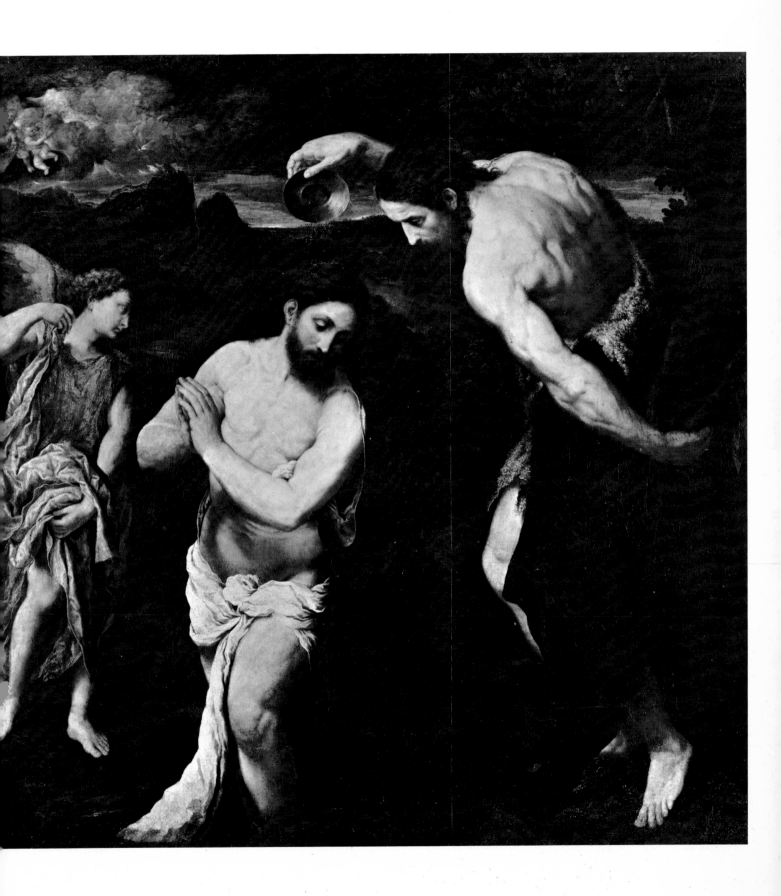

Titian's Schoolmaster

National Gallery of Art, Washington, D. C. Widener Collection.

GIOVANNI BATTISTA MORONI
Albino (Bergamo), 1520/25–1578.
Bergamask pupil of Moretto da Brescia, influenced by Lotto.

Pictures in the Collection of P.A.B. Widener.
Volume III: "Early Italian and Spanish Schools."
Privately printed, Philadelphia, 1916.

He sits sideways to the left, with his left arm extended along the arm of his chair and his hand curving over its rounded end. His body, however, is thrown back, and, like the head, is seen almost facing us. It would seem indeed that, while sitting in profile reading, he had turned suddenly with his lively face and kindly, intelligent eyes to look up at some one who had pleasantly interrupted him, putting meanwhile the fingers of his right hand into his book to mark the place. He is a man between fifty and sixty, and has an intellectual forehead, a strong nose, and a close-trimmed, pointed gray beard. But for a white linen collar, he is dressed in black. The background is gray.

The myth-making spirit of the old connoisseur was seldom more happily inspired than in calling this masterpiece "Titian's Schoolmaster." As a work of art it was regarded as in every way worthy of Titian, and as the sitter had the appearance of a clever and genial man, it was supposed that he must have been Titian's ideal of a schoolmaster. We know better now. The canvas is obviously by Moroni, and neither he nor any other sixteenth-century artist has elsewhere produced a type of the genial scholar as modern as this. If it were not for the costume, he might be living now, or indeed at any time. Here, perhaps even more than in his famous "Tailor," Moroni has freed himself from the conventions of his epoch, without falling into that over-anecdotic characterization which makes the bulk of his work as uninteresting as the average good portrait painted to-day.

Moroni painted this picture during his last years. Three other canvases keep it close and good company. They all represent fine, vigorous, interesting old men seated in their chairs and looking up from their reading.

Portrait of Gian Federico Madruzzo

National Gallery of Art, Washington, D. C. Timken Collection.

GIOVANNI BATTISTA MORONI
Albino (Bergamo), 1520/25–1578.

"The North Italian Painters." 1907.
The Italian Painters of the Renaissance.
Phaidon Press, London, 1952.

Moroni, the only mere portrait painter that Italy has ever produced. Even in later times, and in periods of miserable decline, that country, Mother of the arts, never had a son so uninventive, nay, so palsied, directly the model failed him....

We must judge Moroni, then, as a portrait painter pure and simple; although even here his place is not with the highest.... Moroni gives us the sitters no doubt as they looked, with poses that either were characteristic or the ones they wished to assume. But, with the possible exception of the "Tailor," the result is rather an anecdote than an exemplar of humanity. These people of his are too uninterestingly themselves. They find parallels not in Titian and Velazquez and Rembrandt, but in the Dutchmen of the second class. Moroni, if he were as brilliant, would remind us of Frans Hals.

Venus and Mars United by Love

Signed. 1576–84. The Metropolitan Museum of Art, New York. Kennedy Fund.

PAOLO VERONESE
Verona, 1528–Venice, 1588.
Pupil of Antonio Badile (of Verona); strongly influenced by Brusasorci, Parmigianino and Primaticcio; less, yet noticeably, by Lotto, Moretto, Romanino, and later by Titian.

Sunset and Twilight. From the Diaries of 1947–1958.
Harcourt, Brace & World, New York, 1963.

June 15th, Venice
How account for Paul Veronese! Badile, Primaticcio, Parmigianino, Titian, all may have instructed and influenced him, but at twenty-five at the latest he achieved a serenity, a clarity, a beauty of colour, a form, a composition, nearly perfect and entirely his own. There is a gulf between him and the nearest to him, like Zelotti for instance. He is an instance, an example of sheer genius rivalling Velasquez, and like that great Spaniard springing from a modest provincial source, he from the third-rate Badile, as the other from the even humbler Pacheco. Genius can in no way be accounted for. All attempts merely deal with the circumstances that enable it to flourish, but not to be born.

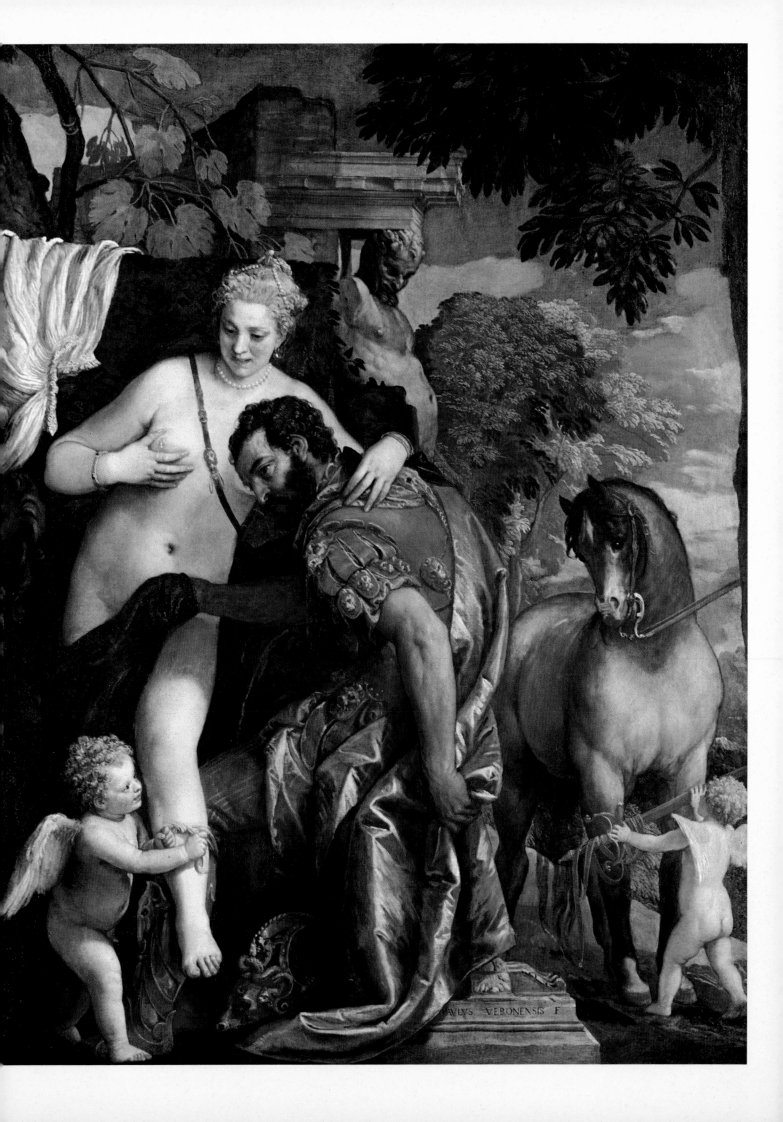

Noblewoman with Old Maid and Lapdog

c. 1561. Fresco. Detail. Villa Barbaro, Maser (Treviso).

PAOLO VERONESE
Verona, 1528–Venice, 1588.

"Paolo Veronese a Maser."
Palladio, Veronese e Vittoria a Maser.
Aldo Martello Editore, Milan, 1960.

What a joyous, life-enhancing, sane, human, and splendid and festive world Veronese plunges us into, and how musically and pictorially he does it. Nothing on walls and ceilings but is an *Augenweide,* a gladness for the eye. The nudes so felicitous in themselves, asking for nothing, making no movement, no gesture not required by the way they act or sit or stand, no appeal to us as spectators, no thought of impressing us, or of asking for our applause. The portraits of the members of the household — the lady on her balcony, the gentleman leaving for the hunt or returning from it — present them in all simplicity... as if not expecting to be seen.

Charming the landscapes, like remembered views of the Italian scene such as are encountered anywhere to the south of the Lombard plain.... When I contemplate Veronese's paintings, I experience a satisfaction so full and perfect that my whole being is engaged — my senses, my faculties, my intellect. If he paints a trifle less subtly than Velasquez or Vermeer, he creates, through his images, much more of a House of Life than either of them, and so, all things considered, I love him at least as much as any painter who ever wielded a brush.

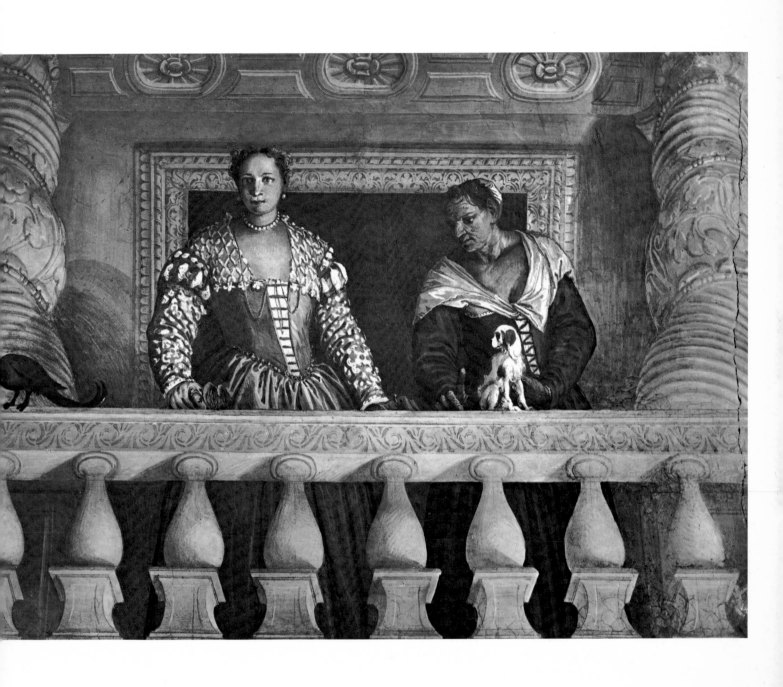

Landscape

c. 1561. Fresco. Detail. Villa Barbaro, Maser (Treviso).

PAOLO VERONESE
Verona, 1528–Venice, 1588.

"Paolo Veronese a Maser."
Palladio, Veronese e Vittoria a Maser.
Aldo Martello Editore, Milan, 1960.

The decoration for the monumental pavilions designed by Palladio and his followers for the gentry of the Veneto was first done at Maser by Paolo as soon as he found himself as an artist. It became the model for all other decorations down to Tiepolo and Tiepolo's imitators and was most closely followed by Paolo's townsman Zelotti at Fanzolo and elsewhere. At Maser we enjoy the first fruits of Paolo's maturity. . . .

Paolo Veronese was one of the artists who helped to make the great of the earth aware of themselves and to live in ways worthy of their status. They stand and move like "gentlefolk," masters of their own destiny. . . . It should be remembered that the Venetian standard of life, owing much to its architects, sculptors and painters, and to Paolo especially, was a standard that gave the tone to the whole of Europe. . . .

Paolo's influence as a painter and decorator was not confined to Venice, where it prevailed over Titian and down to Tiepolo and Tiepolo's followers. It crossed the Alps. The genius of Rubens or Watteau would doubtless anyway have found expression. The expression it found was inspired by Paolo; indeed I feel him in all the French *Dix-huitième*.

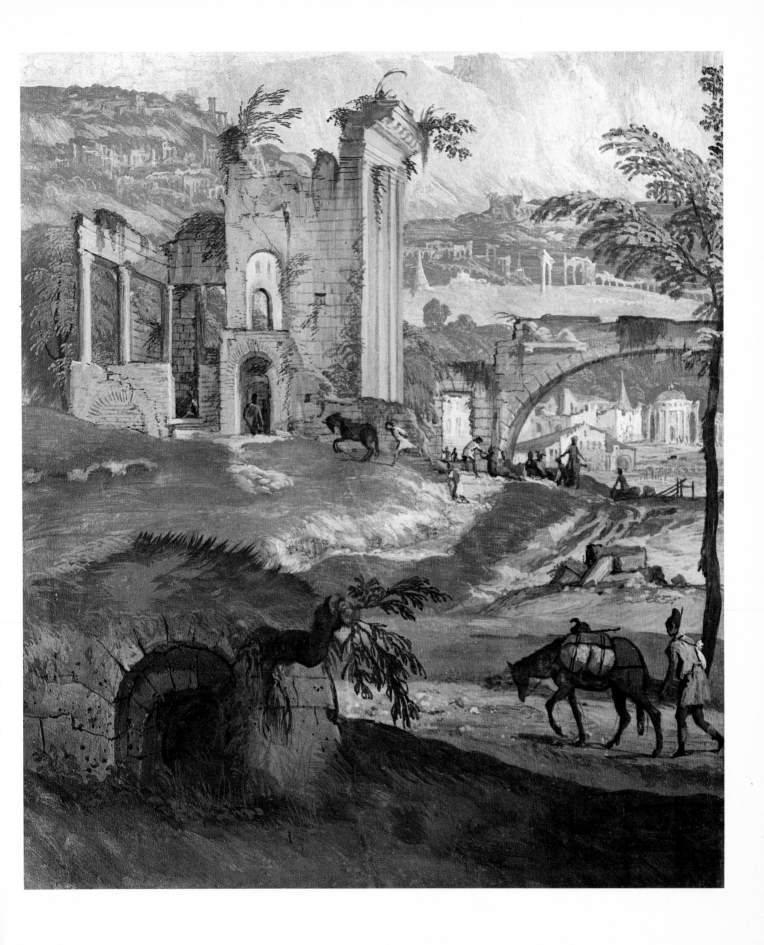

A Basket of Fruit

Pinacoteca Ambrosiana, Milan.

CARAVAGGIO (MICHELANGELO MERISI)
Caravaggio, 1573–Porto Ercole, 1610.
Pupil of Simone Petrazano in Milan; influenced by the Venetians, by Giorgione, Lotto, Pordenone, but also by Savoldo and Sebastiano del Piombo.

Caravaggio: His Incongruity and His Fame. 1950.
Chapman & Hall, London, 1953.

The basket of grapes, apples and figs with their foliage (is) now at the Ambrosiana in Milan. Amber, honey, purple, green, brown, rose, distinct yet singing together, pearly grapes, figs bursting with succulence, bulging apples, leafage still erect, fresh, or on the other hand drying and dropping, but all with contours as precise as jewels. Elegance of every stalk, every vein, every twig. Note that there is but faint indication of a ledge for the basket to rest on, and no suggestion of space, not even of a void, hardly more than in Chinese flower-painting. . . .

We find nearly the same basket of fruit and foliage in two other early works. In the young "Fruit-Seller" of the Borghese Gallery it is almost identical. In the Uffizi "Bacchus" it is more varied and garlands the head.

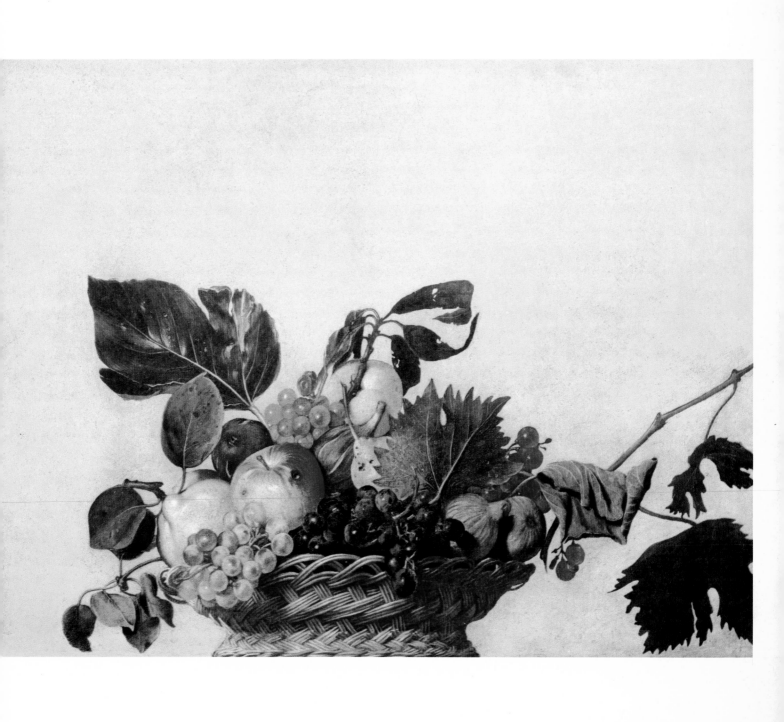

Still Life

National Gallery of Art, Washington, D. C. Kress Collection.

CARAVAGGIO (MICHELANGELO MERISI)
Caravaggio, 1573–Porto Ercole, 1610.

Caravaggio: His Incongruity and His Fame. 1950.
Chapman & Hall, London, 1953.

In the Kress Collection there is a canvas representing pears, apples, grapes, scarcely any flowers and a glass jar half filled with water. This time they rest on a table covered with a cloth and the background is dark. No thought of space.... In Western art from the XIVth century on, flowers rioted over the illuminated vellum and adorned many an altarpiece by Gentile da Fabriano and Angelico. Fruits attracted sculptors first, and Donatello brought them to Padua, where Mantegna, Tura, Crivelli and their fellow-painters gathered them to garland their pictures with. Their flowers more often than not sprang out of vases, or cruses, or bottles, or pots. And everywhere silk hangings, drifted perhaps from far-away China, followed later by Turkey carpets. So many pretexts for the painting of what is now called "still-life." Technique had sufficiently advanced to permit the artist to satisfy his itch to paint what interested him, regardless of symbolical or ethical meaning. Yet nobody thought or dared to make pictures of them in and for themselves, and not merely as ornaments or accessories to sacred subjects. In the North it may have been earlier perhaps, but in Italy still-life came late to a career of its own, later than the first to escape, the portrait, and later even than landscape, which till the XIXth century scarcely ever appears without some faint pretence at a story.

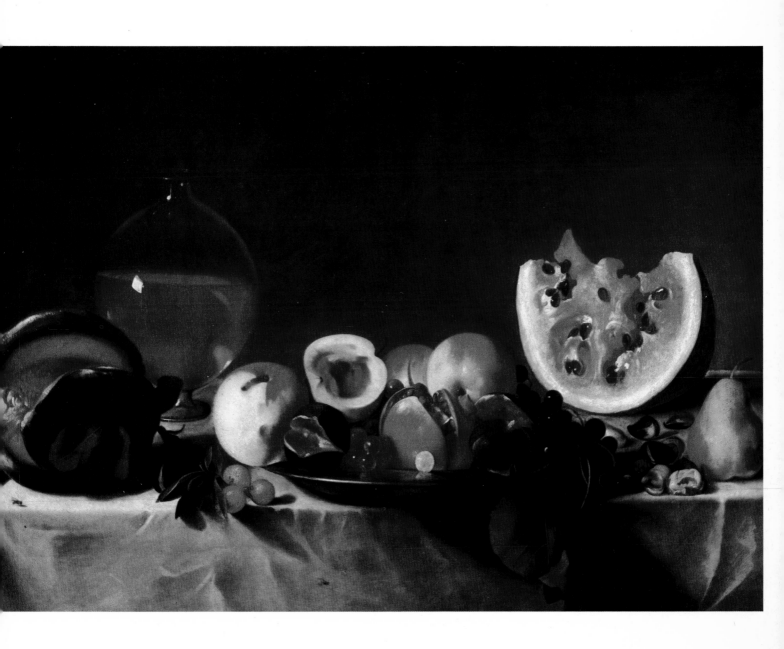

BIBLIOGRAPHY

BY BERENSON

1894 *The Venetian Painters of the Renaissance.* New York and London: G. P. Putnam's Sons. Essay revised and reprinted in *The Italian Painters of the Renaissance;* see under 1930, 1952, 1968. Lists revised and expanded in *Italian Pictures of the Renaissance...;* see under 1932, 1957.

1895 *Lorenzo Lotto: An Essay in Constructive Art Criticism.* New York: G. P. Putnam's Sons. London: G. Bell & Sons. Complete revised edition; see under 1956.

1896 *The Florentine Painters of the Renaissance.* New York and London: G.P. Putnam's Sons. Essay revised and reprinted in *The Italian Painters of the Renaissance;* see under 1930, 1952, 1968. Lists revised and expanded in *Italian Pictures of the Renaissance...;* see under 1932, 1963.

1897 *The Central Italian Painters of the Renaissance.* New York and London: G.P. Putnam's Sons. Essay revised and reprinted in *The Italian Painters of the Renaissance;* see under 1930, 1952, 1968. Lists revised and expanded in *Italian Pictures of the Renaissance...;* see under 1932, 1968.

1901 *The Study and Criticism of Italian Art.* First Series. London: G. Bell & Sons.

1902 *The Study and Criticism of Italian Art.* Second Series. London: G. Bell & Sons.

1903 *The Drawings of the Florentine Painters.* 2 vols. London: John Murray. New York: E. P. Dutton. Amplified Edition; see under 1938.

1907 *The North Italian Painters of the Renaissance.* New York and London: G.P. Putnam's Sons. Essay revised and reprinted in *The Italian Painters of the Renaissance;* see under 1930, 1952, 1968. Lists revised and expanded in *Italian Pictures of the Renaissance...;* see under 1932, 1968.

1909 *A Sienese Painter of the Franciscan Legend.* London: J. M. Dent & Sons. Italian edition, with an epilogue; see under 1946.

1913 *Catalogue of a Collection of Paintings and Some Art Objects [from the Collection of J. G. Johnson].* Vol. I: "Italian Paintings." Philadelphia: John G. Johnson.

1916 *Pictures in the Collection of P.A.B. Widener at Lynnewood Hall, Elkins Park, Pennsylvania.* Vol. III: "Early Italian and Spanish Schools." Philadelphia: privately printed at the DeVinne Press.

 The Study and Criticism of Italian Art. Third Series. London: G. Bell & Sons.

 Venetian Painting in America: The Fifteenth Century. New York: Frederic Fairchild Sherman. London: G. Bell & Sons.

1918 *Essays in the Study of Sienese Painting.* New York: Frederic Fairchild Sherman.

1926 *Speculum Humanae Salvationis.* Oxford: Clarendon Press.

1927 *Three Essays in Method.* Oxford: Clarendon Press.

1930 *Studies in Medieval Painting.* New Haven: Yale University Press. London: Oxford University Press.

 The Italian Painters of the Renaissance. Oxford: Clarendon Press. Contains the four

essays first published separately from 1894 to 1907. For illustrated editions; see under 1952, 1968 (2 vols.).

1932 *Italian Pictures of the Renaissance: A List of the Principal Artists and Their Works with an Index of Places.* Oxford: Clarendon Press. Contains the lists first published separately from 1894 to 1907. Revised, expanded, and illustrated editions; see under 1957, 1963, 1968.

1938 *The Drawings of the Florentine Painters.* Amplified Edition. 3 vols. Chicago: University of Chicago Press. First edition; see under 1903. Reprinted 1970.

1946 *Sassetta, un pittore senese della leggenda francescana* [with an epilogue]. Florence: Electa Editrice. English edition; see under 1909.

1948 *Aesthetics and History in the Visual Arts.* New York: Pantheon. 1950, London: Constable.

1949 *Sketch for a Self-Portrait.* New York: Pantheon. London: Constable.

1950 *Alberto Sani: An Artist out of His Time.* Florence: Electa Editrice.

1952 *The Italian Painters of the Renaissance.* New York and London: Phaidon Press. Illustrated edition of the four essays first published separately from 1894 to 1907.

 Rumor and Reflection. New York: Simon and Schuster. London: Constable.

1953 *Caravaggio: His Incongruity and His Fame.* London: Chapman & Hall. (Italian edition, 1951.)

 Seeing and Knowing. London: Chapman & Hall. (Italian edition, 1951.)

1954 *The Arch of Constantine or The Decline of Form.* London: Chapman & Hall. (Italian edition, 1952.)

 "Decline and Recovery in the Figure Arts," in *Studies in Art and Literature for Belle da Costa Greene.* Princeton: Princeton University Press.

 Piero della Francesca or The Ineloquent in Art. London: Chapman & Hall. (Italian edition, 1950.)

1956 *Lorenzo Lotto: An Essay in Constructive Art Criticism.* Complete revised edition. London: Phaidon Press. First edition; see under 1895.

1957 *Italian Pictures of the Renaissance: The Venetian School.* 2 vols. London: Phaidon Press. Earlier editions, see under 1894, 1932.

1958 *Essays in Appreciation.* London: Chapman & Hall.

1960 *The Passionate Sightseer.* New York: Simon and Schuster; Harry N. Abrams. London: Thames and Hudson.

 "Paolo Veronese a Maser," introduction to *Palladio, Veronese e Vittoria a Maser.* Milan: Aldo Martello Editore.

 One Year's Reading for Fun (1942). New York: Alfred A. Knopf. London: Weidenfeld and Nicolson.

1962 *The Bernard Berenson Treasury. A selection from the works, unpublished writings, letters, diaries, and journals of the most celebrated humanist and art historian of our times: 1887–1958.* Edited by Hanna Kiel. New York: Simon and Schuster. 1964, London: Methuen.

1963 *Italian Pictures of the Renaissance: The Florentine School.* 2 vols. London: Phaidon Press. Earlier editions; see under 1896, 1932.

 Sunset and Twilight. From the Diaries of 1947–1958. Edited by Nicky Mariano. New York: Harcourt, Brace & World. 1964, London: H. Hamilton.

1964 *Selected Letters of Bernard Berenson.* Edited by A. K. McComb. Boston: Houghton Mifflin.

1965 *The Berenson Archive.* Compiled by Nicky Mariano. Cambridge: Harvard University Press.

1968 *Italian Pictures of the Renaissance: The Central Italian and North Italian Schools.* New York and London: Phaidon Press. Earlier editions; see under 1897, 1907, 1932.

The Italian Painters of the Renaissance. 2 volume paperbound issue of the 1952 edition. New York and London: Phaidon Press.

1970 *Homeless Paintings of the Renaissance.* Edited by Hanna Kiel. (Essays originally published from 1929 to 1932.) London: Thames and Hudson. Bloomington: Indiana University Press.

ABOUT BERENSON

1960 *Berenson: A Biography.* By Sylvia Sprigge. Boston: Houghton Mifflin.
1966 *Forty Years with Berenson.* By Nicky Mariano. London: H. Hamilton.

INDEX OF ARTISTS

LIST OF CREDITS

The author and publisher wish to thank the museums and private collectors named in the picture captions for permitting the reproduction of paintings, drawings, and photographs in their possession. The plate on page 313 is reproduced with the gracious permission of Her Majesty Queen Elizabeth II. Photographs have been supplied by the owners or custodians of the works of art except for the following, whose courtesy is gratefully acknowledged: Alinari (including Anderson and Brogi), Florence: 57, 65, 69, 79, 81, 85, 87, 93, 105, 111, 113, 129, 145, 151, 153, 169, 210–11, 213, 215, 227, 230–31, 249, 251, 257, 261, 263, 271, 277, 279, 281, 287, 295, 297, 305, 323, 325, 327, 335, 337, 351; Bazzecchi, Florence: 23, 31, 107, 191, 317; Geoffrey Clements, New York: 91, 253; Conzett and Huber, Zurich: 37, 141, 179; Fiorentini, Venice: 311, 313; Giacomelli, Venice: 347; Keusen, Switzerland: 35; Samuel H. Kress Foundation, New York: 267, 319; Martello, Milan: 2, 73, 89, 103, 123, 149, 177, 209, 243, 245, 265, 273, 275, 299, 301, 331, 349; Yehudi Menuhin, London: 39; Papini, Florence: 27; Scala, Florence: 71, 307; Soprintendenza alle Gallerie, Florence: 33, 67, 95, 119, 127, 131, 139, 161, 173, 183, 185, 197, 303; Walter Steinkopf, Berlin: 171, 175, 181; John Webb, London: 117, 147, 163, 201, 285.